MW00582187

Montage and the Metropolis

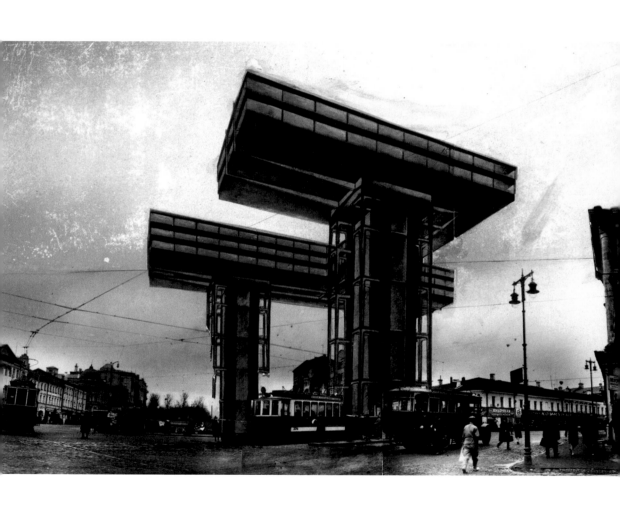

Montage and the Metropolis

Architecture, Modernity, and the Representation of Space

Martino Stierli

Yale University Press
New Haven and London

Published with assistance from the Graham Foundation for Advanced Studies in the Fine Arts.

Copyright © 2018 by Martino Stierli. All rights reserved.
This book may not be reproduced, in whole or in part, including illustrations, in any form (beyond that copying permitted by Sections 107 and 108 of the U.S. Copyright Law and except by reviewers for the public press), without written permission from the publishers.

yalebooks.com/art

Designed by Jeff Wincapaw
Set in Adobe Text Pro by Maggie Lee and Jeff Wincapaw
Printed in China by Regent Publishing Services Limited

Library of Congress Control Number: 2017944507
ISBN 978-0-300-22131-2 (hardcover)
ISBN 978-0-300-24834-0 (paperback)

A catalogue record for this book is available from the British Library.

This paper meets the requirements of ANSI/NISO Z39.48-1992 (Permanence of Paper).

10 9 8 7 6 5 4 3 2 1

Jacket illustrations: *(front)* Paul Citroen, *Metropolis,* 1923, fig. 2.4 (detail); *(back)* Sergei Einstein editing a film, fig. 5.1.
Frontispiece: El Lissitzky, *Wolkenbügel,* fig. 3.16.

To the memory of my parents, in gratitude
To Ilir, with love

Dialectical thought is the organ of historical awakening. Every epoch not only dreams the next, but while dreaming impels it towards wakefulness.

WALTER BENJAMIN
"Paris, Capital of the Nineteenth Century"

The present epoch will perhaps be above all the epoch of space. We are in the epoch of simultaneity: we are in the epoch of juxtaposition, the epoch of the near and far, of the side-by-side, of the dispersed.

MICHEL FOUCAULT
"Of Other Spaces: Utopias and Heterotopias"

Contents

Acknowledgments

This book was written over a period of several years, and many people and the institutions behind them provided invaluable support, guidance, and insight. I first started work on this project as a postdoctoral researcher at the National Centre of Competence in Research "Iconic Criticism" at the University of Basel, where my project was welcomed and generously supported by directors Gottfried Boehm and Ralph Ubl as well as Andreas Beyer. I am indebted to them and to my former colleagues Matteo Burioni, Johannes Grave, Angela Mengoni, Antonia von Schöning, and Arno Schubbach for critical feedback and many insightful comments. As the winner of the Theodor Fischer Prize in 2008, I was fortunate enough to spend a number of fruitful months as a postdoctoral researcher at the Zentralinstitut für Kunstgeschichte in Munich, where Wolf Tegethoff and Iris Lauterbach were generous supporters of my project. Likewise, my postdoctoral fellowship at the Getty Research Institute in Los Angeles in 2012 provided a wonderful opportunity to explore archival holdings and engage in many productive conversations with fellow scholars. My heartfelt thanks go to Thomas Gaehtgens, Alexa Sekyra, and Wim de Wit for providing me with this wonderful opportunity, and to Doris Berger, Shane Butler, Philip Gefter, Joseph Imorde, Thomas Kirchner, Steven Nelson, and John Tain for many shared moments, both intellectual and social.

At the Institute for the History and Theory of Architecture (gta) at the Swiss Federal Institute of Technology (ETH) Zurich, I am indebted to Philip Ursprung for giving me an opportunity to continue my research in a privileged research environment. I am also particularly thankful for the friendship and enriching collaboration with Mechtild Widrich and the entire team of the chair for the History of Art and Architecture as well as many other colleagues at the Institut gta, among them Vittorio Magnago Lampugnani, Bruno Maurer, Ákos Moravánszky, Laurent Stalder, Harald Robert Stühlinger, the late Andreas Tönnesmann, and Daniel Weiss. As the Swiss National Science Foundation Professor at the Institute of Art History at the University of Zurich between 2012 and 2016, I continued to profit from having an excellent framework in which to pursue my research. I am especially thankful to my friends and colleagues Nanni Baltzer, Julia Gelshorn, Bettina Gockel, David Kim, Henri de Riedmatten, and Tristan Weddigen for their friendship and support over the years, and for many stimulating comments and suggestions. My research assistants Luisa Baselgia, Fredi Fischli, Sandra Oehy, and Anaïs Peiser as well as the Mediathek team at the Institute of Art History were all enormously helpful in identifying, collecting, and processing material, for which I owe them my gratitude.

Earlier versions of several chapters of this book were presented in the form of presentations and lectures to various audiences, all of whom provided further invaluable feedback. I would like to mention in particular, at the Princeton University School of Architecture, Stan Allen, Beatriz Colomina, and Hal Foster, and at the Department of History of Art and Architecture at Harvard University, Maria Gough, Robin Kelsey, Neil Levine, and Alina Payne. For their critical feedback in the preparation of these talks, as well as for their friendship and support over the years, I am particularly grateful to Reto Geiser, Andrei Pop, and Thomas Weaver, who helped me to refine my argument in seminal ways. Many other colleagues generously shared insight along the way, and I would like to single out in particular Barry Bergdoll, Giuliana Bruno, Jean-Louis Cohen, Ed Dimendberg, Romy Golan, Dietrich Neumann, Stanislaus von Moos, Anthony Vidler, and Claire Zimmerman for many inspiring encounters.

Many original documents underlying my argument were discovered in various archives, the names of which are listed at the end of this book. I would like to thank all the archivists, research assistants, and other people working behind the scenes without whose insight and patience this publication would not have been possible. At the Department of Architecture and Design at the Museum of Modern Art (MoMA), I wish to thank Pamela Popeson for sharing my enthusiasm about Mies's photomontages and collages many years ago in the museum's storage space in Queens.

In the preparation of the final manuscript, I am deeply indebted to Paul Galloway and Bret Taboada at MoMA's Department of Architecture and Design for providing assistance in many hectic moments. Likewise, I am grateful to Jocelyn S. Wong for proofreading and indexing. As in earlier instances, it has been an enormous pleasure to collaborate with content editor Elizabeth Tucker, without whose sharp insights and suggestions this book would never have reached its current form. I owe her my heartfelt thanks. In the final preparation of this manuscript, I am greatly indebted to the invaluable suggestions and advice by Jean-Louis Cohen, Dietrich Neumann, and two anonymous peer reviewers. At Yale University Press, I am grateful to Katherine Boller for all her help and support in guiding me through the publication process. I am thankful to Laura Hensley for copyediting and to Jeff Wincapaw for his striking layout.

For their financial support of my project at various stages, I am particularly thankful to Iconic Criticism at the University of Basel and to the Swiss National Science Foundation. Furthermore, I am indebted to the Graham Foundation and its director, Sarah Herda, for generously supporting this publication with a grant.

Finally, I am eternally grateful to my late parents, and to my partner and husband, Ilir, for enduring countless hours of loneliness and a long-distance relationship, and for his unconditional love and support, nonetheless.

Introduction

Montage is omnipresent in modern culture and discourse. Rooted in industrial production and popular image practices in the nineteenth century, and achieving its recognizable form in the avant-garde movements of the 1920s, the juxtaposition of photographic elements became, through adaptation and analogy, a primary compositional principle in all artistic media. A direct consequence and function of what Walter Benjamin termed "the age of technological reproducibility," montage addresses the mode of perception specific to the mechanized metropolis. It may therefore be considered a primary cultural technique of modernity, its "symbolic form," to invoke Erwin Panofsky's famous characterization of perspective in the Renaissance. As much as perspective established a system of spatial representation for early modern Western art that encapsulated an entire worldview, montage became defining for Western visual culture in the twentieth century. The Renaissance notion of a continuous and homogeneous space was replaced by the modern notion of a discontinuous and heterogeneous one.

Accordingly, this study understands modernity as the cultural paradigm following industrialization in Europe and the United States from the nineteenth century onward. The combination of steel construction, the railway, the automobile, the skyscraper, and masses of people displaced by war and in search of new forms of employment produced a city that was larger, denser, and taller than ever before and that moved at a faster pace. The scale and speed of the modern city and the new typologies within it enforced changes on the human perceptual apparatus, as was first analyzed by Georg Simmel in his seminal essay "Die Großstädte und das Geistesleben" (1902; "The Metropolis and Mental Life").[1] The modern metropolis required viewers to perceive it in motion, and buildings within it required a sequentialized perception. A great number of adjacent, massive structures could not be apprehended in a single act of viewing. At the same time, new visual technologies, the photographic and soon the film camera, presented themselves both as apparatuses for approaching the metropolis and as metaphors for how it must be approached. In 1941, attempting to convey an image of Rockefeller Center, Sigfried Giedion resorted to photomontage

and commented, "Expressions of the new urban scale like Rockefeller Center are forcefully conceived in space-time and cannot be embraced in a single view. To obtain a feeling for their interrelations the eye must function as in the high-speed photographs of Edgerton."[2] Giedion's photomontage reproduces a pedestrian's experience of discontinuous, mobile, temporally extended perception of mammoth structures incommensurate with the human scale (fig. 1.1). It breaks them down and ultimately makes them more approachable while preserving the effect of their encounter.

I will demonstrate that montage is a technique that is primarily urban, visual, and spatial, addressing the metropolis and its architectural manifestations as phenomena that are negotiated first of all visually. Moreover, it

Fig. 1.1 Photomontage of Rockefeller Center, from Sigfried Giedion, *Space, Time and Architecture: The Growth of a New Tradition* (1941), 576.

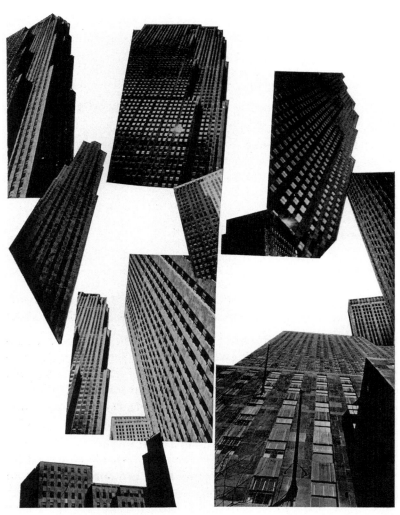

320. Rockefeller Center. *Photomontage. Expressions of the new urban scale like Rockefeller Center are forcefully conceived in space-time and cannot be embraced in a single view. To obtain a feeling for their interrelations the eye must function as in the high-speed photographs of Edgerton.*

is primarily mechanized, in that it is based on the photograph as a proto-cinematic prosthetic of urban vision.[3] At the same time, especially in its early conception, it replaces the monofocal regime of single-point perspective with the shifting perspectives of bodily movement. It cuts down the insurmountable and manipulates the pieces, representing metropolitan space in order to come to terms with it, critically or affirmatively.

While montage in the age of modernity thus served the generally necessary function of coming to terms with the spatial complexities and discontinuities of the metropolis, this function was of prime importance to the discipline of architecture, as the art of the production of built space. In its first architectural use, photomontage was a representational tool that allowed an image of a hypothetical building to be grafted onto a photograph of the real site, lending greater credence to an imagined form through a relationship to the urban context. But the use of montage in its interdisciplinary transit allowed architects to learn from and further develop what visual artists had also concluded about the experience of modern space. Montage became an epistemological tool enabling architects to consider how space had changed under the conditions of modernity so that they could better extend this modern space, or in utopian terms, bring it into realization. Through their engagement with montage as a two-dimensional tool of investigation, architects were able to reconceive three-dimensional space.

In late nineteenth-century France, the word "montage" denoted assembly from prefabricated parts. In the visual arts, the term's usage retained the sense of construction of (an image of) the metropolis from machine-reproduced pieces. If the Dada *monteurs* were initially drawn to photomontage for its destruction of conventional meaning, in their hands montage quickly became meaningful. In theorizing montage as a compositional method that could be applied to writing urban history, Walter Benjamin saw in it the functioning of the Marxist historical principle of dialectic. The dialectical function of montage was also developed by Sergei Eisenstein in his elaboration of a theory for the new visual medium of film, itself produced through the assembly of machine-prefabricated pieces. For both Benjamin and Eisenstein, the perception of contradictory elements in proximity shocks the viewer/reader into intellectual action; the recipient treats the shock by conceiving a synthesis. This aesthetic shock of confrontation with composed, disjunctive elements and the necessity for their synthesis was felt as analogous to the lived experience of the modern city. Although neither Eisenstein nor Benjamin was an architect—even though Eisenstein was indeed trained as an architect and grew up the son of a prominent architect in Riga—both looked to architecture and the physical structure of the city as the key to understanding, for Benjamin, the nature of modern existence and, for Eisenstein, the nature of modern aesthetic perception (which for him is essentially cinematic). Montage, with its ability to make the experience of the city visible and intelligible, became the mode of modern representation par excellence.

As the twentieth century wore on, the city grew larger and more complex, the displacement effects of war were redoubled and globalized, and the metropolis itself became a target of war. This ever-more complex system required a specialized interpreter. The architect, who had learned from the artist in developing montage as a visual tool for understanding the space of the modern city, now learned from the historiographer and turned to literary montage, for which precedent may also have been come from the examples of James Joyce or the French "*nouveau roman.*" Rem Koolhaas saw Manhattan as the "twentieth century's Rosetta Stone" and felt the architect's most pressing task was the written interpretation of its latent content.[5]

In the present study, I consider this multinodal intersection of the visual arts, film, architecture, urbanism, and writing in order to understand the changing vocation of the architect in the modern age as an epistemologist of urban space, with montage as the architect's chief mode of investigation.

TOWARD A THEORY OF (ARCHITECTURAL) MONTAGE

This study traces the evolution of certain montage practices as they became a fundamental research instrument for understanding modern space. Montage has been widely employed and theorized along with practices of artistic production (both visual and nonvisual) that compose works from heterogeneous elements, yet the use of montage in architecture and architectural representation has been given relatively little attention; an attempted definition at this early point in our study will therefore help to narrow the field. Such a definition is necessary especially because the works under our consideration bear a family resemblance—that is, all the works possess many of the same traits, but one work considered in isolation may not show all the traits and may differ from another in the specific characteristics it shows.

1) Montage is defined by a heterogeneity or plurality of the image. Whole reproduced images or their parts are juxtaposed and thus brought into a productive, at times dialectical relationship or synthesis. This heterogeneity or plurality of the image can apply to a work on a single sheet (as in photomontage) or to a sequential work (as in film).[6] In other words, it can be either spatial or temporal. Literary theories of montage have tended to stress the heterogeneity of the montaged text based on the integration of citations. For example, a definition attempted by Viktor Žmegač says: "It can be considered as secured that montage is inextricably connected to the use of 'prefabricated parts,' that is, with materials which then become segments of the newly produced text (work). That technique should be called montage that includes foreign text segments into a proper text in order to be combined or be confronted with it."[7] Such definitions emphasize the distinction between the intrinsic and the extrinsic. To base a concept of montage on this distinction, however, runs the risk of overemphasizing the

question of the origin of the montaged elements. Even though a reconstruction of their original contexts often proves illuminating, it must be underscored that montage produces meaning by combination and juxtaposition; in other words, meaning resides in the way the elements are brought into relation with each another. From the point of view of (visual or textual) heuristics, the referential or indexical dimension of montage is subordinate to the structural dimension. This conclusion is drawn in a famous dispute between art historians Rosalind Krauss and Patricia Leighten with regard to Picasso's cubist collages. Referencing Ferdinand de Saussure's model of structural linguistics, Krauss insisted (in the words of Eve Blau and Nancy J. Troy) "that art, like language, resists fixed meanings; instead, meanings are generated with a system of relationships determined by shifting discursive functions." In Krauss's own terms, "Meaning is always mediated by the system; it is inevitably, irremediably, irrevocably, processed by the system's own structural relations and conventions." This structuralist model lies at the base of the following study, especially as it sees montage primarily as a spatial configuration that produces meaning through adjacency. However, it should be noted that to an extent, the indexical dimension of imported elements is significant in distinguishing collage from montage. That is, Peter Bürger and others have argued that in some cubist examples of collage, it is significant that certain elements come from and point to a real world "outside" art (within the work, they produce meaning through difference from other elements).[8] This distinction will be continued in the section on terms.

While I follow the structuralist model and consider the elements of photomontage as primarily creating significance in relation to each other, montage as a representational system specifically arose to address modernity and the culture of the metropolis, and therefore must be seen not only as a formal problem, but also in a larger sociohistorical context. To view montage in such a context is a primary objective of this study. Moreover, the structuralist understanding of montage itself has a historical dimension. According to the artists who first theorized the phenomenon, montage underwent a process from a primarily destructive to an increasingly productive/constructive device. Raoul Hausmann wrote in 1931, "If photomontage in its primitive form was an explosion of viewpoints and a whirling confusion of picture planes more radical in its complexity than futuristic painting, it has since then undergone an evolution one could call constructive. . . . Photomontage . . . with its opposing structures and dimensions (such as rough versus smooth, aerial view versus close-up, perspective versus flat plane), allows the greatest technical diversity or the clearest working out of the dialectical problems of form."[9]

In the discussion of the inherent plurality or heterogeneity of montage, the question of mediation between the individual elements is another debated issue. Žmegač differentiates between demonstrative (open, irritating) and integrative (disguised) montage.[10] While demonstrative montage displays the breaks and ruptures (and makes use of them for the

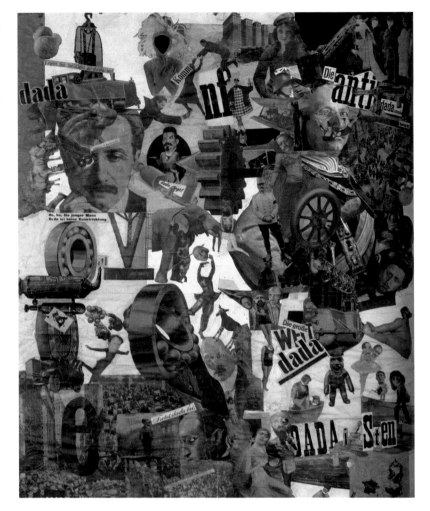

Fig. 1.2 Hannah Höch, *Schnitt mit dem Küchenmesser durch die letzte Weimarer Bierbauchkulturepoche Deutschlands* (*Cut with the Kitchen Knife through the Last Weimar Beer-Belly Cultural Epoch in Germany*), 1919. Photocollage and collage with watercolor, 44⅞ × 35⁷⁄₁₆ in. (114 × 90 cm). Staatliche Museen zu Berlin, Nationalgalerie.

production of meaning), integrative montage seeks to conceal the heterogeneous nature of the image and avoids the dialectical juxtaposition of elements. In the visual arts, demonstrative montage is often employed in order to convey political or polemical messages, such as in the cinematic montage theory of Eisenstein or in works by Berlin Dadaists such as John Heartfield. An exemplary work is Hannah Höch's *Schnitt mit dem Küchenmesser durch die letzte Weimarer Bierbauchkulturepoche Deutschlands,* a full translation of which might read "Cut with the Kitchen Knife through the Last Weimar Beer-Belly Cultural Epoch in Germany" (fig. 1.2). The title directly links the procedure of cutting with a disruptive political program. While Höch directed her knife at contemporary newspaper sources, the surrealist Max Ernst cut and reassembled obscure printed matter from the nineteenth century (fig. 1.3). Ernst concealed the constructedness of his montages and presented his oneiric depictions as taking place in a continuous Euclidian space. Whereas Ernst's disguised collages continued—albeit satirically—the tradition of

Fig. 1.3 Max Ernst, *Die Leimbereitung aus Knochen* (*The Preparation of Glue from Bones*), 1921. Collage on cardboard, 2¾ × 4⅜ in. (7 × 11 cm). Private collection.

the organic work of art of the nineteenth century and its illusionistic space, the Dadaists opposed the traditional idea of art with an exposed, openly imperfect visual configuration. As Žmegač notes: "Whereas covert montage does not break open, but rather affirms the idea of the 'organic' work of art that is sealed by means of illusion, provoking montage resists the conventions of organological aesthetics."[11] The most prominent instance of integrative photomontage in fine art is nineteenth-century composite photography. Needless to say, the openly provocative impetus of demonstrative montage calls for interpretation. Writers such as Ernst Bloch, Theodor W. Adorno, Walter Benjamin, and Peter Bürger have placed it at the center of their aesthetic theories of modernism.[12]

With regard to the relationship between a montage's individual parts and the whole, the term "fragmentation" is frequently used. On the one hand, this term can be misleading, as it evokes an aesthetic of ruins important to a romantic understanding of the work of art. Fragmentation connotes the loss of a preexisting unity, and thus leads away from the question of how montage can produce meaning beyond rupture and loss. On the other hand, the fragment relates to the concept of the *non finito,* in which the work of art presents itself not as a pre-established system of meaning, but one in which meaning is first constructed by the active involvement of the beholder. The fragment as non finito is indeed relevant to montage, where meaning is likewise produced in the mind of the viewer.[13]

Cinematic theories of montage have tended to stress the sequentiality of images and the ensuing narrative structure of filmic montage. The montage of individual shots is seen as a device for activating the viewer, who brings conflicting single images into synthesis. The montage theories of Sergei Eisenstein and their architectural repercussions will be discussed in detail in Chapter 5 of this study. In Eisenstein's terms, a film's activation of the viewer to produce meaning is called "intellectual montage." In the early Soviet Union, the theory of the activation of the viewer is not only

282/01

Fig. 1.4 Bertolt Brecht,
Arbeitsjournal (15 June 1944).
Berlin, Akademie der Künste,
Bertolt-Brecht-Archive.

important for an aesthetics of reception; it also intends real political or social action. In "Montage and Architecture," Eisenstein theorizes architectural perception as a mental montage affecting the viewer's spatial practice. Subsequent to the text's posthumous publication in 1989, a number of architects further developed the notion of the building as a stage for spatial and social practice by openly referencing cinematic theories of montage.

Finally, for historians such as Benjamin and Manfredo Tafuri as well as for Koolhaas, the heterogeneity of artistic montage became a model for a historiographical method that can include a multiplicity of viewpoints, especially those that have been omitted from received accounts.

2) Montage is a spatial constellation. What is already evident in structuralist interpretations of montage has been developed further by theoreticians such as Georges Didi-Huberman. Considering both the open space between the individual elements in the iconic constellation of a montage and the temporal gap between two individual shots in filmic montage, Didi-Huberman insists on the significance of the "interposition" for the production of meaning in the mind of the viewer.[14] If early theoreticians of montage such as Benjamin used "shock" to describe montage's inducement of striking and sudden insights, the montage aesthetic, having been institutionalized and popularized in mass media and commercial culture, has long lost its shocking impact. The proposed reconceptualization of montage as a means for production of meaning through spatial relations provides a highly promising new approach. Didi-Huberman builds on Ben-

Fig. 1.5 Aby Warburg, *Mnemosyne Atlas,* 1924–29, plate 7.

jamin's association of montage with allegory by reformulating it in spatial terms. He reads Bertolt Brecht's *Arbeitsjournal* and *Kriegsfibel,* in which Brecht combined photographs and newspaper cutouts into a "tabular montage"; through their adjacency and juxtaposition, a process of signification is set off in the mind of the viewer (fig. 1.4). Montage, in other words, is concerned with the establishment of a spatial order on the image surface. It is a technique of both spatial representation and spatial research. This understanding underlies the genre of the visual atlas, such as those by Aby Warburg or Gerhard Richter, but also the logic of the picture gallery or exposition.[15] The following study will adopt the spatial understanding of montage as the guiding principle.

Warburg's *Mnemosyne Atlas* (1924–29) is a vast collage of individual photographs mounted on panels; the represented objects include paintings, architecture, sculptures, reliefs, coins, and cameos (fig. 1.5). By

means of the photograph, all these vestiges of human material culture are transported into a flat world where they are brought into a relationship by means of spatial adjacency. Even though architecture only plays a minor role in *Mnemosyne,* Alina Payne suggests that the work can be a model for understanding how architects have made use of images (in the sense of two-dimensional representations) in order to overcome the complicated disorder of the (architectural) world of objects, formed from a complex layering of historical strata. The act of drawing, then, is a way of installing order by means of a two-dimensional abstraction:

> The scientist in his laboratory gaining control over his data is not that different from the architect in his study, coming to grips with the disorder of architecture, forcing it into an order that only abstraction can allow. What is painstakingly dug up and collected needs to be processed and it is the study and the tabletop where drawings, gems, plans, maps, and coins can be looked at and/or produced that permit the selective sorting of material. Small gems and large buildings meet each other on the study table as equals: as scale collapses and the building has shrunk and lies within the power of the viewer, their relative sizes cease to matter. Thus what is large and overwhelming on site is reduced in scale and produces a position of power over the miscellanea that otherwise threaten the ability to synthesize. . . . In final analysis, the architect's worktable is not that different from Warburg's panels from the Mnemosyne: a flat surface upon which heterogeneous information is assembled, thus bringing it within the ordering power of the viewer.[16]

Mnemosyne in particular, and montage as a system of representation based on flatness and the spatial adjacency of heterogeneous elements, would therefore be a model for how the architect makes use of images in the design process. Only pictorial representation allows the designer to come to terms with the complexity of the built world and to impose an order on it that is based on aesthetic considerations.

I contend that montage creates meaning through spatial relationships. In the adoption of montage as a compositional principle in writing, which at least since Gotthold Ephraim Lessing has been considered a "temporal" art form, the printed page undergoes a process of spatialization. Passages appearing side by side (or one below the other) are to be considered quasi-simultaneously, and the visual space between them becomes a space for the viewer's analysis. In *Space, Time and Architecture* (1941), Sigfried Giedion places guiding concepts alongside extended passages of text; in *Delirious New York* (1978), Rem Koolhaas uses blocks of conventionally discursive text under boldfaced single-word headings that introduce a thread of free association. In both works, the juxtaposition of levels of reading (another such level being formed by the images) is enacted on

the two-dimensional space of the page. Meanwhile, in his theorization of film in relationship to prior art forms, Sergei Eisenstein draws from early twentieth-century perceptual psychology in order to conceive of the two-dimensional arts as themselves perceived temporally.

3) Montage is polyfocal and therefore posits a mobile and embodied viewer. If montage is considered not only a spatial constellation but also a means of representing space, it must be seen as a counter-model to the monocular scopic regime of perspective. The concept of polyfocality was introduced by the art historian Werner Hofmann to describe the fact that art before the Renaissance generally allowed a great variety of modes of presentation, points of view, media, styles, and levels of reality within one single depiction, and that it had the tendency to treat single images as part of a larger visual ensemble (such as in an altar).[17] The spectator of such a poly-focal representation is not fixed to one ideal point of view and reduced to a monocular, disembodied entity, as is the case in perspective construction. This applies to montage in modernity as well. That the scopic regime of per-spectivalism underwent a crisis at the beginning of the twentieth century is exemplified by the polyfocality in cubist painting and the invention of cubist collage. In *Space, Time and Architecture,* Giedion argues that cubism brought about a new conception of space that in turn had a great impact on the development of modern architecture. The emerging "new tradition" in architecture is that of "space-time," according to which objects in space are seen "relatively, that is, from several points of view, no one of which has exclusive authority," as in cubist painting. By pointing to the lack of "exclu-sive authority" of any one point of view, Giedion insinuates that this mod-ern conception of space is commensurate with a pluralistic, democratic society, whereas monocular perspective was the scopic regime of absolut-ist rule. (Subsequently, as we will see, architectural historians Manfredo Tafuri and Vincent Scully have demonstrated that the pluralistic under-standing of modern space originates in Giovanni Battista Piranesi's spatial imaginary.) Moreover, Giedion's use of the term "space-time" implies that polyfocal visual perception is temporally extensive, and therefore in keep-ing with modern science: "Space in modern physics is conceived of as rel-ative to a moving point of reference, not as the absolute and static entity of the baroque system of Newton."[18] The crisis in the conception, perception, and representation of space and the ensuing significant transformation at the turn of the twentieth century have also been noted by Henri Lefebvre: "The fact is that around 1910 a certain space was shattered. It was the space of common sense, of knowledge (*savoir*), of social practice, of political power, a space thinkers enshrined in everyday discourse just as in abstract thought, as the environment of and channel for communication; the space, too, of classical perspective and geometry, developed from the Renaissance onwards on the basis of the Greek tradition (Euclid, logic) and bodied forth in Western art and philosophy, as in the form of the city and town."[19]

Although Lefebvre conceives of space mainly as a social and political category, it is significant that he links social systems to conventions of representation. Lefebvre does not explicitly refer to montage, but the grounding of his argument at a specific moment when montage occurred as an artistic and representational phenomenon in the history of the representation of space suggests that it is exactly the new convention he has in mind.

The positing of a mobile and embodied spectator also connects montage closely with forms of cinematic reception. Giuliana Bruno and Anne Friedberg have noted the extent to which cinematic reception must be seen as a spatial practice of embodied movement, or, in Bruno's terms, an instance of "spatio-visuality." Bruno writes: "Film is a product of modernity, the era of the metropolis, and has expressed an urban viewpoint from its very origin. On the eve of the invention of cinema, a network of architectural forms produced a new spatio-visuality. . . . Mobility—a form of cinematics—was the essence of these new architectures. By changing the relation between spatial perception and bodily motion, the architecture of transit prepared the ground for the invention of the moving image."[20] On the other hand, the assumption of a viewer who actively produces space by means of bodily movement also relates montage closely to theories of spatial perception from the late nineteenth century, in particular the writings of August Schmarsow. In Schmarsow's terms, space is perceived through its mediation by the mental image, a process that involves bodily experience as well as the mind's power to imagine.[21] In one possible situation, a viewer in front of a two-dimensional spatial representation produces a virtual space by recollecting actual physical movement. In another, a person viewing an architectural space by walking through it understands the experience by creating a mental sequence of still images. If montage produces a pictorial space, the logic of its perception is similar to that of architectural space.

4) Montage is a consequence of industrialization and the age of technological reproducibility. Etymologically, "montage" derives from the French "*monter*" and originates in the realm of technology. In Denis Diderot and Jean Le Ronde d'Alembert's *Encyclopédie*, compiled between 1751 and 1772, the term "*montage*" relates to ship construction.[22] In early French treatises of architectural theory, the term "*assemblage*" had a similarly technical meaning of the joining of (prefabricated) parts. In his 1770 *Dictionnaire d'architecture*, Charles François Roland Le Virloys defines assemblage as "in general the union and the junction of many parts together" ("*en général l'union & la jonction de plusieurs parties ensemble*"). The author explains that the term is frequently used in carpentry and joinery. A second meaning is associated with the combination of architectural orders in a façade: "Assemblage is also used for the position of the architectural orders, on top of each other, on the façades of large buildings, sacred or profane" ("*Assemblage se dit aussi de la position des ordres d'architecture, les uns sur les autres, dans les façades des grands édifices, sacrés ou profanes*").[23]

In other words, the transfer of the term "assemblage" from a technical to an aesthetic usage dates back at least to the mid-eighteenth century.

In a German-speaking context, the Middle High German word *muntieren* (to install or equip) became "montage" through French influence and took on its technical sense after the Industrial Revolution. The word was introduced as an artistic concept in Dadaist circles after World War I. By referencing industrial production, the pioneers of artistic montage took a stand against bourgeois conceptions of the artist (and of art) and made art a force in the construction of a new society. The open display of the constructedness of their works in demonstrative montage was a rebellion against the classical conception of the work of art as an organic unity to which nothing could be added and from which nothing could be subtracted.[24] While Dadaist montages are of course themselves assembled by hand through an artistic process, photography was chosen as the preferred montage material because it was produced mechanically. A poster at the First International Dada Fair read, *"Dereinst wird die Photographie die gesamte Malkunst verdrängen und ersetzen"* ("One day photography will repress and replace the entire art of painting"). In the revolutionary Soviet context that Dada sought to emulate, the equal value of all aesthetic and nonaesthetic human production was a main tenet; moreover, photography was considered superior to painting because it was closer to fact. Photomontage was thus seen as the vehicle for a radical rethinking of representation in the age of technological reproducibility and political revolution. In a 1926 essay outlining the place of "art in the system of proletarian culture," Boris Arvatov states: "The problem of the reflection of everyday life is a problem of everyday life and can only be resolved on the level of science—with dialectical methods—and technology: photography, film, phonograph, museum, literary records of everyday life—in other words, objective fixation plus dialectical montage of real facts instead of a subjective combination of invented facts, on which such a representational art rests and without which it is unthinkable."[25] In a completely different political context, the German museum director Alexander Dorner also proposed a "way beyond 'art'" in the title to his 1949 study on Herbert Bayer.[26] Like the productivists, Dorner argued that "art" in the traditional sense was no longer viable as a concept of "visual communication" in the modern age. In his view, art's primary social function was to address and engage the public, and this function was in his age best served by graphic design, advertisement, and exhibition design. It is no coincidence that Dorner dedicated his study to Bayer, one of the protagonists of (commercial) photomontage in the late Weimar Republic (who remained prominent well after the Nazi takeover). It could be argued that Dorner transformed montage from a method of avant-garde revolutionary industrial production to one suited to postwar capitalist consumption. As a populist medium, montage was put to use at both ends of the political spectrum. Already in the 1930s, when photomontage was frequently applied in exhibition design on a large scale in the form of "photomurals,"

the application of the medium received a lot of critical attention, as Romy Golan has shown in her groundbreaking study.[27]

Returning to the prewar context, given the close relationship of the term to engineering and industrial production, montage as an artistic category thus openly references the process of (industrial) assembly of prefabricated parts. Even though the underlying division of labor that allows for such a procedure reaches back to the age before industrialization, it is over the course of the mechanization of labor and the invention of the assembly line when montage—or, as it is called in English, "assemblage"—becomes the guiding economic and cultural paradigm. The elements that are subject to montage are the products of a process of industrial prefabrication and technological reproducibility. The newspaper, a quintessential medium of mass production and mass culture and itself structurally a form of montage, became a chief subject of inquiry and source for montage artists. The significance of the illustrated newspaper for the establishment of montage as a visual and intellectual concept can perhaps not be overstated: it was a prime example of visual assemblage and also a source of images.[28] As a visual concept of representation, montage relies on the mass availability of pictures, which was enabled by technological innovations in printing such as the half-tone and offset techniques. Photomontage thus can be seen as a consequence of the development of a modern media society in the early twentieth century. It was therefore also an artistic reaction to what Benjamin H. D. Buchloh has called a "crisis of audience relationships" and the need to reach a mass audience that had been newly formed through the mechanical reproducibility of information and visual media.[29] This transformation was most visible in the emerging metropolis.

5) Montage is a consequence of the perceptual revolution brought about by the modern metropolis and seeks to visualize an (urban) reality not yet seen. Industrialization brought about an entire arsenal of new building typologies such as train stations, arcades, steel bridges, skyscrapers, exhibition halls, and glass pavilions that thoroughly changed the appearance of cities. The invention of modern means of transportation, most importantly the railway, led to an acceleration of perception and a shrinking of space. More and more, the emerging modern metropolis came to resemble what could be called an urban montage. As Eckhard Siepmann has said: "With the industrial revolution the image of the environment, in particular the metropolises, more and more took on a montaged character; the environment increasingly appeared as a reality montage."[30] Or, as Peter Fritzsche remarks with regard to Berlin at the turn of the twentieth century: "The great industrial city, more than any other geographical place, justified turn-of-the-century experimentation with new artistic principles that sought, by technique of shock, juxtaposition, and displacement, to demonstrate the basic incongruity of modern experience." He continues: "The fragmentary nature of the modern city came to be identified with new ways of seeing."[31]

Experimental novels on the modern metropolis made this connection as well, most importantly John Dos Passos's *Manhattan Transfer* (1925) and Alfred Döblin's *Berlin Alexanderplatz* (1929). Both authors eschew traditional narration and structure their texts as a montage of disjointed impressions. These authors were seeking to bring writing closer to photography as an immediate document of the seen, and the newspaper as a form where multiple texts appear side by side.

Meanwhile, visual montage is not merely a representation of the real in the conventional understanding of "representation," but seeks "to extend the idea of the real to something not yet seen."[32] By means of montage, something of the latent deep structure of modernity was to become manifest, something that was not readily available on the level of mere appearances. Montage is able to access what Benjamin called the "optical unconscious" of modern life through the organization and perception of space in the modern metropolis.[33] If the camera is a prosthesis for modern urban vision, montage is a meta-prosthesis. A number of photomontages of the 1920s present the human figure enhanced by technological apparatuses, and the avant-garde filmmaker Dziga Vertov in his filmed manifesto *Man with a Movie Camera* (1929) theorizes the *Kino-glaz*, or "cinematic eye," as vision prosthetically enhanced through the medium of film.

The German sociologist Georg Simmel was among the first to point out the impact of a radically changed urban environment on the perceptual apparatus of its inhabitants. In "The Metropolis and Mental Life," Simmel describes the space of the modern metropolis as organized in a way that resembles what would later become known as montage: "The psychological foundation upon which metropolitan individuality is erected is the intensification of emotional life due to the swift and continuous shift of external and internal stimuli. Man is a creature whose existence is dependent on differences, i.e., his mind is stimulated by the difference between present impressions and those which have preceded. Lasting impressions, the slightness in their differences, the habituated regularity of their course, and contrasts between them, consume, so to speak, less mental energy than the rapid telescoping of changing images, pronounced differences within what is grasped at a single glance, and the unexpectedness of violent stimuli."[34] The "pronounced differences" that Simmel points out are later discussed as dialectical contrast. In "Über einige Motive bei Baudelaire" (1939; "On Some Motifs in Baudelaire"), Benjamin identifies the violent impression of the modern urban environment on the perceptual apparatus as "shock." While in this piece of writing, Benjamin (following Freud) describes the role of the intellect as constructing a shield to protect against shock, in a later essay on Brecht's epic theater, he goes on to theorize that shocks not only have a traumatic aspect; they are also revelatory moments of insight that transform customary experience (*Erfahrung*) into a new experience (*Erlebnis*), bringing the unconscious into awareness: "Like the pictures in a film, epic theater moves in spurts. Its basic form is that of the shock

with which the single, well-defined situations of the play collide. . . . This brings about intervals which, if anything, impair the illusion of the audience and paralyze its readiness for empathy. These intervals are reserved for the spectators' critical reaction."[35] Here shock is a mechanism that allows the theater viewer to reflect critically upon what he or she is presented with. The precondition for this critical stance is the open display of the mechanism of dialectical montage, which Benjamin relates to film.[36]

Benjamin's conception of the "dialectical image" became a fundamental principle of his theory of history. The *Passagenwerk* (1927–40, unfinished; *Arcades Project*) was to be a work of materialist historiography demonstrating the emergence of modernity; in it, montage is both the model for the structure of the text and an epistemological tool for explaining historical evolution based on dialectics.[37] Inspired by the transformation of the city of Paris into a modern metropolis over the course of the nineteenth century, the *Arcades Project* takes architecture as its subject matter: the modern metropolis and its new building typologies are treated as the most evident manifestation of the age of modernity. Benjamin's understanding of montage is inextricably woven into the discourse of modern architecture: first, his theory of montage as a meaning-generating tool based on dialectical juxtaposition is itself founded on construction principles of modern architecture, in particular Sigfried Giedion's reading of them in his 1928 *Bauen in Frankreich* (*Building in France*); second, Benjamin's historiographical methodology seems also to have served as a model for Rem Koolhaas's application of literary montage in *Delirious New York,* in which Koolhaas unearths the "unconscious" history of the quintessential modern metropolis.

Following writers such as Simmel and Benjamin, Manfredo Tafuri saw the (montaged) condition of the modern metropolis, its consequences for (visual) perception, and the ensuing experience of "shock" as a precondition and defining element of the architectural avant-gardes.[38] In Tafuri's account, which we will follow here, the modern metropolis and the principle of montage converged and formed the base for modern architecture culture of the twentieth century.

MONTAGE AND RELATED TERMS

Now that we have tried to define the five critical features of montage—as a concept of the artwork that is heterogeneous, spatial, polyfocal, oriented to mass reproduction, and dialectical or epistemological—it seems useful to place montage alongside related techniques in order to distinguish what montage is not. This is no simple undertaking, since on the one hand, montage is related to collage and was only recognized as a distinct genre in retrospect (if at all), and on the other hand, because "montage" and "assemblage" have different degrees of semantic overlap in the different language traditions. I will aim to give credence to legitimate—at times productive—gray areas while allowing a distinction to emerge.

Assemblage

As we have already seen, in a French context there is significant overlap between the terms "montage" and "assemblage." Both have been in use in architectural theory for centuries with strong technical connotations. In English, "montage" is a loan word from French referring specifically to the artistic technique (with its technical connotation), while "assemblage" at least since the eighteenth century referred to joinery and took on the industrial connotation in connection with the assembly line. The *Oxford English Dictionary* quotes *The Practical Dictionary of Mechanics* from 1875: "This system of interchangeability and assemblage . . . is one of the most beautiful triumphs of modern mechanism."[39]

In more recent architectural theory, Tafuri theorized montage as the cultural technique commensurate with the economic principle of standardization and the assembly line. Therefore, the English translation of Tafuri's *Progetto e utopia* (1973; *Architecture and Utopia*) uses "assembly" as the primary English concept and translates "*montaggio*" as "assemblage": "For all the avant-garde movements—and not only in the field of painting—the law of assemblage [*montaggio*] was fundamental. And since the assembled objects belonged to the real world, the picture became a neutral field on which to project the *experience of the shock* suffered in the city. The problem now was that of teaching that one is not to 'suffer' that shock, but to absorb it as an inevitable condition of existence."[40] "Assemblage" as an artistic procedure that is not necessarily related to industrial prefabrication was first introduced in 1953 by the French artist Jean Dubuffet, who applied the term to three-dimensional works of art composed from heterogeneous elements.[41] This understanding was popularized by the 1961 exhibition *The Art of Assemblage* at the Museum of Modern Art in New York, curated by William C. Seitz. It was an early attempt to historicize and subsume phenomena such as collages, ready-mades, *objets trouvés,* and combine paintings, which were central for twentieth-century art as manifestations of a tradition stemming from cubist collage and the crisis of representation it epitomized. Seitz argues in his introductory text that "the practice of assemblage raises materials from the level of formal relations to that of associational poetry." He particularly stresses the structural closeness of assemblage to everyday life, as Peter Bürger would a few years later—a connection that was also important in Soviet theorizations of photomontage.[42] However, in a Soviet context, the link between everyday life and industrial production was primary; in the United States, at least in the sphere of art, this link was less significant.

In architecture, while both "montage" and "assemblage" relate strongly to industrial prefabrication, "montage" carries the additional connotations of cinematic montage (in the sense of editing) and photomontage. Thus "montage" is strongly related to pictorial representation, whereas "assemblage"

is not. It is for this reason that my study favors the term "montage" over "assemblage," despite diverging usages in English.[43]

Collage

Many accounts fail to make a clear distinction between montage and collage, although the terms signify two different things. Excluding some earlier practices in folk art, artistic collage emerged around 1910 with *papier collé* and is closely linked to painters such as Pablo Picasso and Georges Braque. For its part, montage as a high-art practice generally refers to photomontage. While similar artistic practices can be dated back almost to the invention of photography, the invention of photomontage in the proper sense is generally credited to the circle of the Berlin Dadaists after World War I—though the exact circumstances of this invention are subject to much mythmaking by the protagonists. While authors such as Herta Wescher and Hanno Möbius have interpreted photomontage as an extension of collage practices, it should be underlined that photomontage was conceived as both extending and opposing collage.[44] While cubist collage rejected romantic concepts of artistic invention, montage specifically responded to new possibilities of mechanical reproduction; industrial production and the assembly line are not referenced by collage and collage artists. The etymology of "collage" from the French "*collé*" (glued) points to these works' positioning in the tradition of handcraft. Photomontages were also assembled manually by their producers, but the reuse of industrially reproduced materials and images was essential to the concept.

I differentiate between collage and montage on the basis of three key notions. First, the combining of heterogeneous elements is characteristic of both collage and montage, but their dialectical juxtaposition is the domain of montage. Second, collages draw their force from the inclusion of objects or object fragments from outside the confines of art; montages, on the other hand, use generally photographic representations of objects or images rather than the objects themselves. Collage imports "real" elements into the world of art, whereas all the elements of montage simultaneously come from "outside," in that they are taken from non-art sources, and "inside," in that they are reproductions.[45] Collage is symptomatic of a crisis of representation, directly presenting fragments of reality rather than re-presenting them, whereas montage is the affirmation of the work of art in the age of technological reproducibility. Hence, montage embraces representation, albeit in an altered sense. Third, the inclusion of objects rather than representations of them means that collage is subject to tactile perception, at least on behalf of its maker; montage fundamentally is not. Some photomontages, as in the later works of Mies van der Rohe, include collaged elements. This strategy indicates Mies's affinity with modernist painting and its preoccupation with flatness, a value that became more important to him than dialectic or poly-perspectivalism. This shifting sensi-

Fig. 1.6 John Heartfield, *Die Rationalisierung marschiert!* (*Rationalization Is on the March!*). Photomontage for *Der Knüppel*, no. 2 (February 1927): 5. Heartfield-Archiv, Akademie der Künste zu Berlin.

bility is indicative of the postwar consumerist aestheticization of formerly avant-garde productivist tenets.

Perhaps the most seminal contribution to the theoretical separation of collage from montage is performed by Peter Bürger in *Theorie der Avant-garde* (1974; *Theory of the Avant-Garde*), although he considers collage a rudimentary form of montage that was brought to completion by the avant-gardes. For Bürger, in collage the contrast between painterly abstraction and the "'illusionism' of the reality fragments that have been glued on the canvas" is essential. Despite the disruption these fragments perform, the cubist work of art remains "largely subordinate to the aesthetic composition." By contrast, Dadaist montages call art itself into question. Therefore, the political photomontages of John Heartfield, for Bürger, are "not primarily aesthetic objects, but images for reading (*Lesebilder*)" (fig. 1.6). These montages must not be seen as works of art in the conventional sense, but rather as visual media that serve a didactic purpose. However, if the avant-garde project began as fundamentally critical of bourgeois society, the blurring of the boundary between "art" and "life" (by means of montage) eventually led to the loss of critical distance. This loss was mirrored in the culture industry itself.[46]

Bürger is right in concluding that the use of montage is not inherently "critical"; the principle was (ab)used successfully throughout the 1930s to propagate the cause of fascist regimes. In the final paragraph of his montage chapter, Bürger makes clear that montages are also concerned with the production of meaning: "Even the avant-gardiste work is still to be understood hermeneutically (as a total meaning) except that the unity has integrated the contradiction within itself. It is no longer the harmony of the individual parts that constitutes the whole; it is the contradictory relationship of heterogeneous elements. . . . A critical hermeneutics will replace the theorem of the necessary agreement of parts and whole by investigating the contradiction between the various layers and only then infer the meaning of the whole."[47] Thus, although he defines montage more broadly and places more emphasis on the indexical nature of its elements, Bürger ultimately comes close to an understanding of montage as a dialectical method of meaning production.

The preeminence of collage as an architectural concept is owed mainly to Colin Rowe and Fred Koetter's 1978 work *Collage City,* which was in circulation since the early 1970s and advanced to the status of a manifesto of the postmodern city.[48] Rowe and Koetter begin by assessing the failure of modernist planning doctrine to transform cities according to their principles. If modernist utopias have indeed been realized, the authors argue, this has occurred not on the level of the city, but on the level of individual objects, leaving the city of the present as a sort of scar tissue on which contradictory concepts of urbanism (traditional versus modernist) clash. The contemporary city thus resembles a palimpsest of widely different historical concepts. Rowe and Koetter call for a reconciliation between the traditional and the modernist city based not on assimilation, but on the articulation of difference. Their idea of difference, however, is not dialectical but based in gestalt theory and its opposition of figure and ground. The intellectual genealogy of *Collage City* is thus widely different from that of the (architectural) montage theories outlined above.

For Rowe and Koetter, accepting the modern metropolis as an accumulation of fragmentary realizations of urban utopias means, at the same time, that architects should refrain from total design and learn to read the city and intervene in a preexisting fabric rather than insisting on a tabula rasa. The architectural historian Wolfgang Pehnt characterizes such "involuntary collage" as the basic generative principle throughout architectural history, thus implying that *Collage City* meant nothing less than a return to the *courant normal* of architectural history after the modernist interlude.[49] In our account, *Collage City* is most important because of its role in the intellectual generation of *Delirious New York*. While Koolhaas shared institutional connections with Rowe and studied his book carefully, he (implicitly) criticized the work's apolitical, aestheticizing stance. The concept of urban montage Koolhaas developed was instead intentionally oriented to cinema and dialectics.

Bricolage

In *La pensée sauvage* (1962; *The Savage Mind*), the French anthropologist Claude Lévi-Strauss proposes a fundamental distinction between pre-scientific and modern, scientifically founded cultural practice. His theses are the subject of a chapter in *Collage City,* "Collision City and the Politics of 'Bricolage.'" Koetter and Rowe thereby introduce Lévi-Strauss's terminology into architectural discourse and bring "collage" and "bricolage" into analogy.[50] According to Lévi-Strauss, while modern thinking and cultural practice are informed by rationality and the model of the engineer, mythological, pre-scientific thinking is based on improvisation and happenstance availability, which he calls "bricolage." The anthropologist explains the nature of bricolage (and, by extension, mythological thinking) as follows:

> The "bricoleur" is adept at performing a large number of diverse tasks; but, unlike the engineer, he does not subordinate each of them to the availability of raw materials and tools conceived and procured for the purpose of the project. His universe of instruments is closed and the rules of his game are always to make do with "whatever is at hand," that is to say with a set of tools and materials which is always finite and is also heterogeneous. . . . [The bricoleur's] first practical step is retrospective. He has to turn back to an already existent set made up of tools and materials, to consider or reconsider what it contains and, finally and above all, to engage in a sort of dialogue with it and, before choosing between them, to index the possible answers which the whole set can offer to his problem. He interrogates all the heterogeneous objects of which his treasury is composed to discover what each of them could "signify" and so contribute to the definition of a set which has yet to materialize but which will ultimately differ from the instrumental set only in the internal disposition of its parts.[51]

Collage and bricolage are thus both concerned with the production of artifacts from preexisting materials through improvisation; they are, to some extent, an aesthetic of scarcity. However, while the bricoleur can never go outside a circumscribed set of materials, the collagist reaches beyond the worn-out fine-art tool kit to find everyday materials and objects; their use occurs in the specialized frame of a self-conscious aesthetic activity of meaning production. The collagist is therefore an engineer claiming to be a bricoleur in the self-conscious implementation of certain materials that happen to be at hand, while the montagist is an engineer outright. Montage is the specialized tool conceived for the new purpose of representing the modern city on the basis of a specially procured technological material, the photographic reproduction. It is fundamentally an artistic and

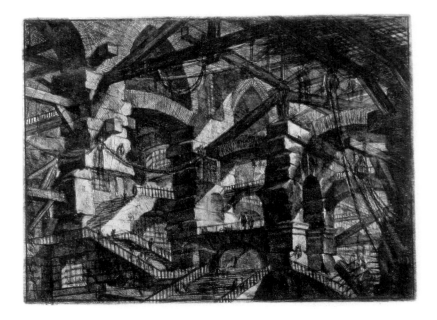

Fig. 1.7 Giovanni Battista Piranesi, *The Gothic Arch*, 1745. Etching, 16 × 21 in. (40.6 × 53.3 cm), from *Carceri d'invenzione* (*Imaginary Prisons*), plate 14.

epistemological practice of the age of modernity, whereas bricolage fundamentally is not.

Theoretical attempts have been made to describe contemporary architectural production based solely on the combination of prefabricated elements, seeing it as an actualization of the principle of bricolage in the age of advanced capitalism. In *Adhocism: The Case for Improvisation* (1973), Charles Jencks and Nathan Silver argue: "Perhaps the largest implications of adhocist means, method and sensibility in architecture suggest that adequate shopping for parts is crucial. In adhocism's full stylistic swing, a good architect would be a consummate shopper."[52] In this study, I am not interested in adhocism as late-capitalist bricolage in which all possible tools and materials are already commercially available. I consider this approach distinct from montage as a representational and epistemological method that allowed architects to arrive at a new understanding of modern metropolitan space, both visually and through writing.

Capriccio

The approach to design described as "adhocism" can be further elucidated with respect to the baroque artistic genre of capriccio. Unlike in the previous comparisons, the distinction between montage as we have been discussing it and capriccio is quite plain. However, capriccio is a main precursor for postmodern design strategies that are often termed "collage," although they are quite distinct from what I theorize as "montage" in this study. Simultaneously, Piranesi's *Carceri* (*Prisons*)—which are not an example of capriccio, although their artist did practice the genre on other occasions—are a fundamental precursor of montage in the proper sense, as an

Introduction

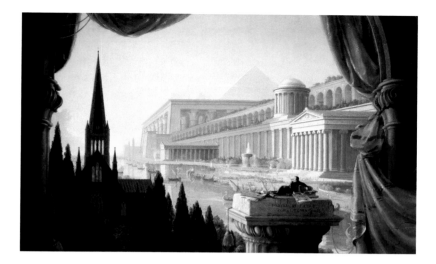

Fig. 1.9 Thomas Cole, *The Architect's Dream*, 1840. Oil on canvas, 53 × 84¹/₁₆ in. (134.7 × 213.6 cm). Toledo Museum of Art. Purchased with funds from the Florence Scott Libbey Bequest in Memory of her Father, Maurice A. Scott, 1949.

and Koetter also reference the Canaletto painting that Rossi discusses in order to theorize an aesthetic perceptual disjunction that, however, does not have a dialectical effect.[57]

A related case involves Thomas Cole's painting *The Architect's Dream* (1840) (fig. 1.9). Cole's fantasy places the dreaming architect on a transhistorical stage with a set composed of iconic elements. Robert Venturi and Denise Scott Brown turned Cole's painting into a programmatic visual statement of the design principles of contemporary architecture when they superimposed it with the signage of the Las Vegas strip.[58] Perhaps this work could be considered a boundary case. While the antiheroic satire does achieve its effect through juxtaposition and contrast, it might be considered an architectural equivalent of collage, in that its main concern is the importation of quotidian objects into the world of art. However, the work's comic effect glosses over the contradictions and violent tensions inherent in the high/low cultural divide and the privileged position of architects in their discretionary (or touristic) relationship to "low" culture as that which has no history. Nevertheless, it could be said that Venturi and Scott Brown's modification brings Cole's painting closer to a modern understanding of the dream as a space where the unconscious reveals itself. Making the metropolitan unconscious visible is a primary function of montage in this study.

MONTAGE IN MULTIPLE TAKES

Artists of photomontage used jumps in scale to represent the hugeness of the modern metropolis and the plethora of detail it contains. This will be my approach to the gargantuan cultural phenomenon of montage. I will apply a structural poly-perspectivalism to allow lesser-known narratives to stand side by side with canonical accounts.

Chapters 2 and 3 are survey chapters devoted to photomontage in the 1920s and 1930s in fine art and in architectural representation, respectively.

A relatively little-studied work, Paul Citroen's *Metropolis* (1923), is considered a quintessential photomontage that deals with the problem of modern urban space, while the fine-art medium's roots in popular printed matter and its impact on advertising design are also examined. In architecture, montaged representations of proposed projects were first of all a pragmatic use of the new medium of photography that capitalized on its "reality effect"; the juxtaposition of project and site becomes dialectical in the visionary projects of the avant-garde such as El Lissitzky's *Wolkenbügel* (1924; literally, "Cloud Hanger"). At the same time, manipulated architectural photography is put to political use in the historic preservation and *Heimatschutz,* or homeland preservation, movements. The affinity between visual and written representations of architectural space is introduced in the figure of Sigfried Giedion.

Then, Chapters 4 and 5 are each devoted to a single protagonist, Mies van der Rohe and Sergei Eisenstein, respectively. Each of these figures begin with avant-garde, dialectical photomontage as a foundational concept and become increasingly concerned with the problem of transparency, with quite different effects. Mies learns the power of dialectic from exposure to Dadaist photomontages and, like other utopian urbanists, he uses it to oppose the urban reality with a visionary (near) future in the Bahnhof Friedrichstraße skyscraper project. In exile in the United States, Mies "moves into the tower," so to speak, in his country house projects, developing a conception of space in which the transparent windows function as impenetrable walls. One criterion of photomontage that Mies's later works effectively counteract is its positing of a mobile viewer. This criterion was of fundamental importance to Eisenstein as developed in his essay "Montage and Architecture," in which he theorizes architectural perception as a sequential mental montage analogous to film. Later, in the unrealized film project *Glass House,* transparent architecture—quite likely inspired by Mies's Friedrichstraße skyscraper project—is a self-reflexive metaphor for film production, at the same time as it allegorizes glass as the commodifying material of a display culture.

Finally, Chapter 6 is devoted to a single work, Rem Koolhaas's *Delirious New York,* for which the dialectical montage structure of the city becomes a model for its written representation in "blocks" of text. Urbanism in writing becomes the primary task for the architect as the unit of the individual building becomes less significant, "surrendering wholeheartedly to the needs of the metropolis."[59] In reconceiving the architect's vocation, Koolhaas draws from earlier models of montage-based architectural historiography, Benjamin's *Arcades Project* and the writings of Tafuri. In the late twentieth century, metropolitan montage becomes an increasingly encyclopedic medium of pluralism. While the number of montage elements increases, the elements taken individually begin to exhibit self-similarity. Koolhaas understands the city as an archipelago of unmediated islands; in a telescoping view, each island can itself be an archipelago. The increasing

levels of focus in the chapters of this present study, from a survey of examples from the 1920s to *Delirious New York,* likewise allow a microcosm in the overall picture of montage to become a macrocosm.

In a different take, the book could also be divided according to media: Chapter 2 is devoted to fine art; Chapters 3 and 4 to architecture; Chapter 5 to film and its relationship to architecture as a proto- and post-cinematic medium; and Chapter 6 to urban historiography, with a cinematic approach. This perspective allows an understanding of montage as a wide-reaching cultural technique that evolved in an increasingly interdisciplinary era, but that is primarily urban in its subject matter and method and that therefore is preoccupied, across media, with coming to an understanding of modern metropolitan space through its architecture. At the same time, this approach maps a shift in disciplinary self-conception from architecture as a visual medium, wherein the architect's job is to design buildings and plan urban interventions, to architecture as the cultural theory of (late) modernism.

Other important narratives run through these chapters. One follows montage in cultural transit from East to West (and vice versa): the first publication of the word "photomontage" occurs in the Soviet magazine *LEF* in 1924, to which Eisenstein was a contributor; Citroen's *Metropolis* is reproduced in the same issue. Eisenstein meets Benjamin at the turn of 1926–27 and Le Corbusier in 1928. Corbusier in Moscow undergoes Nikolai Ladovsky's psychotechnical experiments, which were an important foundation of Eisenstein's theories. The international travel and idea-sharing of artists and urbanists is also politically inflected. Giedion sends Stalin a polemical photomontage criticizing his neo-classicist design selection for the Palace of the Soviets. Eisenstein's own theories change from a strongly materialist intellectual montage to a more organicist sequential montage according to changes in policy from Lenin's to Stalin's regime. In the West, montage is appropriated in fascist graphic design. The medium's roots in popular media and suitability for representing the mass scale make it highly suited to propaganda. The requirement that practitioners of montage comply with totalitarian political agendas, in fascist Germany and Italy as well as Soviet Russia, further cements this relationship. In propagandistic montage, the function of the "gap" between elements is inverted; rather than a space of intellectual productivity, it becomes a space of willed ignorance. In the later works of graphic designer Herbert Bayer, who for a while complied with the Nazi agenda by choosing to stay in Germany for as long as possible, the number of fragments is reduced, their shape and positioning becomes orthogonal and symmetrical, and the perspective is unified. The same can be said of Mies's later montages from his postwar American career, which are so pared down that they are more properly termed "drawings."

This transit in the political application of montage from a revolutionary to an establishment medium is also evident in its aesthetic history. First, as a record of changes in perception that are the result of technologized

construction, transit, and communication practices, and as the voice of mass experience of confrontations with scale and number, it disrupts a bourgeois understanding of the artwork as a unified entity designated for privileged contemplation. In architectural application it allows utopian visions to be grafted onto the existing cityscape. In its written form as urban historiography, it allows untold stories to seep through the cracks in received narratives. In the later twentieth century, as an encyclopedia or compendium, it becomes the medium of pluralism and pluralist agency. It resists attempts at urban planning as top–down control. Meanwhile, it is diluted in capitalist consumer culture. As the widespread reception and canonization of *Delirious New York* attests, montage becomes indisputable at the same time as the technological prerequisites from which it emerged themselves start to change. This trajectory from means of resistance to that which ultimately also requires resisting, in both political and aesthetic spheres, is a testament to the power of montage in its articulation of modern metropolitan experience.

STATE OF RESEARCH

The body of research on collage and montage in the visual arts, important aspects of which have already been pointed out, is vast and multilayered. Rather than attempting to catalog it conclusively, I will briefly discuss a few contributions here that are important to my study. In 1989 Katherine Hoffmann presented a collection that brought together current research along with a historical survey of the theory of collage and montage from the 1960s up to the late 1980s.[60] The volume includes classics of modernist art theory such as Harold Rosenberg and Clement Greenberg; William C. Seitz's introduction into his seminal 1961 exhibition on assemblage; studies on Picasso's collages by Robert Rosenblum, Patricia Leighten, and Christine Poggi; as well as contributions on Eisenstein's montage theory, video art as collage, and so on. No clear distinction is made between collage and montage in this book, which serves more as a compendium of the already large and widely diverging scholarship on the topic, without a precise theoretical framing or specific focus. Most importantly, the volume includes Gregory L. Ulmer's essay "The Object of Post-Criticism" (1983), in which the author interprets collage/montage as the foundational principle of (then) contemporary deconstructivist philosophy, in particular that of Roland Barthes and Jacques Derrida.[61] With respect to the latter, collage/montage is founded on the double-bind between presence and absence, and therefore an instance of semiotic *différance*. Ulmer quotes Derrida: "Each cited element [in collage] breaks the continuity or the linearity of the discourse and leads necessarily to a double reading: that of the fragment perceived in relation to its text of origin; that of the same fragment as incorporated into a new whole, a different totality. The trick of collage consists also of never entirely suppressing the alterity of these elements reunited in a temporary

composition."[62] Ulmer's characterization of collage/montage as ambiguously located between presence and absence was an important contribution to future attempts at theorizing the phenomenon.

Several of the writings of Benjamin H. D. Buchloh gave further credence to the claim that montage is a fundamental principle of avant-garde art. Buchloh's argument is informed by the assumption that the disjointed nature of avant-garde montages invites allegorical modes of viewing and interpreting, affording the spectator an active role in the construction of meaning; his writings in many ways serve as a reference for my own study.[63] In his essay "From Faktura to Factography" (1984), to which I will return repeatedly, Buchloh investigates the question of audience in 1920s Soviet photomontage practices.[64] Buchloh stipulates that photomontage was an artistic answer to the new social conditions and possibilities of communication in a mass society; and, in consequence, that it was geared from the beginning toward propaganda, and therefore doomed to be politically instrumentalized by the totalitarian regimes of the 1930s. Discussing El Lissitzky, Buchloh demonstrates that montage paved the way for avant-garde exhibition designs and spatial forms of display, such as Lissitzky's well-known Kabinett der Abstrakten (Cabinet of Abstract Art) in the Landesmuseum Hannover, or his design for the International Press ("Pressa") Exhibition in Cologne in 1928. Buchloh's argument is particularly important with regard to the main question of my study, the relevance of the montage principle for the modern conception of architectural space, in that it allows drawing a direct line from problems of two-dimensional representation to avant-garde spatial practices. I will examine this trajectory in more detail. In subsequent publications, Buchloh critically responded to Peter Bürger's stipulation in *Theory of the Avant-Garde* that neo–avant-garde artists of the postwar period simply adopted the montage aesthetic of the avant-gardes without honoring its originally political implications. Referencing the model of the atlas (and in particular Warburg's *Mnemosyne Atlas*), Buchloh argues that artists such as Bernd and Hilla Becher, Marcel Broodthaers, and Gerhard Richter transformed montage into an aesthetic of the archive; although this no longer radically negates the myths of the culture industry, it nevertheless resists them through memory work and through replicating and subverting late-capitalist bureaucratic systems of classification.[65] What distinguishes Buchloh's approach is not only his close reading of the history of Soviet photomontage, but also his argument that montage continues to be a major force of critical artistic production in the postwar and contemporary periods.

As opposed to the vast scholarship on montage/collage in the visual arts, the significance of the concept for modern architectural thinking has so far not been thoroughly investigated. Since the late 1980s, architects, theoreticians, and historians have become increasingly interested in montage as a structural principle of modern architecture. An important reason for this shift is certainly Tafuri's discussions of the writings of

Eisenstein and his assertion, beginning in the 1970s, of their relevance for architectural theory.[66] Also important is the English translation and first edition in 1989 of a generally forgotten article by Eisenstein, in which he discusses architecture as a predecessor of cinematic montage and conceptualization of space based on image sequences. In his lucid introduction, Yve-Alain Bois explains that despite the fact that Eisenstein's readings are "rarely accurate," their great significance lies in their potential to question received notions of the category of the image as a static entity—in his words, their "reflections about the inscription of time in a static picture and about the sequential nature of aesthetic perception, ideas that were upsetting the very basis of modernist pictorial aesthetics (such as Lessing's separation of arts of time and of space or Kant's exclusion of duration as a parameter of aesthetic experience)."[67]

Bois's invitation to make use of Eisenstein's montage theory remained mostly unanswered by architectural historians. Architects, however, seemed to sense the great potential of a cinematic approach to space, and figures such as Bernard Tschumi, Jean Nouvel, and, perhaps most importantly, Rem Koolhaas explored techniques of cinematic and dialectic visualization in their spaces throughout the 1980s and 1990s. It was against the background of these experiments that historians and theoreticians became increasingly aware of (cinematic) montage as the intellectual base for a (post-)modern spatiality. In 1993, film scholar Anne Friedberg discussed architectural typologies characteristic of the nineteenth-century metropolis—the arcade, the panorama, the diorama, and so on—as spatial anticipations of the cinema.[68] While Friedberg does not discuss montage, she does examine the nineteenth-century metropolitan mode of perception (that of the flâneur) that prepared the ground for the moving image. In her authoritative study on the subject, *Atlas of Emotion* (2002), Giuliana Bruno further explores the problem of space, perception, and mobility with an in-depth discussion of Eisenstein's text and the impact of montage thinking on postmodern architecture culture.[69]

Stan Allen has considered the concept of montage from the standpoint of a practitioner of architecture. In a collection of essays on "technique + representation" in architecture, Allen includes a short chapter on montage, which he defines with reference to filmmaker Dziga Vertov as "construction with intervals": "Construction 'with intervals' suggests that in montage, it is not the elements that are significant, but the space in-between them that defines the potential depth. The space of the interval is a shallow, compressed space, unfolding in time and linked together by the perception and recall of the observer."[70] Thus, like Bruno, Allen maintains that montage fundamentally changes the relationship of space and time in the perceiving subject's encounter of the montaged work.

In the field of architectural history, Anthony Vidler has further elaborated on the emergence of a new conception of space informed by cinematic montage, most importantly in a number of essays in *Warped Space*

(2000).[71] Jean-Louis Cohen had previously discussed montage as a guiding principle of avant-garde architectural production in a study on Konstantin Melnikov's USSR Pavilion at the 1925 Paris International Exhibition of Arts and Crafts, illustrating how principles of photographic and cinematic representation were successfully applied to architectural construction. Cohen also refers to montage repeatedly in his study on Le Corbusier in the USSR, giving further credence to the assertion that montage was fundamental for 1920s architectural thinking.[72] Another French scholar, Hubert Damisch, has illustrated how the notion of cinematic montage informed Le Corbusier's urbanist thinking.[73] More recently, the architectural theoretician Jason Hill has proposed an interesting (if somewhat underdeveloped) reading of montage as a spatial configuration that has the potential to impel the viewer/user into a meaningful interaction with an image or building.[74] Finally, drawing from Hilde Heynen's insightful study *Architecture and Modernity: A Critique* (1999), Davide Deriu has proposed understanding montage not only as an explicit category of postmodern architectural discourse in the wake of the reception of Eisenstein, but as an—albeit implicit—fundamental structural principle of early twentieth-century avant-garde architecture. In his essay "Montage and Modern Architecture" (2007), he reads Giedion's *Building in France* as an implicit manifesto of the montage aesthetic in architecture. Deriu concludes his argument with the hypothesis that architecture is the only discipline in which the various strands of the meaning of montage—its technological, pictorial, spatial, and epistemological dimensions—are fused together.[75] Deriu's argument is particularly useful for the following study in that he demonstrates that even though montage may not have been thoroughly discussed as an aesthetic category in avant-garde architectural circles, the principle of montage was nonetheless constitutive and determining. It is my own intention to trace the emergence of montage as modernity's symbolic form and its ramifications in various discourses in and beyond architecture in an expanded field.

Photomontage and the Metropolis

In Chapter 1, I argued that the invention of photomontage marks a paradigm shift in the perception and representation of architectural space; this shift was triggered by—and went parallel with—the rise of the modern metropolis, as well as the effects it induced in the acceleration and fragmentation of visual perception by its inhabitants. With modernity, the representation of space, in particular of urban space, increasingly became problematic—a crisis that became key for contemporary artists.[1] As I will argue, photomontage provided a device that could adequately represent the breaks and ruptures in the visual experience of the modern metropolis as described by thinkers such as Georg Simmel, Walter Benjamin, and others.[2]

If it is true that avant-gardist photomontage and its characteristic fragmentation of architectural and urban space was a consequence of the "shock" of the modern metropolis, it may be helpful to distinguish it from other forms of architectural and urban representation as developed throughout history, in order to understand photomontage's specific contribution to the problem of spatial representation.

Going back to the very beginnings of the theory of architectural representation, Vitruvius discerned three types of architectural drawings: ground plan, elevation, and (perspectival) view. But contrary to received conceptions, perspective and the dominant "scopic regime" of perspectivalism were not originally devised as an element of architectural theory, despite their inherently spatial dimension.[3] Instead, perspective was developed as an essential component of early modern painting theory. Leon Battista Alberti saw perspective solely as a tool for painters, leaving architects with plan and elevation, while Raphael's famous letter to Pope Leo X from 1519 concedes that perspective views of buildings can be useful to architects in convincing prospective clients—in other words, perspective can be a rhetorical tool in a manner similar to contemporary digital renderings.[4] Michelangelo generally did not make perspectival projections based on a fixed monocular gaze, instead sketching a certain architectural feature in multiple views that only combine into a unified image in the viewer's mind

Fig. 2.1 Michelangelo, Studies for the staircase and vestibule of the Laurentian Library, Florence (Casa Buonarroti 92A), 1525. Casa Buonarroti, Florence.

(fig. 2.1). He thus emphasized the viewer's virtual mobility (in this way anticipating key notions of Sergei Eisenstein's cinematic montage theories) and arguably stands for an embodied understanding of the perception of architectural space, one that is at odds with and presents a critique of the monocular visuality of perspectivalism.[5]

Considering the history of the representation of architectural space in Western art on an even more abstract level, perspectivalism may even be seen more as an exceptional chapter than as a quasi-natural rule. In his book *Die Moderne im Rückspiegel* (1998; *Modernity in the Rearview Mirror*), the German art historian Werner Hofmann argued that Western art—and particularly spatial representation in Western art—was fundamentally polyfocal throughout the Middle Ages and became so again in modernity. By virtue of this polyfocality, the premodern artwork encompassed a great variety of modes of presentation, points of view, media, styles, and levels of reality within one single depiction, or it had the tendency to treat single images as elements of a pluralistic constellation (such as in an altar). Arguing from a more architectural perspective, Massimo Scolari in *Oblique Drawing* (2015) makes a very similar argument: that illusionistic perspective is not the only, universal, or natural way of representing objects in the world, but rather a peculiar convention that emerged in a specific cultural and historical situation in Western Europe.[6] The beholder of such a

Fig. 2.2 Bernardo Daddi,
Madonna della Misericordia,
Loggia del Bigallo, Florence,
ca. 1350. Fresco.

polyfocal representation is not fixed to one ideal point of view and reduced to a monocular, disembodied entity, as perspectival construction would have it, but rather is embodied and mobile. A comparison Samuel Edgerton makes between a premodern and an early modern depiction of the city of Florence can illustrate this point (figs. 2.2, 2.3). The first image of the city is from a fresco in the Loggia del Bigallo and dates from around 1350; the second is the famous so-called *View with a Chain* from around 1510 (after Francesco Rosselli's original from ca. 1480), thus after the invention of central perspective. The Loggia del Bigallo depiction displays no interest in representing a homogenous (urban) spatial continuum. "Rather," as Edgerton has argued, "[the author of the fresco] believed that he could render what he saw before his eyes convincingly by representing what it felt like to walk about, experiencing structures, almost tactilely, from many different sides, rather than from a single, overall vantage." In consequence, all of the buildings represented in the mural are depicted as individual objects seen from their respective points of view. The depiction presupposes a mobile and embodied viewer; a continuous panorama is only produced in the viewer's mind through a "montage" of the individual depictions into one coherent vision. The *View with a Chain* presents itself quite differently. Here, the city is depicted from a single, detached point of view in bird's-eye perspective. Edgerton remarks, "We can see clearly what happened to human pictorial orientation after the advent of linear perspective. This new Quattrocento mode of representation was based on the assumption that visual space is ordered a priori by an abstract, uniform system of linear coordinates. The artist need only fix himself in one position for the objective field to relate to this single vantage point." In his account of the invention of perspective,

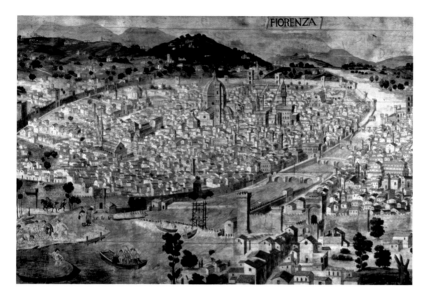

Fig. 2.3 Lucantonio degli Umberti, after Francesco Rosselli, *Fiorenza* (so-called *View with a Chain*), ca. 1510. Woodcut, 23 × 51.8 in. (58.5 × 131.5 cm). Kupfer-stichkabinett, Staatliche Museen zu Berlin.

Edgerton refers to a theory developed by perceptual psychologist James J. Gibson in the 1950s and 1960s. According to Gibson's theory, two "perceptual systems" can be differentiated: the "visual world" on one hand and the "visual field" on the other. The visual world is what is experienced by moving around in the city, with its three-dimensional topography. The visual field, on the other hand, is what is perceived when fixated with the eyes—that is, when the three dimensions of urban space are flattened to a two-dimensional mental or physical image. Perceptual psychology discerns between "depth shapes" perceived in the visual world against "projected shapes" in the visual field, which are seen from a single vantage point. The Loggia del Bigallo would then be a representation of the visual world, while the *View with a Chain* is a visual field.[7]

Looking at an example of a photomontage that reacts paradigmatically to the changes in urbanism in the modern era, *Metropolis* by the German-Dutch artist Paul Citroen, it is evident that the mode of depiction here more strongly resembles the discontinuous spatiality of the premodern example, thus lending credit to Hofmann's theory (fig. 2.4). Prompted by the shock of the modern metropolis, avant-gardist photomontage must be seen as a caesura not only in the history of Western vision, but also in its conceptualization of space. The unifying tendency of the monocular view of linear perspective no longer seemed plausible or adequate in the face of the inherent spatial and perceptual discontinuities of the metropolis. It is perhaps not sufficient to maintain that in modern photomontage, thinking in "visual fields" is again replaced by a conceptualizing of space in terms of "visual worlds." But modern photomontage does seem to presuppose a spectator whose point of view cannot be clearly fixed, but who is mobile and potentially embodied. This fundamentally changes the relationship between the perceived object and the perceiving subject. The pictorial

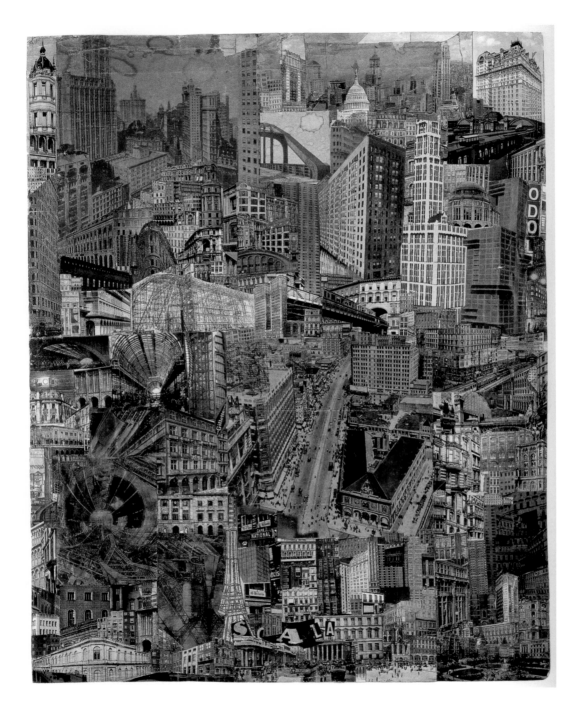

Fig. 2.4 Paul Citroen, *Metropolis*,
1923. Photomontage, 29.9 × 22.8
in. (76 × 58 cm). Prentenkabinet,
University of Leiden.

plane can no longer be grasped at once from an ideal point of view; rather, it must be visually wandered through and explored from many perspectives in order to be understood. What the heterotopic space of photomontage underscores is perception in time, as a sequence and synthesis of conflicting impressions.

Meanwhile, it should be pointed out that the early modern invention of perspective and the ensuing tradition of the representation of space in Western art was not in all instances as strictly monofocal as Hofmann's model would have it or our brief comparison suggests: the Renaissance culture of architectural models, for example, evidences the search for a form of architectural representation that avoids the limitations of central perspective. Inherently three-dimensional, the model calls for the multi-perspectival, shifting point of view of a beholder in motion. Likewise, the baroque period, whose architecture is often seen as exploring and exploiting the visual effects of perspective, also saw the elaboration of anamorphosis, the optical distortions of which revealed to contemporaries that perspective was in fact not a truthful representation of reality, but a special case in the many ways space could be represented in two dimensions.[8] Nevertheless, linear perspective was all too readily adopted as the seemingly natural tool for architectural representation. This consequence was not put into question, but—quite to the contrary—indeed enforced by architectural photography and the monocular constitution of the technical apparatus of the camera lens. Seen in this regard, photomontage, if considered as a device to depict a new understanding of (discontinuous) space, appears not as the logical consequence of architectural photography, but as its radical critique.

It is interesting to note that photomontage became a popular device for the representation of architectural and urban space at roughly the same time as axonometric projection. Countering perspectivalism's determinism with regard to the location of the viewer, both photomontage and axonometric are characterized by their perceptual ambiguity or even indeterminability, and both tend to leave the viewer in the dark as to his or her own concrete position in space. The deceptive stability of representation in perspective is questioned and destabilized, confronting the perceptual apparatus with an irresolvable visual challenge. This point is underscored by Stan Allen, for whom axonometric projection also entails the concept of a potentially placeless and mobile (and by extension, one could argue, embodied) spectator: "If perspective, dependent on a fixed point of view, seemed to freeze time and motion, the atopical space of axonometric suggested a continuous space in which elements are in constant motion. The same property that made axonometric such a useful tool in explaining the construction of complex machinery or spaces . . . could be exploited here to suggest the simultaneity of space and time. The reversibility of the spatial field allowed for the simultaneous presentation of multiple views. . . . Axonometric and technical drawings lend themselves to the multiplication

of views in an effort to describe the totality of the object."[9] These thoughts are helpful in distinguishing between photomontage and axonometric with regard to the object/viewer relationship: while axonometric projection potentially emancipates the depicted object from the viewing subject by opening up a multitude of possible representations that can be deduced from a single, quasi-exemplary depiction, photomontage reinforces the object/viewer relationship by activating the spectator and engaging him or her in a mental process that relates the various elements of the montage in a mental representation. Nevertheless, photomontage and axonometric projection coincided in avant-garde architectural representation. Yve-Alain Bois has credited the De Stijl artists and architects with the reinvention of modern axonometric in 1923, the same year in which photomontage became a preferred device.[10]

PAUL CITROEN, DADA, CONSTRUCTIVISM

In the history of art, the invention of photomontage as an artistic technique is usually credited to the Berlin Dadaists and dated to the final years of World War I. However, the authorship of this invention is highly contested, not least among the exponents of the Berlin "Club Dada" themselves. Given the enormous impact of photomontage and the montage principle on modern thinking in the twentieth century, this dispute should not come as a surprise. Two pairs of Dada artists, all of whom were featured prominently in the First International Dada Fair, are chiefly responsible for the contested accounts: George Grosz and John Heartfield, on the one hand, and Hannah Höch and Raoul Hausmann, on the other. In 1928, more than a decade after the fact, Grosz claimed that he had invented photomontage together with Heartfield as early as May 1916:

> In 1916, when Johnny Heartfield and I invented photomontage in my studio at the south end of the town at five o'clock one May morning, we had no idea of the immense possibilities, or of the thorny but successful career, that awaited the new invention.
>
> On a piece of cardboard we pasted a mishmash of advertisements for hernia belts, student song books and dog food, labels from schnapps and wine bottles, and photographs from picture papers, cut up at will in such a way as to say, in pictures, what would have been banned by the censors if we had said it in words. In this way we made postcards supposed to have been sent home from the Front, or from home to the Front. This led some of our friends, Tretjakoff among them, to create the legend that photomontage was an invention of the "anonymous masses." What did happen was that Heartfield was moved to develop what started as an inflammatory political joke into a conscious artistic technique.[11]

Fig. 2.5 Prussian military souvenir, 1897–99. Berlinische Galerie, Hannah Höch Archive.

At the end of this passage, Grosz explicitly refers to vernacular traditions of montage, which, as we will see, can be traced back to the late nineteenth century. According to Grosz's reading, instances of the popular use of the technique were artistically "unconscious," whereas its Dadaist appropriation amounted to a "conscious" use of the technique for political and artistic purposes. Such an interpretation can hardly be sustained from a contemporary point of view, and it seems to have been contested in its time as well. In another account of the "invention" of photomontage, Raoul Hausmann claimed that he "discovered" photomontage together with Hannah Höch on a trip to the Baltic Sea, where they came across the vernacular tradition of montaged Prussian military photographs—thus exactly the vernacular culture that Grosz referenced (fig. 2.5).[12] Höch remembered the same incident and connected it to her childhood: "Even as a child I knew this technique. There were for example humorous postcards that produced comical situations by gluing together parts of photographs." And: "To be honest, we took the idea from a trick of the official Prussian regiment photographers. They had bona fide montages showing, against the background of a barracks or landscape, a group of men in uniform who were lacking faces; the photographed heads were inserted later and generally colored by hand. If one can speak at all of an aesthetic aim in this primitive photomontage, it would consist of idealizing reality, whereas dada montage wanted to give something completely unreal the appearance of something real that had actually been photographed."[13] The Hannah Höch Archive in the Berlinische Galerie holds six such souvenir postcards. One of them leaves space for portrait photographs of soldiers to be glued on, thereby allowing for

Fig. 2.6 Max Piepenhagen, *Döberitz Drill Ground*, 1902. Postcard. Private collection.

the mass-reproduced image to be individualized by its owners/addressees. Höch retrospectively signed and thus "authorized" this postcard, adding the words "*Der Beginn der Fotomontage*" ("The Beginning of Photomontage"), thus treating it as a sort of ready-made.[14] For Höch and Hausmann, photomontage had indeed been fully developed in Prussian vernacular visual culture as early as 1900, and it was the task of artists simply to recognize the significance of this popular tradition for the production, dissemination, and reception of images in the age of their technological reproducibility. Hence, photomontage was a discovery and not an invention on the part of Dada artists. Importantly, there is no evidence that the term "photomontage" came into use in Dada circles in the years following World War I. Rather, the term seems to have been coined in the Soviet Union in the early 1920s, and from there it was reimported into German usage, making its first public appearance in printed form in László Moholy-Nagy's book *Malerei, Photographie, Film* (*Painting, Photography, Film*) in 1925.

The military—being one of the driving forces of technological modernization—apparently played a key role in the development and dissemination of photomontage as a vernacular representational practice. In addition to the souvenirs Hannah Höch collected and appropriated, there is the example of a postcard of the barracks at the troop drill ground of Döberitz, on the outskirts of Berlin (fig. 2.6).[15] The collotype was photographed and produced in the photo studio of Max Piepenhagen in Berlin in 1902. This postcard is only one in a long series of similar, mass-reproduced images of the site, which were apparently quite popular with soldiers between the opening of the drill ground and the end of World War II. It shows some of the most important barracks buildings from an elevated point of view, including the officers' mess, the post office, the guardhouse, bunk houses, the water tower, and the turbine house. The depiction is polyfocal or multi-perspectival in that each of the main architectural features is displayed from a different angle. In this way, the image takes up earlier post-

Fig. 2.7 Döberitz drill
ground, 1896. Postcard.
Private collection.

card depictions of the Döberitz drill ground, such as a postcard from 1896
in which the various architectural features are displayed as independent
drawings (fig. 2.7). Piepenhagen's postcard, in contrast, takes a number
of individual photographs and then photographically montages them into
the final motif. It is unclear what prompted Piepenhagen, a little-known
Berlin-based photographer of portraits and retail establishments, to resort
to multi-perspectival photography; most likely this kind of representation
was itself informed by the conventions of commercial souvenir postcards
showing several buildings and monuments of a specific place. It is certainly
noteworthy that photomontage, manipulated photography, and polyfocal
forms of representation were being tested experimentally first and fore-
most in the context of military (memorial) culture. It could be argued that
the military was a technologically advanced institution in late nineteenth-
century German culture where people had access to the new medium of
photography, and that the montaged military souvenir provided inexpen-
sive portraiture of soldiers in service. In this way, the military was not only a
catalyst in the experimentation with new forms and techniques of represen-
tation, but also a major force in their dissemination and popularization. As
we will see, technological advancement and the technical apparatus of the
camera would be subjects of reflection in the artistic use of photomontage
as well, and in particular in the depiction of the human figure.

While in their account, Höch and Hausmann discovered montage at the
periphery, they recognized its potential for addressing changes at the cen-
ter of culture, in the city. Another Dada artist, Paul Citroen, produced pho-
tomontages that would become paradigmatic in the representation of a new
urban form and experience in modernity. If Citroen's artistic oeuvre is com-
paratively little known from a contemporary point of view, his metropolitan
photomontages received a great deal of attention from avant-garde circles
of the 1920s and were disseminated widely in their major publications.

Roelof Paul Citroen, a Berlin-born Dutch artist, was a student in painting and sculpture at the Akademie Brandenburg when he was hired by Herwarth Walden in 1916 to supervise the newly opened art bookshop, the Sturmbuchhandlung (that is, the bookshop of "Der Sturm").[16] Walden's gallery, Der Sturm, one of the epicenters of Berlin expressionism, exposed Citroen to modern art and provided a platform for his further artistic and intellectual development. There, Citroen soon met the poet Walter Mehring, who in turn introduced him to the Dada circle, in particular Grosz and Heartfield.[17] Citroen's engagement with the Berlin Dadaists is evidenced by his contribution to the 1920 *Dada Almanach,* where he is presented, alongside Jan Bloomfield, as the leader of the Dutch section of the Dada movement.[18] Very much influenced by the Americanism of the Dadaists, Citroen produced his first early urban photomontage around 1920 while in Amsterdam.[19] Though Citroen's involvement with the Dadaists was relatively short-lived, his urban photomontages were clearly informed by their artistic practices. In 1958 Citroen remembered: "Bloomfield . . . made some Dadaist anti-works of art. On one he glued two small houses next to each other, the way one sometimes sees them on picture postcards. I thought: How would it be if one covered a whole sheet of paper full of houses? It would give the impression of a metropolis. And that's how in 1919 my first large photomontage was made."[20]

Fig. 2.8 László Moholy-Nagy, Spread for *Dynamik der Großstadt (Dynamic of the Metropolis),* 1921–22, from Moholy-Nagy, *Malerei, Photographie, Film* (1925; *Painting, Photography, Film*), 122–23.

Photomontage and the Metropolis

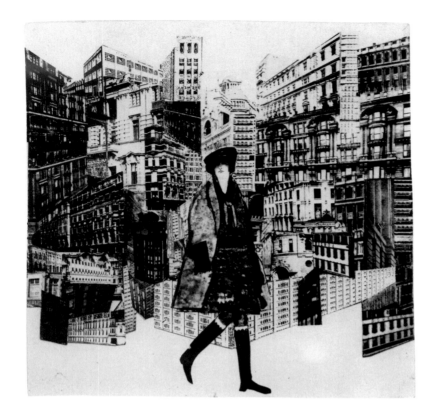

Fig. 2.9 Paul Citroen, *Das amerikanische Mädchen* (*The American Girl*), ca. 1920. Photomontage.

Citroen's urban photomontages made him famous in German avant-garde circles of the 1920s. Enrolling at the Bauhaus as an apprentice in 1922, he was strongly influenced by Johannes Itten in the legendary *Vorkurs* and also caught the attention of László Moholy-Nagy, who signed on as a young teacher in 1923.[21] In his seminal 1925 book, *Painting, Photography, Film,* Moholy-Nagy hailed Citroen as one of the protagonists of the new artistic medium of photomontage. In the book's first edition, he reproduced three of Citroen's photomontages, among them *Metropolis,* which had already been shown at the First Bauhaus Exhibition in 1923.[22] *Painting, Photography, Film* was the first instance in the German-speaking world where the term "photomontage" was used in written form. At the end of the book, Moholy-Nagy includes his sketch for a film manuscript entitled *Dynamik der Großstadt* (*Dynamic of the Metropolis*), in which he translated the technique of pictorial montage into film (fig. 2.8). It can be concluded that Citroen fundamentally inspired Moholy-Nagy's own experimentation with the representation of the modern metropolis and its spatial configuration. *Painting, Photography, Film* and the 1923 exhibition were key in establishing Citroen's lasting fame in avant-garde circles. Consequently, in one of the first surveys of the history of photomontage in the English language, Dawn Ades affords Citroen's *Metropolis* a key place in the discussion of avant-garde urban photomontage.[23] I would argue that Citroen's fame was based not only on his mastery of this new technique, but in particular on

Fig. 2.10 George Grosz, *Erinnerung an New York* (*Memory of New York*), 1915–16. Lithograph, 14¾ × 11⅝ in. (37.5 × 29 cm). The Museum of Modern Art, New York.

the way his urban photomontages introduced a new conception of urban space and its perception.

Das amerikanische Mädchen (*The American Girl*) is Citroen's first photomontage that deals with the topic of the modern metropolis (fig. 2.9; retrospectively dated 1919 by the artist, though not likely to have been produced before 1920).[24] The almost-square picture shows a fashionably dressed young woman walking in the foreground against a montaged urban panorama. As in his later works, the multitude of fragmented photographs produces a dense poly-perspectival configuration, a "wall" made up mainly of turn-of-the-century apartments and offices as well as industrial buildings, many of which are displayed upside down. The artist evokes a condensed but faceted panorama of a contemporary European or American metropolis as it might present itself in fleeting impressions to a hasty visitor. This architectural montage is not read as a spatial continuum; rather, it appears as wallpaper or a stage backdrop. The transition from one element to the next is sudden and abrupt, producing an aesthetic effect like the shock that Benjamin theorized. While in the wide central band, the mode of representation based on fragmentation and reassembly runs counter to any representational convention, the empty lower and upper parts of the image can be read as a sidewalk and open sky. Upon closer observation, the architectural montage is not accidental but can be subdivided more or less clearly—though not as prominently as in some of Citroen's later works—into a series of vertical strips. Verticality was a prominent topic in architectural debates around 1920 in the face of American—and, increasingly, European—high-rise construction.[25] It is difficult to identify the individual buildings in the image with a specific city; instead, the intention seems to have been to

represent a quintessential modern metropolis and its fragmented perception. For this purpose, the artist chose a kaleidoscopic but ordered pictorial form. Somewhat in contrast to the experimental representation of architectural and urban space, the depiction of the human figure in this work is not informed by a montage aesthetic or by the underlying technological apparatus of the camera. The figure serves as a sort of placeholder for street life in the modern metropolis.

As the verticality of the composition suggests—along with its English-language title—American culture and the American metropolis were a strong force of inspiration for post–World War I German culture. Many Dadaists who had initially welcomed the war soon expressed their critique of German nationalism by Anglicizing their names: Georg Gross became George Grosz, Helmut Herzfelde became John Heartfield, and Erwin Blumenfeld became Jan Bloomfield.[26] A lithograph by George Grosz entitled *Erinnerung an New York* (*Memory of New York*) from 1915–16 anticipates Citroen's later montages in several features: the dense representation of buildings and high-rises of various sizes and perspectives and the use of competing letters and advertisement slogans lead to an impression of stimulus overload (fig. 2.10).[27] The idea of montage is also present in the transparent superimposition of graphic elements and the sense of velocity and dynamism exemplified in the train cutting diagonally across the picture. Despite the title of the work, Grosz did not visit New York until 1932. In other words, his print is not based on firsthand experience, but on reproduced images and clichés available to a European audience by 1915—another indication of how the availability of photographic reproductions

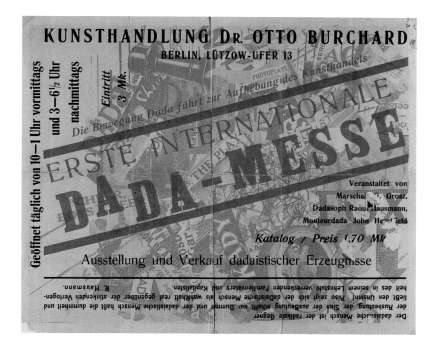

Fig. 2.11 Catalog of the First International Dada Fair, with George Grosz and John Heartfield's *Leben und Treiben in Universal City um 12 Uhr 5 mittags* (*The Life and Goings-On in Universal City at 12:05 noon*), 1919. Photomontage.

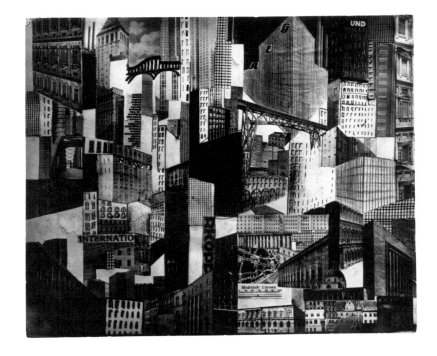

Fig. 2.12 Paul Citroen, *Großstadt* (*City*), 1922. Photomontage.

affected artistic production. A similar work is Grosz's pen drawing *Friedrichstraße* from 1918. Although it emphasizes the figures in the street in the foreground more than the urban architectural setting—they appear as individual figures "montaged" into the drawing in order to create a densely populated urban street—there is a marked sense of speed and chaos along with the superimposition of visual impressions; the same applies to the lithograph *Querschnitt (Platin & Co.)* (*Transversal Section [Platin & Co.]*) from 1919–20, where the urban scene is fitted into more of an orthogonal grid. An important photomontage by Grosz is *Leben und Treiben in Universal City um 12 Uhr 5 mittags* (*The Life and Goings-On in Universal City at 12:05 noon*) from 1919, a collaboration with John Heartfield, which was reproduced on the front cover of the catalog for the First International Dada Fair (fig. 2.11). While to an extent also addressing the modern metropolis, the "Universal City" in the title refers to the Hollywood film studios of the Universal Pictures Company, and the montage overall depicts the components of film production: there are portraits of actors, words and bits of language, a telephone, film rolls, and so on. Whereas Grosz and Heartfield arrange the elements of their montage in a loose configuration that seems to be guided by chance, Citroen pastes his fragments together tightly in a much more formally organized, tectonic structure. This sense of structure is one of the features that distinguishes Citroen's works from the photomontages of the Berlin Dadaists.

Großstadt (*City*) (fig. 2.12), a metropolitan photomontage Citroen made in 1922, in many ways radicalizes *The American Girl*. The later montage no longer includes a figure, and the photographic representation of fragments

of buildings and façades extends to the lower edge of the work. As opposed to the earlier montage, architecture no longer serves merely as a backdrop for an event, but has become the main subject of the depiction. While the polyfocal montage of the architectural elements again defies the conventional notion of representation, a horizon line and indications of some clouds can be distinguished at the upper edge of the work, as in the earlier montage, making this stance ambiguous. The later work, as compared with the earlier, includes more types of urban infrastructural elements as well as advertisements. For example, the letters "AEG" extending toward the upper edge reference one of the most important German industrial companies of the early twentieth century, which fundamentally changed the architectural face of the metropolis, as in Peter Behrens's AEG Turbine Hall in Berlin. However, the word "new" at the center left or the fragmented "internatio" hint at an international or Anglophone context: again, the artist is interested in portraying the phenomenon of the modern metropolis and its disjunctive perception more than a specific city. While it is difficult to identify the buildings in the image, modernist structures seem to dominate, at least in comparison to the earlier photomontage. High-rises and skyscrapers feature prominently. More distinctly than *The American Girl, City* is organized into five clearly discernible vertical strips. The mostly narrow, upright, rectangular bits of the montage produce the effect of a visual staccato, underscoring the impression of density and speed. In addition to the architectural fragments, the photomontage also includes some light and dark areas without detail, giving it a more abstract character. Quite clearly, Citroen intends to produce a balanced, rhythmic composition based on the succession of light and dark, although these elements could also be interpreted representationally as depicting streets or boulevards, squares, gaps between buildings, or undeveloped urban wasteland.

Two specific aspects call for a more detailed discussion. First, this photomontage includes more perspectival drawings of buildings than the earlier work. As already pointed out, as compared with *The American Girl, City* contains more representations of modernist buildings in the urban panorama. Since such buildings were still very sparse around 1920 and photographs were largely unavailable, Citroen resorts to drawing: most prominently, in the perspectival representation of a glass volume at the upper-right edge of the image and in the cubic structure at center right. These elements refer to contemporary utopian projects for steel and glass architectures, such as the "Five Projects" by Mies van der Rohe. If in his earlier photomontage Citroen is interested in representing the contemporary city and the visual perception of its disjunctive space, *City* goes beyond this to project a utopian vision of a future metropolis.

The second aspect that calls for a more detailed discussion is the map of an undefined metropolis at the bottom right in the image. While polyfocality is a key feature in all of Citroen's metropolitan photomontages, the combination of photography with cartography here suggests that each type

Fig. 2.13 El Greco (Doménikos Theotokópoulos), *View and Plan of Toledo*, 1604–14. Oil on canvas, 52 × 90 in. (132 × 228 cm). Museo del Greco, Toledo.

of representation is only able to depict a complex spatial phenomenon such as the modern metropolis to a limited extent. The inclusion of cartography in an urban representation was not invented by Citroen, nor is it limited to modern art. A comparable example can be found in a topographic view of the city of Toledo by El Greco from 1604–14 (*View and Plan of Toledo*, fig. 2.13). While there is no evidence that Citroen was directly inspired by this painting, it is interesting to note that the Soviet filmmaker and montage theoretician Sergei Eisenstein repeatedly referenced El Greco in his writings. For Eisenstein, the synchronicity of plan and view in one single depiction is a prime example of what he calls "cinematism"—that is, the presence of cinematic visual qualities in traditional media such as painting and architecture before the invention of film. The most elaborate discussion of the relevance of El Greco's painting for a cinematic theory of montage can be found in the essay "El Greco y el cine" (1937–39; "El Greco and Cinema"), where Eisenstein states, "This view of Toledo isn't possible from any real point of view in space. This view is a montaged complex, a representation composed by montage where objects photographed in isolation are interposed that, in nature, conceal one another or turn their back to the spectator 'shooting' from this place."[28] Eisenstein underscores that this characteristic combination of different visual conventions of the representation of the city presupposes changing points of view and a mobile spectator; for this reason, it may be seen as a predecessor to cinematic montage. In a slightly different, but comparable vein, Victor Stoichita, in his analysis of the painting, has called the artist's strategy "bifocal": "The view is the territory of the representational, the symbolic; the map is the territory of accurateness. Both the view and the map have a common 'referent': 'Toledo.' But neither the view nor the map are in themselves capable of 'represent-

Photomontage and the Metropolis

ing' it entirely. The 'true' Toledo can neither be found in the view nor in the map: it is the point towards which both depictions converge." And: "[The map's] real role seems to be to force a split of vision upon the spectator, a seesaw between a depiction in depth and a depiction on the plane, in short, a sort of optical (and mental) journey between two systems of representation."[29] It is exactly this "bifocal" nature that Eisenstein is interested in when he interprets El Greco's painting as a montage *avant la lettre*. By consciously or unconsciously referencing this pictorial tradition, Citroen's photomontage offers a contemporary example of a poly-perspectival representation that relates both to the history of painting and to avant-garde film theory. The convergence of thought between Citroen and Eisenstein underscores how, at this historical moment, artists, architects, and theoreticians were deeply involved with formulating a theory of montage across various visual media based on the ideas of juxtaposition, adjacency, and polyfocality.

Metropolis (1923) is undoubtedly the most famous of Citroen's metropolitan photomontages (see fig. 2.4). (The extent to which its author became identified with this singular work is evidenced in a portrait of Citroen by his friend and colleague Otto Umbehr, known as Umbo, in which Citroen's portrait is superimposed on a section of the photomontage.) The development toward a totalization of the representation of the urban fabric as observed in the earlier photomontages reaches its climax here. If *City* had still featured various undefined areas, in *Metropolis* the entire picture plane is covered by a dense constellation of montaged elements. The all-over virtually extends beyond the edges of the picture and seems to continue ad infinitum; what is presented seems a mere aperture onto a potentially endless urban spectacle. Worm's- and bird's-eye views lie side by side with normal perspectives of buildings and façades; unmediated jumps of scale also strengthen the montage quality of the image. Like the earlier works, *Metropolis* features a horizon line at the top, again maintaining a last trace of conventional representation.[30] The heterogeneous quality of the image seems further enhanced by the different colors of the individual pasted elements of the montage, but this variety is unintentional, as it results from the aging and fading of the different papers used.

Contrary to the more informal configuration of most Dadaist photomontages, Citroen's vision of the metropolis is structured by axes that run through the image both horizontally and vertically, lending it a tectonic, almost architectural grid. The horizontal line running across the center of the image provides a clear visual hiatus. The rectangular compartments of the montage that result from the axial grid take on the quality of imaginary windows that open up a view onto a metropolitan scene characterized by dynamics and shifts of perspective. Heavily fragmented areas alternate with more expansive ones. Meanwhile, despite its polyfocality, the urban scene overall presents itself to an elevated viewer looking down onto it.[31]

In a fashion now familiar, Citroen combines photographic reproductions of buildings from various places into an all-encompassing metro-

Fig. 2.14 Spread showing the Pennsylvania Hotel, New York, from *Berliner Illustrierte Zeitung*, no. 18 (5 February 1920): 29.

politan vision. Read from the bottom upward, the montage begins with a square-like situation at the lower right and ascends, via a central view onto a broad urban boulevard from a bird's-eye perspective, to vertically oriented structures at the top. It presents a multitude of different building types: in addition to façades of apartment and office buildings, there are civic, cultural, and government buildings, infrastructure such as railway bridges, stations, or tunnels, and steel/glass constructions such as shopping arcades, galleries, or exhibition halls. There are also advertisements and other signs, such as the letters "Scala" at the bottom center and "ODOL" at the top right. More so than in Citroen's earlier photomontages, some of the buildings can be identified: the Eiffel Tower (bottom center), the Galleria Vittorio Emanuele in Milan (center right), Daniel Burnham's Flatiron Building in New York (upper left, in two parts), various other American skyscrapers from cities such as New York and Chicago, the cupola of the Capitol Building in Washington, D.C., or a Berlin train station (below, center right). Contrary to the earlier photomontages, *Metropolis* not only displays façades and views of urban exterior spaces, but also allows the viewer to enter interior spaces visually, such as the Milan shopping arcade or a railway tunnel just below it. This subterranean gaze is reminiscent of Giovanni Battista Piranesi's counter-Enlightenment capriccios, and in particular his *Carceri* (see fig. 1.7). As much as *Metropolis* seems to celebrate progress and modernization through technological innovation as well as the dynamization of the perception of urban space, there is also a darker, oneiric, and

uncanny dimension. It should be mentioned in passing that Manfredo Tafuri, taking up an argument voiced by Eisenstein, saw in Piranesi's *Carceri* the beginning of a modern, fragmented conception of space, one that led directly to a montage conception of architectural space in the early twentieth century.[32] If for Tafuri and others the *Carceri* are the underbelly of a modern conception of disjunctive space, then Citroen's *Metropolis* is perhaps the most explicit visualization of this both utopian and dystopian idea.

The association with Piranesi also brings up the implicit dialogue of *Metropolis* with the German expressionists. As already mentioned, when Moholy-Nagy reproduced the photomontage in his *Painting, Photography, Film,* he compared it to a "*Steinmeer*" (sea of stones).[33] This references a neologism from the first line of the first tercet of the sonnet *Berlin II* by expressionist poet Georg Heym, published in 1911 in the anthology *Der ewige Tag* (*The Eternal Day*):

> Der hohe Straßenrand, auf dem wir lagen,
> War weiß von Staub. Wir sahen in der Enge
> Unzählig: Menschenströme und Gedränge,
> Und sahn die Weltstadt fern im Abend ragen.
>
> Die vollen Kremser fuhren durch die Menge,
> Papierne Fähnchen waren drangeschlagen.
> Die Omnibusse, voll Verdeck und Wagen.
> Automobile, Rauch und Huppenklänge.
>
> Dem Riesensteinmeer zu. Doch westlich sahn
> Wir an der langen Straße Baum an Baum,
> Der blätterlosen Kronen Filigran.
>
> Der Sonnenball hing groß am Himmelssaum.
> Und rote Strahlen schoß des Abends Bahn.
> Auf allen Köpfen lag des Lichtes Traum.[34]

While celebrating the sights and sounds of the metropolis, the poem has some apocalyptic undertones: "gigantic sea of stones" (*Riesensteinmeer*), "river of people" (*Menschenströme*), and "throng" (*Gedränge*) evoke an atmosphere of anxiety in which the individual threatens to be drowned or crushed.

While Citroen, more than any other artist in this period, consistently explored the impact of disjunctive space on the visual perception of the urban dweller, several of his colleagues also showed an interest in the impact of modern building types on the face of the city and, by extension, on the emerging mass culture. We have already spoken of Hannah Höch and Raoul Hausmann's "discovery" of the vernacular practice of photomontage.

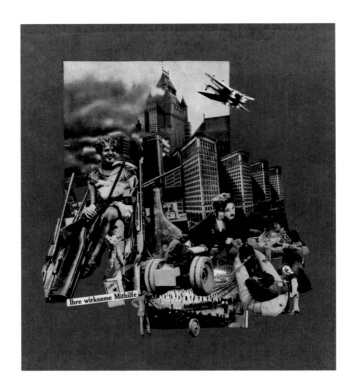

Höch was one of the most prolific artists to explore the potential of this practice as a device to produce visual meaning by means of the juxtaposition of elements. Three of her photomontages focus on the representation of the modern metropolis.[35] The first is her programmatic monumental *Cut with the Kitchen Knife* . . . from 1919 (see fig. 1.2), publicly presented for the first time at the First International Dada Fair (for which the montage by Grosz and Heartfield served as the catalog's cover image). While Hanne Bergius interprets Höch's work as a "grotesque political allegory" speaking to the situation in Berlin in the early days of the Weimar Republic, Karin Heyltjes has pointed out the degree to which this work addresses the issue of the modern metropolis.[36] In particular, the area on the bottom left is taken up by photographs of the narrow streets of an American city (identified by the skyscrapers) whose streets are filled with crowds marching in protest. The buildings shown in these fragments, taken from the *Berliner Illustrierte Zeitung* (BIZ), are the New York Stock Exchange and the New York Times Building.[37] While Citroen's primary interest is urban space and its perception, for Höch, the metropolis—and the American metropolis in particular—is the site of an emerging technology-driven mass society and its culture. A fragment at the top center of the image shows the four towers of the Pennsylvania Hotel, also in New York, which would also feature in another, untitled photomontage by Höch from 1920. Constructed in the previous year by McKim, Mead, and White, it was at the time the largest hotel in the world (fig. 2.14). The symbolic function of this hotel in Berlin avant-garde circles is further evidenced by the 1926 photomontage

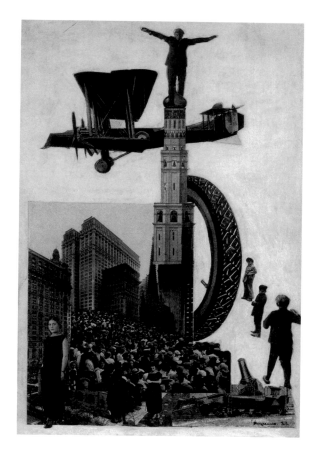

Fig. 2.16 Alexander Rodchenko, *I Am at the Top*. Photomontage for Vladimir Mayakovsky's *Pro eto (About That)*, 1923. Art © Estate of Aleksandr Rodchenko/Artists Rights Society (ARS), NY.

Ihre wirksame Mithilfe (*Your Effective Assistance*) by Bauhaus artist Marianne Brandt (fig. 2.15). Covering the central area of a rectangular sheet, the montage presents a number of figures (among them Charlie Chaplin) against the background of an American metropolis, the anonymity of which is represented by the Pennsylvania Hotel's repetitive, monotonous façade.[38] The depiction of figures, all of which are taken from printed reproductions, contrasts markedly with Citroen's relatively conventional treatment in *The American Girl:* their size does not correspond to the scale of the buildings in the background, but seems dramatically exaggerated if compared to a perspectival representation; what's more, they vary considerably in size from one another and are ostentatiously juxtaposed. The figures are shown next to and in close relationship to a number of different weapons and munitions that appear as technological extensions of the body. As we will see, other artists would go a step further in the semantic and visual amalgamation of man and machine, for which the principle of montage, itself a product of the technological reproducibility of images, provided the necessary tools.

The visual organization of Brandt's work was inspired by a photomontage by the Russian artist Alexander Rodchenko, which includes another signature building of New York architecture, Ernest Graham's 1915 Equitable Building on Broadway (fig. 2.16).[39] At one time, this structure was

Fig. 2.17 George Grosz and John Heartfield, *Dada-merika,* 1919. Photomontage.

Fig. 2.18 Hannah Höch, *New York,* 1949. Photomontage.

the largest office building in the world, with space for sixteen thousand employees. The controversy surrounding its obstruction of light at the street level led to the adoption of the famous 1916 zoning restrictions, which called for setbacks in all subsequent high-rise buildings. The Equitable nevertheless obviously impressed contemporaries with its size and technological mastery. A reproduction of it was also introduced in the photomontage *Dada-merika* from 1919, a famous collaboration by George Grosz and John Heartfield (fig. 2.17).

Another, later work by Höch, *New York* from 1949—which like Citroen's *Metropolis* presents an expanse of montaged urban elements covering the entire sheet—is made up exclusively of reproduced photographs of American skyscrapers (fig. 2.18).[40] In the background, a view of Manhattan from a bird's-eye perspective shows the city's characteristic gridiron plan. This is overlaid by three cutout vertical strips giving fragmentary views of high-rise façades, which are connected by a horizontal fourth element showing illuminated lights and a lit Christmas tree. The pasted elements of the montage can be identified with the RCA Tower (1931–33) and the Associated Press Building (1937–38) in the Rockefeller Center complex.[41] The specific superimposition of two levels of representation here can again be likened to the "bifocal" strategy in Citroen's montage *City:* while the underlying aerial photograph transforms the bird's-eye view to an almost abstract cartographic image, the superimposed vertical strips convey the experi-

ence of standing on the street and looking up in awe at the skyscrapers. It goes without saying that the superimposition of Rockefeller Center into the fabric of Manhattan has been a favorite topic of twentieth-century architectural theory. Its significance to Sigfried Giedion was already discussed in Chapter 1. Rem Koolhaas would later devote an entire chapter to the construction of Rockefeller Center against the background of the New York gridiron plan in his urbanist manifesto *Delirious New York* (1978), which is structured as a literary montage. On the front cover of the German edition is an aerial view of Manhattan's skyscrapers very similar to that used by Höch in her photomontage. This image seems to visualize twentieth-century urbanist thinking, and in particular the impact of high-rise construction on the human perceptual apparatus.

One more work that programmatically addresses the metropolis is Marianne Brandt's *Unsere irritierende Großstadt* (*Our Unnerving City*) (fig. 2.19). The montage of architectural and figurative photographs dates from 1926, after the publication of Citroen's *Metropolis* in Moholy-Nagy's *Painting, Photography, Film;* it is likely that Brandt was aware of her fellow Bauhäusler's work.[42] Like Citroen's montage, Brandt's shows an array of reproductions of contemporary, historical, and ancient architectures, most prominently a dramatic worm's-eye perspective of Fritz Höger's tapering Chilehaus in Hamburg, at the very top of the image. The composition gives rise to a visual "vacuum effect that pulls at the montage's elements"; this sense of dynamism and perceptual vertigo is also symbolized by images of cars, bicycles, a cycling track, and a tunnel-like wood structure at the center.[43] There are significant differences between Citroen's photomontage and Brandt's: *Metropolis* shows an uninterrupted wall of façades, while *Our Unnerving City* leaves the margins of the support uncovered; *Metropolis* is organized orthogonally, while *Our Unnerving City* produces a dynamic rotation by arranging the individual elements in relation to the gravitational center; *Metropolis* does not contain figures, while *Our Unnerving City* does. As in the contemporaneous *Your Effective Assistance,* discussed earlier, the figures vary in size considerably and are juxtaposed with architectural elements rather than being integrated into an architectural setting. In this case, however, they maintain their human integrity rather than being absorbed into a man/machine continuum. In sum, while Citroen's work addresses the metropolis of the late nineteenth century through its buildings and typologies, Brandt's piece portrays the dynamism, speed, and perceptual vertigo of the contemporary city that has taken hold of culture at large and threatens to suck it up.

Except perhaps for the last work discussed, all of these examples basically treat the modern metropolis as a visual repository of architectural and urban elements. The relationship of these photomontages to the modern city is therefore mainly iconographic. Nevertheless, the frequent referencing of different modern building typologies such as the high-rise, the

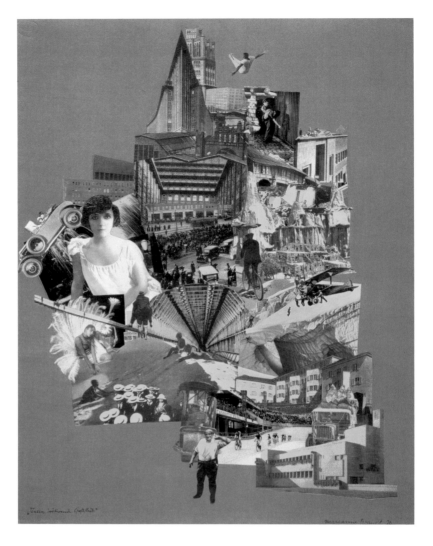

arcade, and the train station points to a strong conceptual connection between the disjunctive space of the metropolis and photomontage as a technique.

The disputes over the "invention" of photomontage among members of the Dada circle is reflected in the lack of a generally accepted definition of the term. Theoreticians have tended to define photomontage either as a technical procedure or as a semantic principle for the generation of meaning; Citroen, who made *Metropolis* two years before the term's first printed use in German, surely drew upon both aspects in constructing his "Dadaist anti-works of art." Among those who emphasize the term's technical sense, the art historian William Rubin states in his 1968 exhibition catalog, *Dada, Surrealism, and Their Heritage:* "The most significant contribution of the Berlin [Dada] group was the elaboration of the so-called photomontage, actually a photo-collage, since the images were not montaged in the darkroom."[44] This brings us back to the differentiation between montage and

collage as proposed in Chapter 1 of this study. While Rubin makes a valid attempt at distinguishing between the two terms, I will argue that montage is primarily a semantic operation that draws its meaning from the dialectical juxtaposition of (visual) elements and their synthesis in the mind of the viewer. This is the stance taken by the Russian art theorist Sergei Tretyakov, who, writing about John Heartfield in 1936 and informed by the cultural politics of the USSR, was among the earliest commentators on the phenomenon: "It is important to note that photomontage need not necessarily be a montage of photos. No: it can be photo and text, photo and colour, photo and drawing. . . . If the photograph, under the influence of the text, expresses not simply the fact which it shows, but also the social tendency expressed by the fact, then this is already a photomontage."[45] Tretyakov argues for a multimedia understanding of photomontage; but more importantly, for him, as for its Soviet proponents, photomontage also has the potential to be a social and political agent. Even though that may not necessarily always have to be the case, I suggest understanding photomontage essentially as a form of representation that engages the viewer to participate actively in the production of meaning based on juxtaposition.

Tretyakov's deliberations on photomontage are a culmination of a debate on the new artistic technique and its political implications throughout the late 1920s and early 1930s. Germany and the Soviet Union, in particular, witnessed a substantial number of publications dealing with this topic. As we will examine in more detail, the first known text explicitly using the term "photomontage" was published in the Soviet avant-garde review LEF in 1924 and is today generally attributed to one of the cofounders of the journal, Osip Brik. Another important early Soviet text was written in 1928 by artist Varvara Stepanova, the wife of Alexander Rodchenko. Even though not published until 1973 in the Czech journal *Fotografie,* the essay was one of the first attempts to sketch a history of Russian photomontage. Stepanova essentially distinguishes two phases that point toward a dynamic evolution of the medium.[46] A German counterpart to this attempt at historicizing photomontage could be seen in Raoul Hausmann's lecture delivered on the occasion of the 1931 *Fotomontage* exhibition organized in Berlin by the Dutch artist and graphic designer César Domela-Nieuwenhuis. As one of the protagonists of Berlin Dada, Hausmann recounts that group's contribution to the genesis of photomontage as both artistic and semantic. At the same time, he asserts that at that time (that is, around 1930), photomontage was practiced mainly either as political propaganda or commercial advertising. Despite this commodification and instrumentalization of the technique, Hausmann underscores that "photomontage can contribute a great deal to the education of our vision, to our knowledge of optical, psychological, and social structures."[47]

After László Moholy-Nagy's introduction of the term "photomontage" in his 1925 Bauhausbuch *Painting, Photography, Film,* it was Franz Höllering, a frequent contributor to the review *Der Arbeiter-Fotograf,* who wrote

one of the earliest texts on the topic in the German language. As the title of the publication suggests, Höllering took a decidedly political stance. While criticizing the meaningless proliferation of photomontage as a "horrible epidemic," Höllering praises John Heartfield's use of the medium. The author defines photomontage as a technique in which "several photos are put together, assembled, into a single picture"; the result conveys "the worldview of the person creating [it]." What Höllering rejects is an apolitical, commercial use of the medium, as is the case in advertisements, which he trivializes: "It may indeed be fun, pasting little pictures together. Little children have always enjoyed it."[48] As the example of Heartfield demonstrates, photomontage can be a deliberate artistic and educational tool in the service of social revolution. Its "mission" is to produce "a record of reality."[49] Höllering's stance is clearly in line with Soviet factography of the period, and returns to Heartfield's own distinction between the "conscious" and "unconscious" use of montage.[50]

In an essay on the issue published in 1931, the Dutch artist and graphic designer César Domela-Nieuwenhuis criticizes the fashionable use of photomontage: "The fact that currently many people think they can make photomontages without having the slightest notion of the matter does a great deal of harm to photomontage. In most cases they paste happily away and call their product a photomontage."[51] Contrary to Höllering, however, Domela-Nieuwenhuis does not object to using the technique for advertising purposes. This is perhaps not surprising, as Domela-Nieuwenhuis, the son of a prominent socialist leader, was a member of the Ring neue Werbegestalter (Circle of New Advertising Designers), and as such believed that commercial graphic design was a viable tool to introduce the modern visual language to the general public. In this educational mission, photomontage was to take a main role. This point of view was shared by figures such as Herbert Bayer, who played an ambiguous role in the context of fascist politics in the 1930s.

The prominence of the technique of photomontage in the aesthetic discourse of the interwar period is also evidenced by a synopsis for an unpublished survey book on photomontage by the influential German typographer and book designer Jan Tschichold.[52] The preliminary table of contents not only proposes distinguishing between different understandings of the term "photomontage" (such as photocollage, photo sculpture, photo composition, photo painting, and so on). It also hints at nineteenth- and early twentieth-century predecessors of photomontage, thus pointing at the vernacular tradition of the technique. Two chapters directly reference its significance for avant-garde architecture culture, first in the case of "applied" photomontage in architectural drawing (Tschichold explicitly mentions Le Corbusier, Jaromír Krejcar, and El Lissitzky), and second in exhibition architecture (El Lissitzky, Moholy-Nagy, and Hans Schmidt). In his brief comments on the meaning of photomontage, Tschichold mentions not only the mechanical (and dialectical) composition of several (parts of)

Fig. 2.20 Poster for the *Fotomontage* exhibition, Lichthof, former Kunst-gewerbemuseum, Berlin, 1931. Getty Research Institute, Los Angeles. Jan and Edith Tschichold papers.

photos on one sheet, but also the so-called "photo composition," which relates to the technique of composite photography as devised in the nineteenth century, as we will see. Interestingly, Tschichold discusses such practices under the heading of "interpenetrations" (*durchdringungen*), a term that was equally present in architectural and cinematic montage theories of the time.

Finally, the presence of photomontage as a critical category addressing the problem of representation in avant-garde discourse is further evidenced in an exhibition devoted to the subject in the *Lichthof* of the former Kunstgewerbemuseum in Berlin held from April 25 to June 31, 1931 (fig. 2.20).[53]

LÁSZLÓ MOHOLY-NAGY

The fame of Citroen's metropolitan photomontages is without a doubt directly related to their reproduction, already mentioned, in László Moholy-Nagy's 1925 Bauhausbuch, *Painting, Photography, Film*. Indeed, Moholy-Nagy would have to be considered the most important student of Citroen's photomontages among his contemporaries. The Hungarian artist

first became familiar with Dadaist techniques of montage in the winter of 1922–23, when he shared a studio with Kurt Schwitters. As Moholy-Nagy later recollected in his biographical sketch "Abstract of an Artist" (1944): "Under the influence of cubist collages, Schwitters's 'Merz' painting, and Dadaism's brazen courage, I started out with my photomontages, too."[54] Moholy-Nagy had first seen Citroen's *Metropolis* at the First Bauhaus Exhibition in 1923. In *Painting, Photography, Film,* he reproduced it along with two other of Citroen's photomontages as well as a work by Hannah Höch entitled *Der Milliardär* (1923; *The Billionaire*). In the first edition of the book, *Metropolis* was captioned as "Die Stadt I" ("The City I") and the work later known as *Großstadt* (*City*) as "Die Stadt II." The third of Citroen's works reproduced was *Boxkampf in New York* (*Boxing Match in New York*), a fairly conventional image upon which Moholy-Nagy commented: "Tension: the über-metropolis as background of a modern sport spectacle" (fig. 2.21). In all three instances, the works were credited to "Citroen/Bauhaus." In the second, 1927 edition of the book, Moholy-Nagy reproduced only one of Citroen's works, *Metropolis,* now with the caption "Die Stadt." It is also in this second edition that he added his comment likening the work to a "sea of stones," mentioned earlier.[55]

As stated previously, Moholy-Nagy's book was one of the earliest instances of the printed use of the term "photomontage." Interestingly, Moholy-Nagy only applied the term "photomontage" to the works by Citroen and Höch, whereas he labeled his own montages *Fotoplastik* (photo sculptures).[56] The reason for this may be seen in the artists' different approaches to their works' construction: while the montages by Höch and Citroen combine fragmented pieces of photographic reproductions, Moholy-Nagy uses more complete photographic elements (this, along with his strong aesthetic sense for composition, identify him as an exponent of constructivism as opposed to Dadaism). Elizabeth Otto has pointed out that Moholy-Nagy's completed "photo sculptures" were not the montages themselves, but photographs of these montages.[57] In other words, in Moholy-Nagy's application of the term, photomontages are unique; *Fotoplastiken,* by contrast, are reproducible.

In the chapter "Die Zukunft des fotografischen Verfahrens" ("The Future of the Photographic Process"), Moholy-Nagy called the montages of the present "a more advanced form than the early glued photographic compositions (photomontage) of the Dadaists."[58] Thus, right at the moment of the invention of the term "photomontage," Moholy-Nagy applies it to a form of artistic experimentation of the recent past that has already been superseded by more up-do-date artistic practices such as his own "Fotoplastik." Nevertheless, Moholy-Nagy internalized the concept of "montage" and modeled his artistic persona according to it, frequently appearing in public in an orange *Monteuranzug* (machinist's coveralls). This costume paid homage to his Dadaist lineage—John Heartfield was known as "Monteur-Dada" among his colleagues—at the same time as it made overt the connection of

Fig. 2.21 Paul Citroen,
Boxkampf in New York
(*Boxing Match in New York*),
1924. Photomontage,
from László Moholy-Nagy,
Malerei, Photographie, Film
(1925; *Painting, Photography,
Film*), 97.

„Boxkampf in New York". Photoplastik: **CITROEN / BAUHAUS.**

Die Spannung: Die Übergroßstadt als
Hintergrund einer modernen Sportschau.

97

artistic montage to industrialization, Taylorism, and the age of the machine.
He thus shifted the meaning of the term "montage," bringing it into line
with constructivist ideology. This artistic self-styling is highly relevant with
regard to the changing perception of the human figure in an age driven by—
and at times skeptical of—technological innovation: by basically depicting
himself as an operator of a larger technological apparatus, Moholy-Nagy
underscores the gradual shift from the humanist perception of the human
figure—and, by extension, the artist's persona—as possessing absolute indi-
vidual integrity, toward an understanding of the human being as a mere
actor in a technology-driven system. While the portrait of Moholy-Nagy
would indicate an embrace of this shift, several of Brandt's photomontages,
obviously drawing from the devastating experience of the first war of the
Industrial Age, would take a more critical stance.

Moholy-Nagy's constructivist redefinition of montage would not have
resonated well with Paul Citroen. Citroen had studied with Itten at the

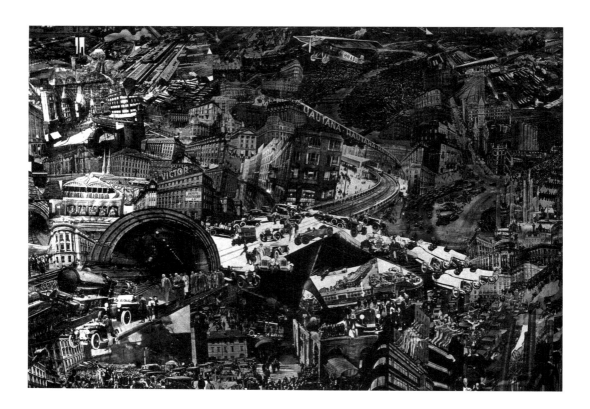

Fig. 2.22 László Moholy-Nagy, work for Erwin Piscator's production of *Der Kaufmann von Berlin* (*The Merchant of Berlin*), 1929. Photomontage, 11¹³⁄₁₆ × 15⅝ (30 × 39 cm). Theaterwissenschaftliche Sammlung, Cologne.

Bauhaus and was an avid follower of the latter's design pedagogy. For this reason, he was not receptive to Moholy-Nagy replacing Itten as instructor of the Vorkurs in 1923. Moholy-Nagy's start at the Bauhaus is generally seen as the end of the institution's expressionist early phase and as the beginning of the transition to a constructivist and productivist design pedagogy. As Citroen later commented: "This 'Russian' trend that had evolved outside of the Bauhaus with its exact, allegedly technical forms was repulsive for us, who were devoted to the extremes of German expressionism." In an essay published in 1927, Citroen took a stand against the idea of the artist as an engineer or constructor: "Painting is a romantic affair. All painters are romanticists, and one must not renounce romanticism, but emphasize it in order to paint good paintings."[59] Though such a statement seems inconsistent with the artist's montage experiments of only a few years earlier, it seems to point to a fundamental artistic conviction.

While in *Painting, Photography, Film,* Moholy-Nagy distances himself from early Dadaist "photomontage," its potential for contemporary artistic production and the subject of the metropolis seem to have preoccupied him. As already mentioned, in the unrealized film script *Dynamics of the Metropolis,* included in the last pages of his book, the essence and perception of the contemporary city were to be explored through a filmic montage (see fig. 2.8). Architectural elements and motifs can be found in the photomontages that he produced from 1922 to his death in 1946, even though contemporary architecture or the modern metropolis are never

these works' main subject. An exception is a work he produced for Erwin Piscator's production of Walter Mehring's play *Der Kaufmann von Berlin* (*The Merchant of Berlin*) in 1929 (fig. 2.22). Piscator produced a film roughly thirty minutes long that was presented in his theater at Nollendorfplatz. Moholy-Nagy was in charge of the stage design of the play, set in 1923, which told of the rise and fall of an Eastern European Jew who had migrated to the inflation-ridden German capital. Moholy-Nagy's photomontage, likely presented as a background projection for one of the final scenes, is obviously informed by Citroen's *Metropolis,* despite clear differences: not limiting itself to the typical architectural elements of the modern industrialized city such as office buildings, chimneys, tunnels, boulevards, and tenement houses (and thus avoiding the impression of a dense and static "sea of stones"), Moholy-Nagy's montage emphasizes the dynamic of modern means of transportation such as the car, the railway, and the airplane, as well as their dynamization of spatial perception.[60] In addition, Moholy-Nagy makes conspicuous use of the diagonal as a structural element, compared to the grid-like organization of Citroen's piece: a bright square or intersection busy with cars and people is placed at the center, and the rest of the image is arranged dynamically around it—in this regard, the composition resembles Brandt's *Our Unnerving City* with its visual vacuum effect.[61] Also like Brandt and unlike Citroen, Moholy-Nagy includes humans in his metropolis, making it an inhabited urban space rather than an urban stage. Again, these figures appear mainly as operators of technical devices (cars, trains, bicycles) that serve as extensions of the body. Both Citroen's and Moholy-Nagy's photomontages as well as those by Höch and Brandt suggest that the modern metropolis can no longer be grasped from a stable point of view; now, a mobile spectator is needed, who can understand and appreciate the breaks and discontinuities in the contemporary image of the city as an essential visual and conceptual quality of modernity. Such images may be seen as a visual critique not only of the tenets of central perspective, but also of conventional architectural photography, which tended to enhance perspectivism's scopic regime. If the modern city had produced a new sense of space that called for a changed, mobile, and embodied perception, photomontage provided a representational technique suited to this new spatial order.

FROM THE BAUHAUS TO SOVIET FACTOGRAPHY

The historical and epistemological significance attributed to Citroen's *Metropolis* by his contemporaries is documented by the work's immediate dissemination in a variety of publications. The year following its first public appearance at the First Bauhaus Exhibition in Weimar in 1923, it was reproduced in *LEF,* the journal of the Left Front of the Arts, mouthpiece of avant-gardist artists and theoreticians in the Soviet Union in the early 1920s (fig. 2.23). That same year, Citroen's photomontage was also reproduced in

the October–November issue of an unidentified German magazine, in what appears to have been an advertisement for the Weimar Bauhaus (fig. 2.24).[62] The page spread shows a symmetrical composition of several photographic reproductions, with Citroen's *Metropolis*—here titled "Die Stadt der Welt" ("The City of the World")—taking center stage, surrounded by two photographs of Oskar Schlemmer's *Triadic Ballet* and a material construction in the form of a primitive mask. The central position of *Metropolis* underscores the paradigmatic significance of this work during the second, constructivist period of the Bauhaus (at least in the eyes of those responsible for publishing this ad). In this sense, *Metropolis* could be seen as replacing Lyonel Feininger's expressionist woodcut *Kathedrale* (1919), which had adorned the cover of Walter Gropius's 1919 Bauhaus manifesto, the *Programm des Staatlichen Bauhauses in Weimar* (*Program of the State Bauhaus at Weimar*). The change of media—from woodcut to photomontage—epitomizes the shift from an artistic/expressionist to a productivist/constructivist mindset.

LEF was edited by the futurist poet Vladimir Mayakovsky and the writer and literary critic Osip Brik. Essentially a literary journal, it counted among its contributors not only writers and poets such as Mayakovsky, Brik, Sergei Tretyakov, and Viktor Shklovsky, but also the film directors Sergei Eisenstein and Dziga Vertov, as well as the artist Rodchenko, who, as the journal's

Fig. 2.23 Double-page spread from *LEF* 4 (1924): 42–43, with Paul Citroen's *Metropolis* and Liubov Popova's photomontage for a stage set.

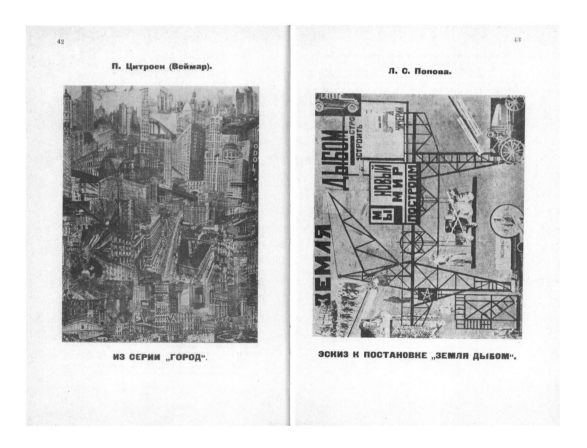

Fig. 2.24 Paul Citroen, *Metropolis,* 1923. Photomontage, from a Bauhaus Weimar advertisement, November 1924. Getty Research Institute, Los Angeles. Jan and Edith Tschichold papers.

house artist, was in charge of the cover designs while also contributing to its content.[63] The film historian David Bordwell has indicated how important *LEF* was for the development and propagation of cinematic montage theory in the Soviet Union, which took place through an interdisciplinary exchange of ideas.[64] It was in this context that Eisenstein and Vertov developed and presented their montage theories to a wider audience for the first time. It is thus highly significant that Citroen's *Metropolis* should appear in *LEF* as one of the first documents of the visual revolution.

LEF initially appeared between 1923 and 1925, and after a two-year hiatus again from 1927 to 1928 under the title *Novyi* LEF (*New* LEF); in both instances the publication was funded by Narkompros, the state-run People's Commissariat of Enlightenment, which was in charge of all affairs of education and culture in the early Soviet Union. Unlike the first series, which hardly included any visual material, the second run reproduced photographs and photomontages frequently and in large numbers. It served mainly to promote "factography," which, as stated by Benjamin H. D. Buchloh, was the "new method of literary representation/production that accompanied [the program of productivism]." Tretyakov, the movement's main promoter, defined factography's aims: "The problem of the fixation of fact: raising the interest in reality of those most active, asserting the primacy of the real over fiction, the commentator on public affairs over the belletrist—this is what in *Lef* is now most burning and immediate."

Even though factography may seem like a backlash to the experimental and constructivist currents in Soviet art of the early 1920s, Leah Dickerman has demonstrated that it was a counter-model to emerging socialist realism. Taking the photographic index as a model, it privileged the mode of description over narrative exegesis and strove for a great density of naturalist detail: "The factographic project as a whole might be seen as archival: an accumulation of facts, each a singular impression registering the trace of a specific moment in time."[65]

Citroen's *Metropolis* was one of the few images in the first run of *LEF*, sharing a double-page spread with a Soviet example of a photomontage, a design for a stage set by Liubov Popova (see fig. 2.23). The editors' inclusion of these two visual works underscores their programmatic significance. The works appeared along with an anonymous text titled "Photomontage." As already mentioned, this was most likely the earliest use of the term in print anywhere and preceded Moholy-Nagy's use of it in *Painting, Photography, Film* the following year. This essay has long been attributed to Rodchenko, but more recent scholarship has established that it was likely written by *LEF*'s co-editor, Osip Brik.[66] Its major passages read as follows: "'Photomontage' we understand to mean the utilization of the photographic shot as a visual medium. A combination of snapshots takes the place of the composition in a graphic depiction. What this replacement means is that the *photographic snapshot is not the sketching of a visual fact, but its precise record.* This precision and documentary character of the snapshot have an impact on the viewer that a graphic depiction can never attain. . . . An advertisement with a photograph of the object being advertised is more effective than a drawing on the same theme."[67] Brik's praise of photography for its "precise fixation" of facts and its "documentary" character reads like an early instance of factography. Photography is here considered a transparent medium that allows a direct and unhindered representation of the world. However, no attempt is made to differentiate between photography and photomontage or to examine—as Eisenstein would in the medium of film—how montage produces meaning by means of its inherent breaks and ruptures. In sum, despite the programmatic title "Photomontage," the essay serves more as a justification of photography than a theory of photomontage in the context of Soviet cultural politics of the time. However, Brik does mention photography's (and photomontage's) ability to address a mass audience for advertisement and propaganda purposes. As Buchloh has pointed out, photomontage was thus defined from the beginning "as an agitational tool that addresses the Soviet Union's urban masses."[68] What made photomontage so interesting from the point of view of the communist revolution was its potential to address a large audience and to turn its members from passive observers into active participants—both in the production of visual meaning and in the political process (a potential that Eisenstein also stressed repeatedly). From here, it was a logical step to the political use of photomontage. While Citroen's *Metropolis* hardly lent itself to such an agitational

use in a revolutionary sense, the editors of *LEF* quite apparently recognized its paradigmatic conjunction of the metropolis, a mass audience, and the generation of visual meaning based on juxtaposition.

FROM PHOTOMONTAGE TO FILM

Perhaps more than Paul Citroen's photomontage *Metropolis*, Fritz Lang's 1927 movie of the same title stirred the popular imagination about the city of the future. Based on Thea von Harbou's 1927 screenplay, the film addressed many of the pressing issues of urban society in the Weimar Republic. As the film critic Siegfried Kracauer recollected in 1947: "Thea von Harbou was not only sensitive to all the undercurrents of the time. . . . *Metropolis* was rich in subterranean content that, like contraband, crosses the borders of consciousness without being questioned." Despite its over-laden symbolism and somewhat reductionist plot structured between good and bad, *Metropolis* was so memorable because of its phenomenal imagi-nation of a future cityscape.[69] According to the filmmaker's own recollec-tion, the inspiration for the film's architectural set had occurred to Lang when on a trip to New York in 1924: "The view of New York by night is a beacon of beauty strong enough to be the centerpiece of a film. . . . There are flashes of red and blue and gleaming white, screaming green . . . streets full of moving, turning, spiraling lights, and high above the cars and ele-vated trains, skyscrapers appear in blue and gold, white and purple, and still higher above there are advertisements surpassing the stars with their light." Here, Lang is obviously less interested in the architectural forms per se than in the aesthetics of light and color in the urban nightscape. One result of the trip was a famous double exposure of Broadway by night, an image that Erich Mendelsohn included in his photographic essay *Amerika: Bilderbuch eines Architekten* (1926; *Erich Mendelsohn's "Amerika": 82 Photographs*), falsely crediting himself as its author in the first edition (fig. 2.25). The visual language of the film *Metropolis* was undoubtedly inspired by the real

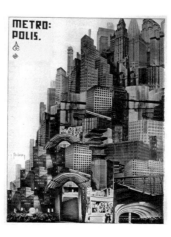

Fig. 2.25 Fritz Lang, *Broad-way*, 1924, from Erich Men-delsohn, *Amerika: Bilderbuch eines Architekten* (1926; *Erich Mendelsohn's "Amerika": 82 Photographs*), opp. 44.

Fig. 2.26 Boris Bilinsky, Theater decoration for the first screening of Fritz Lang's *Metropolis*, 1926. Photomon-tage. National Film Archive, London.

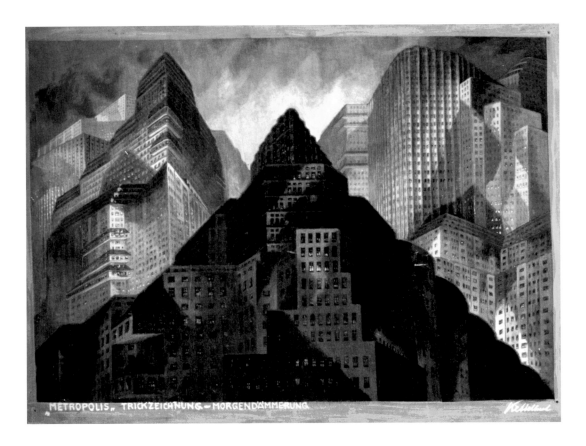

METROPOLIS, TRICKZEICHNUNG — MORGENDÄMMERUNG

Fig. 2.27 Erich Kesselhut, Set design for *Metropolis*, 1926. Deutsche Kinemathek, Berlin.

experience of the spectacle of the American city, to which European visitors seem to have been particularly vulnerable.[70] Beyond that, it is tempting to examine a possible connection between Citroen's metropolitan vision and Lang's. The various mock-ups of the film set and the advertisements for the film show striking similarities to Citroen's work. This is particularly evident in a photomontage produced by Boris Bilinsky to decorate the theater for the first screening of *Metropolis* in 1926 (fig. 2.26).[71] An image executed by the movie's set designer, Erich Kesselhut, indicates that he was likely aware of Citroen's photomontage as well (fig. 2.27), and a poster designed by Bilinsky in 1927 for the film distribution company L'Alliance Cinématographique Européenne (ACE), in order to promote the movie in France, is also clearly indebted to Citroen's work (fig. 2.28).[72] Unlike the movie itself, Bilinsky's poster represents the metropolis as a dense collection of soaring skyscrapers intersected by bridges and railway lines. The poster also integrates the film's title, with its individual letters taking on the character of collaged architectural elements. In fact, Bilinsky's poster has more in common with Citroen's representation than with Fritz Lang's expressionist interpretation of the metropolis.

The impact of Citroen's *Metropolis* extends further in the German film culture of the late 1920s. In the advertisement campaign for Walter Ruttmann's *Berlin—Die Sinfonie der Großstadt* (1927; *Berlin—Symphony of a*

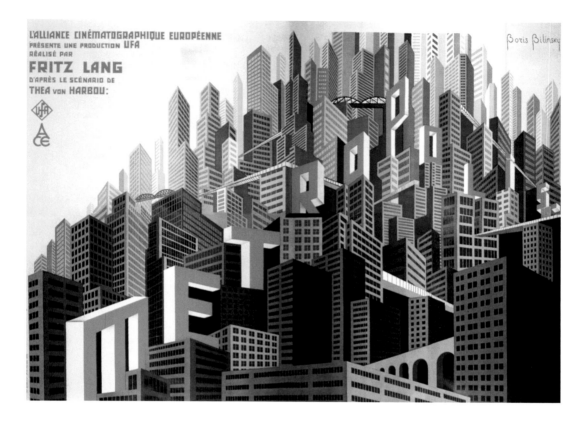

Fig. 2.28 Boris Bilinsky, Film poster for *Metropolis*, 1927.

Great City), photomontage was (again) prominently used (fig. 2.29). The movie, a highly dynamic portrait of a day in the "life" of a metropolis, makes use of cinematic montage to convey a sense of rhythm and speed. Ruttmann commissioned a number of artists to produce some twenty photomontages that would be used for the promotion of the film. One of these is based on reproductions of iconic high-rise buildings of the time, including the Woolworth Building in New York and Höger's Chilehaus in Hamburg, and features a large pocket watch to point to the topic of time and speed. While authorship for most of these mock-ups has not been securely established, two sheets are signed by Umbo; they were kept in the private archives of Citroen, who was Umbo's close friend and collaborator. The first of these two photomontages, both of which date to 1926, is one of the most well-known of its genre: Umbo's *Der Rasende Reporter* (*The Racing Reporter*), which was printed on the back of the French advertisement brochure "Symphonie d'une grande ville" distributed by the Société des films artistiques (SOFAR) in 1928. The image was simultaneously an homage to Egon Erwin Kisch, one of the Weimar Republic's most prominent journalists, famous for the literary and at times photographic style of his "reportages." The work's title referred to Kisch's 1925 edition of journalistic essays, which made its author famous as the "reporter of American speed." Representation of the city plays only a subordinate role in *The Racing Reporter;* Umbo's main interest is the figure of the journalist, who observes modern

Fig. 2.29 Walter Ruttmann,
Publicity material for
*Berlin—Die Sinfonie der
Großstadt* (*Berlin—Sym-
phony of a Great City*), 1927.
Photomontage. National
Film Archive, London.

life in the city. All his limbs and sensory organs are replaced with techno-
logical devices so that he becomes a super-human android. If the blurring
of the boundaries between man and machine is tested in the contempora-
neous photomontages by Marianne Brandt and László Moholy-Nagy, their
merging is fully achieved in Umbo's piece. The artist seems to welcome this
integration enthusiastically by demonstrating the degree to which techno-
logical inventions enhance the capacity of the human senses to perceive the
surrounding world. As the photo scholar Herbert Molderings has pointed
out, Umbo "never again came closer to the constructivist philosophy of life"
than with this work.[73]

Umbo's amalgamation of the human figure with technical apparatus is
highly reminiscent of the Soviet filmmaker Dziga Vertov's idea of the Kino-
Glaz, or cine-eye, which Vertov first developed in his "WE: Variant of a
Manifesto" written in 1919. From Vertov's point of view, the human eye,
which can achieve the potential of vision only imperfectly, requires sup-
plementation by the technical apparatus of the camera. In the introductory
passage of his "Provisional Instructions to Kino-Eye Groups," he writes:
"Our eye sees very poorly and very little—and so men conceived of the
microscope in order to see invisible phenomena; and they discovered the
telescope in order to see and explore distant, unknown worlds. The movie
camera was invented in order to penetrate deeper into the visible world,
to explore and record visual phenomena, so that we do not forget what
happens and what the future must take into account."[74]

Vertov's notion of the Kino-Glaz is exemplified in a still from his
chef-d'oeuvre, *Man with a Movie Camera* (1929), in which the human eye

Fig. 2.30 Dziga Vertov, Film still from *Man with a Movie Camera*, 1929.

is superimposed by the lens of a camera (fig. 2.30). The film is a portrait of contemporary life in the Russian metropolis, but the main interest here as well is the act of journalistic reporting and the figure of the reporter. Like Umbo's hero, the man with the movie camera takes on the detached position of a surveyor of the city and, by means of his prosthetically enhanced, mechanized vision, enjoys all-encompassing perception. At the same time, the technique of cinematic montage produces a new level of consciousness in its mass audience. It is precisely this potential of (photo)montage that must have drawn LEF's editors to Citroen's *Metropolis*.

Very much related both in form and content to Citroen's metropolitan photomontages are the works by Krakow artist Kazimierz Podsadecki from the late 1920s and early 1930s, in particular his photomontage *Miasto młyn życia* (*City the Mill of Life*) (fig. 2.31). Podsadecki's interest in urban photomontage must also be seen in the context of his fascination for film and his engagement in the so-called Praesens group, a hotbed of the Polish constructivist avant-garde. The painter Władysław Strzemiński, the leader of the Praesens group, advocated photomontage in the mid-1920s as a means of communication in mass culture. According to him, photomontage, in its use of ready-made photographic reproductions, allowed maximum productivity and efficacy in communication, analogous to the rationalization of industrial production advocated by Frederick Taylor and Henry Ford.[75] This interpretation marked a clear difference from the Soviet usage of photomontage as a model for revolutionary, anti-capitalist art as put forward by early Eisenstein, LEF, Rodchenko, Lissitzky, and others. Podsadecki's *City the Mill of Life* first appeared on the cover of the June 1929 issue of the popular magazine *Na Szerokim Świecie*. The image was likely inspired

Fig. 2.31 Kazimierz Podsa-decki, *Miasto młyn życia* (*City the Mill of Life*), 1929. Photomontage, 16⅝ × 11½ in. (43 × 29 cm). Museum Sztuki, Lodz.

by Umbo's advertisement poster for Ruttmann's *Symphony of the Metropolis* of 1927, and that for Fritz Lang's *Metropolis* from the preceding year, both of which seem to draw, as we have seen, from Citroen's iconic photomontage. Like Citroen's work, *City the Mill of Life* displays a dense array of American high-rise buildings, though unlike *Metropolis*, Podsadecki's work leaves a margin that is free of architectural elements. *City the Mill of Life* introduces an anecdotal or even narrative dimension into the photomontage that is foreign to Citroen's *Metropolis* and that likens the work to the visualization of a film plot. The montage includes several frozen scenes of open violence: on the lower right, a man fires a rifle; next to him, a man in a coat falls down; above that, someone is strangled. As if struck by both awe and horror, a large portrait head in the center of the photomontage witnesses all of this without being able to take action. This figure embodies the highly ambiguous stance of this photomontage toward both the modern American metropolis and capitalism, which is also very evident in Lang's epic *Metropolis:* awe for the technological and architectural achievement

Photomontage and the Metropolis

these cities represent merges into horror in the face of the dangers they hold for modern life and society. As a matter of fact, *City the Mill of Life* was only the beginning of a series of photomontages in which Podsadecki expressed an increasingly gloomy interpretation of rapid urbanization and its impact on urban life. Another of these photomontages, published in the magazine *Na Szerokim Świecie* in 1931, illustrates a text that likewise takes a critical stand: "No doubt, contemporary moloch-cities, such as New York or Chicago in America . . . in a sense may be considered as prototypes of future cities. The skyscrapers, several hundred metres high . . . do not make an encouraging image of the future. Already nowadays in our biggest cities life has become so complicated in technological terms, requiring of its citizens enormous nervous tension, that the urban development cannot follow the same course for too long. If those anthill-cities keep growing with the same momentum, its inhabitants will be destroyed both physically and psychologically."[76] All of the examples cited so far exhibit a great fascination with the technological apparatus and its impact on a modern visual culture, as the use of photomontage is a strong assertion of the industrialized age of technological reproducibility. At the same time, the medium expresses self-reflexive concern about the cultural conditions of modernity.

PHOTOMONTAGE BEFORE PHOTOMONTAGE

As we have seen, Dadaist photomontage drew significantly from vernacular traditions of manipulated photography as it was practiced throughout Prussia, mainly in humorous and military contexts. Dadaist photomontage thus could count on a certain degree of visual literacy or familiarity with such images in popular culture. On this basis, Dadaists developed photomontage into a device for the production of visual meaning based on the juxtaposition and contrast of the montaged elements. It could be said that the beginnings of manipulated photography—the technical experimentation that would eventually lead to photomontage in the sense sketched out here—can be traced to the very beginnings of photography.

One way to understand why photographers, at an early stage of the evolution of the new medium, started to manipulate images in the process of their production is through photography's precarious status between science and art.[77] Indeed, pioneers of the medium as early as the mid-1850s anticipated the critique voiced against positivist science in the early twentieth century. One of their most powerful rhetorical tools for disrupting the claim that photography's task was to truthfully represent reality was the invention of photomontage, among other strategies of manipulating photographs. Such manipulations occurred from photography's very beginnings—the process of producing a print, from the framing of an image to the chemistry in the lab up to the final product, allows for a whole range of creative interventions and manipulations. However, photographers soon consciously exploited their medium's accessibility to such manipulations in

order to emancipate photography from its ancillary function in the sciences and instead to stress the medium's artistic quality. For example, the British painter-turned-photographer William Lake Price published his *Manual of Photographic Manipulation* as early as 1858. In 1861 the journal *Photographic News* likewise published an article on the problem of photographic manipulation, stating that "a photographer, like all artists, is at liberty to employ what means he thinks necessary to carry out his ideas. If a picture cannot be produced by one negative, let him have two or ten: but let it be clearly understood, that these are only means to the end, and that the picture when finished must stand or fall entirely by the effects produced and not by the means employed."[78] In light of the avant-garde discourse on photomontage, this quote is striking in that it takes photographic manipulation and the recombination of negatives as an almost natural possibility offered by the technological process of photography. What counts is not at all what such a combination may mean, but exclusively the artistic effect achieved by the combination print. In contrast, in avant-garde photomontage, the ostentatious juxtaposition of individual elements is both part of the aesthetics and semantics of the constructed image.

One of the major techniques developed to affirm photography's status as an art (thus capable of more than scientific documentation or the mere re-presentation of an extra-pictorial reality) was so-called "composite imagery" or "combination printing," which can be seen as the historical ancestor to the avant-garde photomontage of the twentieth century.[79] "Combination printing" was the term for the nineteenth-century high-art photographic practice of combining several individual negatives into one print. A prime example is the allegorical picture *The Two Ways of Life* (1857) by the Swedish-British artist Oscar Gustav Rejlander, one of the

Fig. 2.32 Oscar Gustav Rejlander, *The Two Ways of Life,* 1857. Combination print, 16 × 30 in. (40.6 × 78.5 cm). Royal Photographic Society, London.

Fig. 2.33 Henry Peach
Robinson, *Fading Away,*
1858. Combination print.

masters of combination printing (fig. 2.32). The image is clearly inspired
by Raphael's famous painting *School of Athens.* A sage standing on a plat-
form or dais at the center of the depiction introduces two youths in front
of him to two opposing ways of life: virtue, on the right, and vice, on the
left. Produced with the aid of Madame Warton's troupe, a popular theater
group famous for its performances of *tableaux vivants,* the photograph was
composed from more than thirty individual negatives.[80] Despite the mul-
titude of individual postures of the figures represented in the image, this
"montage" does not display its manner of construction. The scene presents
itself as a coherent narrative within a homogenous, monocular space, and
its artificial, theatrical nature is indicated by parergonal features such as the
curtain at the top and the blending of natural and architectural elements in
the background of the image.

Nineteenth-century combination printing was also quite popular in
landscape photography. The French photographer Gustave Le Gray used
the technique to produce dramatically atmospheric lighting in his land-
scapes and seascapes. His Roman colleague Gioacchino Altobelli staged the
antique ruins of his home city in equally theatrical night shots, which was
only possible with the help of the combination technique. Another exam-
ple of combination printing that illustrates particularly well the technique's
implications for conceptions of space and time in photography is the work
Fading Away (1858) by the British photographer Henry Peach Robinson
(fig. 2.33). What may appear as the realistic documentation of the death
of a young woman in the presence of members of her family is in fact a
print based on a combination of five individual negatives; the result is a

highly allegorical depiction of death and transcendence. Robinson was well known to first sketch his ideas on paper and then stage them with the camera. Capturing the actual moment of death would hardly have been possible (or desirable) in reality, nor could a documentary photograph have produced such a strongly symmetrical and symbolically charged image. Robinson's picture may be seen as an important step toward photography's emancipation as an autonomous form of art.[81] It is significant that the image violates the Aristotelian unities of place and time that are normally given in photography.[82] Despite this fictionalization, the aim is to induce in the observer a kind of "reality effect," to borrow Roland Barthes's term. In this regard, nineteenth-century combination prints have more in common with contemporary digital rendering practices than with avant-garde photomontage. The boundaries between reality and fiction are blurred, and the image presents itself to the viewer's imagination.

At its inception, photography was hailed as an instrument that would be capable, unlike any other medium, of representing reality truthfully. Photography was considered to be "objective" and scientifically impartial (and, as we have seen, it is precisely this aspect that would appeal to advocates of Soviet "factography").[83] Henry Fox Talbot, one of the early pioneers and theoreticians of photography, called the medium the "Pencil of Nature."[84] Clearly, the pictorial compositions by Robinson and Rejlander discussed here are diametrically opposed to this kind of "naturalism." Instead, they are concerned with an idealized and fictionalized depiction of the world. Combination printing offers a strange paradox: technically highly innovative, these images are oriented toward the conservative aesthetic norms of nineteenth-century academic painting. The reason for this seems quite clear: the protagonists of the new mechanized technique sought to establish it among the arts, and in order to do so, they resorted to aesthetic norms as codified in an established, pre-mechanical artistic practice.

THE REPRESENTATION OF DISCONTINUOUS SPACE

If we consider Rejlander's *Two Ways of Life,* it is evident that the depiction, despite its montage character, remains within the conventions of a traditional representation of space. By means of the layering of planes and architectural framing, the image creates an illusion of continuity and depth of space according to the laws of linear perspective. This is certainly not the case in *Aberdeen Portraits No. 1* (1857) by the Scottish photographer George Washington Wilson.[85] In an oval shape, it combines the faces of roughly one hundred inhabitants of the city of Aberdeen into a planar depiction. At first sight, the logic of this composition evokes Dutch group portraits from the seventeenth century. What is striking in Wilson's montage, however, is the absence of interest in producing any kind of illusionistic spatial depth. Instead, this image seeks to exhibit the two-dimensional quality of its presentation. The individual portrait photographs themselves are "representa-

Disdéri Phot MOSAÏQUE.
Breveté s ġ d ġ

tions" in the conventional sense of the term; but this is no longer true for the composition as such. As the photo historian Robert Sobieszek remarks: "There is really no attempt to disguise the composite nature of Wilson's photograph, which is very much in keeping with twentieth-century attitudes such as honest use of material, delight in construction for its own sake, and multiple viewpoints. And while the Victorian viewer might not have been able to see this picture in just these terms, it would have required an incredible naiveté to judge it on completely naturalistic grounds." From the 1860s onward, similar early instances of photomontage become more frequent. An interesting case is the "carte-de-visite mosaïque" by the French photographer André-Adolphe-Eugène Disdéri, which he patented in April 1863 (fig. 2.34). His group portrait of the contemporaries of Napoleon III is not unlike the *Aberdeen Portraits* by Wilson; however, Disdéri organizes the image hierarchically: the portraits of the emperor and his wife and son (at the upper edge) are larger than the rest, evoking the *Bedeutungsperspektive* (status perspective, or perspective that sizes persons and objects according to importance) familiar from medieval sacred imagery. Like Wilson's work, Disdéri's mosaic is nearly spaceless, with the individual faces completely taken out of their "natural" context and grouped in an allover constellation. Another example of Disdéri's mosaics presents an arrangement of dancers' legs at the opera (fig. 2.35). Unlike in the group portrait,

Fig. 2.34 André-Adolphe-Eugène Disdéri, *Mosaïque de dignitaries sous Napoléon III* ("*Mosaïque" of Dignitaries under Napoleon III*), 1864. Photomontage.

Fig. 2.35 André-Adolphe-Eugène Disdéri, *Les Jambes de l'opera* (*The Legs of the Opera*), ca. 1870. Albumen silver print, 3 1/3 × 2 in. (8.8 × 5.1 cm). George Eastman Museum, Rochester, N.Y. Gift of Eastman Kodak Company, ex-collection Gabriel Cromer.

Fig. 2.36 László Moholy-Nagy, *Das Weltgebäude* (*The Structure of the World*), 1927. Photomontage. Photo International Museum of Photography at George Eastman House, Rochester.

the individual elements of the depiction are now rigidly aligned into nine rows. By limiting himself to the lower body, Disdéri attempts a "symbolic portrait of the dancers" that Sobieszek calls "a formalistic and conceptual wonder."[86] Indeed, this carte de visite seems more like an abstract exercise in the organization of space in a grid than a representation of a human being. With his interest in the structural order of the two-dimensional planar representation, Disdéri antedates László Moholy-Nagy's photomontage *Das Weltgebäude* (1927; *The Structure of the World*) by sixty years (fig. 2.36). Against an empty, seemingly endless and undefined open space in the background, Moholy-Nagy positions a wooden framework of both orthogonal and oblique elements, which supports a cruciform figure again composed of numerous human legs. At its summit a monkey holds onto a pole that runs diagonally through the entire image—a rather pessimistic or at least ironic comment on the "structure of the world." Even though Moholy-Nagy is unlikely to have known Disdéri's work, the latter quite obviously anticipates constructivist experimentation with the structural order and geometry of the image as well as the abandonment of linear perspective.

A work such as *Bradley & Rulofson's Celebrities* (1876) indicates that depictions in the tradition of Disdéri's mosaic became a fashion toward the end of the nineteenth century in the United States as well. At the same time, this work is structurally much less rigid than the previous examples, and the size of the individual heads varies considerably. The appeal of this image is obviously the optical play it presents to the viewer. Sobieszek has rightly argued that this kind of composite image has striking similarities to Citroen's metropolitan photomontages. Despite their rather different subject matter, "The treatment of the material, the compositional elements, and the structuring of the entity that is entirely pictorial in character are remarkably alike."[87] Even though avant-garde artists followed different aims in their photomontages, their breaking up of a spatial continuum as well as the idea of combining photographic reproductions from different contexts into a single image was obviously anticipated by nineteenth-century photographic experimentation of this kind. The exploration of discontinuous architectural space and its perception became a major field of investigation for Dadaist and constructivist artists, and photomontage was the prime medium to undertake this inquiry. For them, "space" primarily meant the social and architectural space of the metropolis, which they saw as a "symbolic form" of modernity. Fittingly, architects also took up montage practices. For them, the manipulation of photography became a key instrument for the visualization of their ideas and the promotion of their prospective projects.

Photomontage in Architectural Representation

The relationship between modern architecture and photography has often been described as an elective affinity.[1] In the mid-nineteenth century, when photography was an emerging and still technically imperfect medium, the static nature of buildings made them a patient and forgiving subject. What is thought to be the first photographic image, a heliograph taken by Nicéphore Niépce in 1826, shows a view from a window onto a nondescript set of buildings. From its inception, photography was celebrated as providing a new "mechanical objectivity" in replacing the draftsman's subjective view with the (allegedly) distanced and incorruptible "take" of a technical apparatus.[2] The discipline of architecture and the new preservation initiatives in the second half of the nineteenth century made increasing use of photography to visually chart the built world. Photography was deemed the perfect method for preserving the memory of urban scenes and individual buildings for eternity. Exhaustive photographic campaigns in places such as Prussia and France aimed to make a record of the built national heritage.[3]

While nineteenth-century positivist science hailed photography as a great invention supporting scientific truth and truthfulness to reality, this belief was increasingly questioned by a critique of methodology. In the 1930s, the French philosopher of science Gaston Bachelard coined the term "phenomenotechnique" and—in opposition to the positivism of his time— argued that apparently "natural" phenomena as observed by scientists were actually highly artificial and subject to interpretation in the process of being observed and, thus, that scientific theories and assumptions generated their own reality.[4] From this perspective, the scientist is not a neutral observer who describes, classifies, and identifies natural phenomena, but rather is their active generator. By extension, photography is by no means a "transparent" medium that simply reports "reality" truthfully. In contemporary terms, it is an "index" that points at reality but cannot be reduced to a trace.[5] It is an apparatus (in the Foucauldian sense) that produces and

constructs a visual reality in the first place by means of framing and other decisions made by the photographer, establishing a difference between the three-dimensional (architectural) object and its two-dimensional photographic representation.

Indeed, modern architects soon became aware of photography's potential not only to represent buildings faithfully, but also to be actively manipulated. If a building was always only an imperfect representation of an ideal architectural or spatial conception—and thus, as part of a social and economic reality, subject to compromise—the manipulation of photography provided architects a means with which to represent more precisely their abstract idea(l)s of space, form, and light.[6] In addition, the new medium, together with advances in printing and reproduction technology, allowed architectural ideas to spread over large distances and become available to a much broader audience. With the advent of photography, architecture entered the age of technological reproducibility.

As we have seen, the "official" invention of photomontage is usually associated with the Berlin Dadaists and dated to the end of World War I. I contend that this historical account is incomplete without a discussion of manipulated photography in the late nineteenth century, in an artistic setting as previously discussed, and more importantly in its wide use in architectural representation. In modernist architectural production, photomontage would advance to become a primary representational form; it would also become an epistemological principle, as is evidenced in the writings of Sigfried Giedion. This chapter also traces the political (ab)use of photomontage in the 1930s, when its power to address and activate the viewer was used increasingly for propagandistic purposes.

FROM MANIPULATED PHOTOGRAPHY TO PHOTOMONTAGE

Photomontage as a technique for the representation of architectural and urban space became a well-established practice for avant-garde architects such as Le Corbusier and Mies van der Rohe. However, architectural photomontage in the sense of retouched photographs or photographs with inserted drawings dates back well before the 1920s and was in fact widely used in architectural publications from the 1890s onward, thanks to rapid technological innovations in the printing industry. Likely the first magazine to introduce photography into architectural publishing, the *American Architect and Building News* started to include heliographic reproductions of photographs as early as 1876, in its first issue.[7] The halftone process allowed the reproduction of photographs in journals to become widespread. The first image printed with this technique, an image of Steinway Hall in New York, appeared in the *New York Daily Graphic* on December 2, 1872. Halftones became common in the 1890s in architectural publications in German-speaking countries, where the underlying process was

introduced in 1892.[8] This technological development laid the base for the mass reproduction and dissemination of photographs.

From early on, photographs were manipulated post factum in order to enhance a certain quality of the depicted buildings. The main procedure in architectural publishing was so-called "machine retouching" (*Maschinenretouche*), in wide usage up to the 1950s. This was an umbrella term for any revision or alteration of a photograph as a last step before the automated printing process. In 1911 a manual was published on the usage and function of this technique, demonstrating its significance in the printing industry.[9]

Machine retouching was frequently employed to isolate photographed objects from distracting foregrounds and backgrounds or nearby buildings. Examples of this strategy in architectural publications of the time evoke the common practice of photographically isolating monuments from their surroundings in nineteenth-century historic preservation, a practice that has become known as "constructive destruction" (fig. 3.1).[10] A particularly controversial case in this field was the proposed "reconstruction" of the castle of Heidelberg, a far-reaching project proposing measures far beyond simple conservation and maintenance. To promote the project, a manipulated photograph was produced in which surrounding elements were cleared away in order to enhance the visual power of the building; a drawing was also inserted (fig. 3.2). The conservation of the Heidelberg Castle had been an issue since the mid-1860s. In 1888 the architects Fritz Seitz and Julius Koch published their building survey, which they had meticulously prepared during the past six years on behalf of the building commission for the Heidelberg Castle. In 1890 the two architects addressed the public, calling for a "systematic restoration of the ruins as such, combined with a partial reconstruction in all those places where enhanced technical quality seems desirable." This proposal caused controversy: Karlsruhe building director Josef Durm voiced concerns and called instead for a straight conservation of the ruins. In 1891 the Ministry of Finance established a committee "for the examination and assessment of the question of which measures should be taken for the conservation of the Heidelberg Castle." The committee came to the unanimous conclusion that "a complete or partial restoration of the castle is out of the question."[11]

Fig. 3.1 E. von Ihne, Project for Pariser Platz, Berlin, 1908. Photomontage, from *Deutsche Bauzeitung* 42 (1908): 225.

Photomontage in Architectural Representation

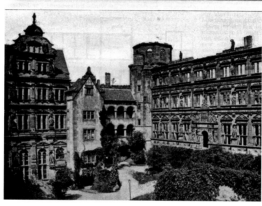

Fig. 3.2 Fritz Seitz, Reconstruction proposal for the Heidelberg Castle, 1902. Photomontage, from *Deutsche Bauzeitung* 36 (1902): 5.

The controversy continued: Seitz's proposal was published (again) in *Deutsche Bauzeitung* in January 1902 and illustrated with two images, one showing the current state, the other the prospective future restoration. The latter image shows no traces of its fictional nature; rather, by blurring the boundaries between building and project, it appears as a true-to-life representation. The comparison with the actual state of the ruined castle functions polemically: the presentation of the aesthetically "better" image against the "worse" image is addressed at a viewer ignorant of historical concerns. The pictorial comparison, which had been developed as a major instrument of analysis by emerging academic art history, was widely used in late nineteenth-century architectural publishing, most importantly in historic preservation and the German Heimatschutz movement.[12] The British neo-gothic architect Augustus Pugin is considered the inventor of this kind of pictorial comparison: in his *Contrasts* (1836), Pugin illustrates the alleged descent of European architectural culture from its medieval climax to the rehashed neo-styles of his time (fig. 3.3). Thereafter, the visual comparison of "good" and "bad" examples became a standard mode of argument for authors such as Paul Schultze-Naumburg, Hendrik Petrus Berlage, Theodor Fischer, Max Dvořák, and others.[13]

Fig 3.3 Augustus Welby Northmore Pugin, Comparison between a "Catholic town" in 1440 (bottom) and 1840 (top), from *Contrasts* (1836).

The role of the emerging field of historic preservation for the genesis of architectural photomontage should not be underestimated. Another contributing factor was the establishment throughout Europe of comprehensive photographic archives that would be available to current and future generations of architects and preservationists. Archives aim for encyclopedic completeness and provide the plurality, spatial adjacency, and juxtaposition of images that are preconditions of montage. Benjamin H. D. Buchloh has demonstrated that contemporary artists such as Daniel Buren, Marcel Broodthaers, Louise Lawler, and Gerhard Richter have appropriated visual encyclopedias and the picture atlas, and that their works can be described in terms of a montage aesthetic.[14]

The strategy of monumentalization by isolation, as evidenced in Pariser Platz in Berlin (see fig. 3.1), came full circle in modernist large-scale urban planning schemes, from Le Corbusier's unexecuted Plan Voisin for Paris (1925), in which the most outstanding historical monuments were saved, isolated, and glorified by clearing away the surrounding urban fabric, to Mussolini's *sventramenti* in Rome in the 1920s, whose main purpose lay in elevating the architectural remnants of antiquity to freestanding monuments that would speak of the glory of the nation's past. While practices of manipulating photographs are not to be held accountable for the worst effects of purist ideology based on highly questionable historical (re-)constructions, photographic retouching certainly helped prepare the ground

Fig. 3.4 Friedrich von Thiersch, Project for a new castle and parish church, Castle Hohenaschau, 1899. Photomontage. Architektur-museum der Technischen Universität München.

by disseminating and popularizing the purist aesthetics associated with it. In this manner, manipulated photographs became a powerful political and propagandistic tool.

It is important to point out that I am using the term "manipulated photographs" here to distinguish this group of works from photomontages as defined at the outset. There is no use of photographic material from different sources and no tension between montaged elements; instead, a photographic negative is altered or a drawing is inserted before a photograph's mass reproduction. Authors such as Dan Hoffman have suggested using the term "drawing-photograph" for this latter type of image.[15] Instead, I propose the term "manipulated photograph" for two reasons: first, to underscore that these works involved a manual alteration of the photographic image; and second, to point to the manipulative power of such alterations, which were often used polemically in order to influence public opinion about a certain (proposed) project and its impact on an existing built context or landscape. The aesthetic manipulation of photographic images was thus mirrored in the political manipulation of the public.

Manipulated photographs were not only used in reproductions in a journalistic setting; they also became a favorite tool in architects' presentations to illustrate the impact of a projected building on the existing cityscape or landscape. The Munich-based architect Theodor Fischer repeatedly made use of photography in this way. This strategy was particularly popular in cases where projects were of monumental scale or affected historically or artistically significant buildings. Dating from 1899, one of the earliest known examples of an architect's use of proto-photomontage is the Munich architect Friedrich von Thiersch's unexecuted design for a new castle

and parish church as well as the expansion of the existing castle at Hohenaschau (fig. 3.4).[16] The project was intended as an expansion of the existing medieval castle, prominently situated on a hilltop. To be placed at the foot of the existing structure was a longitudinal volume flanked by two cylindrical towers with characteristic neo-baroque roofs at each end. Thiersch made deliberate use of a number of neo-styles in order to blend the new project with the existing building. Nevertheless, Freiherr von Cramer-Klett, whose father had acquired the castle in 1875, ultimately commissioned the Munich architect Max Ostenrieder to undertake the expansion and modernization of the castle, which was executed between 1905 and 1908. Again, Thiersch's depiction goes beyond machine retouching since it involves the insertion of a pen and ink drawing into the photograph of the existing situation at the building site. The photograph's mounting on cardboard indicates its use for presentation purposes, likely to convince the client of the qualities of the project. It could be argued that this is also not yet a photomontage in the proper sense, but another, more elaborate form of manipulated photography: there is no reuse of photographic material and no notion of juxtaposition or conflict within the depiction.

A better-known photomontage is Thiersch's project for a new bathhouse in Wiesbaden dating from 1902 (fig. 3.5). The architect's archive at the Technische Universität in Munich holds a large number of photographs on the project, including several that were altered by the insertion of draw-

Fig. 3.5 Friedrich von Thiersch, Project for a new bathhouse, Wiesbaden, 1902. Photomontage. Architekturmuseum der Technischen Universität München.

Photomontage in Architectural Representation

ings or model photographs.[17] Again, the best-known of this series is, strictly speaking, a drawing of the project made on a photograph of the site. It is particularly interesting in comparison with a photograph of the previously existing building by the architect Christian Zais, dating from 1810, from the same perspective: whereas the existing building is marked by a two-story portico flanked by two one-story longitudinal wings, Thiersch's project proposes a much larger building of monumental dignity. The portico appears enlarged and has an imposing presence, and the ancillary wings are given two stories throughout. Formerly a somewhat modest piece of tourist infrastructure in neoclassical garb, the structure now has the regal appearance of a baroque palace. Thiersch also used pictorial comparison in order to influence his prospective clients, the representatives of the city of Wiesbaden. Before presenting his project, he produced a number of large-scale panels, 50 by 60 centimeters, on which he mounted his (manipulated) photographs arranged in pairs. In each case, one of the images showed the existing situation with the modest structure from a specific point of view, while its counterpart depicted the same situation with the proposed alterations drawn in white gouache and black ink on top of the photograph. Significantly, Thiersch signed each of the manipulated photographs, apparently fully aware of their innovative potential.[18] The architect clearly anticipated the impact of such pictorial comparisons on his clients' judgment—to his own profit, as he was eventually awarded the commission for the stately sum of six million Goldmarks.

The technique of the polemical juxtaposition of a modern project with an existing situation was frequently used in urbanist debates around 1900 as well, in a period during which German cities experienced rapid growth. An illustrative early example is the proposal for the expansion of the city of Stuttgart published in the *Deutsche Bauzeitung* in February 1902 (fig. 3.6). Among other suggestions, the project proposed building on the flanks of the undeveloped hills characteristic of the city's topography. In the publication, a photographic reproduction of the current situation of Reinsburg Hill is compared to a photomontage showing the same hill "architecturally crowned" by a monumental church. In contrast to the polemical but anti-modern use of pictorial comparisons as employed by authors

Fig. 3.6 Proposal for the expansion of the city of Stuttgart, with a project for a monumental church on Reinsburg Hill, 1902. Photomontage, from *Deutsche Bauzeitung* 36 (1902): 101.

such as Schultze-Naumburg, the Stuttgart project employs the method so as to emphasize the aesthetic and cultural validity of the proposed new construction in the context of the existing urban fabric. In this way, photomontage becomes an instrument for the promotion of grand, even utopian projects. Not only was this tradition readily taken up by avant-garde architects such as El Lissitzky and later by neo–avant-garde groups such as Archigram or Superstudio, often with an ironic or even dystopian undertone; it also anticipates digital rendering techniques of the present.

An interesting early example of a photomontage serving to illustrate the impact of a proposed project on the existing cityscape was produced in the context of plans for the new main building of the University of Zurich (1907–14) by the Swiss architect Karl Moser of the firm Curjel and Moser, which designed a large number of important civic buildings in Switzerland and southern Germany during that period. The project is particularly illuminating because of the highly exposed site of the future building on a hill behind the old town and in direct vicinity to Gottfried Semper's Polytechnic. The new building was to provide a widely visible addition to the cityscape and at the same time complete Zurich's "Stadtkrone," or city crown. Moser produced an enormous number of preliminary sketches and drawings and also used photography to visualize the impact of his project on the existing city (fig. 3.7). One of these images, dating from 1910, shows a drawing of the project inserted into a photograph at the site of the future building. Even though the solution for the crowning "tower" at the center of the building is still substantially different from the executed version, it is clear that the architect is striving for a formal solution that would make his building the defining landmark in the city. The date of the depiction is significant: the competition had already been decided in 1908, and the design contract was issued to Curjel and Moser in February 1909, but the manipulated photograph was not executed until 1910. The image was thus likely used during the regular meetings of the architect with the authorities during the design process. This type of image, however, was also produced during an architect's own experimentation in order to arrive at the best solution. In other words, the insertion of drawings of projects into photographs not only served as a polemical tool to influence the public (or, in this case, the governmental body in charge of construction); it was also a conceptual tool in the design process.

A similar situation presented itself in the project for the Fluntern reformed church in Zurich. The competition took place in 1913–14, while the construction for the university's main building was still underway, but the church was not completed until 1920. Among a large number of drawings, sketches, and plans, Moser again produced a manipulated photograph, this time likely in direct connection with the competition (fig. 3.8). As in the case of the university, the photograph serves to present the prospective building within its urban context on the slope of Zürichberg; at the same time, it underscores the potential of the new church to lend this wealthy

Fig. 3.7 Karl Moser, Project for the Kollegiengebäude of the University of Zurich, 1910. Photomontage. gta Archiv, Institut für Geschichte und Theorie der Architektur, ETH Zürich, Nachlass Karl Moser.

Fig. 3.8 Karl Moser, Project for Fluntern church, Zurich, 1913–14. Photomontage. gta Archiv, Institut für Geschichte und Theorie der Architektur, ETH Zürich, Nachlass Karl Moser.

neighborhood a distinctive identity by giving it a prominent landmark. The underlying photograph was chosen so that the project would occupy the center of the depiction, and the neo-baroque steeple that has been drawn in is the only architectural element to pierce the horizon line in the background. The drawing shows the church as the central element of a larger compound, almost in the manner of a traditional convent with its ancillary buildings. Indeed, the project included a large-scale housing scheme for which Moser produced a number of designs. In the end, only the parsonage and two freestanding buildings were executed by Moser, while other buildings were built by different architects more or less according to the master plan.[19] The manipulated photograph once again illustrates the concern for urbanist issues in architectural planning and thinking of the period.

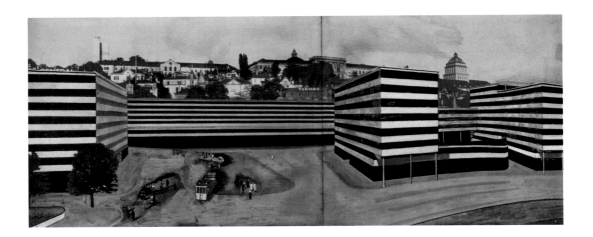

Fig. 3.9 Karl Moser, First
scheme for the redevelop-
ment of Niederdorf, Zurich,
1933. Photomontage. gta
Archiv, Institut für
Geschichte und Theorie
der Architektur, ETH Zürich,
Nachlass Karl Moser.

Moser was to return to manipulated photography toward the end of
his career in one of his most controversial projects: his scheme for the
redevelopment of a substantial part of the old town of Zurich, the so-called
Niederdorf study of 1933, which was never executed. As in many other cit-
ies throughout Europe at that time, the historic old town of Zurich was con-
sidered to be a socially and hygienically undesirable shantytown unfit for
the demands of modern living and transportation. Moser's two redevelop-
ment projects for the neighborhood on the right bank of the Limmat River
stand in a long list of similar proposals in other cities that suggested radi-
cally clearing away the historic urban fabric. They are clearly informed by
Le Corbusier's Plan Voisin and an intense reading of *Précisions sur un état
présent de l'architecture et de l'urbanisme* (*Precisions: On the Present State
of Architecture and City Planning*), his defining treatise on urbanist issues
from 1930.[20] Again, Moser produced depictions of each of his two succes-
sive projects by inserting a drawing of his proposal into a photograph of the
existing cityscape (fig. 3.9). The image for the first project of 1933 shows
the vicinity of Leonhardsplatz (today Central) at the north end of the area
in question. In a perspective seen from the river from an elevated point of
view, Moser's scheme is represented within the existing context, with the
main buildings of the Polytechnic and his own university building in the
background. The project is characterized by a series of rectangular blocks
aligned orthogonally along the river and held together by a longitudinal
slab, thus opening toward the river a series of large squares that provide
public space. The buildings are elevated on stilts and seem to float in the
air; their façades are structured by continuous horizontal windows, giving
the entire development a unified yet dynamic appearance. The contrast
with the existing medieval urban fabric could not be harsher. As in his use
of manipulated photography two decades earlier, Moser shows his project
embedded in its prospective urban context. But here, the aim is obviously
not to blend in with the context or to enhance it by harmoniously bringing
it to a conclusion. Rather, the project strives to be at odds with its context,
with regard to both aesthetics and scale. In this way, Moser, who in 1932

design, and exhibition design—in fact, this crossing of boundaries could be seen as the hallmark of this period, when artists were seeking to overcome the divide between art and life. As one consequence, constructivists abandoned easel painting and took a productivist stance in the service of a future socialist society. Maria Gough and others have pointed out how this experimentation constituted a radical epistemological shift.[35] Despite his early close ties to Malevich's suprematism, Lissitzky worked on what he called *Prouns,* abstract drawings and paintings made up of geometrical shapes and planes floating in an undefined and seemingly endless open space, which could be considered blueprints for a new, abstract architecture. Significantly, the artist defined his Prouns as "interchanges from painting to architecture." Lissitzky's spatial exploration was influenced by his contact with the UNOVIS group and its founder, Malevich. As Éva Forgács has pointed out, "*Proun* enabled Lissitzky to assert himself as an innovative, 'architectural' Suprematist."[36]

The extension of formal research in two-dimensional representations into the third dimension and—most notably—into the actual space of the observer was a fundamental concern in Lissitzky's architectural thinking. This concern coincides with and foregrounds what Benjamin H. D. Buchloh has described, with regard to the post-revolutionary art of the Soviet Union, as a "crisis of audience relationships" and a subsequent redefinition of the object/viewer relationship in modern mass societies.[37] This interest was already clearly noted by contemporaries, most importantly Alexander Dorner, director of the Landesmuseum Hannover, who installed Lissitzky's famous Kabinett der Abstrakten (Cabinet of Abstract Art) in the Hannover Gemäldegalerie in 1927 (fig. 3.14). This installation was modeled after the Raum für konstruktive Kunst (Room for Constructivist Art), Lissitzky's temporary exhibition at the 1926 International Art Exhibition in Dresden.[38] In a brief description of the Cabinet of Abstract Art in Hannover in the journal *Die Form,* Dorner states, "The meaning of the abstract movement in art lies in its aspiration to tentatively advance beyond the previous construction of the image into a new unknown world of imagined spaces and bodies." If we follow this train of thought, Lissitzky's spatial experimentation was an early and groundbreaking contribution toward a rethinking of the object/viewer relationship in an art of participation *avant la lettre* anticipating installation art.[39] Moreover, as already briefly discussed in the introduction, Buchloh has argued that Lissitzky's interest in montage paved the way for avant-garde exhibition designs and spatial forms of display, as evidenced in his Cabinet of Abstract Art or his design for the International Press ("Pressa") Exhibition in Cologne in 1928. I would contend that the montage principle not only played a significant role in the various media with which Lissitzky experimented; in fact, it served as a guiding structural principle in his artistic and architectural output during this period.

An interesting instance of Lissitzky's use of architectural photomontage is an image he reproduced in connection with his article "sssr's

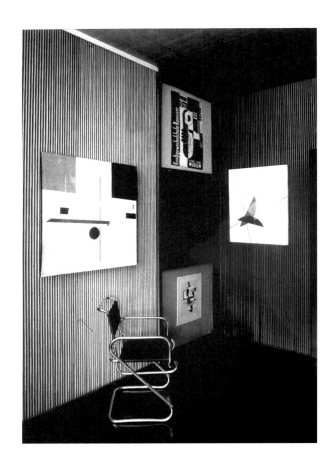

Fig. 3.14 El Lissitzky,
Kabinett der Abstrakten
(Cabinet of Abstract Art),
1927. Provinzialmuseum
Hannover.

Architektur" ("Architecture in the USSR"), which was published in the German publication *Das Kunstblatt* in 1925 (fig. 3.15). Structurally as well as in its combination of photographs and plans, the montage is vaguely reminiscent of Paul Citroen's urban photomontages, which would have been known to Lissitzky at this point. However, its function is polemical, as it contributes to contested debates about the status of modern architecture in the Soviet Union. In its rhetorical nature, it not only paved the way for Sigfried Giedion's photomontage protesting the outcome of the international competition for the new Palace of the Soviets, which was sent to Stalin in 1932, as we will see; it also may well have served as a model for Pietro Maria Bardi's satirical *Tavola degli orrori* (*Panel of Horrors*) exhibited at the Second Exhibition of Rationalist Architecture in his Galleria d'Arte di Roma on the Via Veneto in Rome in 1931, as we will also see. Both montages lamented the lack of a truly modern architecture in their respective countries.

Lissitzky's article in which the photomontage appeared was one of the first accounts of the architecture of the Soviet Union published abroad, and it anticipated his 1930 book *Russland: Die Rekonstruktion der Architektur in der Sowjetunion* (*Russia: The Reconstruction of Architecture in the Soviet Union*), which was also published in Germany. His assessment is decidedly pessimistic: "Modern Architecture in Russia? There is no such thing. What

Photomontage in Architectural Representation

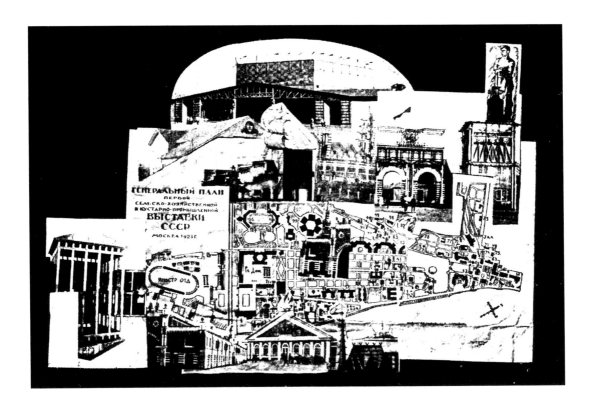

Fig. 3.15 El Lissitzky, *SSSR's Architektur* (*Architecture in the USSR*), from *Das Kunstblatt* 9 (1925): 49.

one does find is a fight for modern architecture, as there is everywhere in the world to-day. Still nowhere is there a new architectonic CULTURE." Lissitzky briefly sketches the artistic aims and struggles of avant-garde architects in attempting to establish a radically new architecture culture in the post-revolutionary USSR, beginning with the rejection of the Western European beaux-arts tradition. According to Lissitzky, the immediate pre-revolutionary period of 1917–18 was characterized by the search for a synthesis of architecture, sculpture, and painting, the first results of which he dismisses as "destructive." Lissitzky then briefly discusses the contributions by the foundation of Vkhutemas, the Russian state art and technical school, in Moscow in 1921 and the Association of New Architects (ASNOVA) in 1923. From his point of view in 1925, despite his negative assessment, Lissitzky sees much potential for the future: "Have patience. We are just in the middle of the work and are happy to be accomplishing it specifically for the present time."[40]

Lissitzky's photomontage addressed the situation more pointedly. It is made up of a large number of photographic reproductions of buildings for the USSR's First Agricultural Exhibition held in Moscow in 1923, which were, according to Lissitzky's caption, "accomplished by degenerate students of Palladio and impotent architects." Despite a few exceptions—such as the large hall construction at the top of the montage or two tower-like structures on the left and right edges, which express a certain constructivist ethos—the majority of the reproduced photographs show exhibition halls

in neo-classicist garb, including columns, pediments, and arches, as well as figurative sculptures. Ivan Zholtovskii's general plan of the exhibition grounds and his pavilions can be identified in the background.[41] Lissitzky's use of photomontage as a representational technique is highly conscious. His caption may be seen as a self-reflexive comment: "This is not Dada. These are no excavations of the Forum Romanum. Neither reconstructions of Pompeii."[42] Lissitzky's attribution of the origin of photomontage to Dadaism, rather than to the popular arts or advertising, strongly suggests that he was familiar with works by Citroen and others. But whereas Dada artists cut and paste images of real historical/historicist architecture in order to comment on modernity, that modernity is absent in Zholtovskii's case; Lissitzky is using photomontage not to promote a radically new understanding of architecture (the way his Proun drawings and paintings would have done), but to represent the fragmentation and lack of direction in contemporary architectural production. Photomontage here is not used to produce a meaning beyond the objects depicted; rather, the meaning lies in the (lack of) structure of the montage itself.

Lissitzky also used montage in a completely different way. His famous photomontages of the *Wolkenbügel* project may indeed be seen as an attempt at finding new means of representation for a new architecture culture (fig. 3.16). Like his polemical montage on the First Agricultural Exhibition, the image of the Wolkenbügel made its way into print right away. It was reproduced on the cover of Adolf Behne's influential book *Der moderne*

Fig. 3.16 El Lissitzky, *Wolkenbügel*, 1924–25. Photomontage.

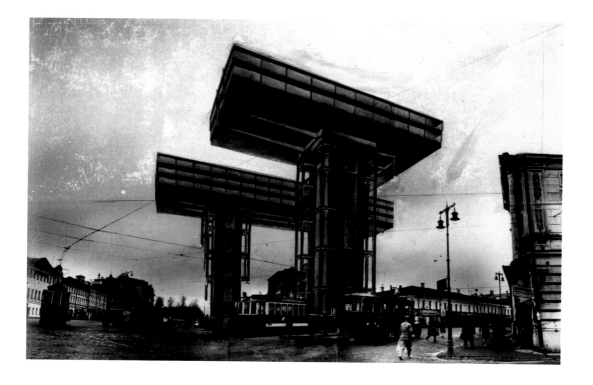

Photomontage in Architectural Representation

Zweckbau (*The Modern Functional Building*) of 1926 and in the ASNOVA *News* that same year.[43] The project obviously serves as an impressive demonstration of what modern architecture in 1925 could and should be, according to Lissitzky: a bold antithesis of the neo-classicism of Zholtovskii and his colleagues.

The famous photomontage of the Wolkenbügel is the culmination of an entire series of technical drawings as well as perspectival representations of the project that El Lissitzky made in 1924–25 while undergoing a tuberculosis treatment in Minusio, Switzerland.[44] It shows an ink and crayon drawing of the project inserted into a black and white photograph of the urban situation at Nikitsky Square in Moscow, in a worm's-eye perspective as seen from Nikitsky Boulevard. This introduction of a proposed project into the existing urban fabric is reminiscent of Mies van der Rohe's Friedrichstraße skyscraper depictions, but stands in stark contrast to the tabula rasa modernism as exemplified in Le Corbusier's roughly contemporary Ville contemporaine pour trois millions d'habitants of 1922. As a matter of fact, Lissitzky openly criticized the latter's take on urbanism, blaming it for its lack of engagement with a specific site and social situation.[45] The montage ethic and aesthetic as exemplified in the Wolkenbügel image is strongly committed to addressing urban social reality in a communist society, which could ideally be transformed and overcome by means of architecture.

The depiction is executed so as to show the project as it would present itself to an observer on the street. This "reality effect" is underscored by the juxtaposition with modern means of mass transportation such as a bus and a tramway. Moreover, there is a formal resemblance between the horizontal expanse of the transparent architecture and the vehicles on the street, which emphasizes the building's dynamic quality as well as its use of technological materials such as steel and glass. The project's dynamism is further enhanced by its asymmetrical shape and the lack of a distinct main façade. Overall, the photomontage appears as a still in a cinematic sequence: it invites the viewer to walk around the structure in his or her imagination and gain a more complete idea of the building than a single representation can provide. The notion of movement is not only implicitly evident in Lissitzky's Proun series; it is an obsessively recurring theme in his contemporary writings, which express a cinematic appreciation of architecture and space. In his 1920 contribution "PROUN. Not World Visions, BUT— World Reality," Lissitzky contends that "the surface of the Proun ceases to be a picture and turns into a structure round which we must circle, looking at it from all sides, peering down from above, investigating from below." The photomontages of the Wolkenbügel seem a direct visualization of this representational program voiced four years earlier. The consequences for architectural spectatorship are addressed even more explicitly in the same text when Lissitzky observes that "Proun is leading us to construct a new body."[46] The scopic regime of the Proun—and, by extension, of modern

space—is no longer grounded in the disembodied eye of central perspective; now, there is a mobile and embodied viewer.

The rejection of perspectivalism and the inclusion of the aspects of time and movement into a modern conception of space are taken up and significantly expanded upon in Lissitzky's manifesto-like "K. und Pangeometrie" ("A. and Pangeometry") of 1925. Here, the author explicitly references the filmic experiments of Viking Eggeling and his successors (including Hans Richter) for the construction of an "imaginary space"; these references also underlie Mies van der Rohe's photomontages and his spatial thinking of the period. The technological advancement that allows for such an evolution of space into a dynamic configuration in time is addressed in Lissitzky's short 1923 essay "Rad, Propeller und das Folgende" ("Wheel-Propeller and What Follows"). In this text, Lissitzky discusses the evolution of (architectural) form throughout human history as a three-step process in which new means of locomotion bring about new form. In the first historical period, man moves about on foot, which is architecturally reflected in the pyramid. The second period is defined by the wheel, which is continually accelerated, leading to architectures of motion: trains, ocean liners, and cars. Finally, the third period is marked by the propeller, allowing for flight and free floating. Even without explicit mention, it is clear that Lissitzky sees his Prouns as a contribution to a search for an architectural form adequate for a new, forthcoming era: "Only inventions will determine design. Even for revolutions new forms must be invented."[47] Seen in this way, the Wolkenbügel, not quite liberated from gravity, but striving for free floatation in space, would seem to represent a compromise between the age of the wheel and that of the propeller. This hybrid or ambivalent character of the Wolkenbügel will later need to be discussed again in more detail from the point of view of utopia versus realism, as we will see.

The Wolkenbügel drawing is juxtaposed to the existing urban fabric at Nikitsky Square, which consists of relatively low, opaque buildings in stone. The proposed construction appears a complete aesthetic break in terms of size, shape, and materialization. However, Lissitzky adjusts the color of his project drawing to the tonality of the underlying photograph, thereby potentially moderating the montage aesthetic and visually integrating the project into the cityscape.[48] Lissitzky proposes an H-shaped horizontal structure of slab-like volumes floating some fifty meters above street level, supported by three transparent pillars. Offices in the horizontal slabs would have been quickly accessed from public transportation and the street level by rapid elevators. One of these was to extend belowground in order to connect to the (albeit up to then still nonexistent) Moscow metro system. The characteristic horizontality of the project was a deliberate, antithetical response to the model of the American skyscraper, in a manner ideologically similar to but formally rather different from Malevich's proposal for New York discussed earlier. The Wolkenbügel brings horizontality and verticality into an antithetical tension, an issue that was widely discussed

in contemporary Soviet architectural discourse.[49] Lissitzky intended to reproduce the Wolkenbügel eight times at the major intersections on Moscow's inner ring boulevard; the structures would encircle, and with their longest extensions point toward, the Kremlin in the geographical and political center of the new capital city of the Soviet Union.[50] The project thus anticipated the so-called Seven Sisters, a series of monumental buildings executed during Stalin's regime in the 1950s in order to express the might of the Soviet Union.

The Wolkenbügel has often been considered a utopian project. However, the fact that El Lissitzky asked the Swiss architect Emil Roth for advice on this project, who in turn produced a large number of meticulous construction drawings, indicates that it was intended as a real proposal rather than a mere utopian gesture. Lissitzky also published an article in the *ASNOVA News* explaining the project. He discusses a number of technical details, including soundproofing and insulation materials, as well as the use of chemically processed glass, demonstrating his awareness of the technological possibilities of the time. Lissitzky was thus quite serious about the possible realization of his project. In a letter dated December 29, 1924, Lissitzky relates having had a long meeting with "his engineer," adding, "He raises my hopes. But he is a nice guy and very diligently calculated the Wolkenbügel. I revolutionized him and incited him to calculate an altogether new construction in iron-steel. . . . In the Wolkenbügel I hope to land the big strike."[51] However, while steel and glass would have been available in the mid-1920s in large quantities in the United States, in the USSR—at least in the post-revolutionary period—it is questionable whether the country's building industry would have been capable of producing the structure. Despite material scarcity, there was a boom in construction after 1923–24 in the USSR, which would explain Lissitzky's regained interest in architecture during this period.[52] The Wolkenbügel may therefore best be understood as an attempted synthesis between utopia and reality, in which the two poles of formalism and utilitarianism were to merge. We have already seen how Lissitzky's mentor, Malevich, rejected a utilitarian approach and considered it essential, in the search for a new architecture, to come to terms with formal problems first. It can be said that for his part, Lissitzky attempted to reconcile the two opposing poles in Soviet avant-garde thinking of the period—suprematism on the one hand and constructivism on the other. In the words of Tatiana Goriacheva, he "truly believed that Suprematism and Constructivism converged, rather than diverged." Malevich, in turn, saw this as betrayal on the part of his protégé, and wrote to him in 1924, "You, constructor, got a fright from Suprematism . . . and now—what are you now? A constructivist-installer. [And] where are you now? You wanted to emancipate your personality, your Self from what I had done . . . and went to Gan and Rodchenko; you became a constructor, not even a prounist."[53] What Malevich here interprets psychologically as a sort of patricide should rather be seen as the result of Lissitzky's search for a position that

Fig. 3.17 Samul Kraveis, Sergei Seranmov, and Mark Felger, Gosprom Building, Kharov, Ukraine, 1929, from *Building the Revolution, Soviet Art and Architecture 1915–1935* (2011), 116–17.

would allow for radical formal innovation while at the same time serving an evolving communist society. The Wolkenbügel illustrates this stance: it is a formally utopian design, though with the potential to be realized and thereby transform society. It is precisely the use of photomontage, with its characteristic overlay of project and reality, that enabled presenting this intellectual and ideological connection between reality and utopia visually.

In broader terms, the Wolkenbügel is an eminent example of the power of images for the discourse of architecture, irrespective of whether the project is actually constructed. Lissitzky's project seems to have haunted the collective imagination of architects ever since its first publication in 1926. It certainly doesn't seem too daring to interpret the Gosprom Building executed in Kharov (Ukraine) in 1929 by architects Samul Kraveis, Sergei Seranmov, and Mark Felger as a built homage to Lissitzky's project (fig. 3.17). Having lost no power over time, his bold vision finally became a full reality in two projects from the early 2000s: Steven Holl's Horizontal Skyscraper in Shenzhen, China (2006–9), and perhaps more strikingly, Rem Koolhaas/OMA's CCTV China Central Television Headquarters in Beijing (2002–12). Like Lissitzky's Wolkenbügel, the CCTV has become an icon of the dynamism and force of a rapidly changing society, albeit under completely different political and economic conditions.

Finally, we turn to Lissitzky's Prouns and *Demonstrationsräume* (demonstration rooms) (see fig. 3.14). I contend that Lissitzky's increasing interest in (architectural) space must be seen as an extension of the montage principle into three dimensions. The spatial configuration Lissitzky establishes in his demonstration and exhibition spaces are montages in a double sense: first, they juxtapose individual elements in order to produce visual meaning based on a plurality of images, and second, they directly address the viewer and invite him or her to participate actively in producing this meaning by moving physically through space. It has often been argued that the "spatial turn" of Lissitzky and other Soviet avant-garde artists in the 1920s must be seen within the broader context of the attempted redefinition of art as a socially conscious and relevant discipline that moves beyond the traditional aesthetic domain into real social and lived space. This boundary-crossing is coupled with a political aim: to transform the passive spectator into an active participant, both on an aesthetic and a

Photomontage in Architectural Representation

political level. As Éva Forgács has put it: "For the progressive artists of the early 1920s, real space as opposed to the illusory space of flat paintings was a new means of grasping reality. The word *real* resonated as 'true' as well as 'present,' in stark opposition to the word *art,* which came to mean 'obsolete,' 'imagined,' or 'contrived.' Real space transformed the artwork from an object of passive contemplation into a lived event; it anticipated a future in which people would experience added dimensions, freedom of movement, and active participation in the world."[54] Lissitzky's 1923 Proun Room at the Great Berlin Art Exhibition, his 1926 Room for Constructivist Art at the Internationale Kunstausstellung in Dresden, his 1927 Cabinet of Abstract Art in Hannover, and his various exhibition designs are successive steps in the exploration of this potential offered by space as an artistic medium. It is not possible to discuss in detail these various exhibition spaces in the context of this study. However, it is crucial to observe, contrary to interpretations of his Demonstrationsräume as totalizing artistic environments in the manner of the Gesamtkunstwerk, that Lissitzky made consistent use of the montage principle of juxtaposition in his exhibition spaces.[55] Maria Gough has argued convincingly that Lissitzky's spaces and in particular his Dresden Room for Constructivist Art was a powerful alternative to the typical exhibition space of the time: "The traditional exhibition space of the time, with its walls carpeted with gilt-framed pictures, created a cacophony of *simultaneously* competing voices, an overloaded environment in which difference is erased. Overstimulation, Lissitzky suggested, induced indifferentiation. The international exhibition, with its inexorable law of exchangeability, anesthetizes the visitor, who then becomes passive, lethargic, bored; according to Lissitzky, 'in his march-past in front of the picture-walls . . . [the visitor is] lulled by the painting into a certain *passivity.*' The demonstration space, by contrast, must *interrupt* this cacophonous simultaneity. . . . The demonstration space must orchestrate not only spatial but also temporal rhythms in order to slow the encounter between visitor and exhibited object."[56] It can be concluded from these remarks that the Dresden exhibition was not to be perceived all at once, simultaneously, but rather as an ordered sequence in time by a viewer in motion. The individual elements of the exhibition (the pictures and sculptures) are thereby differentiated from one another, and the viewer is afforded an active role in mentally combining the individual elements into a coherent sequence. As Gough states: "Lissitzky's *Standard* is . . . driven by two imbricated objectives, each directly dependent on the temporal extension of the process of looking: *differentiation* of exhibited object, *activation* of exhibition visitor. Through differentiation, activation; through activation, differentiation." I argued in the introduction that differentiation (or juxtaposition) in the sense posited here is a quintessential feature of montage as an epistemological tool for the production of meaning. Lissitzky's Demonstrationsräume not only introduce the concept of sequential (and active) perception of space in time that is so relevant for Sergei Eisenstein's montage theory; they also

Fig. 3.18 El Lissitzky, "Photofresco" at the Soviet Pavilion, International Press ("Pressa") Exhibition, Cologne, 1928.

fundamentally recalibrate the relationship of object and observer. Gough has pointed out that Lissitzky's thinking is strikingly similar to contemporary theater theory, and in particular to Bertolt Brecht's epic theater in this regard. Its major feature, the effect of defamiliarization (*Verfremdungseffekt*), has in turn been characterized by Walter Benjamin as an instance of montage thinking. It is the principle of montage, according to Gough, that structures both Lissitzky's exhibition spaces and Brecht's notion of the epic theater: "In Brecht's case, the traditional relationship between stage and audience, text and performance, director and actor, was to be transformed by means of what Benjamin called a montage-like device of 'interruption'; in Lissitzky's, the traditional relationship between work of art and the wall on which it is hung—and, thus, the relationship between work and visitor— was to be transformed chiefly through the invention of devices that solicit . . . not only the latter's active participation but also, and most especially, his or her sensory disorientation."[57] As previously mentioned, the recalibration of the relationship between object and observer is also the major focus of Benjamin H. D. Buchloh's analysis of Lissitzky's exhibition spaces. Buchloh was one of the earliest critics to link the importance of (photo) montage in Soviet avant-garde art to this redefinition of spectatorship and the audience. Regarding Lissitzky's Demonstrationsräume, Buchloh remarks: "The vertical lattice relief-construction that covers the display surfaces of the cabinet and that changes value from white, through gray, to black according to the viewer's position clearly engages the viewer in a phenomenological exercise that defies traditional contemplative behavior in front of the work of art."[58]

The new audience that Lissitzky's art sought to address was no longer the individual contemplative viewer, but the mobile spectator as a member of a mass audience, who, by means of the installation, is invited to actively participate, both aesthetically and—eventually and implicitly—politically. Photomontage blown up to monumental proportions was highly conducive

Photomontage in Architectural Representation

Fig. 3.19 Kurt Schwitters, *Merzbau*, Hannover, ca. 1933.

to this activation, and Lissitzky used it repeatedly, most famously in the so-called "photofresco" in his exhibition design for the Soviet Pavilion of the 1928 "Pressa" exhibition in Cologne (fig. 3.18). In this and other examples, photomontage takes on architecture's traditional role, through sheer size becoming a monument to the technology-driven society of the present. However, this way of engaging a mass audience also paved the way for its use in service to political ideology, as we will see.

It should be mentioned at least in passing that Lissitzky's Cabinet of Abstract Art in Dorner's Provinzialmuseum Hannover was installed in close geographical proximity to another significant example of architectural montage in the 1920s, Kurt Schwitters's *Merzbau* (fig. 3.19). The *Merzbau,* installed in the house of Schwitters's parents at Waldhausenstraße 5, was essentially an assemblage of urban remnants collected by the artist that were gradually, over several years, transformed into an interior sculpture of architectural proportions. On the grounds of its secondary usage and assemblage of the (visual) residue of twentieth-century urban culture, the *Merzbau* shares fundamental characteristics with the photomontages of Paul Citroen and others, although the *Merzbau* makes use of actual materials found in the streets, as opposed to their pictorial representation. Various authors have pointed out the extent to which the *Merzbau* and Schwitters's artistic thinking were informed by contemporary architectural theory and production of the 1920s.[59] The *Merzbau* was also the progenitor of a specific

Fig. 3.20 Frank Gehry, Gehry Residence, Santa Monica, 1978. Photo by Tim Hursley.

strand of contemporary architecture culture that relates in similar ways to found urban materials. A particularly illuminating example is Frank Gehry's house in Santa Monica of 1978, with its use of cheap, prefabricated materials and seemingly haphazard assembly (fig. 3.20). On the other hand, the *Merzbau* has also been seen as a formal predecessor of some deconstructivist practices in the works of Peter Eisenman, Steven Holl, Gehry, or OMA/ Rem Koolhaas.[60]

ARCHITECTURAL HISTORIOGRAPHY: SIGFRIED GIEDION

While many of the examples we have examined in this chapter used spatial photomontage to represent individual architectures, sequential photomontage was also explored as a device to represent architecture over time, in particular in the oeuvre of the Swiss architectural historian Sigfried Giedion. What we see here is the transfer of the technique from an artistic context to its application in support of a historical-theoretical argument. In light of Giedion's eminent role in the shaping and dissemination of the discourse of modern architecture—both as author and as president of the CIAM—his frequent use of montage as a visual and conceptual tool is highly significant. Giedion's interest in photomontage may have been roused by his close friendship with the artist László Moholy-Nagy, one of the pioneers in the discourse on (photo-)montage, as we have seen. Moholy-Nagy and Giedion and their wives became close friends from 1925 onward and spent several extended summer vacations together in France, Switzerland, and the Netherlands. Their respective advances into a new photographic language in the manner of the *Neues Sehen* or "new vision" were mutually

Photomontage in Architectural Representation

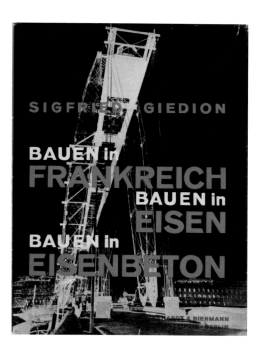

Fig. 3.21 Cover of Sigfried Giedion, *Bauen in Frankreich* (1928; *Building in France*).

influential and accomplished in one another's presence.[61] For example, in a review of recent Bauhaus publications in the journal *Cicerone,* Giedion praised Moholy-Nagy's *Painting, Photography, Film* for "its photos from above, from below, from close-up, from a distance and the underlying discovery of the photographic eye as well as for presenting it productively in the realm of art. . . . Quite besides the contents, these books are a typographic event by means of their clearness, loosening and consolidation of the type. Something of the contents adheres to the typographic organization, as one is otherwise used to in musical scores."[62] Giedion became increasingly interested in the potential of montage for the visual construction of a historical narrative, as demonstrated in his two early books promoting the cause of modern architecture: *Bauen in Frankreich* (1928; *Building in France*) (fig. 3.21) and *Befreites Wohnen* (1929; *Living Liberated*). Giedion's interest in the notion of visual synthesis based on the combination and/or juxtaposition of several images must be seen in connection with his training under Heinrich Wölfflin. Art history had developed the method of *vergleichendes Sehen,* or comparative seeing based on the parallel projection of two photographs, around the end of the nineteenth century.[63] It was in Wölfflin's classroom as well as in his writings, most importantly in the *Kunsthistorische Grundbegriffe* (*Principles of Art History*) of 1915, where Giedion became familiar with dichotomous image comparisons for historical argument. We have already seen how the manipulated photograph functioned in the context of image comparisons in architectural production; for Giedion, the comparison itself became a form of montage. Giedion's wife, Carola Welcker, whom Giedion also met while a student at the University of Munich, was herself a prolific art historian and promoter of avant-garde

art and brought Giedion into contact with work of the Berlin Dadaists, Kurt Schwitters, and other contemporary avant-garde artists, all of whom were experimenting with photomontage at the time.

However, Giedion's interest in the potential of montage for the production of visual meaning in the larger context of historiography cannot be explained simply by his exposure to established art historical methodology. Rather, it must be seen in connection with two decisive moments in the early 1920s: the publication of Le Corbusier's *Vers un architecture* (*Toward a New Architecture*) in 1922 (which prompted Giedion to visit the 1925 *Esprit Nouveau* exhibition in Paris, where he met Le Corbusier in person for the first time), and the Bauhaus exhibition in 1923, where Giedion would have seen Citroen's *Metropolis*, among other works.[64] In *Toward a New Architecture*, Le Corbusier stunned his contemporaries with bold visual comparisons between ancient Greek temples and Voisin automobiles, thereby opening a mental space for the reader to fill with interpretive meaning, in the manner of what Eisenstein would call "intellectual montage." Giedion's visit to the Bauhaus coincided with the end of the school's early, expressionist phase and the beginning of its constructivist phase, and the latter particularly drew the art historian's attention. It has been argued that the new typography of the Bauhaus, developed by protagonists such as Moholy-Nagy and Herbert Bayer and presented in the famous *Bauhausbücher* series, was particularly influential for Giedion's "visual language" and his attempts at developing a discourse on modern architecture based on photography and other visual media.[65] When Giedion was preparing his first publication on modern architecture, *Building in France*, he asked Moholy-Nagy to design the cover and to "over[see] typography and layout." It is not clear when exactly the artist became involved in the design; however, he seems to have followed Giedion's instructions quite closely.[66] In any case, in a letter dated May 3, 1927, Moholy-Nagy congratulates Giedion on the second part of his article series on French architecture in the journal *Cicerone* (which formed the basis for *Building in France*), noting the "clear language, concise expression of most important thoughts, the structure clearly incising the essence of mod. architecture—great, s.g.!"[67] By early 1928 the collaboration seems to have been fully established, with Giedion reporting in a letter to Moholy-Nagy that he is eager to see the cover design. Moholy-Nagy seems also to have proofread the text before it went to print.[68]

In a preliminary note, which functions as a kind of instruction manual for the book's handling, Giedion underscores the programmatic nature of the layout and design with regard to the "new vision":

> This book is written and designed so that
> it is possible for the *hurried reader* to understand the developmental path from the captioned illustrations;
> the text furnishes closer explication;
> the footnotes provide more extensive references.[69]

Hence, the book is structured in two superimposed layers, each of which addresses a specific type of "reader." The first layer is the visual narration through images and captions; their juxtaposition and sequencing tells the heroic story of modern architecture from the "anonymous" beginnings of nineteenth-century steel construction to contemporary steel and glass architecture. In several instances, Giedion and his graphic designer, Moholy-Nagy, make use of two-page spreads, often employing graphic signs such as arrows to emphasize the historical argument. The second layer is the text proper; it is the secondary plane of signification. In a recent discussion of *Building in France,* Davide Deriu, calling the book an "implicit manifesto of architectural montage," presents four critical categories—"assemblage," "elevation," "cinematism," and "exposition"—related to the montage principle.[70] Partially based on this differentiation, I would like to propose four categories of montage important to Giedion:

1) Montage as the principle of industrial assemblage: In *Building in France,* Giedion charts the rise of the architectural aesthetics of the Neues Bauen or "new construction" back to industrial and engineering construction of the nineteenth century. As the author asserts: "CONSTRUCTION BECOMES EXPRESSION. CONSTRUCTION BECOMES FORM."[71] Two of the main buildings under discussion are the Eiffel Tower and the Pont Transbordeur in the harbor at Marseille. Giedion and Moholy-Nagy had both photographed these structures on several instances in the mid- and late 1920s, and a photo of the Pont Transbordeur by Moholy-Nagy is reproduced on the book's front cover (see fig. 3.21).[72] As the image implies, the aesthetic possibilities of a new architecture rely on mechanization, the rationalization of production, and the principle of the assembly line, just as "montage" in the sense of the assembly of prefabricated parts or modules provides the method of construction for modern architecture, as exemplified, for example, in Le Corbusier's Maison Dom-ino (1914–15).

2) Montage as transparency or the superimposition of images: A key effect of steel construction, which Giedion hails as the material base of a new architectural aesthetic, is its visual openness, allowing for what he calls *Durchdringung,* or interpenetration. In the words of Hilde Heynen, "For Giedion, *Durchdringung* . . . refers to an essential characteristic of the new architecture: its capacity to interrelate different aspects of space with one another."[73] Heynen further indicates that Moholy-Nagy's thinking evolved around much similar terms. His second book from 1929, *Von Material zu Architektur* (*From Material to Architecture*), terminates in a double exposure (fig. 3.22) with the following caption: "From two over-lapping photographs (negatives) the illusion comes forth of a

Fig. 3.22 Spread from László
Moholy-Nagy, *Von Material
zu Architektur* (1929; *From
Material to Architecture*).

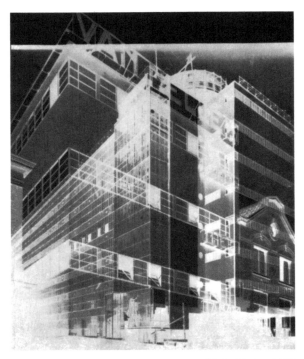

abb. **209** „architektur"

foto: jan kamman / schiedam

aus zwei übereinanderkopierten fotos (negativ) entsteht die illusion räumlicher durchdringung, wie
die nächste generation sie erst — als glasarchitektur — in der wirklichkeit vielleicht erleben wird.

spatial interpenetration, which only the next generation might
be able to experience in reality—as glass architecture."[74] Giedion,
however, did not locate interpenetration only in transparent glass
architecture yet to come—as his famous comparison of Gropius's
Bauhaus with Picasso's painting *L'Arlésienne* (1912) in *Space, Time
and Architecture* would illustrate. He also found it in the steel con-
struction of the Eiffel Tower and the Pont Transbordeur: "In the
air-flooded stairs of the Eiffel Tower, better yet in the steel limbs of
a *pont transbordeur,* we confront the basic aesthetic experience of
today's building: through the delicate iron net suspended in mid-
air stream things, ships, sea, hoses, masts, landscape, and harbor.
They lose their delimited form: as one descends, they circle into
each other and intermingle simultaneously."[75] In this aesthetic con-
ception, architecture becomes a diaphanous veil, a visual appara-
tus that allows a level of reality beyond that of architecture proper
to become visible. It is evident how these thoughts prefigure the
notion of "phenomenal transparency" as put forward later by Colin
Rowe and Robert Slutzky.[76] "Interpenetration" also relates to the
cinematic technique of the superimposition of two images, with
which Eisenstein experimented in his early films in developing the
notion of cinematic montage.

Photomontage in Architectural Representation

3) Montage as a cinematic narrative: Perhaps the most obvious evidence of Giedion's montage thinking is the layout of the book itself, the sequences and juxtapositions that make the book read like a film. As Sokratis Georgiadis aptly notes with regard to its author: "Equipped with the visual apparatus of modern man—formed and educated, above all, through the study of Cubism and Neoplasticism—he wanders through his objects in cinematographic fashion." This is not only evidenced in the final printed product, but also in the mock-ups Giedion produced for some of the most visually striking two-page spreads of the book (fig. 3.23).[77] It is here where the impact of Moholy-Nagy and his screenplay for *Dynamic of the Metropolis* is most clearly visible. Replying to a rather critical review of the book by the CIAM architect J. J. P. Oud, Giedion writes, "I am delighted that the book . . . makes the impression of the cinematic-technological, the journalistic." In the book itself, Giedion refers to cinematic techniques of representation in the chapter on Le Corbusier's housing development Quartiers Modernes Frugès at Pessac (1924). He makes it quite clear that the montage techniques that cinema offers and the notion of mobile vision are the most adequate visual devices available for the representation of modern

Fig. 3.23 Sigfried Giedion, Mock-up of a sample page spread for *Bauen in Frankreich* (1928; *Building in France*). gta Archiv, Institut für Geschichte und Theorie der Architektur, ETH Zürich, Nachlass Sigfried Giedion.

architecture: "One would have to accompany the eye as it moves: only film can make the new architecture intelligible!"[78] It is this notion of the seriality of individual images and their perception in space and time that underlies Giedion's *Building in France.* In her analysis of Moholy-Nagy's *Painting, Photography, Film,* which is structured according to the same principle, the photo historian Andrea Nelson has labeled it "narrative montage." Nelson rightly underscores the existence of the spaces between the individual photographs as an important precondition for the activation of the viewer's imagination: "Narrative montage recognizes the physical spaces between juxtaposed photographic and graphic elements, emphasizing the spatial and temporal construction of the series. These spaces are explicit components of the overall design and implicit gaps of time and information, requiring the viewer to interact with the work by constructing meaningful transitions and connections."[79] "Narrative montage" not only entails the existence of such between-spaces (a notion that was explored by Georges Didi-Huberman); it also entails the transition from single images to their plurality. Moholy-Nagy quite openly theorized this shift to the (cinematic) image sequence as a pivotal element of a new vision: "this is the logical culmination of photography. the series is no longer a 'picture,' and none of the canons of pictorial aesthetics can be applied to it. here the separate picture loses its identity as such and becomes a detail of assembly, an essential structural element of the whole which is the thing itself."[80] While Nelson's term "narrative montage" seems justified with regard to the production of meaning in a literary text, the obsession of avant-garde artists and architects with the moving image makes it more plausible to see Moholy-Nagy's and Giedion's book montages as examples of cinematic montage as applied to the ancient medium of the book. Eisenstein's theories of montage equally presuppose the linking of individual images and the rendering productive of the between space for the production of visual meaning. Giedion's book montages engage in visual historiography and construct a historical teleology for the idea of "space-time." It is interesting to note that Walter Benjamin was highly impressed by Giedion's methodology. In his *Arcades Project,* he sought to put the principle of montage to use for his own metropolitan historiography, albeit from a rather different angle.

4) Montage as an aesthetic of technological reproducibility: In his 1929 illustrated book *Befreites Wohnen* (*Living Liberated*), Giedion explored the aesthetic of photomontage in yet another way. He produced several montages in which photographic reproductions of buildings were overlaid with newspaper clippings as well as typed and handwritten notes, then furnished with explanatory captions.

Fig. 3.24 Sigfried Giedion cutting and pasting. gta Archiv, Institut für Geschichte und Theorie der Architektur, ETH Zürich, Nachlass Fritz Stucky.

While mainly utilizing mechanically reproduced imagery, these works are not dialectical in nature, and they feature a certain hand-made cut-and-paste-aesthetic, whereby the clear differentiation from collage becomes blurred. They are less indebted to Citroen or Moholy-Nagy than to the collages by Kurt Schwitters, many of which combined newspaper tear-outs and other printed matter. In these works, Giedion introduces a haptic dimension to his idea of montage. While these works underscore the ubiquitous presence of printed matter in the age of reproducibility, they paradoxically also highlight the aspect of manual labor involved in book and magazine production (fig. 3.24).[81]

Perhaps Giedion's most audacious use of photomontage as communication was the work he sent to Stalin along with an official message from CIAM on April 28, 1932, in protest against the outcome of the international competition for the new Palace of the Soviets (fig. 3.25). In the montage, a photograph of a model of the project by the unknown, twenty-eight-year-old, New York–based British architect Hector Hamilton is flanked by a church by Fritz Höger and the Karstadt department store in Berlin-Neukölln. Hamilton's project had been selected by the Council of Experts in February 1932 as one of three finalists for the third round of the competition, along with the famous scheme by Boris Iofan (which was finally declared the winner in May 1933) and one by Ivan Zholtovskii. All three finalists exhibited a neo-classicist aesthetic. The schemes of progressive architects such as Le Corbusier, Walter Gropius, and Erich Mendelsohn were not considered. Among the architectural avant-garde, this reactionary selection caused an outcry that Giedion's photomontage to Stalin rendered visible. The hand-written comment on the sheet reads, "The Palace of Soviets that is to be

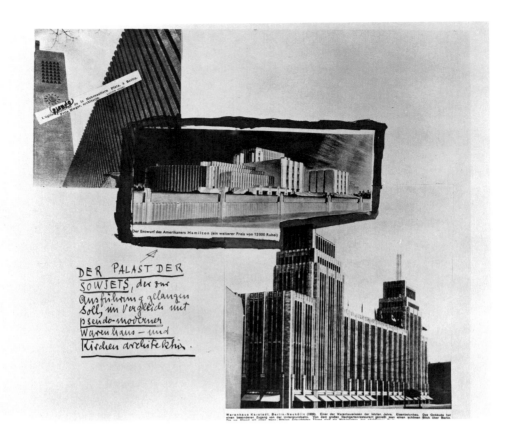

DER PALAST DER
SOWJETS, der zur
Ausführung gelangen
soll, im Vergleich mit
pseudo-moderner
Warenhaus – und
Kirchen architektur.

Fig. 3.25 Sigfried Giedion, Protest photomontage sent to Stalin in the name of CIAM, 1932. gta Archiv, Institut für Geschichte und Theorie der Architektur, ETH Zürich, Nachlass Sigfried Giedion.

built in comparison with pseudo-modern architectures for department stores and churches."[82] By comparing Hamilton's project for the administrative center of the USSR to a church and a "cathedral" of capitalist consumer culture, Giedion asserts that, if selected, this project would perpetuate the very bourgeois aesthetic and underlying value systems that the communist revolution had sought to overcome. Giedion was not alone in using photomontage for a polemical argument, as we have seen in the examples of El Lissitzky and others. More and more, architects became aware of the tool's potential to directly influence and shape public opinion.

THE POLITICS OF ARCHITECTURAL PHOTOMONTAGE

I previously argued that Citroen's photomontage *Metropolis* took on the status of a paradigmatic representation of the discontinuous space of modernity and, in particular, of the modern metropolis. The impact of this seminal work was not limited to the visual arts but extended to architecture as well. If we now turn to the question of how architectural photomontage was increasingly seen and used as an instrument for political agitation, it is interesting to compare Citroen's *Metropolis* with Pietro Maria Bardi's *Panel of Horrors,* which was exhibited in the "*saletta polemica*" ("controversial room") section of the Second Exhibition of Rationalist Architecture in his

Galleria d'Arte di Roma on the Via Veneto in Rome in 1931 (fig. 3.26).[83] Bardi had assembled the photomontage very likely with the help of other rationalist supporters such as Giuseppe Pagano and Carlo Belli.[84] The similarity between the two montages is striking mainly for structural reasons. At the same time, several authors have argued that Bardi's representation was directly inspired by Lissitzky's monumental photomurals, in particular those at the 1928 "Pressa" exhibit.[85] Bardi's panel was a polemical contribution to the architectural discourse of the late 1920 and early 1930s in fascist Italy. It was reprinted in Italian newspapers and caused a heated debate. In these years, Italian architecture was concerned with finding a suitable formal repertoire for the expression of fascism. Essentially, two factions opposed one another: on the one hand, the rationalists, who advocated an abstract, modernist architectural language, and on the other hand, the so-called culturalists around Marcello Piacentini and his *stile littorio*, who fought for a conservative architecture drawing from a classical language. The rationalists had staged a first exhibition in Milan in 1928. Following this exhibition, in 1930 the Movimento Italiano per l'Architettura Razionale (MIAR) was founded as a permanent national organization that would serve the rationalist cause.[86] The MIAR soon planned a second exhibition to be held in Rome in 1931 and found in Bardi a collaborator who was committed both to the fascist revolution and to the cause of modern art. This second installment of the exhibition did not limit itself, like the first, to displaying recent projects and buildings by the members of the group, but also took a polemical stand against recent contributions by the conservatives. Bardi's large *Panel of Horrors* mounted on the walls of his gallery formed the centerpiece of this political statement. While there is no evidence that Bardi was aware of Citroen's work, it was highly visible in international avant-gardist publications in the mid-1920s, so Bardi would not likely have

Fig. 3.26 Pietro Maria Bardi, *Tavola degli orrori (Panel of Horrors)*, Second Exhibition of Rationalist Architecture, Galleria d'Arte di Roma, 1931.

missed it. Very much in the same vein as *Metropolis,* Bardi's photomontage, representing the conservative aspects of Italian cultural life, consisted of a dense array of pasted fragments from cut-out photographs of buildings as well as magazine and newspaper headlines and old postcards. The composition included historicist and eclectic buildings by Roman architects associated with Mussolini such as Marcello Piacentini, Gustavo Giovannoni, Cesare Bazzani, and Armando Brasini.[87] Unlike Citroen, however, Bardi was not interested in celebrating the visual revolution and the plethora of new building types that the modern metropolis had engendered. On the contrary, his montage served to expose the reactionary character of much of Italy's recent architecture. With regard to its presentation, the panel goes beyond Citroen's model and adapts Lissitzky's strategy of monumentalization; photomontage is transformed from a contained pictorial unit into a defining element in architectural space. MIAR president Alberta Libera had invited exhibitors to submit critically annotated photographs for a saletta polemica, but the response was moderate, so Bardi made the submissions into a photomontage.[88]

The photomontage was not accompanied by a caption in the gallery display, but Bardi published a short description of the piece in April 1931: "At a recent moment in the last century, when the architectonic idea—even the scent of it—had been lost, the *architetto culturalista* was born. Perhaps he was born in the shop of a junk dealer in antique prints, the union of an eclectic father and an accommodating mother. . . . We have killed the *architetto culturalista,* we have opened his skull, and we have accurately extracted his entire paradise. We have recomposed it minutely and photographed it in order to give an accurate notice of it to our reader."[89] Bardi describes his panel as a snapshot of the troubled brain of a "culturalist architect," which, according to him, is filled with formal debris from the past. By selecting and rearranging examples of culturalist architecture in a haphazard way, Bardi presents it as an intellectually unrefined approach that is based on the more or less random combination of architectural motifs.

Bardi quite deliberately sought to stage a controversy by including buildings by well-known and respected figures such as Marcello Piacentini and Armando Brasini. His intention to engage directly with cultural politics and prompt Mussolini to adopt rationalism as the official architectural language of the regime is evidenced by another statement from 1931: "We say that the State has an interest in controlling the delicate question of architecture according to unifying and dictatorial criteria and in establishing the general character of all buildings programs. . . . He who proposes this does not ask for a State architect, but for a State that establishes definite and strict norms regarding architecture."[90] In the end, Mussolini refused to interfere in this debate directly, and Bardi's bold visual provocation had a counterproductive effect: the National Syndicate of Architecture, membership in which was a precondition for professional practice, threatened to expel the MIAR collaborators. As a result, MIAR ceased its activities in the fall of 1931.

Fig. 3.27 Giuseppe Terragni,
Sala del' 22, Exhibition of the
Fascist Revolution, Rome,
1932.

This, however, did not mean the end of rationalist architecture in Italy. Photomontage continued to be used in Italian architectural politics, prominently, for example, in Giuseppe Terragni's so-called *Sala del' 22* ("Sala O") in the 1932 Exhibition of the Fascist Revolution, which commemorated the tenth anniversary of the March on Rome in 1922, the beginning of the fascist regime (fig. 3.27). Terragni combined photomontage with three-dimensional elements in a way "that transformed [the March on Rome] into an event of mythic proportion."[91] The large mural included a photograph of a large crowd of people applied to the three-dimensional mock-up of a turbine. He thus referenced a similar use of a crowd photograph in two montages by the Russian artist Gustav Klutsis (fig. 3.28). However, while Klutsis's works encouraged active (political) participation by applying the photograph of the crowd to a large outstretched hand symbolizing the force of the collective, Terragni's montage subordinates the masses to the industrial complex. It therefore appeared as "an image of anonymity and subjugation rather than one of individual participation in the construction of a new collective."[92]

If Terragni's use of photomontage proved politically ambivalent at least, it should be emphasized that the avant-garde technique was by no means used exclusively by progressive voices. In Germany, photomontage continued to be a popular technique to address a mass audience after the Nazi takeover. Particularly interesting for the change in use and meaning of

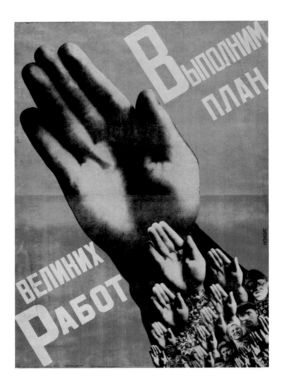

Fig. 3.28 Gustav Klutsis, *Let's Fulfill the Plan of Great Works*, 1930. Lithograph based on a photomontage.

photomontage throughout the 1930s is the work of the artist and graphic designer Herbert Bayer. Bayer had studied at the Bauhaus between 1921 and 1925, and in 1925 became the head of its newly founded Werkstatt für Druck und Reklame (Workshop for Printing and Advertising), which he supervised until 1928, the year of Walter Gropius's resignation as Bauhaus director. Bayer then became the art director in the Berlin branch of the American advertising agency Dorland until he finally went into exile in 1938. During his ten-year tenure at Dorland, and despite the Nazis' rise to power, Bayer advanced to become Germany's best-known and most successful graphic designer. Bayer's "Dorland Studio" became something of a hotspot for former Bauhäusler after the school was closed down by the Nazis in April 1933. Even after this date, Dorland Studio produced surprisingly progressive graphic design campaigns clearly oriented on the Bauhaus model. It has been argued that the agency was used deliberately by the regime for propagandistic purposes: by allowing Bayer and his colleagues to continue in their modernist style, the regime successfully established the notion abroad that it was liberal and open-minded with regard to the arts.[93] This is particularly evident in the various covers designed by Bayer for the lifestyle magazine *die neue linie,* of which at least sixteen date from after the Nazi takeover.[94] One of them, a special edition on Italy from 1938, was co-financed by the Staatliche Auslandspropaganda (Ministry of Foreign Propaganda) and featured a portrait of Mussolini, whose profile was merged with the outline of the Italian peninsula (fig. 3.29). Bayer also lent his skills as graphic designer to several important propaganda exhibitions shown in

Fig. 3.29 Herbert Bayer, Cover for *die neue linie* (January 1938). The Getty Research Institute.

Berlin between 1934 and 1937, as we will see. Despite this obvious willingness to collaborate with the regime, Bayer increasingly became the target of political attacks and was included in 1937 in the *Entartete Kunst* (*Degenerate Art*) exhibition. This led him to seek exile in the United States, where he launched a successful career as an exhibition and graphic designer. He was hired immediately by the Museum of Modern Art in New York to curate the retrospective on the Bauhaus there in 1938.[95]

Despite Bayer's Bauhaus origins, his work as a graphic designer and typographer took an increasingly classicist turn throughout the 1930s. Bayer's aim was now to synthesize the classical with the modern. A telling example is an advertising brochure for "Bayer type," which Bayer devised in 1935 for the Berlin type foundry H. Berthold AG, one of the most successful and influential foundries of the modern age. A short text included in the brochure characterizes Bayer type as "the absolutely modern form of Antiqua, filled with classical spirit, but designed with strictly economical means."[96] This text is laid over a photomontage that places a series of stumps of fluted Greek columns next to an aerial view of the maze of Manhattan skyscrapers—thus accomplishing the ideological objective of bridging the gap between classical and modern by identifying verticality as a shared formal criterion.

In addition to his commercial graphic design, Bayer was also in charge of designing the catalog of a number of important propaganda exhibitions staged by the regime between 1933 and 1937 in Berlin. The first of these was *Die Kamera* (1933), originally planned by the Deutscher Werkbund but

Fig. 3.30 Herbert Bayer, Double-page spread from the *Wunder des Lebens* (1935; *Wonder of Life*) catalog. The Museum of Modern Art, New York.

adopted by the Nazis for their purposes, which would set the standard for their subsequent propagandistic aesthetics.[97] Its use of monumental photomontage and state of the art reproduction technology was clearly indebted to Lissitzky's exhibition designs, such as at the "Pressa" in Cologne (see fig. 3.18).

While Bayer was not involved in this exhibition, he would take a major role in the subsequent "trilogy" of propaganda exhibitions staged by the regime in Berlin: *Deutsches Volk—Deutsche Arbeit* (1934; *German People— German Work*), *Das Wunder des Lebens* (1935; *The Wonder of Life*), and *Deutschland* (1936). The role of former Bauhäusler—among them Walter Gropius, Mies van der Rohe, and Lilly Reich—in laying out and designing the first show in this series (*German People—German Work*) was downplayed in official communications. But Bayer was in good company when he designed the accompanying catalog in what Rolf Sachsse calls the "best Bauhaus manner." The booklet made use of the square format, which Bayer had first introduced with his pamphlet for the Century of Progress exhibition in 1933 in Chicago, and which established the standard for all subsequent Nazi propaganda shows up to 1938.[98] Bayer made frequent use of text and image montages in his catalogs. For the back cover of his pamphlet for the *German People—German Work* exhibition, Bayer employed a technique first introduced by his former Bauhaus colleague Moholy-Nagy in his 1929 *From Material to Architecture:* he applied the exhibition title to a pane of glass and projected it onto a photograph of a landscape. In the exhibition proper, Werner Graeff, the former co-editor of the avant-garde journal *G,* contributed a large-scale photomural that called for the "unification of the German people under the Führer."[99]

Bayer's designs for the poster, magazine, and catalog of the 1935 *Wonder of Life* exhibition are equally interesting. For the cover design, Bayer variegated the motif of "vitreous man" first made popular in the 1930 Inter-

Photomontage in Architectural Representation

national Hygiene Exhibition in Dresden.[100] The major aim of the 1935 exhibition was to display man, "this highest form of organization that nature . . . has created, in the interaction of its organs and systems in a long row of large, plastic dioramas."[101] Images/photographs were displayed in a monumental format so as to create an immersive space "completely near to life and the people"—that is, transmitting contents to the viewer easily.[102] While the catalog dwells mainly on topics such as the functioning of the human body, the senses, and health, a number of chapters are interesting from the point of view of photomontage. A first two-page spread juxtaposes a schematic drawing of the human body illustrating the "law of life" (according to which, sensory perception is transformed into physical action) with a photomontage of decidedly political content (fig. 3.30). The two halves of the spread are directly related in a parallel montage. The effect of this visual analogy is to position the Führer as the brain of the *Volkskörper,* the body of the nation. He is in charge of perceiving problems as they present themselves to the body (in this case, a high unemployment rate) and to set the labor force to work so that a newly constructed Autobahn (as depicted on the left) will emerge for the common good. This analogy naturalizes Hitler's absolute leadership and the removal of agency from the body's "limbs" at the same time as the montage erases the brutality employed in mobilizing the workforce. If intellectual montage activates the mind of the viewer to imagine what might fill the gap, propagandistic montage functions in a reverse manner: the mind of the viewer is trained to ignore what is being left out.

In the last section of the exhibition and catalog, devoted to the "places of life" (*Stätten des Lebens*), Bayer combines a drawing of a model settlement of single-family houses in aerial perspective with an isometric drawing of a single house unit as well as text. This montage gives a sense of how

Fig. 3.31 Installation view of *Deutschland* exhibition, Berlin, 1936.

an ideal society was going to be organized architecturally and urbanistically according to the Nazi regime: in individual family units that would permit each family to grow its own produce in a family garden, but at the same time integrated into a larger uniform settlement structure, whose shape in turn conforms picturesquely to the characteristics of the landscape.[103] There is no residue here of a discontinuous modern space in the metropolis and its impact on sensory perception. Instead, a conventional settlement form is glorified, although, paradoxically, it is based on the industrial replication of a single building type.

The third exhibition in the trilogy, *Deutschland,* coincided with the 1936 Berlin Olympic Games. It was designed by Emil Fahrenkamp according to modern principles of exhibition design. Like its predecessors, the show made ample use of Lissitzky's invention of the monumental photomural in order to impress and awe the audience: the atrium of the Hall of Honors presented itself with a gigantic photographic portrait of Hitler against the background of a crowd of people aligned in the shape of a pyramid (fig. 3.31). In the context of its display, the photomural itself took on an architectural character, as the pyramid visually completed the series of rectangular pillars on the floor below with an imaginary roof. It could be said that the architecture of the exhibition hall and the photomural combined to form a multimedia image of architecture that had both iconic and symbolic meaning: as a powerful representation of the steadiness of the Führer and his people. It was on this occasion that Joseph Goebbels, the *Reichspropagandaminister,* attempted to define photomontage as the quintessential representational technique of the regime. As the *Berliner Tageblatt* quoted him saying on July 18, 1936: "The manner of depiction in enormous photomontages is born from the spirit of the new Germany."[104]

The exhibition's pamphlet, again designed by Bayer, is a telling illustration of this commandeering of the political potential of photomontage by the totalitarian regime (fig. 3.32). On one of the two-page spreads, it shows on the left the colonnade of Karl Friedrich Schinkel's Altes Museum in Berlin, on top of which is inserted, in the manner of a tableau, a drawing of Schinkel's Theater at Gendarmenmarkt. This constellation is juxtaposed on the right with a partial view of the stands of the Berlin Olympic stadium by architect Werner March, again with a tableau-like insert, this time a photograph of the model of the entire project. The two parts of the montage are held together by an inscription in the form of an open book. It states in four languages: "Classicism, because of its rigorous style called the Prussian Style, is embodied to its purest in Berlin. The new Germany creates its own style."[105] Quite obviously, Pietro Bardi's critique of the irrational culturalist approach in his Roman display is here utterly reversed: the satirical disarray of the Italian example is countered with a strictly symmetrical composition. The linking of Schinkel's historical precedent with March's contemporary arena by means of juxtaposition and a literary explanation underscores the superiority and timelessness of classicism, and at the same time frames con-

temporary architectural production within cultural history. No troubling experimentation with the representation of discontinuous space can be found here, but only an affirmation of the allegedly eternal validity of lithic monumentality. Bayer's montage does not display its ruptures, but is a mere superimposition of two monumental views. Buchloh has aptly described the political implications of such a shift in the representation of space with regard to a photomural on display at the 1933 exhibition *Die Kamera:*

Fig. 3.32 Herbert Bayer, Spread from the *Deutschland* catalog (1936). The Getty Research Institute.

> To erase even the last remnant of modernist practice in photomontage, the seams and the margins where the constructed nature of reality could become apparent—and therefore its potential for change obvious—had now become a standard practice in totalitarian propaganda, and construction was replaced by the awe-inspiring monumentality of the gigantic, single-image panorama. What had once been the visual and formal incorporation of dialectics in the structure of the montage—in its simultaneity of opposing views, its rapidly changing angles, its unmediated transitions from part to whole—and had as such embodied the relationship between individual and collectivity as one that is constantly to be redefined, we now find displaced by the unified spatial perspective (often the bird's-eye-view) that travels over uninterrupted expanses (land, fields, water, masses) and thus naturalizes the perspective of governance and control, of the surveillance of the rulers' omnipresent eye.[106]

With these developments, photomontage turned against the cause of the avant-gardes, who had promoted the technique as a way to adequately represent modernity and modern space. Instead, it had become a powerful tool in the hands of those who opposed their tenets.

Mies Montage

The historiography of modern architecture has tended to associate Ludwig Mies van der Rohe with two main issues. On the one hand, he is considered to be the architect who pushed the idea of the flowing interior to its limit and thereby ushered in a modern conceptualization of space.[1] On the other, given his background as the son of a stonemason and his nonacademic training in a vocational school, he is seen as the ultimate representative of the tradition of the master builder, a craftsman whose distinctive architectural language grew out of his intuitive sense for materials. Meanwhile, scant attention has been given to the role of visual media as a key element of his architectural discourse and production.[2] While there is no doubt that Mies changed how space is understood in modern architecture, I will argue that this contribution to modernity is equaled in significance by his command of media and his appreciation of the fact that architecture is as much about representation as it is about space; in this way, Mies's fundamental rethinking of the problem of space is essentially mediated and performed in and by the image. Indeed, Mies's fame is based to a considerable extent on the production and presentation of image architectures and architectural images, on what was often pejoratively labeled "paper architecture"—not least by Mies himself. This applies in particular to the famous "Five Projects" from the early 1920s, which were conceived as theoretical contributions and immediately brought their author to the forefront of the architectural avant-garde.[3] The visual rhetoric of Mies and his office was founded to a large extent on photomontages and collages, media he used for his own purposes like no other modern architect.[4] His use and perfection of these media gave him the means—both graphic and epistemological—to revolutionize architectural representation and to elaborate his own conceptualization of space.

A note on terminology: At the beginning of this volume, I proposed a distinction between the concepts of montage and collage based on three main criteria: dialectical versus non-dialectical construction, exclusion versus inclusion of "objects" as opposed to their representations, and visuality versus tactility. Based on these criteria, it is important to note that the early (European) works by Mies differ substantially from the later (American) ones. The visualizations of the skyscraper projects from the early 1920s are

mainly based on photography and should be termed "photomontages," principally also on account of their dialectical structure. The later images from the American period, by contrast, do not make use of juxtaposition as a device for the creation of dialectical meaning and often directly include materials such as cut-out reproductions of artworks, wooden veneers, or even glass panels: they should therefore be identified as photocollages. While the early montages are clearly informed by an avant-garde sensibility, the later collages, many of which were actually executed by Mies's students, are more artisanal in character. This shift in representational mode is congruent with the consumption of the political project of the avant-garde, the transformation of their tenets into an aesthetic or "style," and the separation of aesthetic experience from practical life in the context of American postwar capitalism.[5] At the same time, in the photocollages from this period, we see a change in role from representation of exterior to interior space and a heightened frontality so that space is conceived through the layering of planes or images.

MONTAGE BEFORE MONTAGE (AGAIN)

The famous Friedrichstraße photomontages from the early 1920s have contributed to the common perception of Mies as a lone architectural visionary who came up with a powerful means to represent his architectural ideas almost *ex nihilo* (fig. 4.1). It is possible to argue, on the contrary, that Mies's "genius" emerges from his awareness of developments in architectural representation beginning in 1900, as well as his familiarity with vernacular traditions reaching farther back into the late nineteenth century, particularly in German military and popular cultures. Paradoxically, it is precisely his most utopian architectural visions that are the most revealing of these subconscious links to anonymous tradition.

The earliest instance of the use of photomontage in Mies's oeuvre occurs in the context of one of his first known projects: the entry he submitted with his brother Ewald in the 1910 open competition for a national monument honoring Bismarck, the driving force of German unification, on the centennial of his birth at a site overlooking the Rhine at Bingen.[6] Two photomontages have survived from the entry of the Mies brothers, both of which show the project embedded in the context of the Rhine Valley's romantic landscape (figs. 4.2, 4.3). One of them shows the design as seen from the riverbank, looking up at its elevated hillside location; the other takes a much closer viewpoint from a fictional approach on a nearby footpath. Both visualizations insert a photograph of the model produced for the competition into one of the site, while the second image is augmented by watercolor. An additional sketch indicates the three different segments from which the first montage was assembled. Two forms of manipulation can be distinguished in both images: drawing on or painting

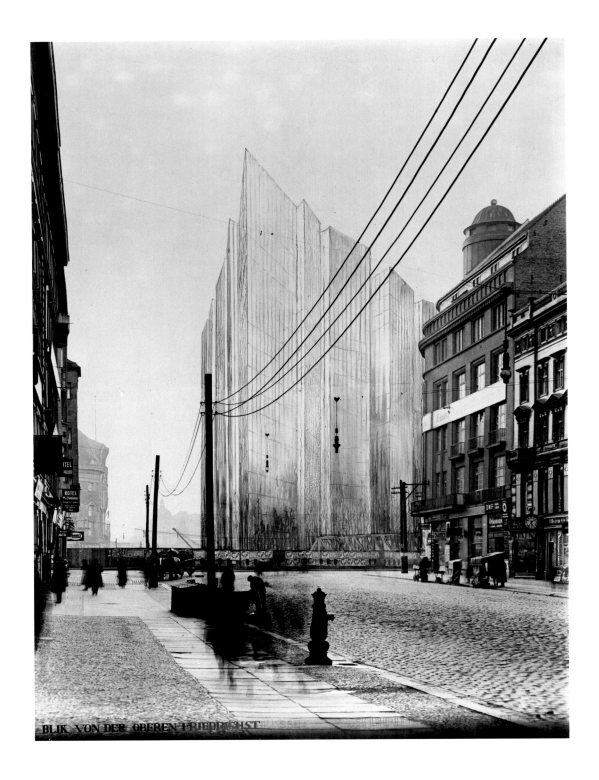

Fig. 4.1 Ludwig Mies van der Rohe, Friedrichstraße skyscraper
project, Berlin (perspective from the north), 1921. Photomon-
tage. The Museum of Modern Art, New York.

Fig. 4.2 Ludwig Mies van der Rohe and Ewald Mies, Bismarck National Monument, Bingen, 1910. Photomontage with model photograph. The Museum of Modern Art, New York.

Fig. 4.3 Ludwig Mies van der Rohe and Ewald Mies, Bismarck National Monument, Bingen, 1910. Photomontage. The Museum of Modern Art, New York.

over photographs and collage/montage in the literal sense of the term as the technique of cutting and pasting of image fragments.

Mies may well have learned such image manipulation techniques from his father's stonemason's workshop.[7] However, such speculations do not decisively answer why the medium of photomontage specifically would take on such significance in the architect's production. In order to properly judge Mies's contribution to the representation of modern architecture and space, the competition for the Bismarck monument is highly illuminating. The competition brief not only asked for various plans and sections, but specifically requested "perspective views, inserted into exposures [of the building site] to be obtained from the committee."[8] The jury provided four different photographic views of the landscape (including fig. 4.4), which

Abb. 1. Ansicht der Elisenhöhe.

Fig. 58
Ein Haus will ich bauen Dir zum Gedächtnis (Nr. 125). Bildhauer Rudolf Bosselt

Fig. 4.4 Photograph of the site of the prospective Bismarck National Monument provided by the competition jury, from *Bismarck-National-Denkmal: Hundert Wettbewerbs-Entwürfe* (1911).

Fig. 4.5 Rudolf Bosselt, Bismarck National Monument, Bingen, 1910. Photomontage, from *Bismarck-National-Denkmal: Hundert Wettbewerbs-Entwürfe* (1911).

had been produced as black and white heliographs by the renowned Dresden firm Römmler and Jonas.[9] It is therefore not surprising that a number of other entrants also submitted photomontages (that is, photographs augmented by drawings), among them the sculptor Rudolf Bosselt (fig. 4.5), the architects Theodor Fischer and Otto Leitolf, and the team of Hans Poelzig and Theodor von Gosen. However, these entrants inserted drawings into the landscape photograph rather than using a second (model) photograph, as Mies did. In any case, it is significant that already in 1910, the competition organizers recognized the value of manipulated or augmented photography in assessing the impact of the proposed monuments on the surrounding landscape.

The manipulation of photographs by means of drawings was already a common practice at this point. The emergence of manipulated architectural photography and the insertion of drawings into photographs at the end of the nineteenth century was already discussed, in particular in the case of the Munich architect Friedrich von Thiersch's project for a new castle at Hohenaschau from 1899, one of the earliest known examples of an architectural photomontage (see fig. 3.4). It is interesting to note that there are direct biographical connections between von Thiersch and Mies: as a young architect in 1907, Mies worked as a draftsman for von Thiersch's nephew Bruno Paul, who recommended him to the office of Peter Behrens, where Paul had previously been office manager.[10] It therefore can be assumed that Mies first became aware of such new forms of architectural representation in von Thiersch's practice, as mediated through his nephew. However, in contrast to von Thiersch's visualizations, which are photographs augmented by drawings, Mies's depictions of the Bismarck monument are photomontages in the technical sense of the term, since they combine different photographs in a single image. His early use of this technique appears to be quite unparalleled at the time, and becomes all the more striking when one considers that the "invention" of photomontage is usually attributed to postwar Berlin Dada circles. That said, Mies's use of photomontage proper is not entirely singular in architectural representation at the time, and seems to have been more common than is generally acknowledged.

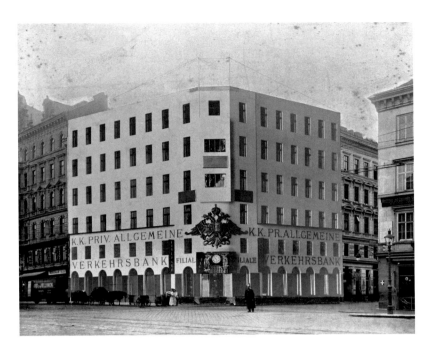

Fig. 4.6 Adolf Loos, Photomontage showing the residential and office building of the K.K. Priv. Allgemeine Verkehrsbank in Vienna, 1904. Albertina, Vienna.

This is evidenced by a famous photomontage by Adolf Loos for the K.K. Priv. Allgemeine Verkehrsbank at Mariahilferstraße 122 in Vienna from as early as 1904, which combines a model photograph with one of the existing streetscape (fig. 4.6).[11] As we have seen, the official genealogy of photomontage is a matter of great controversy, as the manipulation and montage of photographs dates back to the inception of the new medium in the mid-nineteenth century. In the appropriation of the montage technique for "high art," the Dadaists deliberately referred to artifacts from popular and military culture in order to unsettle and challenge received conceptions of what "high art" should be. Mies's Bismarck monument montages also demonstrate this under-recognized kinship between avant-garde montage and eclectic image practices.[12]

As we have seen in the discussion of early manipulated photographs, such depictions often sought to achieve the maximum visual integration of the project into the landscape or urban context. The state-of-the-art representational technique was employed not to contrast the individual fragments or elements dialectically, but rather to smooth out inconsistencies between them. Nevertheless, the Aristotelian unities of place and time, normally a given in photography, are transgressed since a number of different vantage points and levels of reality (that is, landscape and model) are integrated into a single depiction. The aim is to induce in the observer a kind of "reality effect," to borrow Roland Barthes's term.[13] But appearances can be deceiving: with photomontage, the idea of "representation" has come to an end, for what it offers is truly virtual. This is what Mies achieves in his early photomontage of the Bismarck National Monument as well: the projection of an imagined architecture onto the image of a real site. By means of this

Fig. 4.7 Philipp Schaerer, Bildbau no. 5, 2007–9. Digital photomontage. Courtesy of Philipp Schaerer.

"reality effect," photomontage turns out to be the historical forerunner of digital rendering practices in which the boundaries between reality and fiction are increasingly blurred (fig. 4.7).

THE DADA ENCOUNTER

Even if Mies experimented with photomontage and augmented photography at an early stage, a clear shift of intention in his use of the medium can be discerned from the early 1920s, starting with his famous projects for the Friedrichstraße skyscraper (see fig. 4.1) and a second glass skyscraper that he produced as an experiment. As is evidenced in the object list, both projects were shown as part of the First Bauhaus Exhibition in August 1923, alongside a drawing and a photo of one of the country houses from the same period. Both skyscraper projects had been shown to the public for the first time in the November group section at the Great Berlin Art Exhibition, which opened a year before, in May 1922.[14] However, it has been established with great certainty that the photomontages were not part of Mies's original submission to the competition for a skyscraper at Bahnhof Friedrichstraße held by the Turmhaus-Actiengesellschaft Berlin in November 1921; more specifically, these large-scale montages were not produced before April–May 1922.[15] In other words, the enormous popularity and significance of the large-scale photomontages of the Friedrichstraße skyscraper came about only due to publications and exhibitions after the competition, by means of their public display. From that time on, Mies would make use of photomontage repeatedly. It served him both as a device of architectural and spatial research and for the representation of his architectural ideas.

Mies's neo-classicist designs of the 1910s and his modernist visions of the 1920s seem to be separated by eons. In order to explain this break in his architectural thinking, a cathartic experience is frequently brought into account: the rejection of his entry to the Exhibition for Unknown Architects, which was organized in the spring of 1919 in Berlin by Walter Gropius for the Arbeitsrat für Kunst (Worker's Council for Art), the mouthpiece of the expressionists between 1918 and 1922.[16] Mies submitted his 1912 project for the Kröller-Müller House in Wassenaar in the Netherlands, an unbuilt commission inherited from his former employer, Peter Behrens. The decision to submit a prewar design cannot be explained solely by his military service from 1915 to 1918, but seems to reflect a real crisis in the architect's production. Gropius's rejection of the project came as a wake-up call. Mies himself remembers being told: "We can't exhibit it, we are looking for something completely different."[17]

However, it is questionable whether the radical shift in Mies's oeuvre can be attributed to this experience alone, especially given that the Exhibition for Unknown Architects favored expressionist designs by figures such as Wassili Luckhardt and Hermann Finsterlin. Rather, it is striking that at this time, Mies—up to then an inconspicuous and little-known architect—started to develop an interest in the artistic avant-gardes and their rethinking of representation. For a while, the architect refrained from participating actively in the most important Berlin avant-garde groups. For example, he never became a member of the Arbeitsrat für Kunst, and he only joined the Novembergruppe in 1922, a moment when the group had transformed from a politically active force to a mere sounding board for the interests of the member artists. He only became a member of the Werkbund in 1924; as the vice president of this group he was entrusted, in 1926, with the planning and coordination of the exemplary Weißenhof Siedlung exhibition that took place in Stuttgart the following year. Likewise, Mies took a formative role in the group surrounding the journal G: Material zur elementaren Gestaltung and Hans Richter (as we will see), as well as in the Zehnerring (Ring of Ten), a loose association of progressive architects who met regularly at Mies's studio, Am Karlsbad. However, it was considerably earlier that the architect started taking a keen interest in the activities of the Berlin artistic avant-garde, and this interest must be seen in direct connection to his architectural reorientation. The importance of the intellectual exchange with these artists for his architectural thinking and production was something Mies himself emphasized in retrospect. Gene Summers, an employee in the Chicago office, recounts asking Mies about the reasons for his epiphany: "He had just gotten back to Berlin where so many things were happening in the arts. I am not sure that these were the exact words, but that was the meaning: He said, 'I knew that I had to get on with it. I had to make this change.'"[18] The project for the high-rise at Bahnhof Friedrichstraße was, according to Mies, intended from the very beginning as an architectural manifesto without any chance of being realized, a theoretical contribution

to architectural discourse in the form of an image. That Ludwig Mies from now on started to call himself Mies van der Rohe, thereby establishing a professional public persona, underscores how strongly he was seeking a break both in his previous professional and private lives.

In the context of the Berlin avant-gardes, it was above all the Dadaists to whom Mies turned for inspiration, in particular Hannah Höch, John Heartfield, Raoul Hausmann, Hans Richter, and Johannes Baader, but also the Hannover-based Kurt Schwitters.[19] A photograph dated June 30, 1920, shows Mies van der Rohe among the visitors to the First International Dada Fair held in Otto Burchard's gallery in Berlin (fig. 4.8). The photograph is of paradigmatic significance for the architecture culture of the early Weimar Republic. Of all the artistic movements active in the aftermath of World War I, Dada was the single most radical. In the photo, we see a rather well-behaved group of young men in spotless suits; only the woman in the center of the picture makes an explicit statement for "reform" clothing with her loose skirt—she is apparently pregnant—while the checked cap of a man to her left speaks of a certain bohemian attitude. Despite the apparent informality, however, what we are looking at here is not a random sample of the *jeunesse dorée* of the Berlin bourgeoisie, but some of the most outspoken and ferocious critics of Wilhelmine society. The photograph belonged to Höch (shown at far left), whose writing identifies the following visitors: "From right to left: 1. [Johannes] Baader, 2. Unknown,

Mies Montage

3. Mies van der Rohe, 4. [Rudolf] Schlichter, 5. Wieland Herzfelde, 6. John Heartfield's wife, 7. Dr. Burchard (host), 8. child of John Heartfield. Himself behind (invisible), 9. [Raoul] Hausmann, 10. [Otto] Schmalhausen (OZ), 11. [Hannah] Höch."[20]

The Dadaists' primary artistic impulse was to destroy the ossified forms of bourgeois taste, to radically question the traditional understanding of the work of art prevalent up to the end of the nineteenth century, and to replace it with a heterotopic (visual and linguistic) order based on dialectical tension between individual elements, resulting in a new aesthetic of fragmentation and juxtaposition that freed images and poems alike from their traditional grammars. It has been argued that this poetics of iconoclasm reflected the traumatic experience of the war and the end of the *ancien régime.* However, it should be underscored that the initial aesthetics of negation and destruction were soon replaced by a more constructive paradigm, a quest for alternative means for the production of visual knowledge beyond established conventions, which often implied a polemical or ironic stance toward the social and political situation of the Weimar Republic.[21] In many ways, the artistic aims of the Dadaists were not an end in themselves but were situated in a larger political context. For them, art was the primary instrument and weapon in what they saw as their real struggle, which was to radically change society. Read against this political program, the conforming attitude of the crowd assembled in Burchard's gallery seems rather astonishing. Is this a group of political and artistic radicals indulging in the comforts of the bourgeois salon? Or was perhaps the whole Dada attitude merely a performance, a sort of petty and well-contained rebellion sprung from the nurseries of the very same Wilhelmine society they were attacking? Whatever the answer, the bourgeois and the bohemian universes do not seem to be as antipodal as the accounts of the Dada protagonists themselves and their hagiographers have suggested. Rather, they form the dialectical but necessarily interdependent opposites of Janus-faced modern life. And Mies seems to be perfectly at ease with this.

Various slogans at the First International Dada Fair exhibited the movement's primary anti-bourgeois impulse (fig. 4.9). For instance, a poster with the portrait of a screaming John Heartfield reads: "Nieder die Künste / DADA ist GROSS und John Hartfield [sic] ist sein Prophet / Nieder die bürgerliche Geistigkeit!" (Down with the arts / DADA is GREAT and John Hartfield is its prophet / Down with bourgeois spirituality!). However, this heroic account of the artistic and social aims of the Dadaists must be relativized to some degree. Even contemporary critics questioned their revolutionary impact. Adolf Behne, in reviewing the exhibition for the July 9, 1920, issue of *Die Freiheit,* underscores the artistic as opposed to the political significance of the Dadaist endeavor:

> The Dadaists Hausmann, Dix, Albrecht, Groß, Hannah Höch, and some others have opened an exhibition at Salon Burchard for

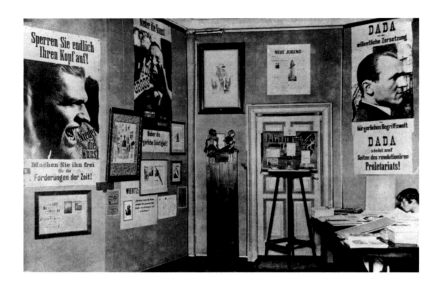

Fig. 4.9 Installation view of the First International Dada Fair, Galerie Otto Burchard, Berlin, 1920. Berlinische Galerie, Hannah Höch Archive.

which they are charging 3.30 Marks admission, likely in the expectation that only the well-heeled of the West will come. So while it is asserted on a poster in the exhibition that Dada is on the side of the revolutionary proletariat, the exhibition in effect presents an urban middle-class with proletarian dictates for a fee. Hence it is "art" through and through. . . . Today, the *Elysian Fields* can only be painted by a fool. Today, all "beautiful" colors and forms are a sham. The Dadaists show the spirit of 1920 in pictures that are pasted together from poster stamps, photos, train tickets, iron crosses, razor blades, laces, bits of gold braid, and newspaper clippings. They exchange the heads in photographs, cut apart and recombine and have developed a technique in which an uncanny tension can be felt and which without question is a substantial enrichment for our paintings. . . . Several truly brilliant collages by Hannah Höch, Raoul Hausmann and George Groß make a visit worth the price.

Behne's review illustrates a fundamental contradiction in the Dadaists' mission: on the one hand, they openly opposed and ridiculed the bourgeoisie and bourgeois notions of the work of art by embracing the visual codes of a proletarian mass culture; on the other hand, their works in the end continued to address a bourgeois audience who could appreciate their operations as avant-gardist aesthetic gestures. The political objectives of the Dadaists thus became aestheticized before they could ever trigger political action. Meanwhile, another contemporary source mentions that George Grosz's caricatures titled *Gott mit uns* (*God with Us*), which had been published in a portfolio by the Malik Verlag and which were on display at the Dada Fair, were confiscated on orders of the Reichswehrministerium, the Ministry of Defense. This episode even led to a lawsuit against the artist for defamation of the armed forces. Despite this scandal, and despite the consider-

able amount of attention given to the event in the press, public interest was apparently only moderate, at least according to a letter Johannes Baader sent to Hannah Höch and Raoul Hausmann on July 16, 1920, while they were vacationing on Rügen.[22]

The Dadaists' prime field for artistic experimentation and expression was photomontage, which they made to serve as a direct reflection of their aesthetic and political goals (see fig. 1.2). According to canonical theories of the avant-garde, two aspects are essential for the Dadaist montage technique: on the one hand, the production of the work of art as an organic whole is renounced in favor of the act of selecting ready-made materials; on the other hand, the sometimes stark contrast effected by juxtaposition of these materials, media, and (reproduced) images is valorized.[23] Even though, as we have seen, the aesthetic effect of such contrasting juxtapositions has repeatedly been described as "shock" (by Georg Simmel, Walter Benjamin, and others), it was only at the beginning of the movement that the Dadaists took destruction and fragmentation as an end in itself; they soon began to investigate a new visual semantics based on juxtaposition. Raoul Hausmann (retrospectively) stated in 1931: "In the medium of photography [the Dadaists] were the first to create from structural elements of often very heterogeneous materials or locales a new unity that tore a visually and cognitively new mirror image from the period of chaos in war and revolution; and they knew that their method had an inherent propagandistic power that contemporary life was not courageous enough to absorb and to develop."[24] Despite the obviously self-promoting undertone of Hausmann's statement, his figure of the "mirror image" suggests that the Dadaist project was in fact communication (or resemblance) through contrast. In the words of the architectural historian Manfredo Tafuri, "Dadaist nihilism, in the hand of a Hausmann or a Heartfield, became the expression of a new technique of communication. The systemic use of the unexpected and the technique of assemblage were brought together to form the premises of a new nonverbal language, based on improbability and what Russian formalism called 'semantic distortion.' It was therefore precisely with Dadaism that the theory of information became an instrument of visual communications." Thus, for the Dadaists, photomontage was not merely a means to represent the industrialized metropolis and the traumas it inflicted on the individual and his or her perception; it was also a heuristic model for the production of visual meaning by the unmediated juxtaposition of disparate elements and the surplus of meaning released by their contrast.[25] The First International Dada Fair was the first presentation of these possibilities to a larger audience. The exhibition presented various photomontages that honored the programmatic artistic and political claims of the Dadaists. I contend that the profound transformation in Mies's architectural language that took place shortly afterward is clearly a result of his confrontation with Dadaist pictorial grammar. I would argue for this reason that only through his exposure to Dada did he learn to understand and apply photomontage

as an epistemological tool that could produce a visual meaning far surpassing what earlier architectural visualizations had accomplished by means of manipulated photography.

Mies's main link to Dada was through his close friendship with Hannah Höch, who was surrounded by a group including Kurt Schwitters, Hans Arp, Theo van Doesburg, László Moholy-Nagy, and Raoul Hausmann, most of whom Mies also knew personally. Evidence of the architect's friendship with Höch include his having helped her obtain a visa for a journey through Italy in 1920, a trip that proved significant both artistically and personally.[26] Also, on March 31, 1925, when Nelly van Doesburg and Kurt Schwitters gave a joint performance in the house of a Mrs. Kiepenheuer in Potsdam, Mies drove Höch there in his car. Höch marks this as "a memorable day" in her diary; indeed, it was most likely the very first public performance of Schwitters's tone poem *Ursonate,* a montage of a stupendous sequence of rings and tones that broke down the boundaries between language and music and relied considerably on improvisation.[27] Mies's presence at this avant-gardist performance underscores his interest in experimental forms of representation across media, and the search for alternative forms of signification beyond established artistic, linguistic, and architectural grammars.

Schwitters, too, held Mies in great esteem: he dedicated one of the secret "caves" in his legendary Hannover *Merzbau* to the architect, an honor reserved for a select number of friends and prominent figures in the Weimar Republic.[28] Moreover, Schwitters featured Mies's projects for a glass skyscraper in issue 8/9 of his magazine, *Merz.* Co-edited by El Lissitzky, the double-issue's Latin title was *Nasci,* meaning "I have been born." One model photograph of the glass skyscraper was reproduced on a two-page spread (fig. 4.10). By its comparison to a human bone, the building was presented as a quasi-anthropological form, as something that is both structurally sound and "naturally" arising from functional considerations. At the same time, the transparent materiality of the project is not directly addressed by, or rather is juxtaposed to, the opacity of the bone.[29] The curve at the top of the bone echoes the curve at the top of the building, as the dark channel of marrow resembles the building's convex shaded areas. These formal similarities play against the oppositions primitive/technological and opaque/transparent at the same time as the two structures, bone and skyscraper, belong to different orders of magnitude. Schwitters himself contributed to *G* magazine, where Mies played an editorial role. Mies's admiration for Schwitters is confirmed by his collection of collages by the artist, a dozen of which he kept in a special cabinet in his otherwise sparsely furnished Chicago bedroom. Their mutual friendship is also attested by the fact that Mies provided several anecdotes from Schwitters's life for Robert Motherwell's seminal anthology on the Dada painters and poets.[30]

Schwitters became aware of collage and montage as a new means of artistic expression around 1918 through Herwarth Walden, owner of the gallery Der Sturm (where Paul Citroen had been employed) and patron of

the avant-garde. This discovery had a decisive impact: the collage, montage, and assemblage of found objects and all manner of detritus gathered from the city streets immediately became a key mode of his work (see fig. 3.19). Schwitters had sought to be included in the Berlin Club Dada but was rejected because the group saw him as a bohemian bourgeois. His peculiar position between the avant-garde and the (petty) bourgeoisie was particularly detested by Richard Huelsenbeck and George Grosz, but was less of a concern to Hausmann and Höch, who saw him as both the "veritable artist who gave himself over to art to the point of self-sacrifice" and the "perfect complacent bourgeois" (*Spießer*).[31] This rejection led him to withdraw to his hometown, Hannover, where he established his own artistic practice and distinctive take on Dada, which he named *Merz,* short for *Kommerz* (commerce). But while Schwitters embraced the Dadaists' practice of montage and collage, sharing their interest in–and astringent critique of— prewar bourgeois society and in the metropolis as both a symbolic form and an artistic repository for modernity, he took a less dialectic approach. The collages he produced had a strong sense of materiality and a memorial quality—resonating as artistic digests of the modern metropolis as much as they were reminders of a certain transience, in the tradition of the still life.[32] Through them, Schwitters pursued the poetics of the *objet trouvé* and the aesthetics of the ugly and ordinary. He also used collage as a vehicle for extending the two-dimensionality of the image into space—very much in line with his friend El Lissitzky's Prouns as the "transfer station from painting to architecture"—thereby aspiring to overcome traditional panel painting from within its own medial conditions.[33] The work of Schwitters makes it clear that in German artistic discourse around 1920, montage and collage were concepts that were not universally agreed upon, but were subject to much heated debate.

Fig. 4.10 Double-page spread from the special issue, *Nasci*, of the journal *Merz*, no. 8/9 (1924): 81–82, including a model photograph of Mies van der Rohe's glass skyscraper.

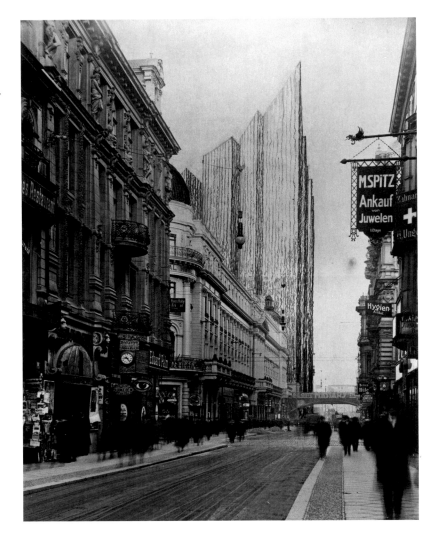

Fig. 4.11 Ludwig Mies van der Rohe, Friedrichstraße skyscraper project, Berlin (perspective from the south), 1921. Photomontage. The Museum of Modern Art, New York.

Mies, a keen observer of these disputes, was well aware of the potential of montage and collage techniques for the production, representation, and dissemination of architecture. Like the Dadaists, he sought to investigate the modern metropolis as the symbolic form of a new cultural paradigm. However, his stance toward the impact of the metropolis on individual experience—as theorized early by Georg Simmel in his seminal essay "The Metropolis and Mental Life" of 1902—was highly ambiguous: on the one hand, he embraced the possibilities of industrialization for his architecture; on the other hand, his transparent skyscraper projects seem to remove themselves from the chaos of the modern city, whose image is absorbed, mirrored, or distorted on the convex surfaces of his glass curtain walls.[34] In between the political agitation of the Berlin Dadaists and Schwitters's more descriptive mode of commentary, Mies adopted a different path that drew its power from a strong belief in change through technological progress, as also manifested in his use of then-state-of-the-art representational tech-

Mies Montage

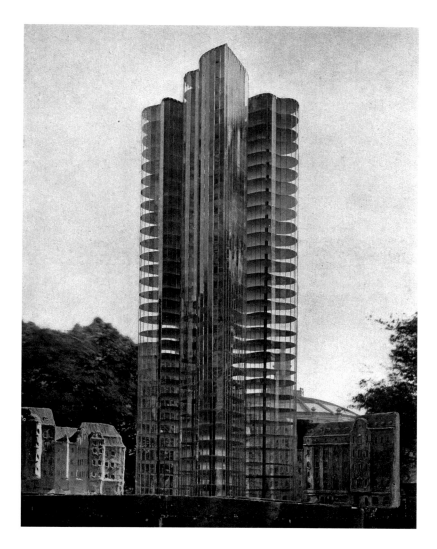

Fig. 4.12 Ludwig Mies van der Rohe, Skyscraper project, 1922. Model photograph, from *Cahiers d'Art*, no. 3 (1928).

niques. Photomontage served him as both a frame for study and a means of representing an architectural idea.

THE BERLIN SKYSCRAPER PROJECTS

Unlike the heterotopic and fragmented handling of space in Dadaist montages or in Paul Citroën's *Metropolis* series, Mies's Friedrichstraße photomontages do not break up the image space but, like other examples of architectural photomontage that have already been discussed, remain committed to an illusionistic perspectivalism. In contrast to his own early montages for the Bismarck monument, however, the dialectic principle is now applied purposefully in order to produce a strong pictorial assertion (fig. 4.11). Rather than integration, these visualizations seek an overt display of difference between project and (urban) context. This effect is also evident in the model photographs of a glass skyscraper, a project that was

Fig. 4.13 Harvey Wiley
Corbett, Bush House,
London. Photomontage,
from *Architectural
Review* 55 (1924): 33.

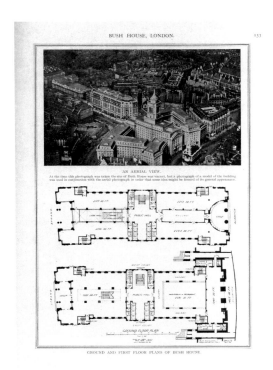

evidently inspired by the competition for a skyscraper at Bahnhof Fried-
richstraße, but which Mies worked on without a commission or a desig-
nated site. For this reason it can be considered an architectural experiment
with an epistemological purpose (fig. 4.12). In these model photographs,
the strategy of juxtaposition is exaggerated to the point of caricature. Even
though they are not photomontages in the proper sense, the images embody
the strategy of embedding the project in its urban context while being in
fundamental conflict with it—a visual logic that is diametrically opposed
to the integrated aesthetics of the Bismarck designs. It is also revealing to
compare Mies's use of the model photograph with that of contemporary
American practitioners, among whom the American architect Harvey
Wiley Corbett is a particularly interesting case in point. Corbett served as a
studio critic in the early 1920s at the Columbia University School of Archi-
tecture, whose director, William Alciphron Boring, was pivotal in promot-
ing model-making for the study of architecture.[35] Corbett argued against
Boring, saying that the most compelling presentation of architectural
models was in composite photography, a technique that had already been
developed in the nineteenth century and can be seen as a forerunner to pho-
tomontage. This technique was adapted for model photography by insert-
ing the image of the model into one of the site and then re-photographing
it in order to arrive at a "seamless"—or what we have called integrative
or disguised—montage amounting to an illusory vision. Corbett himself
demonstrated his understanding of the use of the technique in a compos-
ite model photograph of Bush House in London using the bird's-eye view

(fig. 4.13).[36] Quite obviously, the technique was employed to seduce the potential client visually, to use make-believe in order to convince him of the feasibility of the project. While Mies also made use of this technique of composite photography for his skyscraper project, and while his montage may also be considered "seamless" on the level of workmanship, his coupling of the avant-garde project with the conventional streetscape is fundamentally dialectical in an epistemological sense. The photograph places the skyscraper in a row of characteristic Wilhelmine houses, quite obviously to emphasize the tension between old and new. More specifically, Mies asked the sculptor Oswald Herzog to produce plaster models of the traditional houses as a photographic backdrop for his model. Their doughy appearance seems to refer less to the real architecture of the metropolis than to expressionist stage sets such as Hans Poelzig's design for *Der Golem, wie er in die Welt kam* (*The Golem: How He Came into the World*) from 1920. According to the recollections of Werner Graeff, one of the editors of *G* magazine, Mies asked Herzog to mold a "piece of Friedrichstraße, as it once was; it does not have to be exact, only in principle."[37] Set against the skewed bulk of the houses, the translucent skyscraper appears almost as a sacred vision of light, a monstrance in the constricted space of the historic city. In contrast to the translucent volume, the row of houses is not executed as a three-dimensional model, but as a two-dimensional backdrop, in the spirit of a film set. It was clearly intended and specifically produced for photographic representation, and it could thus be argued that it is the photograph rather than the model that fully embodies Mies's architectural idea. That said, the doughy appearance of the plaster houses should not be over-interpreted, as this was, at least partly, a consequence of the qualities of the material. It can also be seen frequently in contemporary architectural models where no polemical meaning was intended.[38] Mies seems to satirize the traditional modeling material by using photography to represent it—the high-tech medium of photography being the suitable means to represent his high-tech model (and idea of architecture). Mies's polemics against premodern architecture and conventional techniques of (architectural) representation would seem to mirror the Dadaists' scathing critique of bourgeois society. It is also significant in this regard that Mies stages his model and the plaster houses against the background of real trees and the glass cupola of the so-called Marine-Panorama in the background.[39] This juxtaposition not only emphasizes the "fakeness" of the Wilhelmine façadism, but also the historical genealogy of his visionary architecture in nineteenth-century glass and steel construction.

Notwithstanding European debates surrounding high-rise buildings in those years, Mies's montages related to the past and at the same time cast their shadow to the future.[40] By contrasting old and new, the architect performed his own version of the pictorial contrast. Like other architects, Mies no longer relied on the pairing of images, but combined the two poles in his montages. However, his meticulous approach to setting his skyscraper

Fig. 4.14 Ludwig Mies van der Rohe, Friedrichstraße skyscraper project, Berlin, 1921. Charcoal on paper. The Museum of Modern Art, New York.

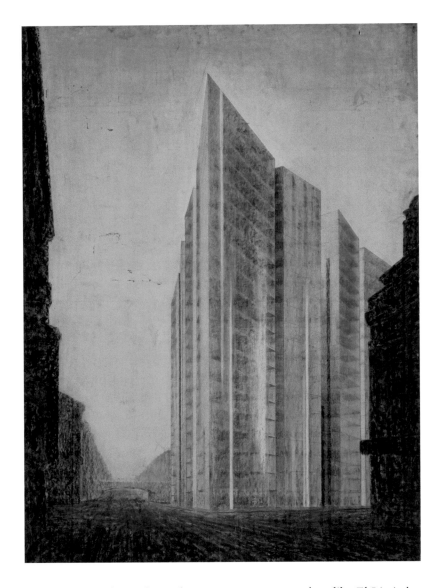

visions against the traditional city seems to suggest that, like El Lissitzky, he was striving for a synthesis rather than mere polemics or a tabula rasa. His montages went beyond the disintegration and fragmentation of the traditional image of the city and instead proposed something entirely new: aesthetic rupture is considered not the problem, but the solution. In this regard, Mies's montages anticipate the concept of the "collage city" that Colin Rowe and Fred Koetter developed into an urbanist *leitmotif* in the 1970s, arguing that the modern metropolis is constituted through its fragmentary aesthetic as a palimpsest of heterogeneous historical strata.[41]

The same principle—integration into the (real or imagined) urban context, while radically differentiating the project with regard to materiality, form, dimensions, and light—underlies the designs for a skyscraper at Bahnhof Friedrichstraße, which marginally preceded the second, theoretical

Mies Montage

project.[42] In addition to several photomontages, Mies produced a charcoal drawing for this project, whose dialectics do not depend on the montage and juxtaposition of photographic elements, but merely on graphic means, indicating that he adopted the dialectical principle to more conventional forms of architectural representation as well (fig. 4.14). Quite apparently, Mies was not at all concerned with Le Corbusier's definition of architecture as the "masterly, correct and magnificent play of masses brought together in light."[43] Rather than clarity and architectural precision, blurring seems to be his goal, as well as ultimately to evoke an atmospheric impression. Mies seems to mimic the aesthetic practices of turn-of-the-century photography, in particular the pictorialism of Alfred Stieglitz or Edward Steichen, which in turn took painting as a key point of reference. At the same time, the charcoal drawing is also reminiscent of the frottage technique that Max Ernst derived from collage.[44] Mies thinks not in terms of volumes, but in a pictorial frame. He is acting not as an architect but as an artist. Compared to the photographic representations, the contrast between light and dark is even more explicit here. However, the antagonism between the "dirty realism" of the everyday streetscape in the photograph and the "philosophical calm" of the transparent tower is sublimated. The details in the foreground are largely deleted.[45] The silhouettes of the buildings along the street are identical in the drawing and in the photomontage. It could therefore be assumed that the montages served as a sort of intermediary step in Mies's visualization of an architectural idea. However, the large dimensions of the two extant sheets clearly indicate otherwise (fig. 4.15). As Mies understood modernity as the age of media, and modern architecture, by extension, as a matter of representation, these montages were explicitly produced for the purpose of public display. The large format, the *forme tableau,* the use of perspective, and the reality effect produced by photography all serve

Fig. 4.16 Ludwig Mies van der Rohe, Study for Alexanderplatz, Berlin, 1929. Photomontage. The Museum of Modern Art, New York.

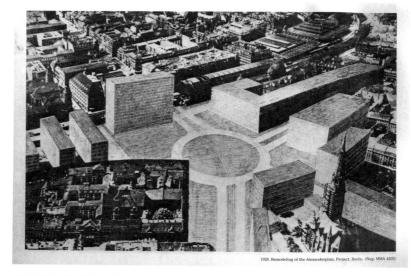

1928. Remodeling of the Alexanderplatz, Project. Berlin. (Neg: MMA 4205)

Fig. 4.17 Ludwig Hilberseimer, Berlin Development Project, Friedrichstadt District: Office and Commercial Buildings; Bird's Eye Perspective View. "Anwendung des Princips auf Berlin" (Applying the Principles to Berlin), 1928. Photomontage of ink on paper mounted on aerial photograph, 6¾ × 9⅘ in. (17.2 × 25 cm). The Art Institute of Chicago. Gift of George E. Danforth.

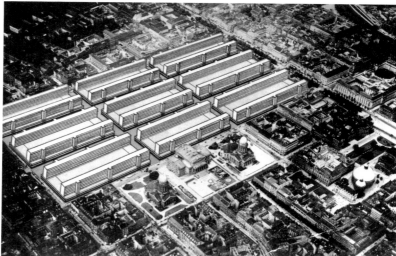

to simulate an urban experience within the gallery space, and the figures depicted in the foreground take on the role of identification figures for the viewer. The photomontages are more than a means to an end; they are themselves the bearers of a striking architectural idea.

Similar to the competition entry for the Bismarck monument, the montages for the Friedrichstraße skyscraper present the exterior of the prospective building in order to present the design within its physical context. This time, however, the context is not rural or pastoral, but decisively urban. Although the Friedrichstraße project pretends to be part of a larger urban setting, any connection between everyday life and the realm of visionary architecture is severed. This is particularly evident in the way the glass volume is tied to the ground. While the charcoal drawing makes a point of contrasting the vertically looming, lucid volume against the dark horizontal

Mies Montage

plane of the street, the two photomontages showing the project from the north (see fig. 4.1) skillfully hide the zone at the foot of the building behind a construction wall plastered with advertisements, as if to stress the contrast between the realm of architecture and the urban everyday. In the photomontage showing the skyscraper from the south, it is a passing car that acts as a visual barrier (see fig. 4.11). Interestingly, the technique of inserting a drawing into a photograph as practiced in all these instances would seem to challenge their qualification as "photomontages" in a technical sense, since they clearly move beyond the use of photography as the sole basis for their composition; however, the juxtaposition of drawing and photograph in fact enhances the dialectical juxtaposition of reality and vision, and the polemics thus implied. The Friedrichstraße skyscraper thus becomes an inaccessible manifestation, a phantom that seems to float, disconnected, above the urban chaos. It is a sacred apparition rising out of profanity, "a clearing of implacable silence in the chaos of the nervous metropolis."[46] The lack of any continuity between the sanctuary of art and architecture and the banalities of everyday life appears to be a key concept of Mies's architectural thinking. Thus, his project for the remodeling of the Alexanderplatz in Berlin (1928) is located within its specific urban context, but any communication between the two spheres is denied–most dramatically, in the foreground, where Mies's design clashes with the existing urban fabric (fig. 4.16). The dialectical juxtaposition of photograph and drawn elements is similar to that in the Friedrichstraße images. As has been pointed out by others, this photomontage forms a counterpart to Ludwig Hilberseimer's scheme for the Friedrichstadt district dating from the same year, which the architect presented in the form of a photomontage showing a complex

Fig. 4.18 Mies van der Rohe, Armour Institute (now Illinois Institute of Technology) campus, Chicago, 1947. Photomontage. The Museum of Modern Art, New York.

of office and commercial slab buildings superimposed onto an aerial view of central Berlin (fig. 4.17). Mies's project resulted from an invited competition by Berlin's city planner, Martin Wagner, for the reconstruction of the Alexanderplatz. Wagner's brief asked for projects that would produce a Sittesque closed square with rounded street walls, but Mies ignored this requirement and proposed an open square loosely defined by rectangular slab buildings. Even though Mies's project was disqualified, Hilberseimer defended it precisely for its openness, and submitted his own project of parallel rows of superblocks for the vicinity of the Schauspielhaus.[47] Hilberseimer's photomontage is obviously informed by Mies's earlier submission but radicalizes the architectural language by enforcing the qualities of monotony and repetition of the linear structures.

Mies's montage attitude becomes even more outspoken in his master plan for the Campus of the Armour Institute (1947) in Chicago (fig. 4.18), where the entire site seems elevated on a pedestal—in a fashion that in turn seems indebted to Hilberseimer's proposition from the late 1920s. The relationship of all these projects and buildings to their context consists in "being at odds with it," which again applies to the representational technique as well.[48] In all these instances, the full meaning of Mies's architecture only reveals itself in the dialectical contrast brought about by montage. Mies's montages take a stand against the image of the chaos of the metropolis. His aim is, by importing the logic of photomontage into real urban space, to introduce zones of transcendental detachment. This urbanist ideal would have been unthinkable without his encounter with the Dadaist aesthetics and politics of montage. His transition from an early integrative aesthetics to a dialectical conception of the image in his avant-garde work of the 1920s can only be plausibly explained with this encounter. Through this fundamental epistemological rift, Mies anticipated the fractured postwar image of the metropolis. Mies provided apologists of an urban collage/montage aesthetic a visual tool that enabled an understanding of the historically determined ruptures within contemporary cities—not as haphazard manifestations of irreversible historical processes, but rather as the site of an aesthetic tension in the manner of a palimpsest that could be made productive for architectural and urban design.

A CINEMATIC CONCEPT OF MONTAGE

Filmmakers and film theorists were also strongly involved throughout the early 1920s in developing montage as an aesthetic principle and as an instrument for the production of visual meaning. In turn, early film and film theory had a widespread impact on artistic practice, and not least architecture. Given Mies's associations with the German film avant-garde of the 1920s, it seems that his continued interest in the visual possibilities offered by the new medium is reflected not only in his architectural representations, but in his architectural thinking generally.[49] The influence of

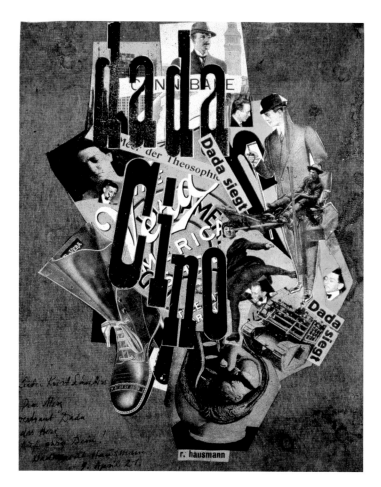

Fig. 4.19 Raoul Hausmann, *Dada im gewöhnlichen Leben (Dada Cino)* (*Dada in Everyday Life [Dada Cino]*), 1920. Photomontage, 12½ × 8⅞ in. (31.7 × 22.5 cm). Private collection, Switzerland.

cinematic concepts of the image on the Berlin Dada group in particular is evident in an early text by Raoul Hausmann entitled "Synthetisches Cino der Malerei" ("Synthetic Cinema of Painting") from 1918, as well as the (now lost) photomontage *Dada im gewöhnlichen Leben (Dada Cino)* (*Dada in Everyday Life [Dada Cino]*), supposedly the artist's first photomontage, a kind of static cinema (fig. 4.19). In the manner of its announcement, the image seems to imply that artistic experimentation with photomontage was decisively informed by the confrontation with the new filmic medium. Sergei Eisenstein credited Hollywood director David Wark Griffith with having been the first to consistently explore the potential of cinematic montage.[50] Cinematic montage not only disrupts the continuous flow of cinematic narration; it also destroys the notion of a homogenous filmic space and replaces it with a faceted and discontinuous conception of space. Whereas a nascent Hollywood employed montage as a mere technical device for the production of film, Eisenstein, Dziga Vertov, and other early Soviet film-makers saw it as an epistemological device for the production of meaning.[51] The theories of Eisenstein are particularly relevant in terms of their relationship to architecture. As will be discussed, Eisenstein worked on a text

in the late 1930s titled "Montage and Architecture," which was to have been included in a book-length study on montage that was never published. In this essay, Eisenstein sketches a teleological model of history in which film is considered the logical continuation of historical media such as painting. Importantly, he considers architecture and urbanism the true predecessors of film, calling the Acropolis in Athens "the perfect example of one of the most ancient films."[52] In his text, Eisenstein isolates "sequence" and "montage" as the two essential characteristics of film, the presence of both of which he (somewhat inconsistently) also discerns in architecture. However, in this relatively late contribution to architectural montage, he largely suppresses the aspect of dialectical juxtaposition, instead stressing the sequentiality of the "moving image" in architecture and film.[53] These considerations converge widely with the spatial theories of Le Corbusier, and in particular with the latter's notion of the architectural promenade. It is hardly thinkable that Mies would not have taken notice of this convergence of architecture and film around 1920, especially given his artistic and intellectual milieu at the time.

Although his definition of montage in "Montage and Architecture" is rather undialectical, Eisenstein developed a different understanding of montage elsewhere that was more in line with the Berlin Dadaists. In his 1942 book, *The Film Sense*, Eisenstein describes the nature of montage as "the fact that two film pieces of any kind, placed together, inevitably combine into a new concept, a new quality, arising out of that juxtaposition."[54] Contrary to the conventional "continuity editing" of Hollywood cinema, this "intellectual montage," as he calls it, causes the spectator to mentally combine seemingly unrelated images in a sequence whose meaning goes beyond the sum of the individual images employed. Meaning, in other words, unfolds from context.

The most relevant aspect of Eisenstein's writings in relation to Mies and to avant-garde art and architecture in general is not so much his groundbreaking contribution to the definition of film as an autonomous art form, but rather his fundamental rethinking of the very idea of the image. Eisenstein developed his theory of the image under the heading of "cinematism," a term that mirrored his search for the proto-cinematic in art and architecture.

The question remains open if and in what ways Mies's photomontages reveal his preoccupation with a cinematic understanding of the image. Phyllis Lambert has argued that his habit of producing a series of photomontages of a single design from different viewpoints can be seen as a cinematic approach to space, since it implies movement and sequential perception and, consequently, the "montage" of individual visual impressions into a coherent image in the mind of the viewer. Several of Mies's photomontages indeed seem to imply a strong sense for sequential movement—most importantly, his Friedrichstraße depictions, in which he chooses a variety

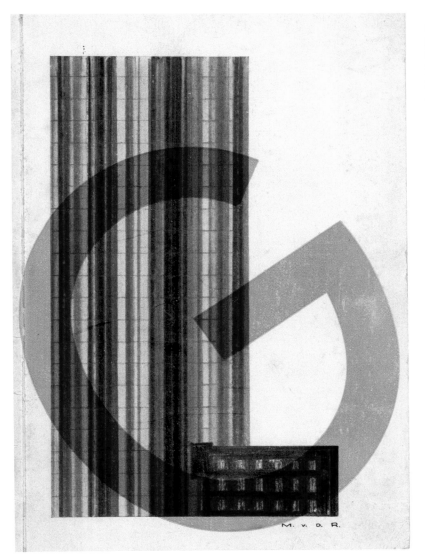

Fig. 4.20 Cover of the journal G, no. 3 (1924), with a drawing of Mies van der Rohe's glass skyscraper project. The Museum of Modern Art, New York.

of perspectives from different directions. However, there are no indications that Mies would have concerned himself with the montage theories of Eisenstein or other authors, should they even have been available to him at this early stage. Conversely, film scholar François Albera has drawn attention to the fact that Eisenstein was very much aware of the Berlin experiments with glass skyscrapers from the early 1920s and most probably knew Mies's projects.[55]

Whatever Mies's relationship to Soviet film theory may have been, there is no doubt that he took a keen interest in the avant-garde film experiments of his contemporaries. This is evidenced mainly by his close association with the artist and filmmaker Hans Richter and his colleague and friend Viking Eggeling, who in 1923 cofounded G, one of the leading European avant-garde journals in the 1920s (fig. 4.20).[56] It was mainly inspired by the

Fig. 4.21 Brochure of the
Liga für unabhängigen Film
(German League for Inde-
pendent Film), 1931. Library
of Congress, Washington,
D.C., Mies van der Rohe
papers.

Russian-language journal *Vesc* published by Ilya Ehrenburg and El Lissitzky
in Berlin, who also suggested the title *G*. The journal covered all categories
of creative production, from photography, typography, design, and fashion
to architecture and urban design, but featured trends such as sports or jazz
as well, in line with its founders' belief that modern artistic production was
universal, extending beyond the confines of the traditional disciplines. Mies
contributed both intellectually and financially to the journal from 1923 to
1926, and his studio became one of the main meeting points for the edito-
rial staff during this time. According to Richter's recollections, Mies was not
just any collaborator; rather, "his person, his work and his active collabo-
ration was more indispensable and decisive for *G* than all of the others."[57]
G assembled a group of post- and anti-expressionist artists and intellec-
tuals from various fields, among them figures such as Walter Benjamin,
George Grosz, Raoul Hausmann, Friedrich Kiesler, Tristan Tzara, Hans
Arp, and Ludwig Hilberseimer. Most of them shared a constructivist, anti-
subjectivist approach based on their conviction that art should merge with
science and technology: they considered artistic production as the equiv-
alent of industrial assembly and capitalist production. Mies's contribution
to the third issue of *G,* dating from June 1924, affirmed this productivist
stance, arguing for standardized and industrialized "montage" fabrication
in building construction.[58]

Eggeling and, most of all, Richter, the two champions of early Ger-
man abstract constructivist film, both critically inspired Mies's interest in
the cinema and its conception of space based on montage. In his mem-
oirs, Richter muses on the synesthetic quality of Mies's plans: "The plans
. . . looked indeed not only like Mondrian's or my own drawings, but like
music, just that visual music we were talking about, which we were dis-
cussing, working on and realizing in film. This was not only a plan, this was
a new language—one that seemed to unite our generation."[59] Thus, Rich-

ter understood modern architecture not as an autonomous discipline but as a symptom of a greater concept, manifested as a sort of "visual music" across different fields of contemporary visual culture. His (and Eggeling's) abstract filmic compositions were based on a governing principle that Richter called "rhythm" (*Rhythmus*)—a principle that, as Gilles Deleuze points out, fundamentally differed from Eisenstein's dialectic conception of montage.[60] Richter characterized rhythm as "articulated time," which he saw as "the elemental quality of film and its inner structure." This is another version of the sequential understanding of film as an art that realizes itself in temporal succession. However, at a later time Richter also made it clear that he considered dialectical montage as proposed by Lev Kuleshov and Eisenstein to be a further, indeed *decisive* step in the development of film, which transcended the notion of mere musical rhythm.[61] If this theorization of cinematic aesthetics did not directly link up with Mies's preoccupation with montage, Richter's effort toward a conception of a time-based sequential image certainly did. Needless to say, "rhythm" was a key word in German architectural theory and aesthetics around 1900, helping to establish space as a leading category in the theorization of architecture. From this it can be concluded that the conceptions of space in filmic and architectural avant-gardes of the 1920s were both to a substantial degree informed by the aesthetic theories of the period around 1900.

A final confirmation of Mies's affinity to film and the cinematic is evidenced by his role as a board member of the Liga für unabhängigen Film (German League for Independent Film) (fig. 4.21). Hans Richter had founded the Gesellschaft "Neuer Film" (New Film Society) as early as 1926–27 together with Guido Bagier and Karl Freund. Its programmatic aim was to advocate experimental film that explored the artistic possibilities of the medium, rather than playing to a mass audience.[62] The society was short-lived. But through this initiative Richter was able to participate in the first International Conference of International Film (CICI) at the castle of Hélène de Mandrot in La Sarraz, where he met Eisenstein personally. (This was the same place where the first International Congress of Modern Architecture [CIAM] took place a year before.) In 1930 Eisenstein, together with the lawyer Otto Blumenthal (Bental), founded the German League for Independent Film, which had more openly controversial aims: "Against the taste dictate of the corporations! . . . Against the subjugation of artistic creation to open or disguised censorship! For artistic, independent film as an expression of the time! For a straight representation of reality! For the absolute freedom of word and image!"[63] The rhetoric in favor of artistic freedom and experimentation was as strong as the commitment to political engagement. The league's program consisted mainly of Sunday morning screenings at the Rote Mühle theater on Berlin's Kurfürstendamm. In addition to experimental film, politically controversial movies were also shown, such as Kenneth Macpherson's 1929 film *Borderline,* which (also using experimental means) discussed questions of race and sexuality. However, the league

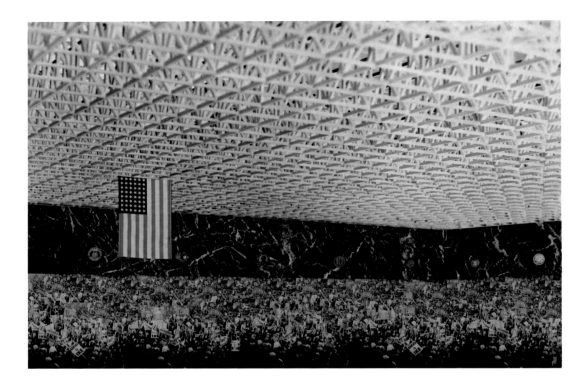

Fig. 4.22 Ludwig Mies van der Rohe, Convention Hall, Chicago project, 1954. Photomontage. Delineator: Edward Duckett, MvdR office. The Museum of Modern Art, New York.

would also only survive for a short while, becoming inactive after Richter left Germany in 1931. Mies's participation in the league confirms his continuing interest not only in cinema and its heterotopic, montage-based spatiality, but also in the aesthetic and political aims of the avant-garde. The political opportunism he demonstrated in the 1930s completes the image of a complex, ambiguous, and sometimes contradictory personality, which earned him the soubriquet "the Talleyrand of modern architecture."[64]

THE POLITICS OF PHOTOMONTAGE (AGAIN)

We have seen that photomontage always had a polemical potential, and that its dialectical structure invited its use for political aims. If Mies van der Rohe's experimentation with photomontage can be understood as a way to come to terms with the problem of architectural representation in the age of technological reproducibility—of the consequences of Fordism both for construction and the production of images—it was also deeply, even though perhaps latently, tied in with political debates. The Dadaist impulse that is so distinctly present in Mies's early photomontages of the 1920s underscores his revolutionary and utopian tendencies in that period. Conversely, Neil Levine has convincingly demonstrated how the architect's photomontages of his second, American career can be read as symbolic representations of a changed understanding of the role of architecture vis-à-vis postwar American society and the so-called "military-industrial complex," and also as artifacts documenting the personal experience of exile

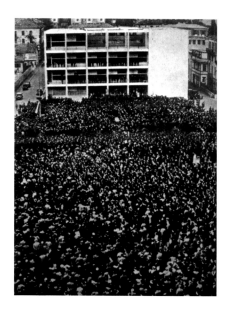

Fig. 4.23 Assembly in front of the headquarters of the Fascist Party, Como, 1936 (architect: Giuseppe Terragni). Photomontage. This image was retouched by Terragni and Pietro Bardi for its publication in *Quadrante* 35/36 (1936), which was a special issue on the Casa del Fascio. The photograph on which the photomontage was based was taken on 5 May 1936 during a rally for the victory in Abissinia.

and loss that became so emblematic for an entire generation of (German) architects.[65] It is this assertion that I would like to take up and expand in order to discuss the impact of photomontage on the architecture culture of the mid-twentieth century, in the context of which Mies's idea of architecture had moved from the avant-garde fringe to the hegemonic position of the Pax Americana. One of the better-known photomontages of Mies's American career shows an interior perspective of his unexecuted project for the Chicago Convention Hall from 1954 (fig. 4.22). Like the majority of the montages/collages of the American period, this image was produced by one of Mies's students or collaborators in the Chicago office, in this case Edward Duckett. It may be argued that this fact complicates any clear statement as to the work's implications for Mies's architectural thinking. However, Mies frequently used these images in publications, indicating that they were indeed representative of his architectural ideas. It is therefore legitimate to claim Mies's conceptual authorship for all the works to be discussed, irrespective of whether he was directly involved in their material production, especially since "authorship" in a collective practice such as architecture is a contested idea in any case.

The Chicago Convention Hall photomontage represents an interior space and is indicative of Mies's postwar obsession with the creation of this kind of unitary space. The montage is divided into three horizontal strata, almost in the fashion of an abstract painting. It epitomizes Mies's understanding of modern architecture: we see a vast interior space entirely free of supporting columns, typical for Mies's ideal conception of modern space as an expansive continuum. A built example of such a generic space would be the Neue Nationalgalerie in Berlin, Mies's last executed project during his lifetime. In order to achieve this kind of space, Mies relegated the steel construction that supports the building to its exterior. The open

and undefined interior space thus becomes completely flexible and adaptable to a multitude of uses. As will be discussed, it is what has been called an "event space."[66] As much as it is modernist, this kind of space is proto-postmodernist: by inviting its users to participate in the definition of the space, it becomes a performative architecture. As such, the Neue Nationalgalerie would be a predecessor of buildings such as the Centre Pompidou in Paris, built by Renzo Piano and Richard Rogers in the late 1970s. In contrast to the Nationalgalerie, the Pompidou displays an expressive, high-tech attitude in that it visually celebrates and exaggerates the structural elements of the construction. But here, too, the structural supports are transferred to the building's exterior in order to generate, in the interior, a completely open, generic space that can be defined entirely by its users. In architectural history, this type of space is usually considered a consequence of the architectural ideas of the British architect Cedric Price—in particular the "Fun Palace Project"—for whose bold visualizations its author also made frequent use of photomontage. The Convention Hall image makes clear that the notion of a vast, generic space open for collective activity is present in Mies's high modernist architectural thinking of the 1950s, which is generally thought of as ideally embodying the capitalist logic of corporate America.

The upper part of the Convention Hall photomontage is taken up by the model photo of the imposing roof structure that would make this kind of vast open space possible. Underneath, we see a zone clad in green marble—Mies used *verde antico* and marble from the island of Tinos—which is typical of the architect's predilection for luxurious materials and recalls many of his buildings from the 1929 Barcelona Pavilion onward. Finally, the lower third of the montage shows a large crowd of people. For this section, the architect used reproductions of a photograph from the Republican Party Convention held in Chicago in 1952, an image he had seen in *Life* magazine.[67] Here Mies juxtaposes the textures of the different surfaces: the chaos of the crowd contrasts with the roof's rigidly organized structure. Architecture, the montage seems to imply, gives order and structure to the society that it shelters. The irregular materiality of the marble wall mediates in this configuration: like the roof, it belongs to the realm of the inanimate, but its irregularity resonates with the crowd's unruliness. It is as if the multitude animates the wall, bringing the building from being an abstract and distanced object into being involved in the political process.[68]

Finally, the fourth element of the montage—the American flag hanging down from the ceiling—reinforces the patriotic flavor of the image. This is a cheap miniature plastic flag that Mies/Duckett included in the manner of the Dada collages. While being a "representation" of a flag, it is at the same time also a "real" object—its ontological status oscillates between the thing and its image, as its inclusion unsettles the work's status as a pure montage. The flag functions as a national symbol without making any substantive political statement. It brings to mind Jasper Johns's series of American flag paintings in encaustic, which Johns began the same year that Mies pro-

duced his photomontage.[69] For both artists the flag is a ready-made. However, for Johns the flag is the artistic and representational problem, whereas in the case of Mies, it functions to fix or perform the meaning of the space.

Within the crowd, the same motifs appear several times. (This is most evident in the "IKE" posters held by participants of the rally.)[70] Mies/Duckett thus appropriated an image from the popular media but continued to further manipulate and reproduce it. In this way they make what is depicted function symbolically rather than representing any particular historical or political event. What makes this photomontage so emblematic for postwar American architecture culture is its double reference to both industrialized building technology (as exemplified by the roof structure) and mass culture (as exemplified by the crowd). But it seems significant, too, that Mies uses the technique of photomontage to illustrate this synthesis. In the afterword of "Das Kunstwerk im Zeitalter seiner technischen Reproduzierbarkeit" ("The Work of Art in the Age of Its Technological Reproducibility"), written in the mid-1930s, Walter Benjamin famously summed up the political situation in fascist Europe as an "aestheticization of politics," which he saw as a consequence of the manipulation of reproductive media such as photography and film by the political powers.[71] Needless to say, the photomontage of the Chicago Convention Hall was produced in a new historical and political setting, the Pax Americana of the early 1950s. But its combination of advanced building technology, modern architectural aesthetics, and a mass audience under the auspices of politics brings to mind another famous photomontage that dates to the years in which Benjamin wrote his essay. It shows a political rally in front of Giuseppe Terragni's masterpiece, the Casa del Fascio, headquarters of the Fascist Party in the city of Como (fig. 4.23). Like Mies van der Rohe's image, this photomontage displays a large crowd on the occasion of a political demonstration together with an icon of modern architecture. Photomontage was again used in connection with the Casa del Fascio by artist Marcello Nizzoli, who was commissioned by Terragni to devise propagandistic mural decorations for the surface of the front façade. Nizzoli presented his design—which included a large-scale photo portrait of Il Duce—in the form of a photomontage, but the scheme was eventually rejected.[72] This is precisely the "aestheticization of politics" that Benjamin had in mind. Is modern architecture thus a medium in the service of state propaganda? Or is Mies coming to the rescue of modern architecture by showing that it does not simply stand on the side of institutional power, but actually gives space to the free political expression of a multitude? Mies was painfully aware of modern architecture's entanglement with totalitarian power, and his photomontage visually acknowledges modern architecture's dilemma between affirmation and critique. From a more distanced perspective, the pair of images also tells the story of a formerly avant-garde revolutionary form of artistic expression (namely, photomontage) in its transition into totalitarian propaganda, and from there to fairly common (and commercial) use in postwar consumer society.[73]

Similar implications are apparent in another photomontage by Mies from 1941–42 (fig. 4.24). This depiction also shows a large interior space, which this time is a mere shelter for the architect's conceptual project for a concert hall in the foreground. The structure shown here is not one of Mies's own buildings; it is the interior of an aircraft plant by the industrial architect Albert Kahn. Here, the bombers that would fly air strikes against Nazi Germany were assembled.[74] Again, Mies uses politically charged imagery. But he makes sure that any trace of the original purpose of the assembly hall is carefully deleted from his representation, as if to make space for oblivion, as his importation of the concert hall repurposes the space for another, peaceful assembly. Beyond that, his use of photomontage is a visual reflection of the status of architecture in advanced industrialization. As we have seen, photomontage, defined by the re-assembly of (mechanically reproduced) photographic material, is related to the mass production of the assembly line and therefore the adequate means to depict the space of industrialized society. However, the political implications of the underlying photograph point toward the dilemma of modernity: the photomontage seems both to celebrate technological process brought about by industrial production and to recall the destructive potential released by the machinery of what President Dwight D. Eisenhower called the "military-industrial complex." Moreover, it is significant that the depiction is not a photomontage proper but uses collaged elements in the forms of the concert hall. During and after the war and the devastation of technologized culture, the collage/bricolage aesthetic called for a return to raw or non-technological materials, to a "humanized" vision of production. The figure is positioned where the audience would sit, and its seated posture also suggests it is representing the concert audience. It is naked and vulnerable. In this way, the concert hall structure seems to be sheltering the figure from the military-industrial structure above it. As a comment on modernity's inhumane implications, this figure, a work by the French sculptor Aristide Maillol that was later pasted over by the figure of an ancient Egyptian scribe, provides a dialectically anthropomorphic counterpoint to the geometric incarnation of the military-industrial complex in the relentless steel structure of the roof. If the image of the enormous assembly hall inspires in the observer what has been called "the industrial sublime," the pensive melancholy of the sculpture in the foreground calls this into question.

Mies van der Rohe's understanding of photomontage is thus political in a double sense. On the one hand, he credits industrialization for the genesis of a new kind of interior space, though at the same time he reminds us that this space is only possible because of architecture's participation in the alliance of technology and politics. On the other hand, the medium of photomontage is itself based on an advanced technology of reproducibility. For this reason, a softened or modified photomontage is the adequate medium to represent this specific historical and political situation in which architecture in the United States finds itself in this historical moment, stepping backward from the industrial carnage of the late 1930s and early 1940s.

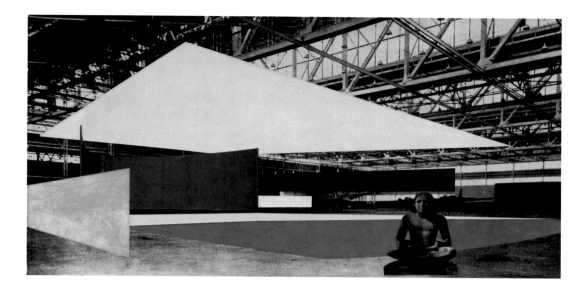

It should be noted that the two works discussed in some detail here introduce "real" objects into the depiction and thereby feature a haptic dimension foreign to the photomontages of the Weimar period. This is particularly evident in the Concert Hall project, where the projected pavilion is described through the insertion of elements of colored paper onto a photograph. For this reason, as discussed at the outset of this chapter, it would seem appropriate to characterize this work as a photocollage. Still political in nature, the depiction illustrates the critical moment when an epistemological principle becomes a mere aesthetic technique. This tendency will become more and more dominant, illustrating the gradual consumption of the tenets of the avant-garde through the forces of postwar capitalism. In the context of the ongoing war, the replacement of montage through collage also points to the disillusionment with what the avant-garde has (not) been able to accomplish. The shock aesthetic has worn out at this point.

Fig. 4.24 Ludwig Mies van der Rohe, Concert Hall Project (interior perspective), 1942. Collage (graphite, cut-and-pasted reproduction of ancient Egyptian scribe [pasted by Mary Callery], cut-and-pasted papers, cut-and-pasted painted paper, and gouache on gelatin silver print of a photograph of Albert Kahn, Glenn L. Martin Assembly Building, Baltimore, 1937–39, on illustration board), 29½ × 62 in. (75 × 157.5 cm). The Museum of Modern Art, New York.

WINDOWS

Against the montages for the Convention Center and the Concert Hall, the photomontages Mies produced for the private vacation house of the Resors in rural Jackson Hole, Wyoming, again show marked differences (figs. 4.25; see figs. 4.28, 4.29). This is a private interior in a rural setting. Although unexecuted, the Resor House project holds a special place in Mies van der Rohe's oeuvre. It was his first American commission after leaving Nazi Germany in 1938. Mies received it with the help of Alfred Barr from the Museum of Modern Art in New York, who recommended the architect to Helen Resor, one of the museum's trustees. Mies was hired to complete a project already begun by the Boston architect Marc Peter, but the building was never completed due to financial difficulties on the part of the clients. It becomes increasingly precarious to qualify this image as a "photomontage."

What we have here is essentially an inversion of the old technique of the drawing inserted into a photograph—here, a photograph of a landscape is now inserted into an architectural drawing.[75] The first piece shows a view from the prospective interior space at an elevated perspective above a river, onto the surrounding mountain landscape. This space is only defined by the large horizontal window in the background and two cruciform columns in the foreground. Its sole purpose seems to be to frame the imposing landscape. The wall has been transformed into a window; the former domain of opacity is replaced by transparency.[76] Against the all-encompassing panorama of a sublime landscape, the architectural design is reduced to an almost invisible perceptual device, a few lines forming the merest indication of spatial confinement. It is as if we, the observers, were standing inside a camera and looking out. The primary purpose of the architecture seems to be to frame the view.

If Mies's architecture can be likened to a stage upon which an architectural idea is performed, then the Resor House marks the point at which the viewer, formerly kept at a distance, is allowed to enter the stage and become an actor.[77] It is notable, in this regard, that Vitruvius in *De architec-*

tura appears to refer to the scenography of ancient drama as an early form of a system of perspective.[78] The most stringent application of perspective to architecture can be found in Renaissance stage sets such as in Sebastiano Serlio's famous stage prospects (fig. 4.26). Mies's drawing not only implicitly refers to this theory of the birth of perspective out of the spirit of scenography; it also decisively affirms the notion of architecture as a stage. His insistence on conical perspective and his refusal to visualize his architecture through other techniques such as the axonometric underscores his understanding of architecture as primarily a visual medium perceived by the eye and not by a mobile body, further indicative of a conception of space that is static rather than "flowing." As architecture becomes a frame for a scenic outlook, the latter takes on the visual quality of an image; exterior space is reduced to a two-dimensional surface. As with the linear perspective of early modernity, the ultimate goal is to construct a mechanism that suggests virtual depth. The minimalist tropes and the rhetoric of abstraction should not distract us from the fact that Mies's American drawings and photocollages of interiors are transformations of the gaze afforded to the viewer in nineteenth-century panoramas and dioramas—popular devices of forget-

Fig. 4.25 Ludwig Mies van der Rohe, Resor House, Jackson Hole, Wyoming (interior view looking north), 1937–41. Photocollage. The Museum of Modern Art, New York.

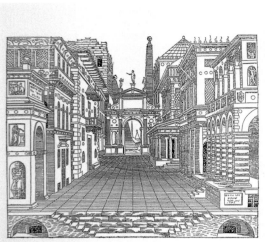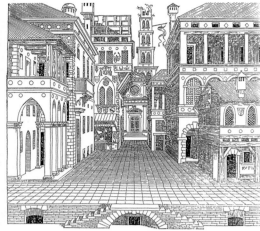

Fig. 4.26 Sebastiano Serlio, *Tragic and Comic Scenes,* 1545. Woodcuts.

ting and illusion that similarly combine an illusionist representation of a scene with the reassurance of being placed in the calm eye of the storm, beyond time and history (fig. 4.27). The symmetrical sectioning of the exterior view by means of the interior columns only reaffirms the effect of stasis. As if to enforce this aestheticizing transformation of exterior space into a panoramic vista, the landscape shown in one of the Resor photocollages has nothing to do with the environment *in situ,* but rather was cut from a movie poster—which further illustrates Mies's interest in the cinema as a device for projecting an illusionistic space (fig. 4.28). Again, what we have here is essentially an architectural drawing with the insert of a reproduced landscape photograph, a painting by Paul Klee, and a reproduction of wood veneer, qualifying the work as a photocollage. Nowhere is the claustrophobic effect of Mies's interior spaces more evident than in this visualization, which denies any release through a visible horizon line. In Mies's architecture, the "vertigo of universal extension" is, as Robin Evans notes, counterbalanced by the "claustrophobia of living in a crack." Only two conclusions seem possible: we find ourselves either masters of the totalizing gaze in the center of the panopticon, or unconscious victims of an escapist dream. While some have seen the "silent theatre of the world" staged in Mies's architecture as a fundamental critique of capitalist consumer culture and its impact on the architectural profession, these observations make it clear that Mies's architecture is really precisely the opposite: it is an architecture of forgetting.[79]

The Resor House photocollage is a striking example of how image and space are interrelated in Mies van der Rohe's architectural thinking. We have already seen that the architecture is reduced to the slightest indication of a structural system. In this way, the collage is a radical incarnation of the architect's motto, "less is more"; it is indeed what Mies called an architecture of "almost nothing." But the real problem addressed in this image and the previous one is obviously not the treatment and character of interior

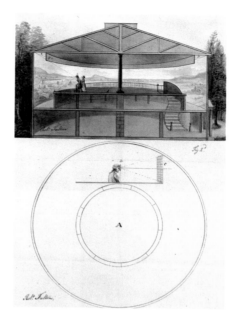

Fig. 4.27 Robert Fulton,
First design for a
panorama-rotunda
with viewing platform,
1799.

space; it is the relationship between interior and exterior space, or, more
specifically, the way the landscape becomes an integral—in fact dominant—
part of the architectural design. It is significant that the interior perspec-
tive looking north out of the living room of the Resor House exists in two
versions. In the first, preliminary version (see fig. 4.25), the main features
of the mountain landscape are the creek that runs through the middle of
the photograph, the scattered trees, the wood cabins, the bridge, and other
traces of human habitation and activity, all of which are surrounded by a
mountain chain in the hazy, distant background. The second version of the
drawing shows a dramatically altered scene (fig. 4.29). The view of the site
has been replaced with an aestheticized view of the distant Grand Teton
range. The representation leaves out almost any trace of human activity,
reduces the foreground to a minimum, and pushes the horizon line to the
upper edge of the image. If the scenery in the preliminary image evokes the
picturesque, this image recalls the sublime.

It would seem that the notion of distance is fundamental for the way
Mies treats the exterior in this second visualization, and I would argue that
this treatment of nature is characteristic for late modern civilization and
its discontents. Distance implies detachment (from life) and powerlessness
to engage beyond mere observing. It is the aestheticization of the world in
the renunciation from politics. It is the condition that Max Horkheimer and
Theodor W. Adorno have famously described through their reading of the
myth of Odysseus and the Sirens for the society of late capitalism in their
Dialektik der Aufklärung (*Dialectic of Enlightenment*): the separation of aes-
thetic experience from practical life, with the ultimate autonomy of both
(for while Odysseus is tied to the mast and exposed to the Sirens' beguiling
song, the oarsmen steer the ship with plugged ears).[80]

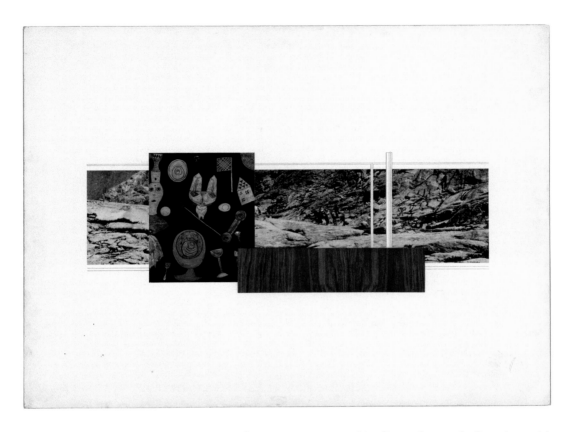

Fig. 4.28 Ludwig Mies van
der Rohe, Resor House,
Jackson Hole, Wyoming
(interior view looking south),
1937–41. Photocollage.
Delineators: George
Danforth and William
Priestly, MvdR office. The
Museum of Modern Art,
New York.

The Resor drawings represent this discomfort and alienation with respect not to the modern metropolis and all that it entails, but to nature—which itself was increasingly a cultural fabrication of an urbanized society. Already in 1976, Manfredo Tafuri postulated exactly this, arguing that in Mies's houses "nature was made part of the furnishings, a spectacle to be enjoyed only on condition that it be kept impalpably remote," a "distant spectacle" that was "easily replaced by a photomontage." It should not be forgotten that the clients for this house, the Resors, were not only trustees of the Museum of Modern Art, but perfect representatives of an affluent and rapidly urbanized American society whose members increasingly saw nature not primarily as an economic resource, but as a site for recreation and leisure.[81] In this sense, the Resor House images, although rural in character, represent that flip side of the age and logic of the metropolis. Grand Teton National Park, which the Resor House was to be situated near, became protected in 1929, leading to the rapid touristic exploitation of the area. At the moment of its conversion into preserved parkland, nature is no longer the environment in which we unconsciously, "naturally" live and operate, in a romantic understanding. Nor is it the wild and untamed "other" that has to be feared, subjugated, and domesticized. Despite or precisely because of its threatening otherness, it has become the subject of aesthetic consumption, an image of itself. One cannot help thinking of the famous panorama window in Hitler's contemporary mountain retreat, the

Mies Montage

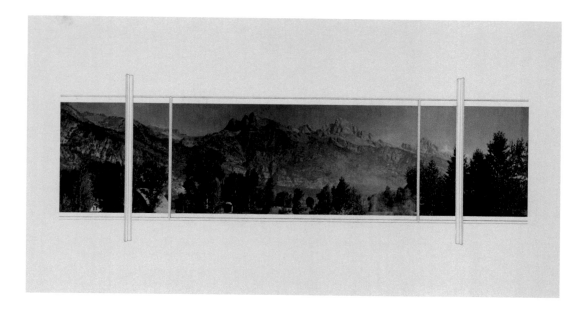

Fig. 4.29 Ludwig Mies van der Rohe, Resor House, Jackson Hole, Wyoming (interior), 1937–41. Photocollage. The Museum of Modern Art, New York.

"Berghof" in the Obersalzberg near Berchtesgaden: the sublime mountain landscape is anything but politically innocent. The sublime is the tool for suppression (fig. 4.30).[82]

Mies's drawings delete the foreground and, thus, any indication of spatial depth. This results in an impression of flatness and depthlessness, almost as if we were looking at wallpaper rather than a prospect onto the landscape. This impression of flatness is further underscored by the architect's choice of symmetrical frontal perspective, so that the outlook window is parallel to the image plane. Mies van der Rohe's architecture has generally been associated with dynamic, "flowing space" and with what ensues from it, the blurring of interior and exterior space (although postmodern critique has radically questioned that assertion).[83] What we find here is quite the opposite: the frontal perspective does not suggest a mobile, dynamic spectator, but rather a monocular, static one. Interior and exterior spaces are not conceived of as being part of a continuum, but are represented as clearly distinct realms. They are connected visually—in the sense of a framed, static outlook—but disconnected spatially. The spectator is relegated to the position of a passive viewer, like the consumer in front of a Hollywood film screen.

The alienation from nature is further enforced by the tripartite division of the panoramic window so that the drawing resembles a triptych, an art form associated with medieval Christian altarpieces and traditionally reserved for sacred subjects. (If this comparison with medieval art seems far-fetched, it should be pointed out that Mies grew up the son of a stonemason in the city of Aachen, one of the centers of the Catholic world north of the Alps, and that his thinking continued to be informed by Catholic philosophy and in particular by the writings of Romano Guardini throughout his life.)[84] If Mies appropriates such a sacred representational convention,

Fig. 4.30 View of the window of the Great Hall in Hitler's mountain retreat, the Berghof, c. 1936, from *Life* (30 October 1939). Photo by Heinrich Hoffmann.

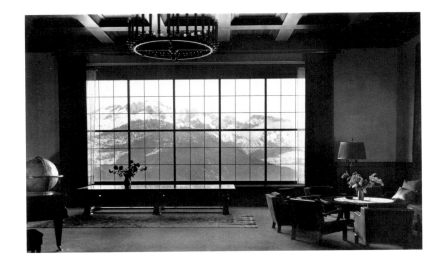

it is to underscore the "sacred" character of the depicted—namely the sublime landscape. The framed outlook takes on the character of an "icon" in the religious sense—it achieves an auratic presence, but a presence paradoxically marked by inaccessibility and absence.[85] The unspoiled Alpine landscape, seemingly untouched by human activity and outside human measures of time and history, takes on a transcendental meaning. Nature has become the subject of sacralization by means of aesthetic distancing.

The architectural motif of the panoramic window is responsible for this effect. In establishing an "aesthetic barrier" between the realm of the observer and a transcending other, the window is closely related to the picture frame, with regard to both its format and its function. It becomes a screen, a "medium."[86] This similarity has been theorized by a number of thinkers. Here is a brief passage from José Ortega y Gasset's seminal text "Meditación del Marco" (1943; "Meditations on the Frame"): "The frame . . . has something of the window about it, just as the window is a lot like a frame. The painted canvases are portholes of ideality which are perforated in the mute reality of the walls. They are openings of illusion into which we can peer, thanks to the beneficent 'window,' the frame. On the other hand, a corner of the city or countryside, seen through the square outlines of the window, seems to split off from reality and acquire a strange palpitation of the ideal."[87] It could be objected that such a reading is unspecific, for obviously (as we know from everyday experience) by no means every window in a real building has this quality of constructing an ideal, transcendent, spatial other beyond the confines of the building. Nor does Ortega y Gasset claim that this is the case. Mies van der Rohe's photocollage achieves this quality not only by the means already discussed, but also by defining the window as primarily a viewing device. In everyday experience, windows have at least two other defining qualities as well: they let in light, and they provide fresh air (notwithstanding modern technical inventions such as the air conditioner and the concomitant un-openable office window). These

fundamental functions of a window are downplayed in Mies's drawings, and the emphasis is uniquely on the window as a visual mediation between interior and exterior spaces. (It could be said that the interior becomes a means for a window.) The two realms must be kept at a distance at all costs, for it is only the double bind of visual accessibility versus spatial inaccessibility that guarantees the transcendental quality of the landscape. If the observer were allowed to trespass the barrier between the two spheres—if, in other words, the sphere of everyday use were to collapse with that of the idealized other—the domain of the sacred would become profane.

Mies van der Rohe's peculiar use of the window is reminiscent of the French theoretician Gérard Wajcman's proposal to differentiate the "architectural window" (*fenêtre architecturale*) for light and air from the "optical window" (*fenêtre optique*), where the window becomes a scopic apparatus.[88] Referencing Leon Battista Alberti's famous comparison between a painting and a window in his 1435 treatise *De pictura* (*On Painting*), Wajcman argues that in architecture, the window is primarily a functional device, whereas in painting it becomes a metaphor for visuality. However, Mies's use of the architectural elements demonstrates that the architectural window, too, has an "optical," or perhaps better, scopic dimension. The notion of the window as a liminal space between the realms of the private and the public has recently been explored by Georges Teyssot. But the window's peculiar status as both an optical apparatus and a transitory space has been theorized throughout modernity.[89]

Mies's drawing not only illustrates the transformation of nature into an object of aesthetic consumption, a landscape, it also includes a definition of what architecture is. For even though architecture is radically reduced to almost nothing, its existence is nevertheless strongly asserted by the way it is distanced from the space of nature—and from the "atrocities" (to quote Reinhold Martin) of the outside world in general.[90] Both these later visualizations, in their relation to nature, and the early Friedrichstraße project, in its relation to the metropolis, seem to assert that modern architecture is that world's other. Here, it is an apparatus for visually framing and aestheticizing it. But exactly through this distance architecture is defined as something completely detached and alienated. Mies's Villa Tugendhat in Brno, Czech Republic, built between 1928 and 1930, features a large, open living room only interrupted by a series of cruciform columns (fig. 4.31). As in the Resor project, this space is defined by a large, fully glazed façade that allows an outlook over the landscape beyond. Unlike the Resor House, however, the windowpanes of the living room could be lowered into the basement, resulting in an interpenetration of interior and exterior spaces. However, even here the distance between the two spheres is clearly reinforced by the dramatic jump in altitude down to the garden level, marking conceptual incongruity between interior and exterior space, architecture and its other.

The Resor House project stands for a specific moment in Mies van der Rohe's personal biography that would seem to be another moment of crisis

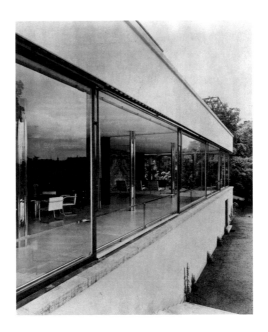

Fig. 4.31 Ludwig Mies van der Rohe, Tugendhat House, Brno, Czech Republic (garden façade), 1930. The Museum of Modern Art, New York.

and reorientation: at the age of 52, Mies was faced with the necessity to leave his home country and to start a new life in a continent completely foreign to him. How much he struggled with the decision is demonstrated by the fact that he did not leave Germany until 1938. This was much later than most of his colleagues and members of the German intelligentsia who were driven into exile after the 1933 Nazi takeover, but it was the same year as the departure of artist and graphic designer Herbert Bayer, whose photomontages for the 1936 Berlin Olympics in the service of Nazi propaganda didn't keep him from pursuing a successful second career in the United States. As the last director of the Bauhaus, Mies had been forced to shut down the institution, but he tried to play along and adapt to the new political conditions for several years. It would seem very plausible that the increasingly hostile political climate had a direct impact on the architect's conception of space. This impact is most clearly evidenced in his series of projects for courtyard houses on which he worked in the mid-1930s (fig. 4.32). Unlike in the Tugendhat House, where the architect to some extent opens his interior to the landscape, the courtyard houses appear from the outside as compact, impenetrable volumes, while inside, their visual axes are directed toward green interior courtyards. In this inward orientation to the private *oikos* and a central opening, the courtyard houses recall the Roman atrium house, evidence of Mies's preoccupation with classical architectural forms and typologies. It may be too simplistic to interpret this turn toward the interior as a reaction to the increasingly hostile political climate, an attempt to provide space for what became known as "inner emigration" for those intellectuals who decided to remain in Germany during the Nazi regime. Nevertheless, Mies's interest in this typology at this historical moment hardly seems coincidental.

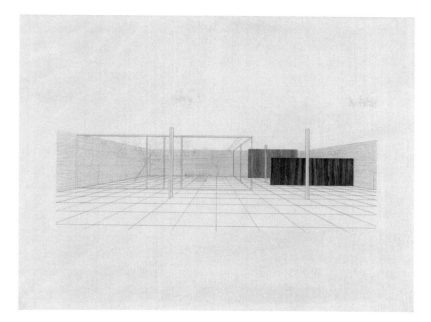

Fig. 4.32 Ludwig Mies
van der Rohe, Row House
with Interior Court project
(interior perspective of
living room toward court),
c. 1938–45. Graphite and
wood veneer on illustration
board, 30 ⅛ × 40 ⅛ in.
(76.5 × 101.9 cm). The
Museum of Modern Art,
New York.

In comparison, the Resor House project at first sight seems character-ized by an emphatic turn outward. But, as already mentioned, the exterior remains spatially sealed off, seemingly flattened to a two-dimensional sur-face. While real space remains inaccessible with the observer trapped in a glass case, its pictorial representation provides space for the imagination. A built example may help to support this argument. In the house for Edith Farnsworth, built between 1945 and 1951 in Plano, Illinois, this dichotomy between interior and exterior space is seemingly resolved (fig. 4.33). The living space is elevated on a slab hovering above the ground. It is accessed indirectly by an intermediary platform. The two levels are connected by a series of steps, thus allowing for a gradual transition from exterior space to the (additionally mediating) terrace, from where the interior of the house can finally be reached. That said, the house remains clearly detached. In one of his rare interviews, Mies significantly discussed the relationship between architecture and nature in this house. Interestingly, in this conversation he makes an explicit point for the interior perspective: "Nature has its own life to lead, too. We should avoid disturbing it with the color of our houses and interior decorations. Yet we should endeavor to merge Nature, houses and man in a higher unity. If you regard Nature through the glass walls of the Farnsworth House, it is given a deeper significance than if you are standing outside. In the first case, more of Nature is expressed—it becomes part of a greater whole."[91]

This statement seems highly significant with regard to the Resor House project as well: according to the architect's point of view, it is precisely the transformation of the real space of nature into its two-dimensional, pictorial representation that gives it what he calls "deeper significance." The depth-lessness of the image, paradoxically, is the prerequisite for substance. This

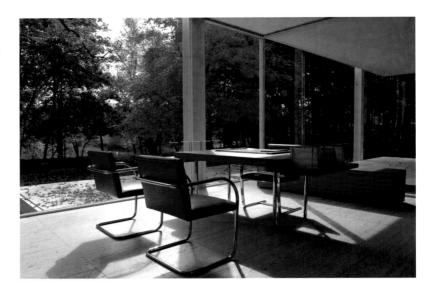

understanding is largely congruent with modernist image theory and in particular with Clement Greenberg's discussion of the flatness of the image with respect to Jackson Pollock. For Greenberg, flatness is a central element of the self-referentiality and radical autonomy of modernist abstract painting. Through the process of deleting any notion of simulated spatial depth from the image, Greenberg argues, abstract art is charged with psychological and emotional depth, driven by the resources of the medium and the opacity of its materiality. As David Joselit has put it, "The expression of *psychological* depth requires the sublimation of *optical* depth."[92]

The framed landscape in the Farnsworth House is neither abstract nor opaque in Greenberg's sense, but quite to the contrary, representational and transparent. But as Mies's statement makes clear, the architect sees the aestheticized, two-dimensional distancing and alienation from the real space of nature as an operation that enables what also becomes possible for the observer of modernist painting: namely, contemplation. Modernist painting and modernist architecture may pursue the same aesthetic aim, but with diametrically opposed means.

Mies's conceptualization of nature as essentially (and ideally) a two-dimensional representation is underscored by his interest in photographic wallpaper. That he was indeed interested in this kind of illusionistic space has been shown by Dietrich Neumann in a study on a so far little-known chapter of the architect's work.[93] Throughout the 1930s, Mies was working together with his then-partner, Lilly Reich, and the photographer Walter Peterhans on the patent for a mechanical apparatus for the production of wallpaper depicting illusionistic landscapes produced through photography (fig. 4.34). Is it too daring to conceive of the Resor interiors as entirely enclosed spaces whose back window does not give onto an exterior space, but rather its illusionistic representation? At the same time, the montage/collage technique underlying the Resor interior perspectives is not just a

means of representation: Mies's executed buildings preserve the effect that the view is compartmentalized into rectangular panels that have been "mounted." In this case, the two-dimensionality of the montage technique, as the positioning of discrete, rectangular areas on a larger sheet, informs what happens in the space that it is being used to conceive. Paradoxically perhaps, this "montage thinking" results in a flattening of the three-dimensional space—rather than imparting the three-dimensional experience of embodied and mobile perception to the two-dimensional sheet. Thus, Mies reverses and internalizes what happens on the modernist transparent façade, whereby the building becomes a screen upon which the surrounding landscape or cityscape is reflected as a two-dimensional image. Photomurals were used to decorate the interior of Mies van der Rohe's German Electricity Pavilion at the World's Fair in Barcelona—the other, far less known of Mies's pavilion buildings there—as early as 1929 (fig. 4.35). While the abstract, nondescript boxy exterior of the pavilion comments on the immaterial labor of the "neo-technical" age of electricity (to use Lewis

Fig. 4.34 Ludwig Mies van der Rohe and Walter Peterhans, Apparatus for the production of dot-composed or screened negatives, U.S. Patent, 1942. The Museum of Modern Art, New York.

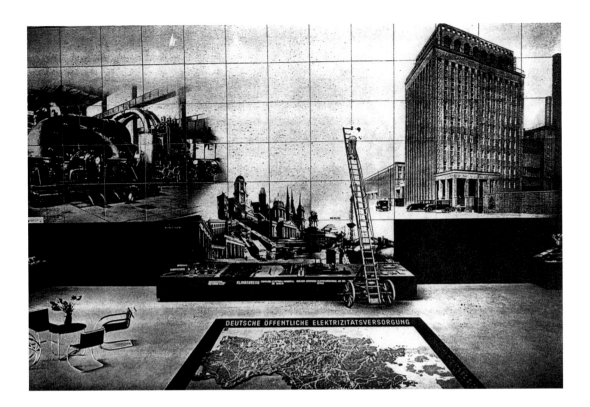

Fig. 4.35 Interior view of
Mies van der Rohe's German
Electricity Pavilion, World's
Fair, Barcelona, 1929. Interior
architecture by Fritz Schüler,
from *Die Linse* (September
1929). Photo by E. Blum.

Mumford's term), the interior design, which was executed by artist Fritz
Schüler, ostensibly draws on nineteenth-century cultures of spectacle such
as panoramas and dioramas and other proto-cinematic devices—except for
the fact that the photomurals are based on montage rather than a contin-
uous visual narration (as one would expect in diorama). It is evident that
here, architecture is not an end in itself, but first and foremost serves as
a container for a pictorial representation. The architect has turned into a
curator or, perhaps, a scenographer. Such illusionistic interior spaces were
a vital part of 1930s American vernacular architecture (fig. 4.36), and pho-
tomurals were also one of the main features of the Museum of Modern Art's
1947 Mies exhibition. Photographic wallpaper is a key to understanding
how Mies conceives of the relationship between image and space, imagi-
nary and real, flatness and depth—and ultimately, architecture and life. The
result, as should be obvious, is neither narrative nor abstract: rather, it is
nature as an image within the interior, an aid to the viewer's contemplative
autonomy. From a modernist perspective, it is interesting to note that Mies
does not seem to object at all to what would commonly be perceived as a
"vulgar" use of nature in a "low" medium (a photographic reproduction);
quite to the contrary, he sees this as the opportunity for deeper meaning.
With the same aim, modernist painting tends toward abstraction and opac-
ity, while modernist architecture, conversely, aims toward representation
and transparency.

Fig. 4.36 "Blossom Room," Huyler's Restaurant, Chicago, 1936, from *Architectural Record* 80, no. 1 (1936): 60. Photo by Drix Duryea.

I would like to conclude my discussion of the window in Mies van der Rohe's architectural and spatial conception with a brief mention of a famous dispute on the ontology of the window in the history of modern architecture. We have seen that in Mies's architecture, the window has basically replaced the wall. This solution is in a certain way a radicalization of the longitudinal window as promoted by Le Corbusier. As part of his seminal "Five Points for a New Architecture," the longitudinal, horizontal window was intended as a polemic against the traditional perforated façade with small openings in an otherwise opaque surface. Indeed, Le Corbusier's polemic led to a notorious dispute between himself and his master, the French rationalist architect Auguste Perret. Perret was of the (classical) opinion that the shape of a window had to reflect the proportions of man and thus be vertical. To justify his panoramic windows, Le Corbusier countered that the human eyes looks horizontally at the landscape (fig. 4.37). Beatriz Colomina has used Le Corbusier's Villa Le Lac on Lake Geneva (1923–24), with its continuous horizontal window looking out onto the lake and the Alpine panorama, to discuss the fundamental visual changes that such a paradigm shift from a vertical to a horizontal window entails: "We imagine a boat going down the lake. Viewed from the *porte-fenêtre* [that is, the vertical window of a traditional house] there would be an ideal moment: the boat appears at the center of the opening directly in line with the gaze into the landscape—as in a classical painting. The boat would then move out of vision. From the *fenêtre en longueur* [that is, the longitudinal window] the boat is continuously shot, and each shot is independently framed."[94] Hence, the horizontal panoramic window produces a series of individual takes, a proto-cinematic sequence of images into which both movement and temporality are inscribed. This is also the fundamental difference between the spatial conception of Mies and Le Corbusier. The latter is obviously interested in a dynamic conception of space, an architecture

Fig. 4.37 Le Corbusier, Villa Le Lac, Corseaux, Switzerland, 1923–24.

that records the passing of time through the continuous horizontal cut of its windows. Mies's use of frontal perspective for his full-height outlook windows, by contrast, produces an impression of stasis and eternity, a position outside time and history.

LAYERING SPACE

Perhaps the most striking feature of Mies's photocollages and augmented drawings of this period is their layering. His use of linear perspective is not an end in itself, but a means to arrange flat pictorial surfaces one behind the other in parallel. The earliest instance of such a conception of (interior) space goes back, again, to perspectival drawings with photographic inserts executed for the courtyard house studies of 1934–35 (see fig. 4.32) and to drawings for the Ulrich Lange House in Krefeld. As opposed to the persistent rhetoric of flowing space, this space does not extend outward, beyond the confines of the interior, but ends abruptly where the large window opens up a panoramic outlook. Once again, Mies develops and visualizes his notion of space out of a dialectical opposition by combining a horizontal, laterally unlimited space with a sequence of surfaces layered one behind the other, what has been analyzed by Sanford Kwinter as an inseparable combination of "space and wall, fixity and flow."[95] This sequencing of flat surfaces would appear to be an extension of montage thinking into the depth of space. This dichotomy of space and wall, of static and dynamic, may be traced back to Theo van Doesburg's theory of elementary architecture based solely on planes, as developed in his text "Zur elementaren Gestaltung" ("On Elemental Form-Creation") published in the first issue of *G*.[96] Mies's design for the Brick Country House from 1924 could be seen as the first example of a building based entirely on the free disposition of wall

slabs.[97] Unlike this early project, however, the later drawings and photocollages do not rely on the immanent three-dimensionality of nodes or orthogonal axes of coordinates, but are based exclusively on the parallel layering of individual planes. Here, two-dimensionality is treated not as a surrogate for space, but as its very condition—a notion that, as we will see, is closely related to August Schmarsow's phenomenology of architectural space.

This peculiar spatial conception is also evident in the photocollages and drawings for the unexecuted Resor House. Here, the architect includes planar elements that are layered one behind the other in absolute frontality, so that the collage appears like an abstract arrangement of planes floating in space. As discussed earlier, the horizontal element in the foreground is a dark wood veneer and represents a piece of furniture (see fig. 4.28). It could be said that the image presents an encyclopedia of contemporary furnishing materials made available by industrialization. As previously mentioned, the element in the middle ground is a reproduction of a painting by Paul Klee, *Bunte Mahlzeit* (1928; *The Colorful Meal*), which the Resors had bought in December 1937. The painting is not presented here as one would expect a work of art to be displayed: it is not hanging on a wall and it lacks a frame.[98] However, in his photocollages, Mies was not propagating the traditional painting hung on the wall as an outlook onto a visionary world; on the contrary, the painting is employed to divide up the space as if it were a wall. It takes on an architectural character. Mies thus executed a double inversion: what had traditionally been a window to a virtual reality is manifest as architecture; what would normally be an outlook onto a real landscape is transformed into its flat representation.

The layering technique is a very peculiar way to visualize and conceptualize interior space, but this is by no means the only project where Mies employs it. A similar arrangement can be found in his project for the Museum for a Small City from 1942 (fig. 4.38). This photomontage, too, combines landscape elements and reproductions of works of art that are layered one behind the other. This particular montage includes two sculptures by Aristide Maillol as well as Picasso's *Guernica*—hardly a coincidental reference in times of war—a painting that again is used as a spatial element. As a matter of fact, according to the architect himself, the idea of the museum design was based on the attempt to display *Guernica* so that "it can be shown to greatest advantage." This meant that it would become "an element in space against a changing background."[99] What we see here is the work of art taken out of its frame and floating more or less freely in a supposedly endless, uniform space. The transformation of the figure/ground relationship between painting and wall seems a direct consequence of the loss of the solid, opaque wall in the glass façade. The formerly "transparent" outlook onto the world, the painting, is transformed into an opaque, physically present object in space.

Mies came back to this idea in some of his later museum projects, some of which were realized. In the Cullinan Wing Addition of the Houston

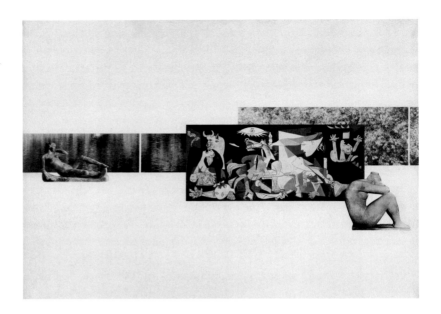

Fig. 4.38 Ludwig Mies van der Rohe, Museum for a Small City, 1942. Photomontage. Delineator: George Danforth, MvdR office. The Museum of Modern Art, New York.

Museum of Fine Arts (1954), he put into practice his conception of the display of art for the first time. A similar system was used again in the Nationalgalerie, Berlin. It is interesting to note that other architects were pursuing similar ideas in this period. Franco Albini's design for the Palazzo Bianco in Genoa dating from 1950–51 should be mentioned, as well as a very effective solution by Lina Bo Bardi for the display of the collection of the São Paulo Museum of Art from 1968. In an homage to Bo Bardi's no longer existing layout, the Dutch architect Aldo van Eyck declared, "In a sense—wrong sense—paintings on walls tend to be seen as windows onto another world, but this denies the tactile reality of their painted surface, i.e., the physical existence of something actually *made*—with paint and brush, stroke after stroke—IN SPACE. . . . The truth being *that [the] essential two-dimensionality* [of a painting] *cannot* breathe fully when fixed—locked—to a wall."[100]

Van Eyck, once again, raises the question of the relationship of two-dimensionality and materiality in painting, and how this relationship further relates to a modern notion of space. All of the examples discussed here speak of a longing for the liberation of art from its spatial context, in a constellation where works of art can communicate freely among each other without any contextual inhibitions. It is a deceptively formalistic, ahistorical approach in which works of art become part of a "parliament of things" (to quote Bruno Latour) that speak to each other in ever changing constellations. The intellectual concept for such an understanding of art and its imaginary space is André Malraux's "*musée imaginaire,*" a term that was, tellingly, translated into English as the "museum without walls" (fig. 4.39). It should be noted, however, that both Mies van der Rohe's project for a Museum for a Small City and Albini's scheme for the Palazzo Bianco anticipate Malraux's conception by several years.[101]

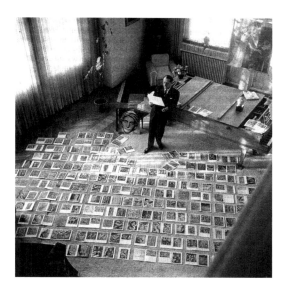

Fig. 4.39 André Malraux selecting photos for his book *Le Musée imaginaire*, ca. 1947. Photo by Maurice Jarnoux.

The use of collage/montage, with its inherent qualities of overlapping and layering, seems particularly suited to the representation of such a spatial concept. In pictorial collage, the two-dimensional picture plane would usually be broken up in order to push the image into space, while retaining the planarity of the support so that the images maintain an object quality. This applies to the works of Kurt Schwitters, for example, which as previously mentioned are represented in Mies van der Rohe's private collection. Contrary to this, however, in many of his photomontages and photocollages the architect insists on absolute frontality and flatness of texture in order to reinforce two-dimensionality, while the two-dimensional overlapping of collaged elements is literally spatialized through this operation. This two-dimensionality is treated not as a surrogate for space, but as its very condition of possibility.

It is interesting to note that Sigfried Giedion, in his 1956 *Architektur und Gemeinschaft* (*Architecture and Community*), characterized the plane as the "[constitutive] element of the new spatial conception," a contention he illustrated by referring to cubist painting and the ensuing artistic revolution.[102] He made use of this argument as early as 1938–39 in his Norton Lectures at Harvard University, which were published in 1941 as *Space, Time and Architecture.* The mediation of surface and space, or two and three dimensions, was obviously a major issue in mid-century modernist architectural thinking, and Mies's photocollages of this period can be seen as a contribution to this ongoing debate. Mies's specific implementation of such a concept of space based on the layering of planes should be seen in relation to the writings on spatial theory in his father's generation, and in particular the German art historian August Schmarsow, who is generally considered the progenitor of the spatial paradigm in modern architectural theory. As noted by Fritz Neumeyer, Mies's spatial conception was strongly informed

Fig. 4.40 Ludwig Mies van der Rohe in his Chicago home, ca. 1965. Photo by Werner Blaser.

by the writings of Dutch architect Hendrik Petrus Berlage and by August Endell, who again were well aware of Schmarsow's contributions.[103]

We will return to Schmarsow in more depth. Here, it is sufficient to state that for Schmarsow, space, whether in perspectival painting or architecture, is perceived through movement between a succession of (flat) images. This movement is either the real movement of the body and the eyes or the virtual movement of the mind, which like physical movement also occurs in a temporal sequence. Schmarsow calls what occurs during this movement the "concatenation of images" (*Verkettung der Bilder*)—that is, their layering.[104] It is from the same tension between space and image, depth and flatness that Mies's photocollages draw their meaning and impact. Schmarsow's theories were of course widely known in German aesthetic and architectural discourse and were intensely received by theorists such as Giedion, Paul Zucker, Herman Sörgel, and Paul Frank.[105] By the 1920s, his contention that the very nature of architecture lay in the creation of space had become commonplace, and there is no doubt that Mies was aware not only of the genealogy of this idea, but also of Schmarsow's conception of space as a successive layering of images. Seen in this light, Mies's photocollages of interior spaces appear as late visualizations of turn-of-the-century aesthetic theories. As much as scholarship on Mies has underscored the significance of technology and materials for understanding Mies's take

on modern architecture, his perspective also cannot be explained without taking into account his sustained and continued intellectual exchange with art, artists, and art history.

Mies consistently returned to photomontage and related techniques throughout his career in order to represent his architectural and spatial ideas. Beyond that, it can be said that the engagement with this two-dimensional medium resulted in a flattening of space and its treatment as a succession of overlapping layers. I would argue that this move illustrates a modernist tendency to understand space—be it political, natural, or abstract space in general—visually, as a product of visual media. By using photomontage and collage, Mies not only keeps up with state-of-the-art visual media in the postwar age of technological acceleration; he also seems to comment on—and participate in—the tendency of media to reduce the world to its image. Unlike Heidegger, who decries the turning of the world into an image, Mies gave images a central place in revising modern space.[106] And he did this in a medium that, far from being new and top of the line, by the early 1940s nostalgically evoked the golden age of the avant-garde.

One last photograph may help to sum up the argument (fig. 4.40). It shows Mies toward the end of his life in his Chicago home. In the background, we see paintings and collages by Kurt Schwitters and Paul Klee neatly framed on the walls. It is remarkable that Mies—by this time the most influential and successful living American architect—preferred to live in a traditional brownstone house rather than a building of his own design. In this regard, the photograph suggests that Mies didn't practice what he preached. But it is also relevant for understanding how space and image relate in his architectural thinking. The wall molding of his traditional home permits the display of the abstract, flat, planar arrangement of artwork that is in fact no longer possible in his glass spaces. This is true, first, for practical reasons—there are hardly any walls to hang pictures on. But, more importantly, it is true for conceptual and aesthetic reasons: where a new spatial order has been built, a visual representation of that spatial order is no longer necessary or sensible—it would lead to an aesthetically unbearable tautology.[107] After all, avant-garde artists in the early years of the 1920s had sought to overcome perspectival space and had proposed a new spatial order based on fragmentation and disjunction using the tool of montage. If their experiments can be seen as pictorial utopias, by the 1920s architects were trying to translate this utopia into reality, in the sense of a "concrete utopia."[108] After the historical catastrophe that followed, this utopia no longer received much credit. The pictures exhibiting this utopia could only be displayed, domesticated and commodified in their frames, as mementos of a distant past. The space of utopia has been reduced to an image on the wall. This is what we find in Mies's living room. The same of course is true of his transparent glass houses, in which the entire wall has been transformed into an image, and utopia has been consumed by private contemplation.

Embodied Spectatorship

Sergei Eisenstein's Theory of Architectural Montage

The Soviet filmmaker and theoretician Sergei Eisenstein was certainly not alone among his avant-gardist colleagues when he assessed the potential of cinematic montage for rethinking the problem of representation. However, Eisenstein's contribution stands out, mainly for two reasons: first, unlike anyone else, he consistently worked toward a comprehensive theory of filmic montage throughout his entire career as a director, thus not only critically reflecting upon his own filmic output, but also adjusting his montage theory according to the technical developments and innovations of the still-new art of cinema (although a comprehensive theory remained beyond his grasp) (fig. 5.1). Second, Eisenstein's take is of particular interest in our context because he frequently refers to architecture and urbanism as pre-cinematic media. In fact, between 1937 and 1940 the Soviet theoretician wrote an essay titled "Montage and Architecture." Originally intended to be included in a book-length study on montage that never materialized, the essay was finally published posthumously in 1989, brilliantly introduced by Yve-Alain Bois.[1] That it appeared in a journal of architectural theory demonstrates the significance of the text for modern and contemporary architectural and spatial thinking. This journal's title, *Assemblage,* one of the English-language synonyms of "montage," is all the more revealing of the programmatic nature of Eisenstein's text. The following chapter will attempt to contextualize this seminal contribution within twentieth-century architecture culture as one of the key moments when architectural and montage theories converged. Eisenstein frequently and extensively referred to architecture and the city, and to the problem of the representation of space, in his most important texts (as in a diagram in which a building functions symbolically, fig. 5.2). Even though Eisenstein also frequently referred to the other arts, among them painting, sculpture, literature, and music, none of these seems to be so closely related to the aesthetics of montage cinema as does architecture. The following discussion is broadly guided by two main assertions: one, that architecture and urbanism took a leading role in Eisenstein's rethinking of the conditions and possibilities of a new form of representation that he called montage. And two, that in "Montage and Architecture" and some other texts, he devised an

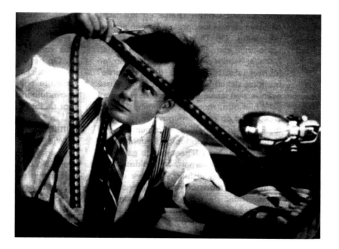

Fig. 5.1 Sergei Eisenstein editing a film.

implicit theory of embodied spectatorship on the basis of mobility in space. It was this theory, I would argue, that made and make Eisenstein's thinking relevant for the theory of modern architecture.

Eisenstein's preference for architecture as a system of representation and a site for the production of social meaning should perhaps not come as a surprise. The son of an architect—the town master-mason of Riga— Eisenstein himself trained as an architect and civil engineer at the Institute of Civil Engineering in St. Petersburg (1916–18) before turning his attention to set design in the Proletkult First Workers' Theatre in the aftermath of the October Revolution. Eisenstein finally turned to film in the early 1920s, having taken film classes with the Soviet film pioneer Lev Kuleshov in 1923.[2] Film scholar Oksana Bulgakowa has gone so far as to call Eisenstein's departure from professional architecture a "patricide" in an Oedipal sense.[3] In any case, architecture continued to preoccupy Eisenstein throughout his life, and it frequently appears as a point of reference in his film theory. His fame as a director is based not least on the architectural passages of his films, most prominently the famous "Odessa steps" sequence in *Battleship Potemkin* of 1925. Moreover, two unexecuted film projects specifically dealt with architectural issues, the *Glass House* project (1926–30), and a film titled *Moscow throughout History*.[4] Eisenstein himself linked his training as an architect to his development of the technique of cinematic montage: "On the roads and crossroads of my path to cinematography I once had to study architecture as well (in the Institute of Civil Engineering). . . . At the basis of the composition of [architecture's] ensemble, at the basis of the harmony of its conglomerating masses, in the establishment of the melody of the future overflow of forms, and in the execution of its rhythmic parts, giving harmony to the relief of its ensemble, lies that same 'dance' that is also at the basis of the creation of music, painting, and cinematic montage."[5] However, it would be too simplistic to see Eisenstein's theorization of architectural montage merely as a result of his biographical predisposition. Rather, architecture serves as a fundamental theoretical

Fig. 5.2 Sergei Eisenstein, *The Architecture of Film Theory*. Drawing, from Oksana Bulgakowa, *Sergej Eisenstein—drei Utopien. Architekturentwürfe zur Filmtheorie* (1996), 29.

category in devising his cinematic conception of space and time. The particular role he affords to architecture may be seen as a consequence of his insight that the media of film and architecture are marked intrinsically by the montage principle, and therefore together serve as a starting point to overcome traditional and static conceptions of the image and the representation of space.

As a practicing architect in the Red Army from 1918–20, Eisenstein was charged with the construction of fortifications and pontoon bridges. Later, in 1934, he devised an urban design plan for the city center of Nalchik, the capital of the Russian republic of Kabardino-Balkaria, which remained unexecuted.[6] Eisenstein stayed in close contact with avant-garde architects throughout his life, and in 1928 he became a founding member, along with Moisei Ginzburg, Alexander Vesnin, and others, of the constructivist group Oktiabr (October).[7] In 1926 he hired Andrei Burov, an architect from the OSA (Organization of Contemporary Architects) group, an association of constructivist architects founded by Ginzburg and Vesnin. Burov, who was to become Le Corbusier's assistant in the building of the Centrosoyuz in Moscow, designed a model collective farm (*sovkhoz*) for Eisenstein's film *The General Line* (1929) that was inspired by the Villa Savoye as well as North American grain elevators. When Le Corbusier visited Moscow for the first time in October 1928, it was Burov who introduced him to Eisenstein (fig. 5.3).[8] This personal encounter is well known; Eisenstein deemed himself a "great adherent of the architectural aesthetics of Le Corbusier."[9] It is therefore not surprising that Eisenstein would mingle with the constructivist architects in Russia, most notably Ginzburg, whose *Style and Epoch* (1924) is often considered the Russian response to Le Corbusier's *Toward*

Fig. 5.3 Le Corbusier, Sergei Eisenstein, and Andrei Burov in Moscow, 1928.

an Architecture.[10] Le Corbusier, too, held Eisenstein's work in great esteem. After a private screening of *Battleship Potemkin* during his Moscow visit, he gave the film director a personally dedicated copy of his *L'art décoratif d'aujourd'hui* (1925; *The Decorative Art of Today*).[11] Le Corbusier reflected, "Architecture and the cinema are the only two arts of our time. In my own work I seem to think as Eisenstein does in his films. . . . His films resemble closely what I am striving to do in my own work."[12] While here, Le Corbusier does not specify where exactly his and Eisenstein's aesthetics converged, Jean-Louis Cohen has pointed out that the "lyricism" in the architect's work is characterized by the two elements of juxtaposition (of individual elements) and sequence, both of which are fundamental concepts of Eisenstein's montage theory.[13] As we will see, Eisenstein's theory drew from the same source that Le Corbusier used in *Toward an Architecture* for devising his conception of the *promenade architecturale:* Auguste Choisy's analysis of the acropolis in Athens in *Histoire de l'architecture* (fig. 5.4). As a matter of fact, Eisenstein owned a copy of the 1908 translation of Choisy's seminal study in his private architectural library. Choisy, Le Corbusier, and Eisenstein all conceive of architectural space as organized according to an embodied and mobile spectator. The notion of embodied vision is generally related to phenomenology, in particular to the writings of Edmund Husserl and Maurice Merleau-Ponty.[14] The historical lineage proposed here—from Choisy to Eisenstein and Le Corbusier—is an alternate genealogy of thought on embodied vision that is fundamentally architectural, and that entails the principle of montage for the production of meaningful sequences of images.

Eisenstein made frequent reference to architectural problems throughout his career. For example, his essay "Montage 1937" considers the problem of representation and cites ancient Greek architecture, in particular the caryatids, as a model for the mediation between form and function: "Greek architecture is astounding, indeed unsurpassed, in that each of its elements *not only fulfills* this or that structural function but simultaneously expresses

Fig. 5.4 Double-page spread on "picturesque" urbanism in ancient Greek architecture, from Auguste Choisy, *Histoire de l'architecture* (1899), 414–15.

the *idea* of that function architecturally. . . . The figures of Atlas and the caryatids of the Erechtheum provide us with a most remarkable image, disclosed in the unity between the idea and its originator and bearer, who is made to embody the idea in his or her own image."[15] In semiotic terms, what intrigues Eisenstein in the architectural element of the caryatid is the conflation of signifier and signified, of form and symbolic meaning—a quality that he is interested in achieving by means of the cinema. In a section of *Nonindifferent Nature* (posthumously published in 1987) dealing with Piranesi's *Carceri* (which Manfredo Tafuri was particularly intrigued by, as we will see), Eisenstein returns to this notion. Obviously influenced by Stalinist cultural politics, he strongly critiques modernist and eclecticist architecture for their failure to produce "strong" images in which the visual and the symbolic dimension merge into what would provide for a metaphorical reading: "The mistake of the so-called leftist architecture—especially the constructivist—is in the rejection of the imagistic content of a building, which is totally reduced to utilitarian aims and the properties of building materials. No less abominable in its architectural ideology is the substitution (in the imagistic content of the building) by an eclectic reconstruction 'in parts' of elements of obsolete architectural epochs, reflecting in their forms ideologies of other nations and social and political conditions alien to us."[16] What could also be seen as a rejection of the architectural aesthetics of his father's generation is in fact, as Geoffrey Nowell-Smith has pointed out, the prolegomenon of a theory of the image and visual metaphor in which, again, object and idea become closely associated with each other: "Partly derived from Symbolism, but interpreted in a Marxist and materialist way, is his fundamental intuition that image, metaphor, and montage are at bottom the same thing: that images are created when the terms of a metaphor

are articulated through montage; that a metaphor which does not give rise to an image is a dead metaphor and an image that has no metaphoric weight is not an image at all; and that montage achieves its destiny only when it escapes from the metonymic linkage of object to object and achieves the metaphoric association, through the image, of object and idea."[17] In other words, in Eisenstein's thinking, montage is a visual tool for the production of meaning through the metaphorical association of signifier and signified.

ARCHITECTURE AND FILM

Eisenstein's belief in the aesthetic and epistemological affinity of architecture and film was not altogether new.[18] As early as 1925, the French architect Robert Mallet-Stevens discussed the relationship between film and the other arts (and in particular, architecture) in a short essay in *Les Cahiers du mois—Cinéma*. Mallet-Stevens's chef d'oeuvre, the Villa Noailles in Hyères on the Côte d'Azur, became famous mostly through the surrealist artist Man Ray's film *Les Mystères du Château de Dé* (1929). In the essay, Mallet-Stevens reaffirms what had been shown in Man Ray's film, that modern architecture was "essentially photogenic: large plans, straight lines, sobriety of ornaments, unified surfaces, clear opposition between shadow and light." He goes on to call modern architecture the "background" for "images in motion"—hence, it is a mere intermediary prop for the primary spatial experience of film.[19] This text could be seen as an early theorization of what has become known more recently as "iconic" or "photographic" architecture—that is, an architecture primarily built for its photographic representation.[20] The author also expresses a wish that cinema would serve as "magnificent propaganda" for "the education of the public," a belief fundamentally shared by Eisenstein, who, as we will see, regarded montage as a tool for engaging the masses mentally and, by extension, politically.[21] Sigfried Giedion, whose 1928 *Building in France* has already been introduced, differentiated more clearly between photography and film: "Still photography does not capture [buildings] clearly. One would have to accompany the eye as it moves: only film can make the new architecture intelligible!"[22] Giedion's embodied spectator informed not only Walter Benjamin's theory of the tactile perception of architecture, but also Eisenstein's concept of architectural montage.

Benjamin famously likened film to architecture in his seminal essay "The Work of Art in the Age of Its Technological Reproducibility" (1936). Both arts were characterized by a similar structure of perception, namely "reception in distraction," which distinguishes them from the other arts: "Distraction and concentration [*Zerstreuung und Sammlung*] form an antithesis, which may be formulated as follows. A person who concentrates before a work of art is absorbed by it; he enters into the work. . . . By contrast, the distracted masses absorb the work of art into themselves. This is most obvious with regard to buildings. Architecture has always offered the

prototype of an artwork that is received in a state of distraction and through the collective. The laws of architecture's reception are highly instructive."[23] Architecture is geared toward collective reception, and for this reason is a model for aesthetic perception in a modern mass society. But collective reception in distraction is not the only parallel between architecture and film, as Benjamin continues: "Buildings are received in a twofold manner: by use and by perception. Or, better: tactilely and optically. Such reception cannot be understood in terms of the concentrated attention of a traveler before a famous building. On the tactile side, there is no counterpart to what contemplation is on the optical side. Tactile reception comes about not so much by way of attention as by way of habit. The latter largely determines even the optical reception of architecture, which spontaneously takes form in casual noticing, rather than attentive observation. . . . Reception in distraction—the sort of reception which is increasingly noticeable in all areas of art and is a symptom of profound changes in apperception—finds in film its true training ground."[24] Hence, for Benjamin, architecture provides for the new medium of film a model of reception that is fundamentally different from traditional aesthetics of reception. If Benjamin seems to exclude a tactile dimension in the reception of painting (a claim that may be disputable), it is clear for him that this aspect is of key importance for architecture and film. Hence, both arts are not only optical phenomena, but depend on the involvement of the viewer's body. That said, Benjamin remains silent about the fundamental difference between the perception of architecture and film with regard to the (im)mobility of their spectators: whereas the architectural spectator is mobile in front of an immobile/static and material object, the filmic spectator is immobile in front of mobile and immaterial images.[25] Nevertheless, Benjamin's ideas are, as we will see, strikingly similar to Eisenstein's own theories of architectural and filmic montage. Moreover, Benjamin's argument not only contains *in nuce* a theory of "tacit knowledge" of architecture—that is, unconscious knowledge based on use and habit; it also connects to contemporary theories of immersive space in which the boundaries between (perceived) architectural object and (perceiving) subject are blurred.[26]

The art historian Erwin Panofsky was also a pioneer in considering the structural similarities between architecture and film. In a now famous lecture at the Museum of Modern Art in New York in November 1936, Panofsky proposed regarding film as a serious art, which at the time was a bold and unexpected view from an established art historian.[27] He praised film—alongside architecture—over the traditional genres for being "entirely alive":

> Today there is no denying that narrative films are not only "art" . . . but also, besides architecture, cartooning and "commercial design," the only visual art entirely alive. The "movies" have reestablished that dynamic contact between art production and art consumption

which . . . is sorely attenuated, if not entirely interrupted, in many other fields of artistic endeavor. Whether we like it or not, it is the movies that mold, more than any other single force, the opinions, the taste, the language, the dress, the behavior, and even the physical appearance of a public comprising more than sixty per cent of the population of the earth. If all the serious lyrical poets, composers, painters and sculptors were forced by law to stop their activities, a rather small fraction of the general public would become aware of the fact and a still smaller fraction would seriously regret it. If the same thing were to happen with the movies the social consequences would be catastrophic.[28]

Panofsky singles out film and architecture as the media most relevant in a contemporary mass society for their ability to address—and emotionally move—a large percentage of the population, which, it is implied, traditional media such as painting or sculpture cannot do because of their elitism. Panofsky almost takes the stance of productivist thinkers here, for whom the artist's chief task is to produce work in service to the common good of society. Panofsky's embrace of the possibilities of film seems all the more surprising in light of his recent departure from Nazi Germany, where the medium was appropriated for propagandistic purposes. Panofsky was apparently not willing to blame film for its systematic abuse in his former home country.

One might guess that in his comparison to architecture, Panofsky was referring to the kind of modern construction that, as pointed out by Mallet-Stevens, Giedion, and others, had developed an understanding of space akin to that in film. However, Panofsky was thinking of something completely different: the medieval cathedral, which according to him resulted from a "co-operative effort," as in the production of movies.[29] In other words, it is not primarily the spatial dimension of architecture that Panofsky is interested in, but rather the cathedral's appeal to a popular audience, its "communicability," which it shares with film and that makes film as well as commercial art more vital and more effective than noncommercial art.[30] Panofsky's opinion seems close to that voiced by Alexander Dorner, his onetime fellow student at the University of Berlin, in the latter's 1947 *The Way beyond "Art,"* with its open espousal of commercial graphic design in postwar consumer society.[31]

Panofsky also clarified what he considered the artistic potential of film beyond the relationship with its audience: "These unique and specific possibilities can be defined as *dynamization of space* and, accordingly, *spatialization of time.*"[32] Panofsky implicitly refers to the dichotomy established by Gotthold Ephraim Lessing in *Laokoon oder Über die Grenzen der Malerei und Poesie* (1766; *Laocoon: An Essay upon the Limits of Painting and Poetry*) between the sphere of painting, which is concerned with the representation of space, and poetry, which is concerned with the representation of time.

Film, for Panofsky, is capable of overcoming this dichotomy and establishing an altogether new representational mode, which Giedion would call space-time. In "Montage and Architecture," Eisenstein demonstrates that architecture has provided this spatio-temporality since ancient times, and therefore presents a much more useful and effective idea of the image for the present than do media such as painting.

The relationship between film and architecture has been explored in a quickly growing number of publications. The majority of these have focused on the interface of built architecture and filmed space.[33] Conversely, the problem of the representation of space by means of film has been addressed in two seminal studies by film scholars: Giuliana Bruno's *Atlas of Emotion* (2002) and Anne Friedberg's *The Virtual Window* (2006).[34] While Eisenstein's theory of montage (and its implications for the study of architecture) is discussed in both studies, a similar investigation has so far not been attempted from an architectural point of view. Such an investigation can profit from a number of contributions that have discussed the significance of the concept of montage for the study of architecture as well as the impact of Eisenstein's writing on modern architecture culture. Most importantly, Yve-Alain Bois's introduction to the first publication of Eisenstein's "Montage and Architecture" calls for a reassessment of Eisenstein's often-overlooked writings and their validity for the concept of the image. Bois specifically underlines Eisenstein's notion of peripatetic vision and the (moving) spectator, an aspect that was, as Bois contends, almost entirely missing from the study of architecture.[35] In an insightful short piece, Anthony Vidler goes further, looking at Eisenstein's text and the similarities and differences between architecture and film from a psychological point of view.[36] Subsequently, Bruno undertook a thorough analysis of Eisenstein's text. Pursuing an interest in the "emotional space" created by the filmic imaginary, she interprets Eisenstein's conception of space and montage as necessitating an embodied spectator, and stresses the notion of a gendered space.[37] This more recent scholarship was anticipated in a seminal text by the architectural historian Manfredo Tafuri, published in 1977.[38] Most likely writing without knowledge of Eisenstein's posthumously published "Montage and Architecture," Tafuri discusses the Soviet filmmaker's concept of montage as a "critical operative method" based on a reading of Eisenstein's essay on the *Carceri*. Tafuri also puts Eisenstein's writings in their political and historical context and interprets them as investigations of the problem of the construction of visual meaning, as we will see.

In the following I will propose a different trajectory: starting out from a rereading of Eisenstein's "Montage and Architecture," but also taking into account a number of his other important contributions that deal with modern architecture and space, I will try to elaborate how the notion of a mobile, embodied spectator forms the basis for the production of meaning through montage.

"MONTAGE AND ARCHITECTURE": THE EMBODIED
SPECTATOR AND THE *PROMENADE ARCHITECTURALE*

Eisenstein repeatedly referred to architectural history and theory as well as spatial conceptions in his writings, the most important of which, besides "Montage in Architecture," are the essays "El Greco and Cinema" and "Rodin et Rilke." Of these, "Montage and Architecture," written sometime between 1937 and 1940 but not published until 1989, most explicitly theorizes the notion of montage as a way of thinking about the visuality of (modern) space.

The main argument of the text is that cinema's fundamental structural principles were already implicitly present in pre-filmic media. Eisenstein called this pre- or proto-filmic aesthetic "cinematism."[39] The purpose of his argument is clear: to provide a validating genealogy for film as a new artistic medium: "It seems that all the arts have, throughout the centuries, tended towards cinema. Conversely, the cinema helps to understand their methods."[40] The filmmaker is less interested in identifying film's distinctive, media-specific qualities. Or, according to film scholar Antonio Somaini, cinematism was concerned with "finding in the universal history of the forms of representation—from the history of the arts to that of languages and rites—all those forms of *pre- and extra-cinematographic cinematographicity* from where the cinema could have drawn inspiration for experimenting with ever more different and efficient montage solutions."[41] Among the most important examples of cinematism in the history of art, to which Eisenstein refers in separate essays, are the *Carceri* etchings of Piranesi and the paintings of El Greco.[42] "Montage and Architecture" demonstrates how such an alternate conception of visuality has been developed since ancient times, in architecture and urbanism in particular. Eisenstein also considers painting an instance of cinematism, though it lacks "visual multidimensionality": "Painting has remained incapable of fixing the total representation of a phenomenon in its full visual multidimensionality. . . . Only the film camera has solved the problem of doing this on a flat surface, but its undoubted ancestor in this capability is—architecture."[43]

Above all, Eisenstein's concern with incorporating time and temporality into the concept of the image led him not only to fundamentally question the received notion of the image as a static entity, but also to begin to understand aesthetic perception as a sequential process. These thoughts very much challenged the basis of received aesthetic theory since Lessing and Kant.[44] It is striking that Paul Klee simultaneously pursued a very similar idea in his *Pädagogisches Skizzenbuch* (1925; *Pedagogical Sketchbook*), writing that "the eye must 'graze' over the surface, sharply grasping portion after portion, to convey them to the brain which collects and stores the impression."[45] The writings of both Eisenstein and Klee may be seen as indications of a new, fundamentally different image theory that is based on temporality and differs radically from traditional thinking—a paradigm shift

that also had a profound impact on the concept of the architectural image. This fundamental rethinking of the concept of the image was directly linked to the writings of scholars such as Wilhelm Wundt, Robert Vischer, Konrad Fiedler, and Theodor Lipps and late nineteenth-century perceptual psychology, which became one of the pillars for modern architectural space theory, as we will see.[46] What distinguishes Eisenstein's concept of cinematism from the ideas of his contemporaries is its inherent intermediality. In this regard, the theory of "cinematism" reflects a search for the proto-cinematic in art and architecture. It was foremost the notion of montage that allowed for this interdisciplinary endeavor.

The text of "Montage and Architecture" can be subdivided into two main sections. In the first section, Eisenstein discusses the concept of "path," referencing Auguste Choisy's interpretation of the Acropolis as an instance of proto-cinematic urbanism. In the second (and far longer) section, the author performs an extended iconographic reading of the coats of arms engraved in the four plinths of the columns of Bernini's canopy in St. Peter's Cathedral in Rome, which he interprets in similar terms, namely as an instance of the "montage technique of sequential juxtaposition,"[47] or the assemblage of individual visual impressions into a coherent and meaningful sequence by a viewer moving through space: "In themselves, the pictures, the phases, the elements of the whole are innocent and indecipherable. The blow is struck only when the elements are juxtaposed into a sequential image."[48] This statement contains the characteristic and even defining principle of montage, as well as of film overall, in Eisenstein's understanding: the pairing of sequence and juxtaposition.[49]

In Choisy's *Histoire de l'architecture* from 1899 (of which Eisenstein owned a copy of the Russian edition),[50] the French architectural historian analyzes the Acropolis as a model case of ancient "picturesque" urbanism based on a peripatetic viewer.[51] While Choisy's interpretation radically departs from classicist conceptions of symmetry and axiality, it represents one of the earliest instances of an architectural theory taking into consideration the object/viewer relationship (see fig. 5.4). What makes Choisy's interpretation so unusual in the mindset of French classicism is his celebration of "oblique views," which he deems to be the major governing aesthetic principle in the "ponderation" of the individual volumes—that is, the way these are brought together into a precarious balance, taking into consideration size, height, and location: "To modern thinking, the Parthenon . . . should be placed opposite the main entrance, but the Greeks reasoned quite differently. . . .The Parthenon first of all faces the spectator obliquely. The ancients generally preferred oblique views: they are more picturesque, whereas a frontal view of the façade is more majestic."[52] Translating Choisy's observations into his own terminology as befits his agenda, Eisenstein states, "The Greeks have left us the most perfect examples of shot design, change of shot, and shot length," and proposes regarding the Acropolis as "the perfect example of one of the most ancient films."[53] Para-

phrasing Choisy, Eisenstein goes on to explain how the individual buildings of the Acropolis are aligned so as to visually accommodate a spectator approaching gradually. In his text "El Greco and Cinema," where he returns to Choisy's reading of the Acropolis, Eisenstein underlines his notion of architectural montage: "An architectural ensemble [is] . . . a montage from the point of view of a spectator in motion. But if the spectator cannot move, he is constrained to bring together in one single perspective the elements of what in reality is scattered. . . . Cinematographic montage, too, is a means to 'connect' in one place—on the screen—different elements (fragments) of a phenomenon filmed in different dimensions, from different points of view and from different sides."[54]

Eisenstein's interest in architecture and urbanism centers on two main questions: first, how individual images or visual impressions are combined into a continuous sequence in the mind of the viewer; second, how image sequences produce meaning beyond that of individual images. In other words, Eisenstein's cinematism addresses the plurality of the moving image as well as the production of meaning based on sequence and juxtaposition. While the idea of sequence is evident in Choisy's interpretation, the notion of juxtaposition, so crucial for Eisenstein's conception of montage, is less so: Eisenstein stresses the breaks and ruptures where Choisy sees linear succession and sequence. In any case, Eisenstein concludes his observations on the Acropolis by pointing out its "montage plan."[55]

Eisenstein's theory of montage is based to a considerable extent on his understanding of architecture as a space that needs to be physically and/or mentally traversed in order to be understood. A very similar notion underlies Le Corbusier's conception of modern space in time as exemplified in his theory of the architectural promenade. As is well-known, in the third section of the "Trois rappels à Messieurs les architectes" ("Three Reminders to Architects") from his 1922 manifesto *Toward an Architecture,* Le Corbusier explicitly references the very passage in Choisy's book that would become the basis for Eisenstein's theory of montage.[56] It is not surprising that the two men found much common ground when they met in Moscow in the fall of 1928. Le Corbusier, who had bought Choisy's book fifteen years previously in Paris,[57] not only used the French historian's theory of the picturesque to polemicize against the normative dictates of those he considered the illegitimate heirs to the classical tradition, namely the Académie; as both Richard Etlin and Jacques Lucan have shown, Choisy's theory also served Le Corbusier in devising the *promenade architecturale,* his own conception of the organization of architectural space in time.[58] The concept of the architectural promenade figures in several of the white villas of the 1920s, among them the La Roche-Jeanneret Houses of 1923. In his *Oeuvre complète,* the architect describes the layout of the building cinematographically in terms of shifts of perspective and light: "[The La Roche House] will be . . . a little like an architectural promenade. You enter: the architectural spectacle offers itself successively to your view: you follow an itinerary and

the perspectives develop with a great variety; we play with the influx of light illuminating the walls or creating shadows."[59]

As for the Villa Savoye, in the second volume of his *Oeuvre complète,* Le Corbusier explains: "Arab architecture has much to teach us. It is appreciated while on the move, with one's feet; it is while walking, moving from one place to another, that one sees how the arrangements of the architecture develop. This is a principle contrary to Baroque architecture. . . . In this house [the Villa Savoye], we are dealing with a true architectural promenade, offering constantly varied, unexpected, sometimes astonishing aspects. It is interesting to obtain so much diversity when one has, for example, allowed from the standpoint of construction an absolutely rigorous pattern of posts and beams."[60] Le Corbusier tellingly represented his masterpiece in the second volume of the *Oeuvre complète* in the form of a photographic sequence, labeling one of the pictures showing the ramp to the rooftop garden a "promenade architecturale" (fig. 5.5).[61] Again, in a lecture to architecture students in 1943, he stated: "Architecture can be classified as dead or living by the degree to which the rule of *sequential movement* has been ignored or, instead, brilliantly observed."[62]

Richard Etlin has pointed out the degree to which Le Corbusier's conception of mobile spectatorship as well as Choisy's reading of the Acropolis were indebted to the conception of the "picturesque" and eighteenth-century English landscape theory,[63] and Beatriz Colomina has demonstrated that Le Corbusier's constructed panoramic vistas are themselves cinematic.[64] I would like to propose a genealogy that begins with Choisy but that is crucially informed by a cinematic conception of the image. Le Corbusier held a conviction that architecture is ideally perceived in motion by a viewer whose spatial experience is constituted by the mental combination of single vistas into a sequential image; this comes very close to Eisenstein's understanding of architecture as proto-cinematic. Architectural and cinematic thinking converged to a large extent at this specific moment in the late 1920s, and it seems likely that Eisenstein's conception of architectural montage was significantly indebted to his exposure to Le Corbusier's ideas, in the same way that the architect's conception of space was predicated by his interest in the "moving image"—both understood as the art of the cinema and as the sequencing of visual impressions in moving through an architectural space.

ACTIVE SPECTATORSHIP, EMBODIED VISION, PSYCHOTECHNICS

Eisenstein begins "Montage and Architecture" by referring to the concept of the "path." It is here, at the very beginning of his essay, that he differentiates between an immobile and a mobile spectator, or what could be characterized as a cinematic versus an architectural *dispositif* of viewing: "The word *path* is not used by chance. Nowadays it is the imaginary path

followed by the eye and the varying perceptions of an object that depend on how it appears to the eye. Nowadays it may also be the path followed by the mind across a multiplicity of phenomena, far apart in time and space, gathered in a certain sequence into a single meaningful concept; and these diverse impressions pass in front of an immobile spectator. In the past, however, the opposite was the case: the spectator moved between [a series of] carefully disposed phenomena that he absorbed sequentially with his visual sense."[65]

In Eisenstein's view, architecture has been superseded by the cinema, and the mobile spectator replaced by an immobile one. Traveling across space and time no longer calls for bodily movement, but can be effectuated just as well by mere eye movement or virtual movement in the imagination. Contrary to Eisenstein's insistence on the strong bonds between architecture and film, Anne Friedberg has used this critical differentiation between mobile and immobile spectatorship to draw a distinctive line between the two scopic regimes: "For the architectural spectator, the materiality of architecture meets the mobility of its viewer; for the film spectator, the immateriality of the film experience meets the immobility of its viewer. Hence, the bodily, haptic, phenomenological perception of an itinerant and peripatetic viewer operates as an entirely different visual system once the itinerary becomes framed, an optical 'imaginary path' with boundary and limit."[66] Friedberg seems implicitly to take a stand for architectural and against cinematic spectatorship, for even though film sets the imagination in motion, the mind is nevertheless "bound" and "limited" by framed images. The film historian David Bordwell has demonstrated the extent to which Eisenstein's early montage theories were informed by Ivan Pavlov's theory of stimulus and reflex.[67] In this thinking, the spectator's mental disposition is seen as the target of the artist's manipulations, making the artist a "calculator of stimulants." This is a rather patronizing view of the audience, whose emotional responses have been calculated beforehand according to the author's intentions. This background renders any rhetoric of the activation of the spectator, let alone her or his (free) participation, highly suspicious.[68]

Pavlov's "materialist" theory of stimulus and response had an impact on Soviet avant-garde architecture in the 1920s as well, in particular in the "psychotechnical" laboratory of rationalist architect and teacher Nikolay Ladovsky at VKhUTEMAS.[69] Ladovsky's experiments were strongly informed by the director of the Harvard Psychological Laboratory, Hugo Münsterberg, who had been a student of Wilhelm Wundt at the University of Leipzig, and who coined the term "psychotechnics" in his 1914 publication *Grundzüge der Psychotechnik* (*Principles of Psychotechnique*).[70] When Le Corbusier came to Moscow on the occasion of his design for the Centrosoyuz in 1928, in addition to screening *Battleship Potemkin* he visited Ladovsky's laboratory and subjected himself to one of Ladovsky's experiments on the so-called prostrometer, a device that measured the

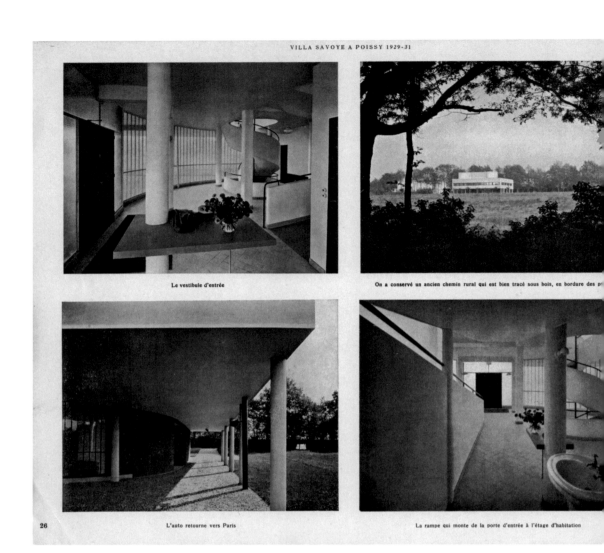

Le vestibule d'entrée

On a conservé un ancien chemin rural qui est bien tracé sous bois, en bordure des p

26

L'auto retourne vers Paris

La rampe qui monte de la porte d'entrée à l'étage d'habitation

Fig. 5.5 Double-page spread illustrating the Villa Savoye in a proto-cinematic image sequence, from Willy Boesiger, ed., *Le Corbusier et Pierre Jeanneret: Oeuvre complète de 1929–1934* (1974), 26.

subject's ability to see stereometrically—and failed.[71] Ladovsky's psychotechnical experiments aimed not only to analyze the effects of architectural and spatial forms on visual perception, but also—by extension—to induce these effects.[72] As Ladovsky was one of the most influential architectural teachers in the Soviet Union of the late 1920s, his experiments directly resulted in the overly complex and unstructured designs of the Russian rationalists. In opposition to the constructivists (around Vesnin), who based their designs on objective principles such as the function of buildings and standardization, the rationalists sought to abstract general principles about the effect of architectural forms on perception from the experiences of particular viewers, as in Ladovsky's experiments.[73] Ladovsky and other exponents of the rationalist school were also very much interested in problems of rhythm and movement and were familiar with the montage theories of filmmakers Vsevolod Pudovkin and Eisenstein.[74] Like Ladovsky, these filmmakers

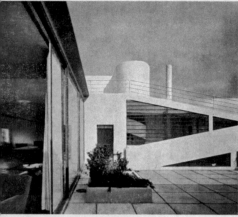

Du jardin supérieur, on monte au toit

Avant d'entrer dans le salon ou dans le jardin suspendu

Le bain de soleil

Du salon, on a le soleil qui vient par le jardin suspendu

27

studied the writings of perceptual theorists such as Münsterberg or Kurt Lewin, whom Eisenstein referenced explicitly in his "Montage of Attractions" (1924).[75] In other words, the perceptual theories underlying Eisenstein's cinematic montage were grounded in the perceptual psychology of the turn of the twentieth century, which became relevant for a modernist spatial conception as well, especially through Ladovksy's mediation.

In Anne Friedberg's view, as quoted earlier, architecture as compared with film seems to give the "itinerant and peripatetic" spectator more freedom of choice as to how far his or her participation in the construction of meaning extends. However, this freedom is not necessarily supported in the architectural apparatus: while it is true that in a building like Le Corbusier's Villa Savoye, the spectator is free to depart from the "promenade" along which a spatial narrative unfolds itself, the villa is nevertheless (necessarily) designed and prescribed by the architect so as to leave the user

only a limited number of options for spatial experience, with carefully arranged visual passages and climaxes. In his analyses of Le Corbusier's urbanist visions, the German architectural historian Thilo Hilpert has indicated the extent to which the architect's thinking was informed by theories of social engineering and the organization of labor, movement, and space as elaborated by Henry Ford or Frederick Winslow Taylor.[76] Their theories were popularized in France by Le Corbusier's "friend," the economist and sociologist Hyacinthe Dubreuil, in his 1929 volume *Standards*.[77] Dubreuil's ideas on the rationalization of labor processes had a considerable impact on the architect's thinking on the organization of space. While there is no direct link in Le Corbusier's writings between his ideas and Dubreuil's—after all, the promenade architecturale had been devised conceptually years before Dubreuil's publication—there is no doubt that the architect's urbanist schemes had strongly rationalist underpinnings. The same principles seem to have guided the design of his living spaces at this time as well. In 1929 (in reference to "minimum lodging"), he stated, "The running of a home consists of precise functions in a regular order. The regular order of these functions constitutes a phenomenon of circulation. An exact, economic rapid circulation is the key to contemporary architecture."[78] A theory of the rationalization and organization of labor space thus served as the model for the reordering of domestic space.[79] The promenade architecturale and the related notion of interior space as structured according to the visual perception and bodily experience of a circulating user is thus linked to the idea of the rationalization of time and space. Both Le Corbusier's and Eisenstein's theories of (spatial) perception in motion are therefore not so much a liberation of the viewer; rather, the viewer is activated within authoritarian spatial structures.

That said, it should be asked fundamentally whether Friedberg's discussion of the question of "freedom" and "choice" is appropriate for either Eisenstein's notion of montage or Le Corbusier's spatial interpretation of it in the promenade architecturale. Both concepts strive to set free the viewer's imagination, necessarily within a limit established by the author. In the domain of modern architecture, the promenade architecturale has proven to be perhaps one of the most convincing and successful methods of charging space with layers of cultural meaning and signification beyond that of mere functionality. By narrativizing architecture, Le Corbusier activated the viewer much more than controlling him or her (though activation seems impossible without some manner of control).

Giuliana Bruno extensively analyzes "Montage and Architecture" over the course of exploring what she terms "spatiovisuality." As Bruno points out, Eisenstein's theory offers cinematic and architectural aesthetics an alternative to the oculocentrism of Renaissance perspective, which "reduced spectatorship to the fixed, unified geometry of a transcendental, disembodied gaze."[80] Rather, the reading of space calls for a double engage-

ment of both haptic and visual perception—a notion that was introduced into art and architectural theory back in the late nineteenth century by theoreticians such as Alois Riegl or August Schmarsow, as we will see. Expanding upon the notion of embodiment and arguing from a feminist perspective, Bruno reads the conflation of body, movement, and space as essentially a gendered practice: "By connecting corpus and space, I am . . . suggesting that film and architecture are gendered practices, linked by their writing public stories of private lives."[81] While addressing yet another important issue that cannot be discussed in detail here—the question of privacy and publicity—Bruno clearly develops ideas first introduced in late nineteenth-century spatial theory that were then expanded upon by figures such as Eisenstein and Le Corbusier in their connecting of vision, body, and space. Bruno's analysis reveals a problematic aporia in the writings of both thinkers. While both Le Corbusier and Eisenstein work toward overcoming the monocular visuality of linear perspective by replacing its fixed gaze with an embodied and mobile spectator, they construct an equally idealized, in fact genderless figure that is more a virtual than a physical presence in real (historical, social, and political) space.

INTELLECTUAL MONTAGE

In other contexts, Eisenstein developed a much more strongly dialectic conception of montage than that presented in "Montage and Architecture." In a roughly contemporaneous text that later became known as "Montage 1937," in a section titled "Laocoön," the filmmaker isolates "micro-montage" as a preliminary stage of montage proper:

> The period of multiple set-up cinema is now commonly called the period of "montage cinema." This is vulgar in phrasing and simply incorrect in substance: *all* cinema is montage cinema, for the simple reason that the most fundamental cinematic phenomenon—the fact that the picture moves—is a montage phenomenon. What does this phenomenon of the moving photographic image consist of? A series of still photographs of different stages of a single movement are taken. The result is a succession of what are called "frames." Connecting them up with one another in montage by passing the film at a certain speed through a projector reduces them to a single process which our perception interprets as movement. This could be called the stage of micro-montage, for the laws governing this phenomenon are the same as for montage. . . . Thus montage pervades all "levels" of film-making, beginning with the basic cinematic phenomenon, through "montage proper" and up to the compositional totality of the film as a whole.[82]

While such statements point at an understanding of montage as an all-encompassing visual dispositif that is essentially synonymous to the sequentiality of moving images, Eisenstein repeatedly makes it clear that he understands montage proper as an epistemological device for the production of visual meaning based on juxtaposition and contrast, or, as could be said with reference to Benjamin, an aesthetics of "shock." In another text from 1929, Eisenstein writes: "What characterizes the montage and hence its role as a cell or movie frame? The collision—the conflict of two opposing pieces. The conflict. The collision."[83] Here, he shows himself clearly indebted to dialectical materialism as advanced by Karl Marx and Friedrich Engels. In another piece entitled "Dramaturgie der Film-Form" (1929; "The Dramaturgy of Film [The Dialectical Approach to Film Form]") from the same year, originally written in German, he asserts:

> In the realm of art this dialectical principle of the dynamic is embodied in
>
> CONFLICT
>
> as the essential principle of the existence of every work of art and every form.
>
> FOR ART IS ALWAYS CONFLICT:
> 1. because of its social mission,
> 2. because of its nature,
> 3. because of its methodology.[84]

Eisenstein terms this production of meaning based on visual juxtaposition "intellectual montage." In his 1942 book, *The Film Sense,* he describes "the fact that two film pieces of any kind, placed together, inevitably combine into a new concept, a new quality, arising out of that juxtaposition."[85] Intellectual montage thus interrupts narrative linearity with "shock," that is, conflict and collision. Sequentiality and montage, the two basic principles of Eisenstein's theory of cinema, thus themselves form a pair of concepts that are related in dialectical tension.

As in the Acropolis example discussed in "Montage and Architecture," intellectual montage has important consequences for the relationship of the perceived object and its viewer. Unlike the technique of "continuity editing" as practiced in Hollywood film, intellectual montage requires the spectator to produce visual meaning actively, by stringing together seemingly unrelated single images into a sequence whose meaning transcends the individual frames. Manfredo Tafuri states that "the principle of montage had always been linked to the theme of activating the public."[86] In other words, (intellectual) montage is of necessity *political*—as is public space, of which the Acropolis is the ultimate prototype.

It is worthwhile to return once more to "Montage and Architecture" in order to look at the large, second part of the essay that deals with the heraldry on the four plinths of the columns of Bernini's canopy in the crossing of St. Peter's in Rome.[87] While Yve-Alain Bois judges this lengthy passage as "disappointing from an architectural point of view,"[88] Bruno reads it as a gendered tale with sexual undertones.[89] I would contend that the passage offers a political reading as well. Eisenstein first discusses the iconography of the eight coats of arms, but he also underlines that these single representations are strung together into a sequence like the single shots of a film in a montage scenario.[90] Perhaps more importantly, the passage serves to demonstrate how montage activates viewers and therefore functions politically. Eisenstein recounts an incident from 1905 when two individual images that had been approved by the censors were arranged in a magazine, so they combined into a single mental image of the (violent) dispersal of a crowd by the military: montage was thus effectively used to skirt censorship in pre-revolutionary tsarist Russia.[91] According to Eisenstein, the eight coats of arms on Bernini's canopy—in their combination—were likewise a strong critique of the policies of the Barberini clan, which remained undetected by its most powerful member, Pope Urban VIII. The meaning of the images only becomes evident when they are "montaged" into a sequence. Eisenstein thus stresses the subversive, political potential of montage and its ability to activate the spectator or, in revolutionary terms, the masses.

On an aesthetic level, the basic idea of intellectual montage relates back to the experiments Eisenstein's former teacher Lev Kuleshov conducted in the late 1910s and early 1920s. Kuleshov is considered to be the innovator of a fundamental montage principle named after him.[92] Hans Richter, a key figure in introducing Soviet film theories into German discourse of the 1920s, describes the "Kuleshov effect" this way: "The decisive step from the idea of 'musical rhythm' to the method of montage was taken by Kuleshov, who historically would have to be considered the father of the montage technique. He too experimented with an 'accidental' addition of individual sequences without any initial relation to each other. In doing so, he noticed something other than just musical rhythm, namely that this releases a process triggered by the nature of the human brain, which defines the respective meaning of two (or more) sequential events. . . . Kuleshov concluded that film directed the imagination of the spectator through image combinations and this was not only caused by the actors' gestures . . . but by the art of combining sequences, that is, montage."[93] Eisenstein owed much to Kuleshov's experiment and its consequences for avant-gardist film theory. His conception of montage cannot therefore be reduced to the aspect of sequentiality (in the sense of a simple addition of individual images that is free from tension), but is equally informed by the notion of dialectical juxtaposition. It is most of all this aesthetic conception that connects Soviet film theorists to the Berlin Dadaists.

The montage "problem" remained Eisenstein's central theoretical preoccupation, to which he dedicated much of his literary and cinematic output throughout his career. His changing attempts at defining montage reflect not only technological advancements in the new art of film (for example, the introduction of sound) and the rapidly evolving theoretical discourse around it, but also the changing political climate in the Soviet Union in the transition from the Leninist to the Stalinist regime. David Bordwell has described two major phases in Eisenstein's montage thinking, separated by what he calls "Eisenstein's epistemological shift."[94] According to Bordwell, Eisenstein's early phase between ca. 1923 and 1930 is "philosophically, historically, and scientifically materialist."[95] It is, as we have seen, strongly informed by Pavlov's theory of stimulus and reflex, according to which the artist is seen as a "calculator of stimulants." Here, montage is developed as a theory of the syntax or structure of individual elements and the tension that arises between these elements when combined: "Montage is thus a characteristically modernist notion, seeing the artwork's context not in the analogy of organic unity but in that provided by physics: unity is the dynamic tension of interacting particles."[96] As Bordwell continues, such a notion of montage as juxtaposition was strongly based on Friedrich Engels's theory of dialectic.[97] In short, Eisenstein's early theory of montage is based on a "fusion of Pavlovian physiology and dialectical materialism."[98] The revolutionary artist's task is to make conflict visible; all art that attempts to smooth over or seal up the breaks and ruptures between conflicting elements is reactionary. This early take is fundamentally revised in Eisenstein's later writings from about 1930 to 1948. Replacing the dialectical-behaviorist epistemology of his early writings with an empirical-psychological position, Eisenstein now stresses organicism over tension and conflict in his montage theory, thus effectively promoting what he had earlier deemed reactionary, with Wagner and the notion of the *Gesamtkunstwerk* as the new model.[99] In Bordwell's analysis, this epistemic shift reflected not only developments within Soviet philosophy of the late 1920s, but also political pressures, most notably through the decree of the Central Committee of the Bolshevik Party, issued on January 25, 1931, that put an end to mechanistic notions of materialism.[100] It is indeed interesting to note that Eisenstein in (the relatively late) *Film Sense* describes the dialectical understanding of montage as "leftist," in an attempt to distance himself from the avant-gardist stance that he had taken earlier, but that had increasingly come under pressure in the reversal of cultural politics under Stalin. Even though it may be argued that Eisenstein's readjustment of his montage theory may follow its own inner logic, its later formulation nevertheless seems compromised and esoteric as compared to the early avant-gardist, dialectical notion.

How, then, does intellectual montage relate to the perception of architectural space by a moving spectator as brought forward in Eisenstein's "Montage and Architecture" and Le Corbusier's promenade architecturale?

In both conceptions, the artifact (architecture or film) does not in itself produce meaning, but relies on the active participation of the spectator to do so. Film scholar François Albera has pointed out that this notion of an active spectator actually lies at the center of Eisenstein's image theory. The Russian language distinguishes between *izobraženie* (representation) and *obraz* (image), and Eisenstein is very explicit in explaining how *obraz* as the "concept-image" is only constituted in the viewer's mind on the basis of individual visual impressions (or representations).[101] In other words, the viewer's mind constructs an image as an epistemic category or a concretization of meaning. The problem of an interactive perception of space was a major focus in 1920s architectural theory. While in the case of intellectual montage, participation is mainly a matter of mental processes, the promenade architecturale involves an embodied spectator actually moving through time and space. This activation of the viewer makes architectural montage, as put forward by Eisenstein and Le Corbusier, a predecessor of more recent participatory theories of art and the production of space, as well as what has been called "relational aesthetics" by critic Nicolas Bourriaud.[102] Understood in this way, architecture necessarily involves a physically and mentally active spectator. It is a spatial practice.

The architectural character of early Soviet montage thinking was theorized most explicitly by one of Eisenstein's colleagues, Vsevolod Pudovkin. For Pudovkin, as for Kuleshov and Eisenstein, montage as an epistemological device for the production of meaning functions through the combination and linkage of elements—that is, through the syntax. As Heather Puttock has suggested, Pudovkin "adopted an architectonic model for film, arguing that the separate strips of film were building blocks that, when arranged in a series, could expand and build upon an idea."[103] The similarity of this idea to what Rem Koolhaas develops in his postmodern urban manifesto *Delirious New York* is striking. Koolhaas maintains that the juxtaposition of city blocks constitutes a form of montage, which is also analogous to the structure of his text.

AUGUST SCHMARSOW'S SPATIAL THEORIES

The conflation of visuality and bodily involvement characteristic of Eisenstein's theory of architectural montage has to be considered, as we have seen, in connection with theories of perception and space from the late nineteenth century. At this historical moment, art and architectural historians were engaged in translating the findings of cognitive science and the psychology of perception into their fields of study. One of the chief producers of a spatial theory grounded in psychology was the German art historian August Schmarsow. What Schmarsow suggested for the future study of architecture may be seen as a double inversion: moving from the traditional focus of architectural history on a building's exterior appearance to its interior spatial organization, on the one hand, and from detached

visual analysis to an emphatic absorption and internalization of space through mind and body by a perceiving subject, on the other. Although Schmarsow never arrived at a systematic theory,[104] two texts in particular had a major impact: his 1893 inaugural lecture at the University of Leipzig, titled "Das Wesen der architektonischen Schöpfung" ("The Nature of Architectural Creation"), and the essay "Ueber den Werth der Dimensionen im menschlichen Raumgebilde" ("On the Value of the Dimensions in Human Spatial Structures"), published three years later.

In his inaugural lecture, Schmarsow likened the experience of "visual appreciation" in architecture to a musical performance that can be repeated at will. The technical aspects of architecture are therefore a mere means to an aesthetic end:[105] "Just [like] the art of music . . . architecture as the creatress of space is based on a systematic command of the material of spatial imagination and constitutes a creative elaboration of the three-dimensional visual image for human satisfaction and pleasure."[106] What he means by the "material of spatial imagination" and "the three-dimensional visual image" remains unspecified. However, in Schmarsow's terms, spatial perception occurs through the mediation of image and space, the second and third dimension, a process that involves not only bodily experience, but also the human mind and its power of imagination. In his 1921 essay "Zur Bedeutung des Tiefenerlebnisses im Raumgebilde" ("On the Significance of the Experience of Depth in Spatial Creation"),[107] Schmarsow identifies two human physiological features as crucial for the creation and perception of space: the vertical line running from head to toe, and the "direction of free movement"—that is, forward locomotion.[108] Vision, which is determined by the location and position of our eyes, is also directed forward. In Schmarsow's terms, "the psychological root of architecture lies in the third dimension," and its aesthetic appreciation results directly from the human physical orientation toward horizontality.[109] The subject's body is an instrument for spatial exploration dependent upon movement. For Schmarsow, architecture is a material instantiation of the results of the physical/bodily examination, according to the body's axes, of the outside world.[110]

While the planar field of vision is rather static, it is enlivened by the movement of the eye and its muscles.[111] This movement is the source of aesthetic pleasure, as motion directly affects emotion. In other words, activity of the physiological apparatus directly affects mental state. The same mechanism applies to perception in space, although at a heightened level, for it is through a combination of "real movement of location and its images of recollection" (*Erinnerungsbilder*) that the planar image is enlivened and the "side by side" of the pictorial surface dissolves into the "one after the other" of spatial perception.[112] During movement or the temporally successive perception of space, not only are images assembled into a coherent linear sequence; they are also combined with impressions stored in memory. The passive reception of impressions is thus reinterpreted as an active mental process. However, Schmarsow fails to demonstrate the specific transforma-

tion of physical/muscular action into psychic movement, of motion into emotion, nor does he justify how the movement of the eyes can be likened to bodily movement in the way suggested.

Schmarsow's reference to "images of recollection" deserves closer attention. As we have seen, for Schmarsow, the experience of space is a combination of stored mental images and impressions perceived through ocular/bodily movement. In fact, in his theory, the actual bodily experience of a space is not even necessary, since it can be substituted with the movement of the ocular apparatus. Aesthetic pleasure is not thereby diminished; on the contrary, "virtual" experience is the final objective of any aesthetic perception of a space. Bodily movement is only the initial step in the aesthetic appreciation of space, which can perhaps best be characterized as a conjunction of visual stimuli and the activation of the imagination based on stored mental representations. Spatial perception, then, is not so much about the actual movement through space as it is about the mental processes released by the visual perception of space. In another instance, Schmarsow talks of the "linking of images" that (in the mind) "entice imagination into poetic interplay."[113]

It is striking that Schmarsow's discussion of real and virtual mobility seems to anticipate directly what Anne Friedberg in her study *Window Shopping: Cinema and the Postmodern* (1993) has termed the "mobilized" and the "virtual" gaze. According to Friedberg (and based on Walter Benjamin's synopsis of the *Arcades Project* titled "Paris, Capital of the Nineteenth Century"), the evolving metropolis created a new regime of a "mobilized gaze," which was personified in the figure of the flâneur. A number of proto-cinematic devices such as panopticons and panoramas and, eventually, the cinema itself allowed the gaze to become "virtual." More precisely, it was movement that became virtual, as these devices allowed the subject to imagine journeys through space and time while being physically immobilized. In other words, "The observer became more immobile, passive, ready to receive the constructions of a virtual reality placed in front of his or her unmoving body."[114] The parallels to Schmarsow's thinking are obvious, even though Schmarsow did not conceive of spatial imagination as passive/receptive, but as active engagement in the construction of a virtual spatiality. As in the cinema, the optical stimuli of an architectural work of art set the viewer's mind in motion, initiating aesthetic pleasure. It therefore seems appropriate to characterize Schmarsow's thinking as a proto-cinematic theory of space.[115]

Thus, Schmarsow strikingly anticipates not only the notion of an embodied spectator, but also Eisenstein's idea of architecture as a proto-cinematic device that generates images through sequence and montage. It is hardly coincidental that Schmarsow elaborated his theory at exactly the historical moment when the Lumière brothers made photographic images move, and when Auguste Choisy put forward his theory of Greek urbanism as organized according to an embodied, mobile viewer. Various

scholars have interpreted the genesis of film as a consequence of then-ongoing research in perceptual physiology and psychology, as evidenced in the experiments of Étienne-Jules Marey, Eadweard Muybridge, the Leipzig physiologist Otto Fischer, and in particular Hugo Münsterberg.[116] On a more general level, the close relationship between psychology and film had already been noted by Walter Benjamin in his "The Work of Art in the Age of Its Technological Reproducibility" (1936). In a key passage, the philosopher compares film's potential to analyze a (visual) fact to psychoanalysis: "[Freud's] *Zur Psychopathologie des Alltagslebens* [*On the Psychopathology of Everyday Life*] . . . isolated and made analyzable things which had previously floated unnoticed on the broad stream of perception. A similar deepening of apperception throughout the entire spectrum of optical—and now also auditory—impressions has been accomplished by film. One is merely stating an obverse of this fact when one says that actions shown in a movie can be analyzed much more precisely and from more points of view than those presented in a painting or on the stage."[117] And further: "Indeed, the train of associations in the person contemplating these [moving] images is immediately interrupted by new images. This constitutes the shock effect of film, which, like all shock effects, seeks to induce heightened attention. *By means of its technological structure, film has freed the physical shock effect—which Dadaism has kept wrapped, as it were, inside the moral shock effect—from this wrapping.*"[118] Benjamin understands cinematic montage as a means for the production of meaning based on "shock," that is, visual juxtaposition. His montage theory is therefore closely related to the concept of dialectical montage as developed by the early Eisenstein. Indeed, Benjamin (like Le Corbusier) had visited Moscow in 1926–27, where he saw several of the programmatic films by Eisenstein, Vertov, and Pudovkin and familiarized himself with the montage theory of the Soviet avant-garde.[119]

MONTAGE AND TRANSPARENCY: THE *GLASS HOUSE* PROJECT

If "Montage and Architecture" provided a theoretical summation of its author's thinking on the relationship of space, body, movement, and visuality, Eisenstein's interest in architecture as a theoretical category is also evidenced in a couple of unrealized film projects. The most relevant of these to our context is *Glass House,* which Eisenstein began in the late 1920s and abandoned for lack of funding. Despite its fragmentary state, the notes and sketches illuminate the author's preoccupation with the avant-gardist architectural problem of transparency and its implications for cinematic montage.

In the film's narrative, an old architect builds a skyscraper. Despite the complete transparency of all the ceilings and walls, the inhabitants cannot see one another or watch one another's actions (fig. 5.6). A poet eventually opens their eyes, but the new insight leads to intrigues and catastrophes and, eventually, the destruction of the building. A robot deals the first blow

to the structure. Standing on top of the rubble when the job is done, the robot takes off its mask—and is identified as the architect himself.[120]

If "Montage and Architecture" attempts to retro-project cinematic categories of montage and sequence onto ancient architecture and urbanism, *Glass House* reverses the relationship between the media by proposing cinema as an interpretation and critical evaluation of contemporary architectural theory. More specifically, Eisenstein uses the film to reflect critically on the architectural problem of transparency through experiments in double exposure. Both *Glass House* and Eisenstein's text "Rodin and Rilke" (1945), with its passages on transparency, strongly emphasize the architectural character of Eisenstein's theory of montage.

The unexecuted film project *Glass House* has been edited in a number of variants and languages, based on Eisenstein's notes and synopsis.[121] Eisenstein worked intensely on the project between January 1927 and June 1930, when he also drafted the synopsis. A first in-depth analysis and interpretation of the project was undertaken by film scholar Oksana Bulgakowa in her book *Sergej Eisenstein—Drei Utopien* (1996; *Sergei Eisenstein—Three Utopias*).[122] Bulgakowa interprets Eisenstein's script as a double polemic: on the one hand, against the utopian visions of glass architecture promoted by Bruno Taut and the *Gläserne Kette* (Glass Chain), and on the other hand, against the Russian productivists' and constructivists' ideal of architecture as an apparatus for organizing life and subordinating it to control.[123] Given Eisenstein's biography as the son of an architect, Bulgakowa reads the script as an Oedipal rebellion against paternal discipline, as epitomized

Fig. 5.6 Sergei Eisenstein, Drawing for *Glass House*, 1926–30, from Eisenstein, *Glass House: Du projet de film au film comme projet* (2009).

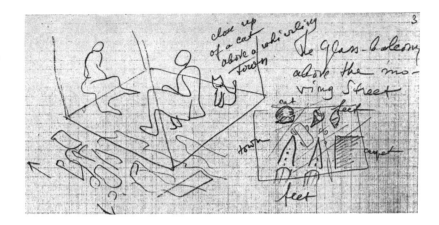

Fig. 5.7 Sergei Eisenstein, Drawings for *Glass House*, 1927, from Eisenstein, *Glass House: Du projet de film au film comme projet* (2009).

in modernist architectural dogma. Film scholar François Albera places a different accent by reading the project as a "grand laboratory for experiments and reflections upon the problems of representation in painting, sculpture, and architecture under the aspect of transparency," and situates it within contemporary architectural discourse, referencing examples from expressionism (Bruno Taut) and post-expressionism (Mies van der Rohe's Friedrichstraße skyscraper project) to modernism (Le Corbusier, Moholy-Nagy, Gropius).[124] Albera argues that for Eisenstein, glass architecture and its qualities of transparency, reflection, and other mirror effects led to a "destruction of form," to the blurring between interior and exterior spaces; a comparable "destruction of form" was to be achieved in film through the means of montage.[125] Albera concludes that architectural problems (such as transparency) are not only pivotal for the *Glass House* project, but serve as a structural model for Eisenstein's entire thinking: "Illuminating for Eisenstein's work . . . is the significance of architecture as a model. . . . This reference pervades his entire theoretical reflection.[126]

In a recent discussion of the project, film scholar Antonio Somaini also reads the *Glass House* against the background of architectural utopias of transparency. He stresses the utopian impetus of glass in the projects and writings of German expressionists from the 1910s such as Paul Scheerbart, Bruno Taut (*Die Stadtkrone* [1919; *The City Crown*], *Alpine Architektur* [1919]), and even the early Mies van der Rohe (Friedrichstraße skyscraper). Somaini also situates Eisenstein's project in the context of Soviet literature of the time, in particular the works of Nikolay Chernyshevsky (*What Is to be Done?*, 1863), Velimir Khlebnikov (*Ourselves and Our Buildings*, 1914–15), and Yevgeny Zamyatin (*We*, 1920–21), all of which develop visions of society on the basis of modern (glass) architecture that oscillate between the utopian and dystopian.[127] Somaini also proposes a comparison between the notion of architectural transparency and Eisenstein's cinematic practice of double exposure and cross-fading (*surimpression*), which will be discussed further.[128] However, the critic's placement of *Glass House* in the context of expressionist debates can be questioned, as those debates were long out-

Embodied Spectatorship

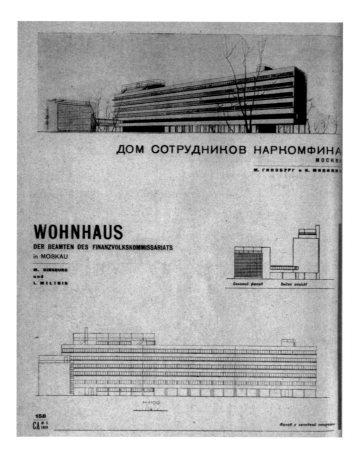

Fig. 5.8 Moisei Ginzburg, Narkomfin building, Moscow, 1928–32, from *SA* 5 (1930).

dated by the late 1920s, when the project was conceived. Somaini does not distinguish between transparency in the proper sense of the term and translucency, which was the main object of expressionist interest in emerging glass architecture. Moreover, I contend that Eisenstein's considerations of the analogy between architectural transparency and cinematic aesthetics must be considered in view of Colin Rowe and Robert Slutzky's seminal distinction between "literal" and "phenomenal" transparency, which dominated architectural debates in the postwar period.[129]

According to a note that Eisenstein dated September 18, 1927, the "theme" of the film would be "alienation and isolation as necessary by-products of a system of chaotic competition. In the capitalist environment there is no solidarity, no one escapes the 'eat or be eaten.' Juxtapose at the same place the ideal communal buildings to the destroyed glass house."[130] Through the building's total transparency and lack of walls in the proper sense, any idea of privacy or private space was put into question (fig. 5.7). This was not merely a dystopian vision of modernist aesthetics or modern (American) capitalism; at the same time, it was also a direct comment on contemporary Soviet theories of collectivism and collectivist architecture—such as, for example, Moisei Ginzburg's Narkomfin building for collective living in Moscow (fig. 5.8). *Glass House* may also be seen as a self-

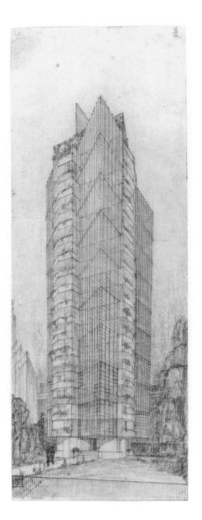

Fig. 5.9 Frank Lloyd Wright,
Project for St. Mark's-in-the-
Bouwerie Towers, New York,
1927–31. The Museum of
Modern Art, New York.

reflexive commentary on the history of cinema: in the medium's initial phase, films were usually produced in structures entirely made out of glass, similar to greenhouses.[131] As an architectural typology, the glass house must be traced back to Joseph Paxton's Crystal Palace at the first World's Fair in London in 1851, where the entirely steel and glass structure served as a giant showcase for the industrial production of nations. As has been pointed out, this "great exhibition of things" was the ultimate apotheosis of high capitalist consumer culture and the concomitant society of the spectacle.[132] Eisenstein's *Glass House* allegorizes glass as a building material that, through the power of display, transforms everything into a commodity, including the social relationships and interactions housed within it.

Eisenstein started thinking about the *Glass House* project in January 1927. The early notes mention that the idea for a "glass skyscraper" had come to him as early as mid-April 1926 in a room at the Hotel Hessler at Kantstraße in Berlin, "under the influence of experiments with glass architecture."[133] While the Hotel Hessler itself was a conventional stone construction, Berlin at large was witnessing a lively debate on highrises, not least with regard to the Friedrichstraße skyscraper competition. A few years later, on June 29, 1930, Eisenstein discovered an illustration of Frank Lloyd Wright's high-rise envisioned for the Bowery in New York—the St. Mark's-in-the-Bouwerie Towers (1927–31)—in *New York* magazine (fig. 5.9). He comments in his diary, "Frank Lloyd Wright proposes a glass tower for New York, he has adapted his art to the machine age."[134] Eisenstein pasted the illustration into his diary and added the words, "This is the glass skyscraper 'invented in Berlin.'"[135]

Eisenstein's knowledge of contemporary architecture and architectural discourse is noteworthy. After Wright's ambitious beginning and his celebrated reception in Europe from 1910 onward (following the famous Wasmuth portfolio of his early work), the architect's career dwindled in the

second half of the 1920s and was overshadowed by a professional and personal crisis. He did receive a number of commissions for private residences in Southern California and Los Angeles. However, with their references to Mayan architecture and vernacular styles of the Americas, these houses showed Wright as more of a latecomer in national romanticism than a protagonist of the modern movement, which was increasingly being defined by the European avant-gardes and their abstract machine aesthetic, which he at times fiercely criticized. The Edgar J. Kaufmann House (Fallingwater) of 1936 is generally considered to have boosted Wright's second, later career and to have launched him back onto the main stage of contemporary architectural debates. Hence, Eisenstein's comments suggest his awareness of Wright's professional situation around 1930: by interpreting St. Mark's-in-the-Bouwerie Towers as a turn to the machine aesthetic that was to be celebrated and canonized in Henry-Russell Hitchcock and Philip Johnson's 1932 *Modern Architecture* exhibition at the Museum of Modern Art, Eisenstein anticipated Wright's later re-inscription into the mainstream of avant-garde architectural aesthetics. However, Eisenstein's interpretation of the project as an "adaptation" of its author's art "to the machine age" seems overstated. The project clearly displays Wright's architectural idiosyncrasies: his organicism (the building's "tap-root" structural system is inspired by a tree), the predilection for diagonals, the sculptural expressionism of the cantilevered concrete balconies, and the use of ornamented precast concrete panels in the interior. Therefore, although the project is based on standardized prefabrication and features a large glass curtain wall—the first in Wright's oeuvre—it cannot fully count as an architecture of transparency in the way Eisenstein saw it in his unrealized film. In any case, the diary page with the pasted image of Wright's project again points to Berlin as the site of invention of "the glass skyscraper," whether Eisenstein is referring to the building typology in general or his film more specifically. There is hardly a doubt that he had in mind Mies's visualization for the Friedrichstraße skyscraper project when he began to conceive his film (see fig. 4.1). If this interpretation is correct, Eisenstein's discovery of Frank Lloyd Wright's Bowery project would have reminded him to come back to an idea that was first sparked a few years earlier in Berlin.

I would like to return to Eisenstein's initial remark that his film project had developed "under the influence of experiments with glass architecture."[136] Unlike earlier interpretations, I would contend that his project had little to do with the expressionist utopias of the 1910s, which not only were historically distant by the time Eisenstein turned to glass architecture, but also pursued an entirely different interest in the aesthetics of glass—that is, translucency, or, what architectural historian Rosemarie Haag Bletter has called "opaque transparency," instead of transparency proper.[137] If Eisenstein's inspiration was indeed related to Mies van der Rohe's Friedrichstraße skyscraper, it is quite likely that he came across the building in its first publication, which appeared—ironically—in Bruno Taut's (post-)expressionist

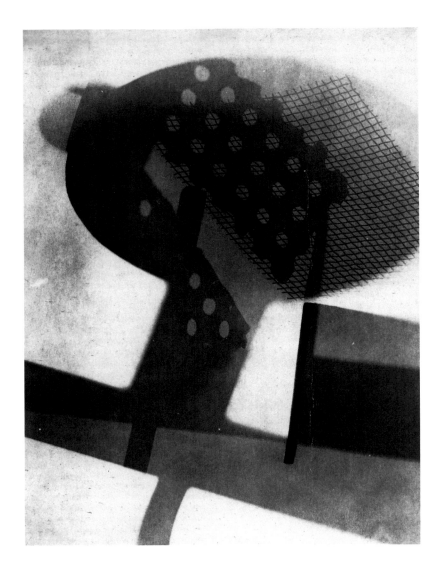

Fig. 5.10 Lázsló Moholy-Nagy, *Photogram*, 1923–30. Photograph.

journal *Frühlicht* in the summer of 1922. In his commentary, Mies discusses his "experiments with a glass model" in order to explore the new building material's possibilities: "In using glass it was not the effects of light and shadow that mattered, but the rich interplay of light reflections."[138] It was precisely the effect of these photographic experiments with the reflection of light on the transparent surface that intrigued Eisenstein and inspired his (unrealized) film.[139] This interest points at the contemporary experimental photography of Alexander Rodchenko in his *Surfaces Reflecting Light* series (!), or the photograms of Moholy-Nagy, who applied the title "glass architectures" to a series of his abstract compositions with transparent, overlapping fields of color (fig. 5.10). Besides these references to photography, Eisenstein seems to take up directly what Mies discussed in his publication of the Friedrichstraße skyscraper. He shares the preoccupation of contemporary architects with the problem of transparency and its effects on the

Embodied Spectatorship

perception of architecture and space. Seen in this light, Eisenstein's *Glass House* project was a continuation of a discourse on architectural aesthetics in the medium of film.

In his 1945 essay "Rodin and Rilke," Eisenstein discusses the "problem of space in art history" and considers at length modernist architecture and cubist collage.[140] Referencing the physicist and perceptual psychologist Gustav Theodor Fechner, Eisenstein argues that a visual phenomenon can be perceived as either a volume or as the organization of space. For him, art is most interesting in those instances where the two modes interact, as in Picasso's cubist painting or Vladimir Tatlin's *Counter-Reliefs*. He goes on to state, "That area which, liberated from a strictly figurative iconicity, required quite naturally . . . that one discovers perfect solutions for the problems of form both as relief and counter-relief, both as interior space and exterior volume, as well as non-figurative image—at the same time concave and convex—was, of course . . . architecture."[141] Here, again, Eisenstein argues that contemporary architecture has significantly expanded and pioneered the possibilities of a modern aesthetic, more so than any other art, except perhaps film. Eisenstein refers to the "unity of the interior and the exterior," a "triple synthesis" of interior design, exterior space, and the relationship between the exterior and the environment, and he credits the Bauhaus and Le Corbusier for having "resurrected" this synthesis after what he calls the "mistakes" of the nineteenth century.[142] In the *Glass House* project, it is precisely this penetration of interior and exterior that holds his interest. In another passage of the same essay, he applauds the new glass architecture for having transcended the old dichotomy between interior and exterior and for having established a synthesis based on new perceptual possibilities: "The architecture of glass walls, an enlargement of the first openings envisaged for light—the windows—permits an unlimited lateral extension of the dwelling—as far as the mountain chains and the horizon line of the ocean."[143]

How do these considerations of the organization of space in modern architecture relate to the problem of (cinematic) montage? For Eisenstein, the connection is quite clear: montage, like architectural transparency, is based on the dissolution and combination of two individual perceptions into a new perceptual synthesis. Thus, in his words, montage in cinematography "wants that from two fragments situated next to each other there emerges a third—a composed image born from a juxtaposition of representations."[144] It is evident that he believes architectural transparency produces similar "composed images." In effect, Eisenstein is proposing a superimposition of different concepts of montage: on the one hand, a dialectical juxtaposition of heterogeneous elements, and on the other hand, a perceptual phenomenon that produces composite mental images born from these elements. Antonio Somaini has pointed out that in his notes for the *Glass House* project, Eisenstein experimented with transparency as a device that unites and separates at the same time.[145] In fact, the filmmaker explored

Fig. 5.11 Film stills from Sergei Eisenstein's *Strike*, 1924, from Antonio Somaini, *Les possibilités du montage* (2012), 94.4.

the possibilities of cross-fades and superimposition in various films such as *Strike* (1924) or *The General Line* (1929) in order to achieve "composed images" similar to those evoked by transparent architecture (fig. 5.11).

The effect of the superimposition of two visual impressions on a glass façade has been a primary preoccupation of modernist architectural thinking. It was the modern metropolis and the advancement of technology that made such a visual experience possible in the first place. Against the Enlightenment myth of transparency as the equivalent of absolute openness and rationality, the experience of transparency in the architecture of the city soon led to an awareness that transparency, through reflection, conceals as much as it displays. Particularly illustrative in this regard are Eugène Atget's photographs of Paris display windows, in which the object on display and the street scene reflected in the windowpane are visible at the same time (fig. 5.12). As is well known, the surrealist artists of the 1920s "discovered" Atget as one of their predecessors and celebrated his photographs for unconsciously prefiguring the surrealist notions of montage and the *cadavre exquis* (exquisite corpse). The effect of mirroring on the glass façade also brings to mind Lacan's theory of the mirror stage, as it makes the viewing subject aware of him perceiving his own self.[146] Anthony Vidler has reminded us that this is an instance of the "architectural uncanny," in Sigmund Freud's understanding. According to Freud, the uncanny results from a confusion of the self with the outside world (which, one could add, is induced by transparency and reflection through the superimposition of images). Vidler invokes the French psychoanalyst Mahmoud Sami-Ali to make this point: "The feeling of the uncanny implies the return to that particular organization of space where everything is reduced to inside and outside and where the inside is also the outside."[147] In this understanding, the cinematic superimposition of images also has an effect of confounding interior and exterior spaces and, ultimately, the limits of perceiving subject and perceived object. While these ideas have informed psychoanalytic theories of space, Eisenstein's use of cinematic superimposition and his interest in the penetration of interior and exterior space seem to deliberately reenact a visual effect on the screen that was first introduced by the architectural (im)materiality of glass façades in the modern metropolis.

In a famous pictorial comparison in *Space, Time and Architecture* (1941), Sigfried Giedion places a reproduction of Picasso's cubist painting

Embodied Spectatorship

Fig. 5.12 Eugène Atget, Display window of a shop on the
Avenue des Gobelins, from *Paris pittoresque,* third series, 1925.

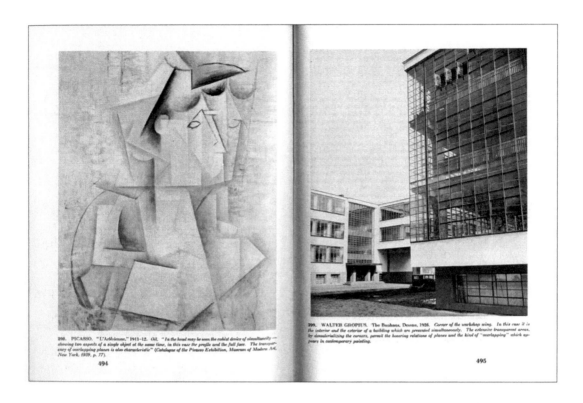

Fig. 5.13 Double-page
spread from Sigfried
Giedion, *Space, Time and
Architecture: The Growth
of a New Tradition* (1941),
494–95.

L'Arlésienne (1911–12) next to a photograph of Walter Gropius's Bauhaus
building in Dessau (1926) (fig. 5.13),[148] and, very much in the manner of
Eisenstein, uses the idea of superimposition to relate the works' effects.[149]
Giedion's concept of transparency is based on what he called a "relational"
space. In the words of architectural historian Detlef Mertins, "For Giedion
and his constructivist colleagues, [transparency] was a function of a four-
dimensional spatiality activated by a mobile and participatory subject. Gie-
dion described this as a 'relational' space rather than a space of objects."[150]
If this interpretation is correct, Giedion's superimposition is not merely a
visual phenomenon that has spatial implications; it also actively involves
the spectator in the construction of a new conception of space. This idea of
relationality strikingly converges with Eisenstein's conception of embodied
spectatorship as developed in "Montage and Architecture." It has to remain
uncertain whether Giedion deliberately references cinematic vocabulary
here or whether, conversely, Eisenstein draws from Giedion's observations;
in any case, it is evident that cinematic and architectural thinking widely
converged at this specific historical moment in the mid-1940s, with a con-
ception of space based on a complex interdependency of visuality, percep-
tion, movement, and embodied spectatorship.

It is striking to note that Eisenstein's "Rodin and Rilke" anticipates
one of the most influential texts theorizing architectural transparency in
the postwar period, Colin Rowe and Robert Slutzky's "Transparency: Lit-

eral and Phenomenal."[151] Very much like Eisenstein (although they were probably unaware of the filmmaker's writings)—and in explicit reference to Giedion—Rowe and Slutzky base their argument about architectural transparency on the cubist paintings of Picasso and Georges Braque. Rowe and Slutzky expand on Giedion's comparison: "Transparency may be an inherent quality of substance, as in a glass curtain wall; or it may be an inherent quality of organization. One can, for this reason, distinguish between a literal and phenomenal transparency."[152] For Rowe and Slutzky, transparency in architecture cannot and should not be reduced to a material quality, but should be explored as an aesthetic quality that relies on what Eve Blau describes as "the simultaneous perception of different spatial locations and superimposed forms that appear to interpenetrate without optically destroying each other."[153] The authors root their reading in gestalt theory, in particular in the writings of Gyorgy Kepes, whose *Language of Vision* (1944) they quote at the beginning of their essay. Gestalt theory illuminates the preoccupation with vision and space shared by the thinkers and authors in our context, as Kepes writes: "If one sees two or more figures overlapping one another, and each of them claims for itself the common overlapped part, then one is confronted with a contradiction of spatial dimensions. To resolve this contradiction one must assume the presence of a new optical quality. The figures are endowed with transparency; that is they are able to interpenetrate without an optical destruction of each other. Transparency however implies more than an optical characteristic, it implies a broader spatial order. Transparency means a simultaneous perception of different spatial locations."[154] Read against Eisenstein's ideas on the "superimposition" of images, it is evident that Rowe and Slutzky's notion of "phenomenal transparency" as defined here may not only be indebted to the writings of theoreticians such as Kepes, Moholy-Nagy, and others, but also may be informed—directly or indirectly—by visual experimentation in avant-garde cinema. While no reference to film is made in their text, it is striking to see how similar Eisenstein's theory of cinematic montage is to the major architectural theories of transparency, which became one of the primary aesthetic preoccupations in modernist architectural thinking. It could be concluded, then, that transparency—and in particular, phenomenal transparency—was the major locus of modernist architectural thought about, experimentation with, and realization of effects that avant-garde cinema had subsumed under the term "montage." Given the extraordinary reception of Rowe and Slutzky in architectural discourse from the early 1960s onward, their text was seminal in shaping an entire generation's understanding of architectural visuality and space. By the same token, given the striking relevance of Eisenstein's largely unknown writings for architectural discourse in this period, the influential architectural historian Manfredo Tafuri's introduction of Eisenstein's theories on montage and space into architectural debates should come as no surprise.

For a long time, Eisenstein's writings were largely unavailable to a Western audience. Therefore, despite their obvious relevance, they were not widely received in art and architectural history until recently. A major catalyst in this later appreciation was the Italian architectural historian Manfredo Tafuri, who in 1970 published an essay titled "Piranesi, Eisenstein e la dialettica," which was translated into English as "The Dialectic of the Avant-Garde" in 1977 in the journal *Oppositions,* alongside a translation into English of Eisenstein's "Piranesi, or the Fluidity of Forms."[155] Tafuri's essay was reprinted under the new title "The Historicity of the Avant-Garde: Piranesi and Eisenstein" as the second chapter of his history of avant-garde architecture, *The Sphere and the Labyrinth* (1987) (original Italian: *La sfera e il labirinto* [1980]).[156]

In Tafuri's definition, which takes into account the seminal works of theoreticians such as Georg Simmel and Walter Benjamin, architectural avant-gardism successfully incorporates the shock experience of the metropolis into architectural design.[157] Tafuri put forward this theory in "The Dialectic of the Avant-Garde," which was included as a chapter in his *Architecture and Utopia*.[158] As an extension of Benjamin's concept of the shock and the montage aesthetic as theorized in the *Arcades Project,* Tafuri likewise references montage as a fundamental element of a modern sensibility (due to the English-language use of "assemblage" to refer to standardized industrial construction, *montaggio* is translated as "assemblage"):[159] "For all the avant-garde movements—and not only in the field of painting— the law of assemblage was fundamental. And since the assembled objects belonged to the real world, the picture became a neutral field on which to project the *experience of the shock* suffered in the city. The problem now was that of teaching that one is not to 'suffer' that shock, but to absorb it as an inevitable condition of existence."[160] In other words, the emergence of the modern metropolis dealt a serious blow to human perception, and avant-garde architecture and art served as an outlet for this psychological condition, by which it could be transformed into a productive force; hence it was a sort of (collective) psychotherapy. In this process, according to Tafuri, the technique of montage or "assemblage" was fundamental in that it allowed this "projection" to take place. Tafuri's understanding of "montage" conforms to what Peter Bürger in his *Theory of the Avant-Garde* calls the integration of "fragments of reality" into the artwork, whereby the fragments are selected and arranged in the "neutral" field of the picture.[161] Exactly what Tafuri means by the "law of assemblage" is exemplified in a subsequent passage discussing avant-garde architectural circles between 1920 and 1930 and in particular *die Neue Sachlichkeit* (New Objectivity), which "adapted the method of designing to the idealized structure of the assembly line. The forms and methods of industrial work became part of the organization of the design and were reflected even in the ways proposed

for the consumption of the object. From the standardized element, to the cell, the single block, the housing project and finally the city: architecture between the two wars imposed this assembly line with an exceptional clarity and coherence. Each 'piece' on the line, being completely resolved in itself, tended to disappear or, better, to formally dissolve in the assemblage."[162] From Tafuri's point of view, then, the aesthetic principle of assemblage or montage is essentially the architectural equivalent of the economic reality of standardization, serial production, and the modern division of labor. That is, assemblage is the cultural superstructure over the economic substructure of the assembly line. It seems doubtful that such a definition can be upheld for art in general: even Dadaist photomontages, with their strong emphasis on the reuse and reassembly of reproduced pictorial elements, in the end relied on manual labor by (usually) a single producer or author. In the field of architecture, issues of standardization and prefabrication increasingly changed the building industry, although perhaps not as radically as modernist rhetoric would have it. Nevertheless, this materialist interpretation of the aesthetics of montage/assemblage is fundamental to Tafuri's reading of the history of the avant-garde, according to which the montage aesthetic is the logical—and, in fact, historically inevitable—result of the economic conditions of modernity under capitalism.

Tafuri's materialist interpretation may seem incongruent with Eisenstein's "embodied" interpretation of montage. Nevertheless, in his reading of Eisenstein's essay on Piranesi's *Carceri* etchings, Tafuri refers directly to the filmmaker's montage theory as applied to the visual grammar of the Enlightenment (see fig. 1.7).[163] Tafuri concurs with Eisenstein that the origins of the avant-garde and of a modern conception of space and its representation must be seen in the mid-eighteenth century, and specifically in Piranesi's work. The "origin" of a modern conception of space has been a subject of heated debate in the history and theory of modern architecture. In *Space, Time and Architecture,* Sigfried Giedion describes the malleability of baroque space as the predecessor of a modernist conception of flowing space. In contrast, the American architectural historian Vincent Scully, in *Modern Architecture* (1965), maintains that baroque architecture conformed to an "absolutely firm order" that only afforded "an illusion of freedom"—in other words, that baroque space belonged to a premodern age of absolutist rule. The real invention of modern space, according to him, occurred in Piranesi's *Carceri,* where "the symmetry, hierarchy, climax, and emotional release of Baroque architectural space . . . were cast aside in favor of a complex spatial wandering, in which the objectives of the journey were not revealed and therefore could not be known."[164] Scully suggests that modernist space places its user (and perceiving subject) in a state of (almost existential) disorientation and insecurity with regard to his or her place in space and time. This idea conforms with canonical historical and sociological readings of modernity. It is also compatible with our understanding of montage, first of all as a spatial representation that, in its polyfocality,

requires an embodied spectator who moves between various points of view, and second of all as a procedure of transparency that shifts the perceiving subject into a state of (locational) uncertainty or uncanniness, as we have seen. Placelessness, in other words, is widely acknowledged by a number of thinkers on modern space, including Tafuri; montage would seem an aesthetic strategy highly suited to visualizing this fundamental condition.

Tafuri's reading of Eisenstein's interpretation of the spaces of Piranesi touches upon another point, the seriality of the individual pictures and their synthesis through montage into a single sequence: "It is clear that Eisenstein reads the entire series of the *Prisons* as discontinuous fragments of a single sequence, based on the technique of 'intellectual montage': based, that is, following his own definition, on a conflicting 'juxtaposition of intellectual stimuli which accompany each other.'"[165] At the same time, "Eisenstein's theory of montage den[ies] any artistic solutions based on continuity"; rather, it is about the "counterposition" of the individual elements and the "explosion" that is released from this tension.[166] However, Tafuri's argument extends beyond merely stating that Piranesi's *Carceri* can be seen as montages *avant la lettre,* and therefore as an instantiation of a modern spatiality. Rather, he sees Piranesi's etchings as a visual discourse on the construction and destruction of visual meaning itself, or, as it were, a discourse on the end of representation in the traditional sense of the concept. In making this interpretation, Tafuri refers to the semiotic theories of the Russian formalists: "We find ourselves in the face of what the Russian formalists had called *priem,* a 'semantic distortion': that is, the 'material elements' of the Piranesian composition undergo a change of meaning, due to the violent alteration of the mutual relations which originally connected them."[167] Or, as Mario Gandelsonas remarks in a postscript to Tafuri's essay, "The modernity of Sergei Eisenstein's sensibility allowed him to see in Piranesi's *Carceri* a subversive action against the basic principles of representational art and therefore of architectural language."[168] Eisenstein, it could be concluded, helped Tafuri to see in Piranesi the beginning of the deconstruction of the classical grammar of architecture and, by extension, the continuous Euclidian notion of space.

Read against Tafuri's overarching project in the philosophy of history, it becomes evident that this insight also functions with regard to contemporary practice: the unity of the past is no longer attainable, but its fragmented formal repertoire looms over the discipline as the elements of a montage to come. Such a reading could be considered as the prolegomenon of the aesthetics of postmodern architecture. Tafuri does not have postmodernism in mind as we know it, but rather the fate of the (Russian) avant-gardes vis-à-vis the conservative backlash under Stalin. As a matter of fact, Tafuri takes up Eisenstein's discourse on the aesthetics of montage in order to turn it against the historic place and moment when this theory emerged and was transformed, the 1920s and 1930s Soviet Union. Tafuri reconceptualizes montage: rather than merely a method for the production

and reception of images, he now interprets it as a device for explaining history. Thus, Tafuri reads Eisenstein's text on Piranesi as an ambiguous move that tried to uphold the (original) avant-gardist impetus of destructing the idea of the organic work of art, while at the same time adhering to a representational formal vocabulary. In Tafuri's reading, this undertaking runs parallel to 1930s socialist realist architecture and its double bind between avant-gardist rhetoric and the reappropriation of historicist architecture. As Tafuri writes: "Precisely in the hidden concept of such an analysis lies the reason for Eisenstein's interest in the *Prisons*. In Piranesi . . . the Soviet director reads the synthesis of two opposites: on the one hand, the experimentalism of the avant-garde and of formalism, which in these examples appears to be sanctioned historically; on the other hand, the confirmation of the character of the totality of the text and the salvation of its organicity, the permanence of the (dynamic) structuralism of the form."[169] In this reading, Eisenstein's interpretation becomes a commentary on the Soviet cultural politics of synthesizing the heritage of avant-gardist abstraction with that of historicist realism. If one wanted to find a way to reconcile and bring into a productive synthesis the completely contradictory notions of architecture and space, Tafuri argues, the Enlightenment's underbelly might be a good place to start looking.

Eisenstein's montage theory is relevant for Tafuri in one important further aspect. Tafuri sees Eisenstein's conviction that montage serves to activate the viewer, and ultimately, to trigger political action, which is in line with the tenets of the historical avant-gardes: "The principle of montage had always been linked to the theme of activating the public."[170] Even though Tafuri ultimately dismisses Eisenstein's claims of the emancipatory power of cinema, it is nevertheless clear that he himself has similar expectations with regard to avant-garde architecture—expectations that were doomed to fail, as history has shown and as Tafuri was well aware.

EISENSTEIN AND CONTEMPORARY ARCHITECTURE

If the mutual interdependencies between Eisenstein's montage thinking and modern architecture culture have been multiple, we will now look into how Eisenstein's theories have resonated with contemporary architects. While a discussion of cinematic approaches in contemporary architectural production would be too far-reaching, the following brief remarks address architects operating with a specific understanding of "montage" as a spatial practice as put forward by Eisenstein.

Movement through space, and by extension, peripatetic, embodied spectatorship, were key issues for modern architecture. This is confirmed not only by Le Corbusier's architectural promenades or Walter Gropius's Bauhaus building in Dessau, which can only be fully appreciated by taking a multitude of viewpoints in moving around the building; the work of Philip Johnson is another example. In his seminal 1965 text "Whence

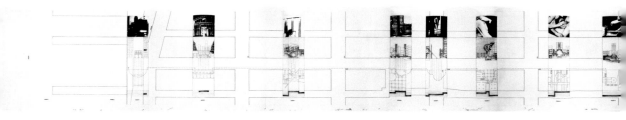

Fig. 5.14 Bernard Tschumi, *The Manhattan Transcripts,* part 2, *The Street,* 1978. The Museum of Modern Art, New York.

and Whither," Johnson states: "Architecture is surely not the design of space, certainly not the massing or organizing of volumes. These are auxiliary to the main point which is the organization of procession. Architecture exists only in *time*."[171] Several years earlier, in planning his Glass House Estate in New Canaan, Connecticut, Johnson inscribed upon the existing topography a network of processional paths interconnecting the various structures. Johnson illustrated his design methodology in a well-known photographic essay that was published in the *Architectural Review* in 1950. On several consecutive two-page spreads, Johnson references a wide array of examples from art and architectural history that had supposedly "influenced" his design, from Le Corbusier's Farm Village Plan to Theo van Doesburg's "Basso Continuo of Painting" and Kasimir Malevich's suprematism to Schinkel's Casino in Glienicke Park and Ledoux's Maison des Gardes Agricoles. Johnson's well-nigh ostentatious referencing of (historical) precedents would seem unusual and surprising for a modern architect.[172] He also cited the very same illustration from Choisy's *Histoire de l'architecture* that Le Corbusier had used in *Toward an Architecture* to illustrate a "picturesque" design and planning principle organized for a peripatetic viewer. The sequentiality of perception of the buildings at the New Canaan site is mirrored in the journal's spreads, which themselves form a montage in which the single depicted elements converge mentally into a larger concept. Despite his cinematic sensibility, Johnson was most likely unaware of Eisenstein's writings at this time.

Perhaps the most important living architect who has "learned from" Eisenstein is Rem Koolhaas. It could be argued that the notion of montage is fundamental to his entire way of thinking and conceiving worlds, and consequently for his practice of design. Koolhaas began as a screenwriter, and many of his buildings can be seen as spatial projectors for sequences of images that are interconnected by a moving spectator. In the linking of these images, montage plays a key role. As Koolhaas has remarked, "I think the art of the scriptwriters is to conceive sequences of episodes which build suspense and a chain of events. . . . The largest part of my work is montage . . . spatial montage."[173] While the idea of architecture as a device for the projection of images is perhaps most evident in the two unexecuted designs for the Zentrum für Kunst und Medientechnologie (ZKM, Center for Art and Media) in Karlsruhe and the Bibliothèque nationale de France, Koolhaas's most consistent application of a cinematic conception of space is

Embodied Spectatorship

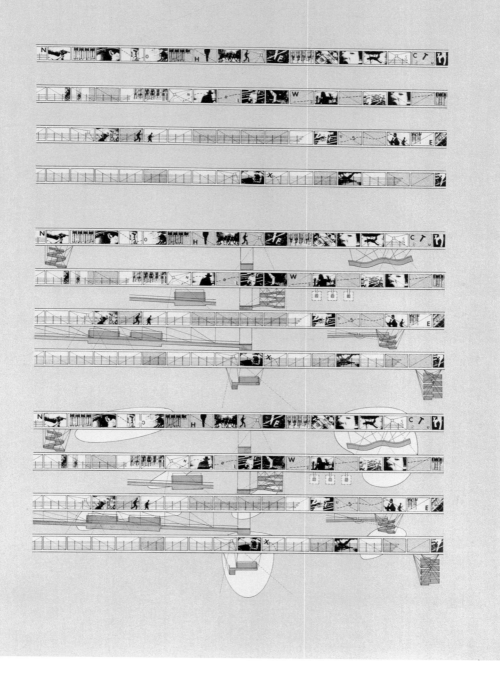

Fig. 5.16 Bernard Tschumi, *The Cinematic Beams,* Le Fresnoy,
Studio National des Arts Contemporains, Tourcoing, 1991–97.

the spaces in Nouvel's Lyon Opera (1986–93) are organized in a sequence that allows for a succession of strong visual experiences. Another device for implementing cinematic sequentiality is his use of horizontal windows, such as in the Kultur- und Kongresszentrum (Culture and Congress Center) in Lucerne (1993–2001), where they frame the landscape of the lake and Mount Pilatus cinematically. Beatriz Colomina's reading of Le Corbusier's *fenêtres en longueur* in the Villa Le Lac at Corseaux (1923–24) on Lake Geneva (see fig. 4.37) can be applied to Nouvel's building as well.[196]

By using terms such as "thickness" and "superimposition," Nouvel hints at the discourse of transparency and reflection, or what the cultural theorist Paul Virilio has termed the "aesthetics of disappearance."[197] As a matter of fact, this dematerialization of architecture into a carrier of images is evident in a number of Nouvel's "media façades" such as the Fondation Cartier in Paris (1991–94), where the architectural structure supports a large semitransparent screen. As transparency and reflection interact, there emerges an ideal representation of the city in which the Tour Montparnasse and the Eiffel Tower can be seen at the same time.[198] Another instance can be found in the metro stop Anděl in Prague (1999–2000), where the architect applied to the façade artificial reflections that reproduce Prague's medieval old town in an ideal panorama, as would not normally be seen from this point of view.[199] However, it may be inadequate to term Nouvel's optical apparatuses "immaterial," for they are materially quite present, as is confirmed by the architect's use of the term "thickness." In a recent study, Giuliana Bruno has proposed introducing the term "surface" into the discussion in order to qualify the ambiguous nature of such (architectural) screens between visuality and physical substance, media and materiality.[200]

More contemporary than the positions discussed would be the New York–based firm Diller Scofidio + Renfro, on the subject of whose work the film scholar Edward Dimendberg has recently written a monograph. With regard to their masterpiece, the High Line in New York, Dimendberg has remarked: "It is fruitful to approach the High Line as analogous to a film composed of improvised scenes edited together in a loosely organized sequence. Although linear, it lacks a single defining image or story line and contains multiple points of entry and exit. Visitors select their trajectories and destinations, yet their experience is nonetheless cohesive. 'Driven by images' whose editing and assimilation the park minimally prescripts, the High Line is a viable alternative to the more organized spaces of leisure and consumption in the contemporary city."[201]

Perhaps the most radical contemporary thoughts on the affinity of architecture and the cinema have been produced by Virilio, Nouvel's former teacher at the École Spéciale d'Architecture in Paris. Not directly referencing Eisenstein's montage theories in his writings, Virilio early on saw architecture in a competition with new media (such as video and film) in which the former is ultimately doomed to vanish. In *Esthétique de la dispar-*

ition (1980; *The Aesthetics of Disappearance*), he states: "The question today therefore is no longer to know if cinema can do without a place but if places can do without cinema. . . . The aesthetic of construction is dissimulated in the special effects of the communication machines, engines of transfer and transmission; the arts continue to disappear in the intense illumination of projection and diffusion. After the age of architecture-sculpture we are now in the time of cinematographic factitiousness; literally as well as figuratively, from now on *architecture is only a movie.*"[202] Virilio's pessimistic stance has not been confirmed by more recent architectural production, and the works of Tschumi, Nouvel, or Koolhaas may be seen as instances of architectural resistance against Virilio's prophecy. Rather than merely disappearing, contemporary architecture has come up with means to accommodate the spectacle within modernity's material culture, and to give spatial shape to the concept of cinematic montage. The examples discussed here may be seen as architectural attempts at asserting the discipline's place in and for the media age.

Montage and the Metropolitan Unconscious

Rem Koolhaas's Delirious New York

Delirious New York, Rem Koolhaas's "retroactive manifesto" for the quint-essential modern metropolis, appeared in 1978, at a moment when literary writing and theoretical discourse had become major media of architectural production as never before (fig. 6.1). The book epitomized a turn to theory and signaled that architects no longer needed to have built projects in order to be taken seriously as protagonists in the discipline. In *Delirious New York,* Koolhaas took on the role of a historian in order to tell the story of the birth of the modern metropolis, on the basis of its built manifestations. His literary account of the pragmatic building culture of super-capitalist Manhattan was intended as a polemic against the "official" historiography of modern architecture, which had neglected such compromised achieve-ments by focusing unilaterally on the utopian projects of the avant-garde and its most talented authors. If American development played a role in these histories, it was generally limited to the technological innovations of the Chicago School of the late nineteenth century and to the individualism of Frank Lloyd Wright. By stressing the joint achievement of a network of actors over individual agency, Koolhaas took up a model of architectural historiography advocated by Alois Riegl in *Spätrömische Kunstindustrie* (1901; *Late Roman Art Industry*) or Sigfried Giedion in *Mechanization Takes Command* (1941) and applied it to modern urbanism. In so doing, Koolhaas aligned himself with the structuralist camp of historiography. While the narrative approach of the discipline explained history on the basis of the agency of a few outstanding individuals, the structuralist camp emphasized that individual agency was determined by the general systemic conditions of a specific historical, political, and economic situation.[1]

 Delirious New York marks an attempt at writing an alternative history of the modern metropolis and its architecture not only as far as contents are concerned, but also with regard to methodology. I contend that in the book, Koolhaas establishes montage as an epistemological principle for the production of historical and historiographical meaning. In so doing, he draws not only from Walter Benjamin's philosophy of history as exemplified

in the *Passagenwerk* (*Arcades Project*), where montage is similarly used as a vehicle for writing urban history, but also from Manfredo Tafuri's historical project, which itself is indebted to a large degree to Benjamin's methodology. These alternate models of historiography use a self-reflexive approach to expose the problematic nature of traditional historiographical narrative. *Delirious New York*'s allegiance to these experiments makes the book a symptom of structuralist and critical discourse of the 1970s, in which the principle of montage played a significant part.

Delirious New York centers on Manhattan's urban development in the period of roughly 1890 to 1940. With this study, Koolhaas proposes an alternative reading of the evolution of a metropolitan architecture and urbanism for the twentieth century, one that distances itself from canonical accounts of the history of modern architecture as put forward by such writers as Giedion, Reyner Banham, Henry-Russell Hitchcock, Philip Johnson, and others.[2] Rather than focusing on and reappraising the heroes of the European avant-garde of the early twentieth century and some of their

Fig. 6.1 Cover of Rem Koolhaas's *Delirious New York* (1978).

Fig. 6.2 Hugh Ferriss at work in his studio.

"predecessors" in the heroic Chicago School of the 1880s, Koolhaas shifts attention to obscure figures such as Hugh Ferriss (fig. 6.2) and Raymond Hood. While the former made his fame as the author of dreamlike, *unheimlich* paper architectures, the latter was quite successful financially, but therefore was considered artistically and morally compromised by the apologists of the avant-gardes. For Koolhaas, however, Hood's example indicates that historical, and by extension, artistic relevance could be achieved by satisfying pragmatic needs. His choice of these two antithetical figures— the utopian visionary and the pragmatic builder—as the major protagonists of his account enables a dialectical approach: a montage of two seemingly irreconcilable opposites into one synthetic urban (hi)story.[3] It should be noted that Manfredo Tafuri discusses precisely these two figures in *La Città americana dalla guerra civile al New Deal,* first published in Italian in 1973. The English translation, published as *The American City: From the Civil War to the New Deal,* was not released in the United States until 1979; however, due to the prominence of the book's author, we can assume that Koolhaas was familiar with Tafuri's argument.[4]

Against historiography's received predilection for an exclusive focus on high cultural architectural practice, Koolhaas posited a model that took into account commercial and "anonymous" practice as well. "It need scarcely be said," states S. Frederick Starr in his 1979 review of the book, "that the mass popularity of Manhattanism sharply contradicts the European and Russian conception of modern architecture as being imposed 'from above' by an enlightened elite."[5] In Koolhaas's terms, Manhattan by the 1920s had achieved, "unconsciously" and seemingly without the aid of a mastermind, what the European avant-gardes were still only dreaming of: it had become the metropolis of the twentieth century. The stress on anonymous production, as we will see, was a key aspect of Koolhaas's montage aesthetics

and of his understanding of cultural production as largely unconscious. A number of writers such as Hitchcock had tested such a reversal of the heroic stance from the 1930s onward, but it was likely Robert Venturi, Denise Scott Brown, and Steven Izenour's 1972 *Learning from Las Vegas* that gave Koolhaas direct inspiration in this regard.[6]

Along with a brief methodological introduction and a highly fragmentary, episodic, and opinionated account of the birth and rise of the metropolis in six chapters, *Delirious New York* presents some of the unexecuted, utopian, and visionary projects by Koolhaas and the Office for Metropolitan Architecture (OMA) in an appendix. While these projects cannot be considered mere illustrations of the theory developed in the first part of the volume, their inclusion cannot be reduced to practical considerations, either, as the adjacency of theory and (theoretical) practice is clearly intentional and cross-references appear frequently (fig. 6.3). Projects such as The City of the Captive Globe (1972), Hotel Sphinx (1975–76), or New Welfare Island (1975–76) are not only set on the same stage—Manhattan—as the contents of the book; they also engage one of Koolhaas's major formal and theoretical obsessions, the Commissioner's Plan of 1811 that superimposed a grid of streets on the island's territory north of Fourteenth Street. The Cartesian rationality of the gridiron plan is the dialectical counterpart and foundation for the surrealist, oneiric projects, whose dreamlike quality is

Fig. 6.3 Rem Koolhaas and Madelon Vriesendorp, The City of the Captive Globe project, 1972. The Museum of Modern Art, New York.

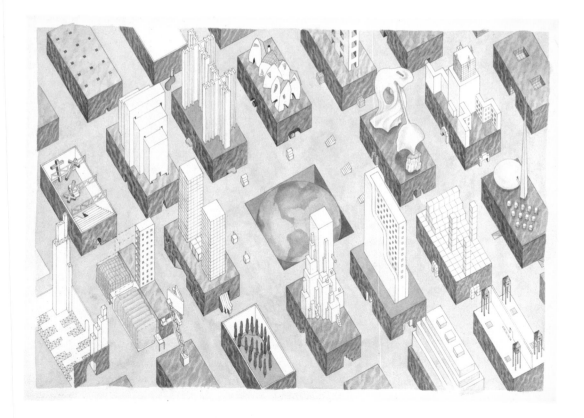

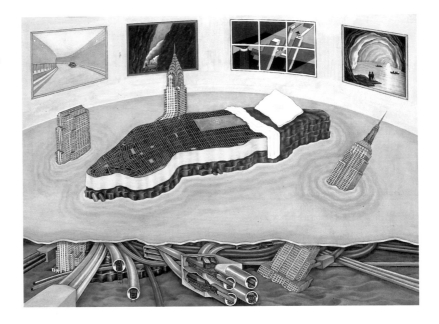

Fig. 6.4 Madelon Vriesendorp, *Freud Unlimited*, 1975. Centre Canadien d'Architecture, Montreal.

enforced both by the imagery of Madelon Vriesendorp's illustrations and the strangely evasive project descriptions (fig. 6.4). The last chapter of the book is partially devoted to Salvador Dalí. Koolhaas applies Dalí's "paranoid-critical method" of producing meaning based on the retrieval of latent images in order to expose what he considers the true essence of New York: the adjacency and simultaneity of opposing ideas. In this way, Koolhaas's treatise echoes Michel Foucault's famous characterization of "heterotopia": "The present epoch will perhaps be above all the epoch of space. We are in the epoch of simultaneity: we are in the epoch of juxtaposition, the epoch of the near and far, of the side-by-side, of the dispersed."[7] New York thus epitomizes modern (urban) space as structured by the principle of montage; conversely, the artistic technique of montage itself can be seen, following Anthony Vidler's argument, as an experimental set-up in search of a new—metropolitan—space.[8] According to Koolhaas, it is the Manhattan of the first decades of the twentieth century where such a new spatial order is achieved.

WRITING ARCHITECTURE: A RETROACTIVE MANIFESTO

Other postmodern manifestos had also hazarded the combination of architectural theory and examples of design.[9] Such a combination confirms that architecture is not restricted to buildings, its location rather being in a realm of ideas that can be expressed in a variety of media. *Delirious New York,* like its postmodern siblings, affirms the idea of an architecture "in the expanded field," with regard not only to the high/low dichotomy, but also to the discipline's self-understanding as a conceptual category rather than a professional trade.[10] *Delirious New York* is a piece of written architecture,

thus a form of architecture itself.[11] For Koolhaas, writing is not a secondary activity subordinate to building, but the opposite: before turning to architecture, Koolhaas first trained as a screenwriter and then worked as a journalist, and the text for *Delirious New York* preceded any built project.[12] Writing (on) architecture is for Koolhaas not an explanatory/reflexive activity in retrospect, but a basic epistemological/generative activity indispensable for design. The architect has described his characteristic design process as follows: "At the beginning of every project there is maybe not writing but a definition in words—a text—a concept, ambition, or theme that is *put in words,* and only at the moment that it is put in words can we begin to proceed, to think about architecture; the words unleash the design."[13] What interests Koolhaas is not so much the performative aspect of writing but the fundamentally textual nature of an architectural project; the architect is an intellectual figure involved in discourse rather than an artist who is primarily concerned with finding or giving form. In his words, "[With *Delirious New York*] I was trying to deemphasize the artistic part of being an architect and describe a role that was much more concerned with intellectual issues."[14] This understanding of the discipline is mirrored in OMA's quasi-scientific approach to design, which is usually based on thorough, multilevel analyses that in many cases take on the status of "projects" themselves.[15] Since *Delirious New York,* Koolhaas has given credibility to this notion in several comprehensive urban-planning studies supported by (pseudo-) scientific tools such as charts, graphics, statistics, and so on. He even went so far as to set up a research department within his firm, OMA; the department—AMO—was conceived to do foundational work for designs while also conducting independent research on urbanism and urban planning. It would hardly be an exaggeration to state that this facility, in recent years, has substantially contributed to a rapprochement between architecture and the sciences, and has led to a new self-image for architecture as a research-oriented discipline.[16] Yet this emphasis on questioning and research as opposed to inventing also polemically opposes the myth of the ingenious creator as claimed by architects of the avant-garde. This image of the architect is replaced by that of the scientist who, faced with an aggregation of facts, deduces the "right" approach for an architectural intervention into an existing urban context. The artistic act—drawing and designing—is not the essence of the activity; rather, it takes a secondary position as "the demonstration of a thesis or a question or a literary idea."[17]

Along with the methodological introduction and the appendix featuring the "fictional" projects by Koolhaas and the OMA, the book is arranged in six major chapters. The first is dedicated to "prehistory," or the urban development of New York from its very beginnings up to 1900, while the last chapter, "Postmortem," traces the period after World War II. The intervening four chapters focus on aspects that are characteristic of so-called "Manhattanism." Among them are the amusement park Coney Island, which acts as a kind of archive for architectural motifs and ideas that

Fig. 6.5 Globe Tower, Coney Island (second version), from Rem Koolhaas, *Delirious New York* (1994), 72.

formed the basis for subsequent construction (fig. 6.5); the skyscraper as a formative building typology; Rockefeller Center as the quintessential metropolitan development; and, finally, as mentioned earlier, the European avant-garde's intellectual appropriation of the city, exemplified by Salvador Dalí and Le Corbusier. *Delirious New York* is concerned as much with the physical fabric of the metropolis as with the images and fantasies leading to and emanating from it. According to Koolhaas, Manhattanism is distinguished by a number of structural principles. First and foremost, there is a "culture of congestion," meaning a celebration of urban density in potentiated form (fig. 6.6). He also uses terms from psychoanalysis and psychiatry such as "schism" or "lobotomy" to identify the characteristic, maximum functional mix in skyscrapers—in sharp contrast to the integrity of the exterior form—where each story is dedicated to a different purpose and these programs can change over time. If Manhattan is structured as a montage and the skyscraper reiterates Manhattan on a smaller scale, the changeability of individual montage elements over time is an innovation that Koolhaas makes to the montage principle. The self-divided and discontinuous subject of the metropolis needs an analyst who can bring to light its collective unconscious. Against the backdrop of Dalí's theoretical observa-

Montage and the Metropolitan Unconscious

Fig. 6.6 Cosmopolis of the Future, from Rem Koolhaas, *Delirious New York* (1994), 84.

tions and surrealist practices of image production, Koolhaas develops his "paranoid-critical" method for architectural design.

The historical analysis of Manhattan's urban architecture is not an end in itself for Koolhaas, but rather a vehicle for understanding modernity as a cultural-historical phenomenon: "Manhattan is the twentieth century's Rosetta Stone."[18] Thus, Manhattan is the key for understanding Western civilization's modern urban culture, at least as far as its architectural form is concerned. Manhattan, according to Koolhaas, evolved without script or master plan, in a space void of theory, unconsciously and at breathtaking speed. Against the rational Cartesian grid at its inception, Manhattan is the result of a feverish dream, a phantasmagoric delirium freed from any rational control. To fill this theoretical vacuum is the author's proclaimed objective.

The literary genre he chooses is the manifesto. Manifestos aim to question radically hegemonic ideologies and discourses. They do not attempt to represent reality objectively, but are highly selective and manipulative in service to the power of their rhetoric. According to the *Historisches Wörterbuch der Rhetorik* (*Historical Dicitonary of Rhetoric*), this involves a "public, programmatic declaration of principle in which carefully determined

intentions and goals are meant to be conveyed expositorily and with deliberate purpose."[19] By contrast to fictional utopias and treatises with their scientific approach, manifestos, like caricatures, are decidedly polemic while expressing their arguments in a determined, simplified, exaggerated, and often metaphorical way.[20]

The programmatic character of the genre clearly finds expression in *Delirious New York*. Yet unlike manifestos, which tend to look forward, Koolhaas's programmatic text aims to analyze an already-existing urban reality rather than to effect a revolutionary inversion: "The fatal weakness of manifestos is their inherent lack of evidence. Manhattan's problem is the opposite: it is a mountain range of evidence without manifesto."[21] By supplying the evidence of the built city with a theoretical framework ex post facto, Koolhaas wrote what he called a "retroactive manifesto." Rather than focusing on the built reality, Koolhaas exposes the level of the project—that is, the guiding principles that underlie Manhattanism, which have only been implemented in compromised and mitigated form: "This book describes a *theoretical* Manhattan, a *Manhattan as conjecture,* of which the present city is the compromised and imperfect realization."[22] What results is a "speculative reconstruction of a perfect Manhattan," a representation—indeed quite similar to caricature—of the phenomenon, as it were, in its pure and unadulterated form. This imaginary Manhattan in a sense is more real than reality itself, especially as it accentuates the fundamental design principles underlying its form. It is important to emphasize the distinction between "retroactive" and "retrospective," for Koolhaas's book is not simply a historical appraisal of New York's architectural history in a conventional sense. Rather, it is an apologia for its imaginary potential, which in turn is meant to serve as a theoretical basis for contemporary architectural production.

THE ARCHITECT AS GHOSTWRITER

The "retroactive method" has repercussions for the role of the architect. In the tradition of modernism, the architect saw himself as a radical innovator who decried the historical city and posited a tabula rasa in order to redesign urban space completely according to principles such as the separation of functions, hygiene, and so on. Koolhaas takes a different approach: instead of a godlike demiurge who more or less conjures the city out of nothing, the architect becomes the interpreter of the urban status quo. He or she assumes the role of a biographer whose aspiration is to sketch a portrait of an era based on its material appearance (in the metropolis). The architect "reads" the city instead of immediately "writing" it. This reading, as performed by Koolhaas in *Delirious New York,* results in a document, a text, a book that provides a foundation for architectural design, by which the architect in turn inscribes himself or herself into the text of the city. In this case, writing is more than a simple metaphor, since literary form acts as a fundament for design.

Consequently, Koolhaas proposes that the architect be the ghostwriter of the modern city: "Movie stars who have led adventure-packed lives are often too egocentric to discover patterns, too inarticulate to express intentions, too restless to record or remember events. Ghostwriters do it for them. In the same way *I was Manhattan's ghostwriter.*"[23] The architect acts as a storyteller (or historiographer) who revives the latent knowledge that haunts the modern conscious. The task of the architect is thus to cull and distill, through the process of writing, the hidden meaning of the metropolis and the rules and structural principles upon which its architectural form is founded. If Foucault saw the architect as a psychiatric warden charged with disciplining society, and if Le Corbusier saw the architect as a surgeon who operates on the organism of the city, then *Delirious New York* suggests that even more than a ghostwriter, the architect is an analyst or therapist: one who renders visible the dreams of modern society about its spatial equivalent, the metropolis. The architect liberates collective images and fantasies from their latency into manifestation. Architecture is work on the text, the written processing of the trauma to which modernism has subjected us.

Architecture, Text, Montage

For Koolhaas, building and writing are structurally related due to their conceptual dimension. This affinity is also expressed in the structure of *Delirious New York*. Each chapter is made up of a large number of rather short paragraphs, all of which are headed by a single word. In the section on Coney Island, for instance, a successive reading of these headings leads to a quasi-Dadaist chain of terms and associations: MODEL—STRIP—CONNECTION—TRACKS—TOWER—FLOTSAM—BRIDGE—TRAJECTORY—ELECTRICITY—CYLINDERS—HORSES—FORMULA—ASTRONAUTS—THEORY—INFRASTRUCTURE, and so forth. The structure of the text is similar to that of an encyclopedia or a dictionary, where unrelated concepts are presented side by side spatially—though *Delirious New York* does without alphabetical order (while Koolhaas's later manifesto, *S,M,L,XL* [1995], references and parodies such traditional systems of the organization and storing of knowledge by including an alphabetical list of terms that runs throughout the entire book).[24]

The composition of the text thus rests not on a continuous narrative but on the harsh juxtaposition of self-contained, autonomous blocks of text. Koolhaas has characterized this structure as a purposeful attempt to visualize, through the form of the text, the urban texture of the typical Manhattan street grid. This texture is (equally) distinguished by the unmediated juxtaposition of different forms and functions. In the introductory chapter, he comments under the heading BLOCKS: "In terms of structure, this book is a simulacrum of Manhattan's Grid: a collection of blocks whose proximity and juxtaposition reinforce their separate meanings."[25] This definition of the

modern metropolis could be read as a paraphrase of my own description of montage throughout this study: it is a structural principle that generates meaning based on juxtaposition and spatial adjacency.

This montage principle in fact literally underlies Koolhaas's take on urban history as presented in *Delirious New York,* as he points out: "The structure of the text is very architectural. . . . It is a book without a single 'however,' and that to me is very architectural. It has the same logic as a city. Anyway, a crucial element of the work—whether writing or architecture— is *montage.*"[26] Hence, the text defies continuous narration; instead, it rests on the unmediated montage of individual, autonomous units of meaning. Appropriately, in this manner the text achieves a syntactic dimension and meaning beyond its individual morphological elements. Unlike in a linguistic understanding of syntax, however, these morphological elements in the city are not inflected, but form unmediated gaps. It is through these gaps that meaning in the sense of urban diversity and plurality is produced. Just like Manhattan, *Delirious New York* itself becomes an artifact whose meaning resides precisely in the dialectical structure according to which it is organized. This structural principle is of a genuinely architectural nature, since it correlates with the internal logic of the modern metropolis.

Although the text does resemble a conventional narrative in many places, it is clear that its ultimate aim is to replace the textual order of sequence and time with one of adjacency and space. According to Gotthold Ephraim Lessing's 1766 treatise *Laocoon: An Essay upon the Limits of Painting and Poetry,* while painting is based on the organization of elements in space, literature is based on the organization of elements in time.[27] By invoking montage as the structural precept of *Delirious New York,* Koolhaas has applied a principle from the visual arts to the realm of writing, thus implicitly challenging and trascending the traditional dichotomy by establishing a visual order in his text. As we will see, the architect was able to draw from historical precedents in this regard, not least from the historico-philosophical writings of Walter Benjamin.

As stated, Koolhaas opts for a structural rather than narrative model of urban history: the "story" is told not as a single narrative, but as a kaleidoscopic arrangement of bits, a "mosaic of episodes" analogous to the structure of the city.[28] Even with this concession on the micro-level toward the diegetic structure of historiography, Koolhaas subverts the narrative paradigm by focusing on places rather than figures. Except for the chapter on Dalí and Le Corbusier, his primary protagonists are not architects or artists, but the sites or forms where the decisive steps toward the birth of the metropolis occur, namely Coney Island, the skyscraper, and Rockefeller Center. Koolhaas's structuralist approach is thus characterized by an inquiry into urban topology, not individuals' biographies.

Delirious New York repeatedly points out that Manhattan's syntax is the montage principle. Each city block strives to be "a City within a City," and this ambition "makes the Metropolis a collection of architectural city-

states, all potentially at war with each other."[29] This warfare is not destructive. Instead, it is the engine for the production of meaning grounded not in uniformity, but in density and heterogeneity (and their ostentatious display).[30] Koolhaas visualized this urban fundamental in exaggerated fashion with the 1972 project The City of the Captive Globe, co-authored by Zoe Zenghelis, which was included as the first proposal in the "Fictional Conclusion" to Delirious New York (see fig. 6.3). Just like Manhattan, his fictional city is structured by a grid of orthogonal streets that separate the individual blocks with their individualistic buildings, appearing as physically and ideologically unrelated islands floating aboveground. These buildings represent Koolhaas's most important self-proclaimed intellectual sources, among them Dalí's Archaeological Reminiscence of Millet's Angelus (1935), El Lissitzky's Lenin Stand, Wallace Harrison's Trylon and Perisphere for the 1939 World's Fair in New York, and Le Corbusier's Plan Voisin (1925). In this zoo of architectural eccentricities, the grid provides a sense of synthesis: "The Grid . . . describes an archipelago of 'Cities within Cities.' The more each 'island' celebrates different values, the more the unity of the archipelago as system is enforced."[31]

ISLANDS AND ARCHIPELAGOS

Koolhaas fails to illustrate in detail the working of this paradox, a rhetorical device for which he displays a certain liking.[32] However, he repeatedly refers to the island/archipelago metaphor as well as the concept of the "city within the city" in order to describe the spatial *dispositif* of the metropolis. In 1976, while he was working on the manuscript for Delirious New York, Koolhaas collaborated with Oswald Mathias Ungers on a planning study for Berlin that was eventually published under the title "Cities within the City."[33] Ungers taught at Cornell University from 1967 to 1974, where Koolhaas attended his courses between 1972 and 1974. In fact, it was because of his interest in Ungers's research on Berlin—in light of his own prior work on the Berlin Wall—that Koolhaas went to Ithaca in the first place.[34] At this time, the Cornell School of Architecture was the epicenter of a "contextualist" understanding of the city, with Ungers and Colin Rowe teaching there simultaneously. While Koolhaas's connections to Ungers are well-known, I would like to propose that Rowe's theories provided an equally important source for Koolhaas's urbanist thinking, even though they may not have been as openly acknowledged. Contextualism sought to integrate the isolated architectural object into the urban fabric. This objective became the defining trait of Colin Rowe and Fred Koetter's theory of urbanism as exemplified in their treatise Collage City (1978). Importantly, as we have seen in the introductory chapter, the integration of architectural object and urban space was meant to produce not homogeneity, but rather, difference and contrast, indicative of a pluralist and heterogeneous urbanism of the

present.[35] "Collage," Rowe and Koetter state in a short 1975 preprint of their argument, "allows us to accept Utopia in fragments."[36]

Koolhaas would seem to have read *Collage City* carefully. In an interview given to the journal *L'Architecture d'aujourd'hui* in 1985, he referenced the text extensively and also quoted from it.[37] However, despite his apparent fascination with the work's theses, Koolhaas took a rather critical stance toward what he considered its aestheticized and compromised contribution to urban planning debates, faulting the authors for their simultaneous embrace of utopian aesthetics and rejection of utopian politics.[38]

While Koolhaas seems to have entered into contact with Rowe only after his move to Cornell in 1972—in a letter to Adolfo Natalini, he refers to the theoretician as a "famous and 'brilliant'" presence[39]—the main topics of *Collage City* were developed by Rowe together with Alvin Boyarsky in seminars held at the Architectural Association (AA) School of Architecture in London between 1970 and 1971. Koolhaas himself studied at the AA between 1968 and 1972. It is therefore not surprising that collage—and montage—became major concepts of Koolhaas's architectural thinking. In fact, while the relationship between Ungers and Rowe at Cornell was notoriously difficult, Koolhaas has underscored the many ideas they shared, in particular with regard to collage.[40] Nevertheless, it should be emphasized that Rowe and Koetter's notion of collage, as an urban historical palimpsest combining fragments of imperfect realizations of utopia, is fundamentally different from Koolhaas's more dialectical and cinematic understanding of montage.[41]

Ungers's teaching at Cornell left an (equally) decisive mark on Koolhaas's architectural thinking. While in the United States, Koolhaas became a member of Ungers's team, along with colleagues Hans Kollhoff, Peter Allison, and Arthur Ovaska. According to Koolhaas, this collaboration functioned almost symbiotically by the end of 1978.[42] Their joint research centered on questions of urban planning and the mediation between plan and object, fragmentation and typology. It was Koolhaas who lent the respective metaphors to his teacher, Ungers, when the latter presented his study "Berlin—A Green Urban Archipelago" in 1977. In eleven theses, the study presents a planning concept for the future development of the then-divided German city. Based on the assumption that the number of inhabitants would decrease considerably (and thus anticipating the discourse of the "shrinking cities" of the post-1989 former East Germany), the authors assumed that the city would transform and consolidate into its most vital urban nuclei, which would be surrounded by green space. Each of the projected nuclei would conserve its own distinctive identity (thus, again, stressing the structuralist idea that the city, like language, is built of a [finite] number of distinctive elements that produce overarching meaning by their syntactic combination). The Ungers team used the metaphor of urban islands loosely related in an archipelago in order to describe this situation: their study's model for future urban development in Berlin could

be called a "farewell [to] the theory of a consistent urban development."[43] Moreover, the study explicitly refers to the "critical antithesis" of contradictory components in favor of a "divergent multiplicity" as the deeper meaning of Berlin's urban structure.[44] Even though the concept of montage is not invoked here literally, it is clear that Ungers's reading of Berlin and Koolhaas's interpretation of Manhattan are based on a similar understanding of the city as a producer of (meaningful) difference by means of adjacency and juxtaposition.

The metaphor of the archipelago surfaced again in OMA's competition entry for the French suburb of Melun-Sénart, near Paris (1987). Unlike in the fictitious City of the Captive Globe project, however, the "voids" between the respective islands were not considered secondary infill; rather, they were the principle aspect of the design. In Koolhaas's terminology, these voids form a "system" of "ribbons" that was to be laid over the territory.[45] The relationship between figure and ground is reversed, with the former (the islands) becoming the new "space in between": "The ribbons define a group of separated islands, the 'interstitial spaces' that differ in their size, form, and position, and in their confrontation with the ribbons. Each of these islands can be developed in almost entire independence."[46] By elevating the given landscape around the project to the top level of attention, Koolhaas not only takes a proto-ecological approach to town planning; he also dismisses modernist totalitarian, all-encompassing planning for a piecemeal, insular development of the region. Again, as in earlier instances, Koolhaas stresses the meaningfulness of such a (montage) aesthetics based on relatively independent and even contradictory elements: "In this model of an archipelago, the extreme individuality of the islands eventually strengthens the cohesion of the entire system."[47] Like *Delirious New York,* the proposal for Melun-Sénart is preoccupied with the question of how the individual architectural elements can combine into a system of meaning that we call a "city." Whereas *Delirious New York* was more thoroughly interested in the question of syntactical montage, in Melun-Sénart the attention has shifted more to the differentiation of the elements.

In a different reading, Jean-Louis Cohen has stressed the linear aspect of the Melun-Sénart design, seeing in it a departure from the grid model as exemplified in the Manhattan projects. By literally likening the "bands" in the design to a filmstrip, Cohen interprets the compositional technique of Melun-Sénart as a cinematic montage, with its unpredictable sequence of individual "images."[48] This metaphorical comparison is perhaps even more convincing if applied to the project Exodus, or the Voluntary Prisoners of Architecture, which was conceived jointly by Rem Koolhaas and Elia Zenghelis as early as 1971–72 as a competition entry for an urban structure in London (fig. 6.7). Here, the strip form is superimposed on the (urban) landscape and at the same time tied to a sequential, cinematic narrative. Exodus is clearly informed by the linear structure of Superstudio's Monumento Continuo, a theoretically endless, linear megastructure superimposed over

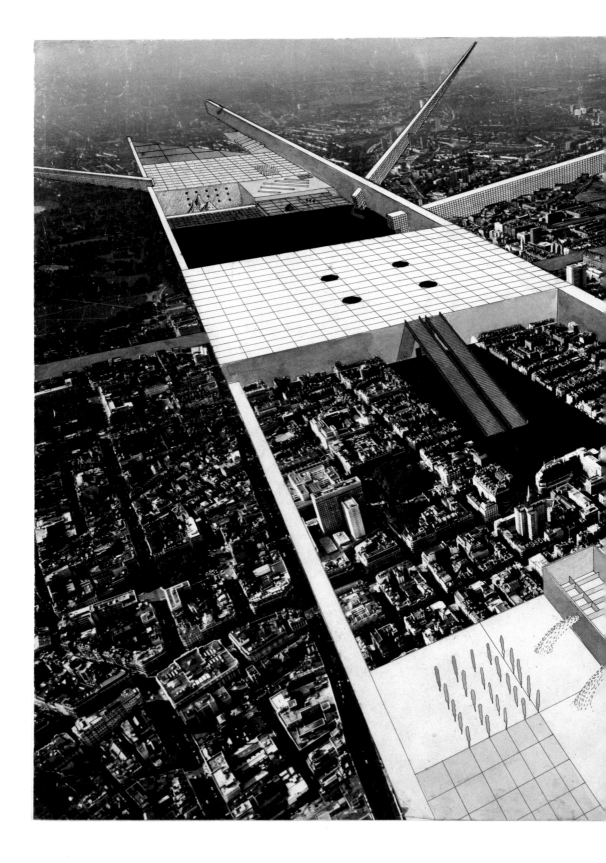

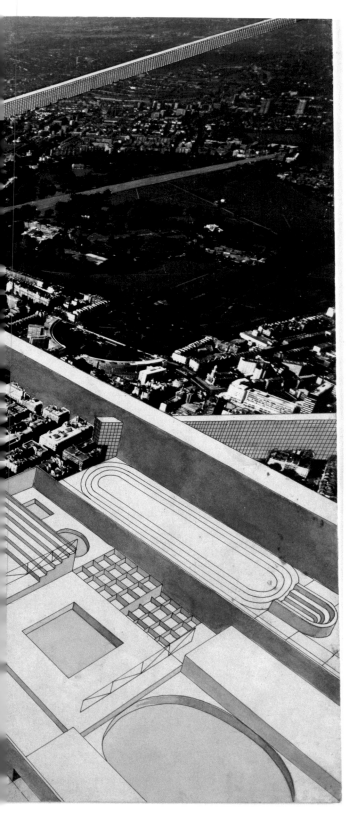

Fig. 6.7 Rem Koolhaas, Elia Zenghelis, Madelon Vriesendorp, and Zoe Zenghelis, Exodus, or The Voluntary Prisoners of Architecture: The Strip (Aerial Perspective), 1972. Cut-and-pasted paper with watercolor, ink, gouache, and color pencil on gelatin silver photograph (aerial view of London), 16 × 19⅞ in. (40.6 × 50.5 cm). The Museum of Modern Art, New York. Gift of Patricia Phelps de Cisneros, Takeo Ohbayashi Purchase Fund, and Susan de Menil Purchase Fund.

Fig. 6.8 Superstudio, Il Monumento Continuo, 1969. Superstudio Archive, Adolfo Natalini.

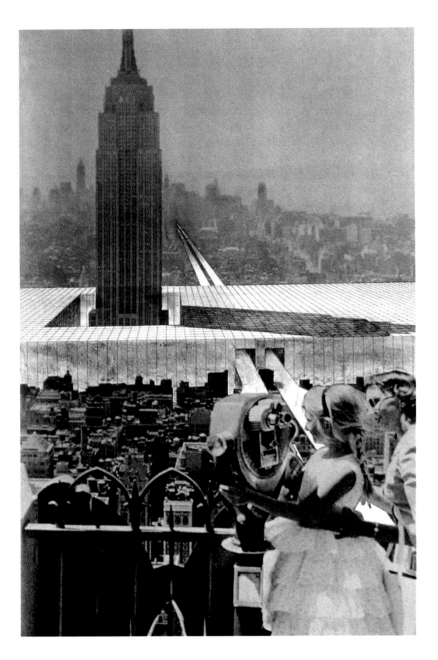

the city and landscape that forms a utopian counterstatement to the existing built environment (fig. 6.8). Very much like Exodus, the Monumento Continuo is structured by a linear, sequential narrative in the manner of a cinematic experience. This is most evident in Superstudio's contribution "Deserti naturali e artificiali: Il monumento continuo/storyboard per un film," published in *Casabella* in 1971, which presents the project as a mock cinema storyboard.[49] In referencing the Monumento Continuo, Koolhaas pays tribute to a major instance of the use of architectural photomontage in late modernism.

MANHATTAN, CAPITAL OF THE TWENTIETH CENTURY: FROM THE *ARCADES PROJECT* TO EMILIO AMBASZ

Koolhaas's fascination with Manhattan in general, and with the grid in particular, at a time when New York was facing economic decline may be seen in a long tradition of European romanticization of the American metropolis. The author himself draws this connection in the chapter of *Delirious New York* that deals with Le Corbusier and Dalí "conquering" New York. In this context it is interesting to note that another European architect was researching a study on Manhattan almost in parallel to Koolhaas: the Swiss architect Bernard Tschumi, whose *Manhattan Transcripts* (1981) also centered on the concept of montage, although here mainly inspired by Sergei Eisenstein's cinematic montage theories. This coincidence indicates how strongly *Delirious New York* captured the zeitgeist in a shared quest for a fundamental and methodological recalibration of architectural and urbanist thinking.

Tschumi conducted his research at the Institute for Architecture and Urban Studies (IAUS), where Koolhaas himself became a visiting fellow in 1972 thanks to a grant from the Harkness Foundation, during which time he also attended Ungers's courses at Cornell.[50] Like the latter institution, the IAUS seems to have played a significant role in shaping Koolhaas's argument and thinking about the city. One of the founding members of the institute and a particularly important figure there was the Argentinian architect and designer Emilio Ambasz.[51] Ambasz shared with Koolhaas an obsession with the Manhattan grid, which became evident in the exhibition layout of his seminal 1972 show *Italy: The New Domestic Landscape* at the Museum of Modern Art in New York, as well as in the cover illustration for an early, programmatic contribution to the Italian magazine *Casabella* (fig. 6.9).[52] In his essay on Manhattan, addressing issues of infrastructure, Ambasz proclaims: "Manhattan is, in essence, a network"—for the processing and exchange of information, matter, and energy. In this view, Manhattan's sub- and super-terranean grid is an omnipotent structure that accounts for the city's fabric: "Manhattan may be seen, either as the overwrought roof of a subterranean physical grid of subway tunnels and train stations, automobile, passages, postal tubes, sewage chambers, water and gas pipes, power wires, telephone, telegraph, television and computer lines; or, conversely, as the datum plane of an aerial lattice of walking paths, automobile routes, flight patterns, wireless impulses, institutional liaisons, and ideological webs." However, Ambasz concedes, "Infrastructure, though necessary, is not sufficient to make a city." He characterizes Manhattan as "the most representative urban artifact of our culture," clearly anticipating Koolhaas's dictum that Manhattan is the "twentieth century's Rosetta Stone." In the third section of his short text, Ambasz outlines what could be seen as a methodological sketch for the historiography of the modern city. While Koolhaas coined the term "retroactivity," Ambasz suggests that inquiry should begin with a

Fig. 6.9 Emilio Ambasz, *Manhattan, Capital of the 20th Century*, 1971.

Fig. 6.9 Emilio Ambasz, *Manhattan, Capital of the 20th Century*, 1971.

3 Istituzioni e artefatti per una società post-tecnologica

Institutions and Artifacts for a Post-technological Society Emilio Ambasz

"retrospective phase," a methodology quite similar to Koolhaas's approach based on "assembl[ing] piecemeal any surviving fragments of memory of the infrastructure."[53]

Ambasz deliberated further on the theoretical and operational implications of a historiographical methodology based on the collection and assembly of fragments. Indeed, his summary reads like a version of the definition of montage discussed in this study: "This tearing of the fragment from its former context, this rescuing of the irreducible word from its sentence, involves not only the usual process of design by discriminate selection but suggests, moreover, a process of bringing together where, instead of establishing fixed hierarchies, the fragments rescued from tradition are placed on the same level in ever changing contiguities, in order to yield new meanings, and thereby render other modes of access to their recondite qualities."[54] The proposed methodology of constructing urban history from the material residues of urban culture is reminiscent of Walter Benjamin's *Arcades Project* on nineteenth-century Paris. Through the title of his own essay, "Manhattan: Capital of the Twentieth Century," Ambasz pays tribute to Benjamin's colossal, unfinished undertaking, a synopsis of which was first published in English in the *New Left Review* in 1968 under the title "Paris—Capital of the Nineteenth Century."[55] If Benjamin had suggested Paris as the ultimate instantiation of modern urban culture of the nineteenth century,

Montage and the Metropolitan Unconscious

then Ambasz proposed a similar role for New York for the twentieth century. It was up to Rem Koolhaas to extend this assertion into a full-blown treatise. I would contend for this reason that *Delirious New York* is indebted to a substantial degree to Benjamin's conception of (urban) historiography, and, moreover, that both works are fundamentally structured by the principle of montage in their respective historiographical approaches. It may very well have been Ambasz's research on Manhattan that triggered Koolhaas's interest in Benjamin's theses and methodology.

At no point in his "retroactive manifesto" does Koolhaas reference the short synopsis of the *Arcades Project,* nor does he mention any other of Benjamin's works anywhere else in his written oeuvre. Nevertheless, both Benjamin and Koolhaas were searching for an "other," alternate model of writing (urban) history. This model saw the urban fabric of the respective metropolis (Paris or New York) as the realization of a collective unconscious, as *écriture automatique* on an urban scale. The aim of both Benjamin, with regard to nineteenth-century Paris, and Koolhaas, with regard to twentieth-century New York, was to use writing as a tool for releasing history from its oneiric manifestations by elevating them to the level of consciousness. Both authors affirmed the possibility of such an alternate urban historiography, even though the preconditions and the outcome were quite different for each. However, in both approaches, the principle of montage played a major role in re-devising the possibilities of (urban) historiography.

The interpretation of the city as écriture automatique, a material manifestation of a latent urban text (or screenplay), underlies Koolhaas's fundamental skepticism toward the idea of planning: "Architecture [becomes] less an act of foresight than before and planning an act of only limited prediction. It has become impossible to 'plot' culture." Elsewhere, the Empire State Building is a "form of automatic architecture, a sensuous surrender by its collective makers—from the accountant to the plumber—to the process of building. . . . All the episodes of its construction are governed by the unquestionable laws of automatism."[56] Manhattan thus appeared as the result of an unconscious "urbanisme automatique," surrealism in built form.[57]

Benjamin's "Paris, Capital of the Nineteenth Century" was devised as a belated synopsis of the unfinished *Arcades Project,* which Benjamin worked on incessantly for the last thirteen years of his life.[58] The title of the short text marks Benjamin's intention to write a comprehensive retrospective study on the nineteenth century, for which Paris served as the prototype. Benjamin read Paris as a comprehensive archive of phenomena and things, a gigantic accumulation of material traces and residues that had to be accessed and decoded in order to become intelligible (again). This process of rendering history's processes conscious was necessary in order to understand history: "From this epoch spring the arcades and the interiors, the exhibition-halls and the dioramas. They are residues of a dream-world.

The utilization of dream-elements in waking is the textbook example of dialectical thought. Hence dialectical thought is the organ of historical awakening. Every epoch not only dreams the next, but while dreaming impels it towards wakefulness."[59] The synopsis has to be considered within the larger scope of the *Arcades Project,* for which it was written. In this large collection of fragments and notes, itself the impressive material residue of an immense mental labor, Benjamin takes further account of his epistemological and historiographical considerations. In section "K" of his notes, he describes his undertaking as an "experiment in the technique of awakening" and characterizes his dialectical approach as a "Copernican turn" for the discipline of historiography: by reconstructing ideology based on its material traces, rather than the other way around.[60] Benjamin's analysis of the characteristic architectural typologies of the metropolis of the nineteenth century (such as arcades, exhibition halls, stations, and so on) was thus not an end in itself, but the base upon which to construe a theory of modernity within the scope of dialectical materialism. Koolhaas, while sharing with Benjamin the notion of a metropolitan unconscious that had to be brought to the level of awareness through a process of historiography, was pursuing a different political agenda. His take on capitalist forces behind the manifestations of the modern metropolis was not critical, but ironically or even cynically affirmative: through the exaggerated glorification of the forces of mere physical and economic power and their literary aestheticization. These ideological differences may be explained by the dissimilar historical situations of the two authors (one of them writing on the eve of fascism, the other on that of postmodernism), and by the different epistemological interests of the philosopher and the architect.

Benjamin writes about his dialectical methodology for historiography quite directly: "The first stage in this undertaking will be to carry over the principle of montage into history. That is, to assemble large-scale constructions out of the smallest and most precisely cut out components."[61] The main objective was to deconstruct the narcotic effects of traditional narrative historiography: "The history that showed things 'as they really were' was the strongest narcotic of the century."[62] Benjamin instead opts for a multi-perspectival stance, one that allows "stereoscopic and dimensional seeing into the depths of historical shadows."[63] Dialectical history based on montage was to be the remedy against hegemonic (bourgeois) historical narratives, and would act to wake up the reader from their numbing effects. It is evident that Benjamin was pursuing a much more fundamental and politically radical project than Koolhaas. While montage in the latter's case remains essentially a device for the production of literary meaning, for Benjamin it is at the same time a tool to raise political awareness in service of the revolution. Koolhaas's account was of course written in an entirely different historical period, when such revolutionary zeal no longer seemed appropriate.

Montage and the Metropolitan Unconscious

Despite these obvious discrepancies, the analogy between the two authors in their respective attempts to fundamentally question and recalibrate urban historiography must not be underestimated. Of particular significance is their mutual conviction that history must take note of the unconscious achievements of an epoch, its unfulfilled wishes and dreams. This is seen in Benjamin's interest in the arcades and exhibition halls, which he considers the oneiric predecessor of modern iron and glass architecture. It is also apparent in Koolhaas's infatuation with the similarly unconscious achievements of early twentieth-century Manhattanism, the skyscraper and the technological fantasies of Coney Island. In the case of Benjamin, there is a direct congruence with Sigfried Giedion's conceptualization of (architectural) history. Benjamin quotes extensively in the *Arcades Project* from Giedion's 1928 work *Building in France*—evidence of their shared conviction that nineteenth-century steel and glass architecture was the quintessential materialization of the age of modernity.[64] In fact, Giedion himself requested that Benjamin be sent a review copy of his book. The latter replied enthusiastically in a letter to the author dated February 15, 1929:

> Dear Mr. Gidion [*sic*]:
> When I received your book, the few passages that I read electrified me in such a way that I decided not to continue with the reading until I could get more in touch with my own related investigations than I had been, due to external circumstances, when the book arrived. . . . I spend hours with your book, in admiration. . . . I deliberately write while I can control the excitement it has caused me. Your book presents one of those rare instances familiar to everybody: to know, before even touching something (or someone, a book, a house, a person, etc.), that this touch will turn out to be most significant. This premonition does not deceive.
> I am studying in your book . . . the difference between radical conviction and radical knowledge that refreshes the heart. You possess the latter, and therefore you are able to illuminate, or rather to uncover, the tradition by observing the presence. Hence the nobility of your work, which I admire most, next to its radicalism. . . .
> Yours very sincerely,
> Walter Benjamin[65]

Benjamin agrees with Giedion that the key architectural achievements of the epoch in Paris were not the representative buildings or Baron Haussmann's urbanist interventions, but the relatively invisible changes in the city's guts and interiors, in its ("unconscious") infrastructure (where Ambasz also locates the relevance of Manhattan for twentieth-century architectural thought). Referencing these instances, Benjamin quotes Giedion: "Wherever the nineteenth century feels itself to be unobserved,

it grows bold."[66] In a letter to Leo Löwenthal dated June 3, 1936, Benjamin explicitly calls for a different kind of historiography that would entail "bringing to visibility, in the unconscious directions and objectives of past epochs, an effort that transcends their conscious ones."[67]

With postmodern hindsight, Koolhaas did not share Giedion's teleology. He did, however, share the methodological conviction that the history of the metropolis must be told on the basis of its unacknowledged achievements, phenomena that had been largely "ignored and even suppressed by the architectural profession."[68] By extending the scope of traditional urban historiography to popular phenomena such as Coney Island or capital-driven real estate development architecture, Koolhaas offered a counter-history of the city in its own right.

As we have seen, for Koolhaas, montage was a fundamental conceptual, epistemological, and textual tool in the presentation of his argument. While the *Arcades Project* never arrived at its final form and remains a fragmentary collection of notes and quotations, Benjamin characterized montage as the key principle of the organization and argument of his text. His most programmatic statements in this regard are mainly collected in section "N" of his convolute, "On the Theory of Knowledge, Theory of Progress."[69] These statements indicate that Benjamin saw montage as the guiding structural principle of a historiography based on dialectical materialism. His very first note filed under this heading states: "In the fields with which we are actively concerned, knowledge comes only in lightning flashes. The text is the long roll of thunder that follows."[70] What Benjamin describes here is what he calls elsewhere the effect of "shock," the abrupt and unmediated juxtaposition of disparate elements as in (cinematic) montage. In his terms, the fragmentation and subdivision of the text and of historical narrative into disparate elements predicates not the destruction of meaning, but, on the contrary, its very production. Meaning is generated in a dialectical manner by the clash of two antithetical propositions whose contradictory nature reveals a sudden insight. In other words, montage is the very essence of Benjamin's historiographical project: "This work has to develop to the highest degree the art of citing without quotation marks. Its theory is intimately related to that of montage."[71] And, in another instance: "Method of this project: literary montage. I needn't *say* anything. Merely show."[72] And: "To write history thus means to *cite* history."[73] The fragmentary form in which Benjamin's *Arcades Project* has survived more resembles a work in progress than a finished literary accomplishment. However, this "involuntary" literary montage may reveal more about the key objective of the project than its finished state ever could have. (It is interesting to note that Benjamin explicitly calls his quotations "rags" and "refuse," calling to mind the Dadaist collages of Kurt Schwitters, which were assembled from collected urban waste.[74])

Despite epistemological similarities, Koolhaas's mode of literary production is quite different from Benjamin's: *Delirious New York* is not a

montage of quotations, but was penned by the author. While Paris and the metropolitan culture of the nineteenth century produced an abundance of theoretical and historical reasoning that only needed to be assembled, the opposite was the case, according to Koolhaas, in early modern New York, where a theory was lacking and had to be produced in the first place by a "ghostwriter." However, for Koolhaas, the guiding principle for the production of a meaningful urban narrative was also montage.

On a further note, it is interesting to explore how Benjamin relies on architectural metaphors and imagery. In convolute "F" of the *Arcades Project,* "Iron Construction," he identifies the art of assembly from small elements in architecture and engineering as the true predecessor of literary montage. His comment relates to a passage in A. G. Meyer's 1907 volume *Eisenbauten, ihre Geschichte und Aesthetik (Iron Construction, Their History and Aesthetic)* explaining the construction of the Eiffel Tower from a large number of small, prefabricated elements: "Never before was the criterion of the 'minimal' so important. . . . These are dimensions that were well established in technological and architectural constructions long before literature made bold to adapt them. Fundamentally, it is a question of the earliest manifestation of the principle of montage."[75] In other words, architecture, and more specifically modern iron construction, is the fundamental (material) manifestation of montage as an epistemological and constructive principle. This principle also grounds an alternate historiography based on the assembly and juxtaposition of preexisting elements in order to produce insight. As different as they are, both the *Arcades Project* and *Delirious New York* are attempts at developing a model of historiography based on this method.

TABLEAU

Both the *Arcades Project* and *Delirious New York* portray an epoch through the description of their respective prototypical city. I would contend that the specific structure and contents of both books should be situated within the literary genre of the tableau as it was devised from the late eighteenth century onward, in particular with regard to the city of Paris. The recurrent themes of the genre are the modernity of life, the crowd, movement, and fashion, as seen from the perspective of the flâneur, who is himself a defining feature of the tableau.[76] Charles Baudelaire, whose writings occupied Benjamin repeatedly (in the *Arcades Project* and other works), gave the title "Tableaux Parisiens" to a group of poems in his *Les Fleurs du mal* from 1861, but the genre was initiated as early as 1781, when the first volume of Louis-Sébastien Mercier's oeuvre, *Tableau de Paris,* was published. Originally stemming from Diderot's theory of the new theatrical genre of the *drame,* the tableau was adapted by Mercier for his collection of over one thousand short, impressionistic essays depicting a wide range of occurrences in the everyday life of Paris. Calling himself a "painter with

the quill," Mercier can be considered a predecessor of literary reportage.[77] Importantly, his main objective was not to describe the capital's "buildings, temples, monuments, its sights," as many others had done before him.[78] Rather, he was interested in the ephemeral situations of everyday life in the metropolis, including its unrepresented sides and its socially and economically underprivileged. Ultimately, Mercier's portrait of a city is only a means to an end, namely the representation of an epoch, a "*tableau du siècle.*"[79] The twelve-volume opus is relevant to urban historiography as exercised by Benjamin and Koolhaas in terms of its methodological approach: the *Tableau de Paris* is a multifaceted rather than continuous representation of urban life that achieves a panoramic quality through fragmentary sketches and impressions. While the collection has often been criticized for its haphazard conglomeration, the principle of its arrangement is in fact contrast: "I have studied all classes of citizens and I did not despise the objects which are remotest from opulence in order to show by these oppositions the moral physiognomy of this gigantic capital." And, more pronouncedly: "If I had the hundred mouths, the hundred tongues, and the iron voice of which Homer and Virgil speak, it would still not be possible to expose the contrasts of the great city, contrasts made even more violent by their proximity."[80] Mercier perceives the city of Paris as an involuntary conglomerate of impressions, and he finds a congruent mode of representation through the device of adjacency and contrast in the tableau. It is this congruence of the fragmentary perception and the literary representation of the metropolis that allows a genealogical line to be established from Mercier's eighteenth-century to Benjamin's nineteenth-century Paris and Koolhaas's twentieth-century Manhattan. If the idea of writing a city's biography was nothing new, it was certainly unusual for an architectural project: with *Delirious New York,* reading instead of writing the city became the motto for the modern architect, thus fundamentally changing the self-conception of the field. Acting as a ghostwriter for the city meant acknowledging it as a quasi–self-contained functional system rather than an entity in need of a structuring intervention.

Literally, the term "tableau" signifies a board or panel; it is used in French to denominate the traditional panel painting. The board or panel is first of all a planar expanse that allows for the arrangement of elements in a spatial constellation. In this vein, Georges Didi-Huberman distinguishes between a "tabular" and a "narrative" montage; but we may also think of Aby Warburg's *Mnemosyne Atlas* as structurally related.[81] If all three major works discussed here can be considered as contributions to the representation of the city, they are also characterized by their respective attempts at overcoming linear, mono-perspectival historiography and depiction in favor of a polyfocal, tabular arrangement in which the spatial proximity of elements becomes meaningful. For Koolhaas, the tableau is no longer conceived as purely two-dimensional, in that individual montage elements can change over time—in the structure of the city, if not in the written representation of it.

SURREALISM, DALÍ, AND THE PARANOID-CRITICAL METHOD

We have already seen that surrealist thought, and especially écriture automatique, was a major point of reference for *Delirious New York*. Koolhaas once again shares this preoccupation with Benjamin, for the latter not only paid repeated tribute to the surrealists and their contemporary writings while he was living in Paris, but also devoted an article to the subject.[82] In *Delirious New York,* the influence of surrealism manifests itself in a variety of ways: in Madelon Vriesendorp's suggestive illustrations for the book, in the terminology and choice of words ("delirious," "cannibalization," and so on), in the interest in Dalí's engagement with New York, and in the appropriation of the "paranoid-critical method" for architectural discourse as performed in the penultimate chapter of the book.[83] As previously noted, both Koolhaas and Benjamin consider the unconscious, latent side of the modern metropolis more relevant for historical interpretation than its official public appearance and history; this idea is not only informed by the methodological tenets of psychoanalysis, but also by the surrealist excursions into the dream world of the unconscious. For Koolhaas (as for Benjamin) the dichotomy of the conscious and unconscious, manifest and latent, is essential, and it is mirrored in the urban fabric by the dichotomy of the rational and surreal: while the grid stands for the former, the individualistic "islands" exemplify the latter. Koolhaas shares with Benjamin the conviction that surrealism is the inevitable flip side of Cartesian rationalism. Thus, in the *Arcades Project* Benjamin singles out André Breton and Le Corbusier as the leading intellectual figures of their time, each standing for one of the dialectical antitheses: "To encompass both Breton and Le Corbusier—that would mean drawing the spirit of contemporary France like the bow, with which knowledge shoots the moment in the heart."[84] Koolhaas's thinking is informed by the same dialectic when he opposes Le Corbusier to Dalí in his essay on the European "conquest" of Manhattan in the twentieth century.[85]

That said, both authors also mark their reservations against the surrealist project. In a methodological prolegomenon to the *Arcades Project,* Benjamin takes a stand against the surrealist writer Louis Aragon, who was cofounder of the French group: "Delimitation of the tendency of this project with respect to Aragon: whereas Aragon persists within the realm of dream, here the concern is to find the constellation of awakening. While with Aragon there remains an impressionistic element, namely the 'mythology' (and this impressionism must be held responsible for the many vague philosophemes in his book), here it is a question of the dissolution of 'mythology' into the space of history. That, of course, can happen only through the awakening of a not-yet-conscious knowledge of what has been."[86] In this reading, by diving into the sea of the unconscious, the surrealists were escaping from reality. Conversely, Benjamin's aim is to render conscious the unconscious of an epoch, and to consider it the venue of historical traumata. Considering dreams, in other words, does not serve to

liberate the imagination, but rather to render manifest historical processes. Koolhaas, in stressing the qualities of surrealism as a conceptual tool and design method, argues in similar terms: "I have had a longstanding interest in surrealism, but more for its analytical powers than for its exploitation of the subconscious or for its aesthetics. . . . I was most impressed by its 'paranoid' methods, which I consider one of the genuine inventions of this century, a rational method which does not pretend to be objective, through which analysis becomes identical to creation."[87] Unlike Benjamin, Koolhaas sees surrealism as a reference not for the writing of history, but for artistic creation, as a process that is subjective but at the same time based on analytics. Koolhaas seeks a procedural algorithm by which the images and fantasies of the collective unconscious can be exploited in the service of artistic/architectural creation. In this way, his project is similar to that of the writer Aragon, but dissimilar to that of the historian Benjamin: Koolhaas is after mythologies, too, mythologies that are the product of both individual research and collective imagination.

It is interesting to note that Koolhaas prefers the renegade Dalí to the doctrinaire Breton. This may be explained by the architect's search for a productive artistic methodology within surrealist thought, which he finds in the "paranoid-critical method" (PCM). Dalí himself did not consider his exploration of the paranoid-critical (PC) as a method, but described it as either a "phenomenon" or an "activity."[88] Nevertheless, for Dalí the PC was a conception of active engagement with which he distanced himself from the purely passive idea of "automatism" as theorized by the other exponents of surrealism. In his 1930 essay "L'Âne pourri" ("The Rotting Donkey"), he states: "I believe the moment is drawing near when, by a thought process of a paranoiac and active character, it would be possible (simultaneously with automatism and other passive states) to systematize confusion and thereby contribute to a total discrediting of the world of reality."[89] Dalí substantiated his take on active paranoiac delirium as being against passive automatism and the dream, with reference to Lacan's PhD thesis, "De la psychose paranoïaque dans ses rapports avec la personnalité" (1932; "Paranoiac Psychosis and Its Relations with the Personality").[90]

From Koolhaas's architectural point of view, reality could be transformed through a nonrational exploitation of the (subjective and collective) unconscious. Thus, Koolhaas defines the PCM as the "conscious exploitation of the unconscious," or, more poetically, "a tourism of sanity into the realm of paranoia."[91] This method would allow not just passively consuming the archive of the unconscious, but actively exploiting it in order to "discredit" or alter reality. Dalí illustrates the functioning of PC activity with a concrete clinical example: "The paranoiac who thinks he is being poisoned discovers in all the things that surround him, down to their most imperceptible and subtle details, preparations for his death."[92] Paranoia "alters" reality by making it correspond to the patient's subjective mind-state. As Haim

Finkelstein has argued, Dalí defines PC activity "in terms of the formation of a systematic delirium and the interpretative act that brings it to light, and as a means of revealing the hidden obsessive character of the object under consideration."[93]

Given Koolhaas's predilection for dialectic as an epistemological tool, it should not go unnoticed that Dalí defines PC activity as a "principle of verification" having a "dialectical value" that combines delirium with action in reality—that is, the "paranoiac" with the "critical": "The paranoiac mechanism cannot but appear to us, from the specifically surrealist point of view adopted by us, as a proof of the dialectical value of this principle of verification, through which the very element of delirium goes in actual fact into the tangible domain of action."[94] Koolhaas interprets the PC "method" as consisting of two consecutive operations: "1. the synthetic reproduction of the paranoiac's way of seeing the world in a new light . . . and 2. the compression of these gaseous speculations to a critical point where they achieve the density of fact: the critical part of the method consists of the fabrication of objectifying 'souvenirs' of tourism, of concrete evidence that brings the discoveries of those excursions back to the rest of mankind, ideally in forms as innocent and undeniable as snapshots."[95] With this algorithm, Koolhaas proposes a way to reinterpret paranoid critique directly as an architectural design methodology: "Architecture = the imposition on the world of structures it never asked for and that existed previously only as clouds of conjectures in the minds of their creators. Architecture is inevitably a form of PC activity."[96] Koolhaas goes on to state: "Manhattan is an archipelago of paranoid-critical islands insulated by the neutralizing lagoon of the Grid."[97] This configuration is translated into one of Koolhaas's own (theoretical) works in the project "The City of the Captive Globe" (see fig. 6.3). Here, the individual island-buildings that result from PC activity physically surround the "captive globe" suspended at the center of the city, to which they ideologically contribute at the same time: "All these Institutes together form an enormous incubator of the World itself; they are breeding on the Globe."[98] The image of the globe thus symbolizes unity through heterogeneity, reflecting a liberalist philosophy in which the functioning of the whole depends on the freedom of expression and the individualist pursuits of each element. At the same time, this image is a *mise en abyme:* the globe is an archipelago within the archipelago. The utopian totalizing vision of modernism is reversed, and the reality of the metropolis is considered to be the place where private utopias have already been achieved. The ability of a single montage element, when magnified, to exhibit the same structural principles as the montage overall—the property of self-similarity, elaborated by Benoit Mandelbrot in the 1960s and 1970s through fractal geometry—is another addition that Koolhaas makes to the montage principle.

DOUBLE IMAGES AND THE EXQUISITE CORPSE

In Dalí's conception, in paranoid-critical activity there are two models whereby images are appropriated and transformed: the "double image" on the one hand and the *cadavre exquis* on the other. Regarding the first, Dalí states in "The Rotting Donkey": "It is by a distinctly paranoiac process that it has been possible to obtain a double image: in other words, a representation of an object that is also, without the slightest pictorial or anatomical modification, the representation of another entirely different object, this one being equally devoid of any deformation or abnormality disclosing some adjustment. . . . The double image (an example of which might be the image of a horse that is at the same time the image of a woman) may be extended, continuing the paranoiac process, with the existence of another obsessive idea being sufficient for the emergence of a third image (the image of a lion, for example) and thus in succession until the concurrence of a number of images which would be limited only by the extent of the mind's paranoiac capacity."[99] What Dalí describes as a double (or multiple) image is ultimately the mind's capacity to productively associate physical images with preconceived mental images, and to superimpose them to form a hybrid intellectual constellation that involves their morphing into each other in one ambiguous form. A prime example of a double image is Dalí's sexualized transformation of Jean-François Millet's painting *L'Angélus* (fig. 6.10).[100] Dalí's book on Millet's painting was the direct source for Koolhaas's own exploration of the potential of paranoid-critical interpretation.[101] Not only does Koolhaas refer extensively to Dalí's permutation in his own explication of the paranoid-critical method in *Delirious New York;* it also served as inspiration for one of Vriesendorp's paintings, which shows the Chrysler and Empire State buildings, rather than the peasant couple in Millet's painting bowing to each other (fig. 6.11).

Fig. 6.10 Jean-François Millet, *L'Angélus*, 1857–59. Oil on canvas, 22 × 26 in. (55.5 × 66 cm). Musée d'Orsay, Paris.

For his architectural conception of the PCM, Koolhaas was more interested in the interplay of a number of adjacent, heterogeneous visual elements and their combination into a new entity. He frequently refers to such a constellation as a *cadavre exquis*, another appropriation of surrealist terminology. In "The Object as Revealed in Surrealist Experiment" (1932), Dalí explains the (initially literary) technique: "The experiment known as 'The Exquisite Corpse' was instigated by Breton. Several persons had to write successively words making up a sentence on a given model ('The exquisite/corpse/shall drink/the bubbling/wine'), each person being unaware of what word his neighbor might have had in mind. Or else several persons had to draw successively the lines making up a portrait or a scene, the second person being prevented from knowing what the first had drawn and the third prevented from knowing what the first and second had drawn, etc. In the realm of imagery, 'The Exquisite Corpse' produced remarkably unexpected poetic associations, which could not have been obtained in any other known way, associations that still elude analysis and exceed in value as fits the rarest documents connected with mental disease."[102] If the exquisite corpse is to be understood as a variant of montage, in that it depends on the adjacency and juxtaposition of individual pictorial elements and their integration into a superordinate synthetic unit, two aspects are particularly noteworthy: the exquisite corpse is the product of a collective effort, and its outcome is dependent not on an act of will but on arbitrariness and coincidence. From these two qualities the exquisite corpse technique draws its "poetic" potential as the product of the working of a "collective unconscious." This procedure is thus contrary to how we have defined montage so far, as the intentional product of a single author. However, in *Delirious New York* Koolhaas introduces a somewhat altered definition of the concept: "The Voisin Plan [was] imposed on Paris as if according to the surrealist formula of 'Le Cadavre Exquis,' whereby fragments are grafted onto

Fig. 6.11 Madelon Vriesendorp, *Manhattan Angélus*, 1975. Oil on canvas, 4 × 6 in. (10 × 15 cm). Collection of Teri and Hubert Damisch.

an organism in deliberate ignorance of its further anatomy."[103] This analogy seems problematic since, in the Plan Voisin, Le Corbusier proposed eliminating entirely—with the exception of a few historical monuments deemed too important for destruction—the existing urban fabric of the center of Paris. Hence his Plan Voisin was anything but a collective endeavor: it was a radical urbanist proposal sprung from a singular mastermind, and in this way it sought to resist rather than integrate the effects of chance.

Apart from *Delirious New York,* the concept of the cadavre exquis served Koolhaas in describing one of his own first realized projects, the National Dance Theater at Spui Square, The Hague (1984–87). This building was reassembled from some parts of an earlier OMA design for a Dance Theater in Scheveningen that was abandoned in 1984.[104] Unlike the original project, the situation in The Hague required the building to be inserted next to another existing structure on the lot, a concert hall designed by the architects Dick van Mourik and Peter Vermeulen. Koolhaas devised several alternatives for this assemblage and documented them in drawings, each of which was given, according to its principal design idea, a name such as "decorated shed," "tectonic," or, in the scheme eventually chosen, "cadavre exquis." This multifaceted design has alternately been dubbed a "surrealist collage" and a "kaleidoscopic" structure.[105] However, it again seems questionable whether this designation is accurate or whether the design can be considered a cadavre exquis in the proper sense of the term. While the scheme combines and brings into confrontation formal references to Ivan Leonidov's Russian constructivism, Venturi and Scott Brown's notion of the "decorated shed," Wallace K. Harrison's United Nations Headquarters buildings, and OMA's earlier projects, the fabulistic (and comical) connotations of the cadavre exquis are largely lost in this—despite all formal references—quite abstract design. Furthermore, while the cadavre exquis relies on the spontaneous and uncontrolled collaboration of a team of individuals, the Dance Theater is in fact, again, a highly controlled creation by one mastermind (and his team). This is a general rule of Koolhaas's appropriation of surrealist concepts and terminology for the architectural design process: the involuntary poetic associations of the cadavre exquis are transformed into a deliberate design principle, with formal and ideological collision being a deliberate aesthetic end. By referring to the surrealist device, Koolhaas seems mainly to signify that his project in both locations would have had to deal with and partially integrate a preexisting structure and "cannibalize" it within its own, rather different architectural identity, as one chimeric "body."[106]

PICTURE POSTCARDS

At the center of PC activity are mental imaginings and their manifestation in graspable images. What the PCM according to Koolhaas describes is the processual transformation of images of the (subjective) imagination into

 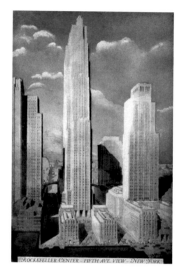

materialized output in the form of an architectural design/project. Images, therefore, stand at the beginning of the creative process, a finding seemingly at odds with Koolhaas's conceptual approach to writing, as discussed earlier. In his 1926 *Le paysan de Paris* (*Paris Peasant*), Louis Aragon calls the surrealists "drunkards of images," thereby pointing at the addictive/narcotic quality of images for the group.[107] While Walter Benjamin became an image-addict in the mid-1930s and began amassing an extensive collection of some one hundred fifty thousand images from postcards, photographs, newspaper clippings, and maps he called "Topographie de Paris," Koolhaas and his wife, Madelon Vriesendorp, fell prey to the same "vice" from the early 1970s onward, when they both began to gather a vast collection of postcards dedicated to New York and all kinds of Americana.[108] Koolhaas included a wide variety of different types of illustrations from a large number of sources in *Delirious New York*. Many of the images originated from popular ephemera rather than "official" architectural publications, and the picture postcards from his and Vriesendorp's collection are a particularly conspicuous presence. Even though Koolhaas also used conventional types of illustration such as drawings, straight photographs, and paintings to build his argument visually, it is primarily reproductions of picture postcards on which both the aesthetic and the argument of *Delirious New York* are predicated (fig. 6.12). Moreover, it is notable how much the pictorial discourse of *Delirious New York* dwells on elements of the city that have been the subject of mass reproduction and circulation.[109] The history of the city, one could argue, can only be told insofar as it is reproduced in popular imagery. The retroactive stance taken by Koolhaas would not have been possible without these mass-produced images, for they are both the starting point and the evidence of the argument. The evidence from which his theses are deduced is not so much the real New York, but the images and fantasies circulating around it. The postcards are thus the repository

Fig. 6.12 Reproductions of historic picture postcards on the project for Radio City Music Hall, Rockefeller Center, from Rem Koolhaas, *Delirious New York* (1994), 84.

of "Manhattanism," the principle of super-urban density in its purest form, uncompromised by reality.

Koolhaas and Vriesendorp began collecting postcards after they had settled in Ithaca when Koolhaas attended classes at Cornell University. At this time, they also became members of the Metropolitan Post-Card Collectors' Club, which allowed them to rapidly expand their collection.[110] While Vriesendorp's interest extended to any kind of Americana, and in particular to its strange, almost surreal instances, Koolhaas focused primarily on the visualization of a real or imagined Manhattan.[111] Their joint efforts led to a collection of several thousand postcards, meticulously filed under a number of typological categories. Both the Americana and the Manhattan postcard groups were stored in suitcases—one metallic, the other tanned leather—reflecting the intrinsic relationship of the postcard to tourism (fig. 6.13). In his letter to Adolfo Natalini from August 1973, Koolhaas explains the postcard collection as a remedy against the boredom and lack of intellectual challenge in rural upstate New York, calling it "stupid research into postcards, Americana, provincial movie-palaces, diners," apparently not anticipating the significance this project would have for his first book.[112] In *Delirious New York,* by arranging the postcards into montage series, Koolhaas produces a visual historiography. This culling of an archive of reproductions and combining the exemplars into a new (visual) narrative epitomizes postmodern image strategies.[113]

In a 1985 interview, Koolhaas reflected: "It was in Ithaca that my wife, Madelon Vriesendorp, and I started collecting postcards and other tourist ephemera from New York. I discovered that one must look beyond the official channels to find the true meaning of this architecture."[114] The picture postcard became affordable and available for the mass market thanks

Fig. 6.13 Suitcase with a part of Rem Koolhaas's and Madelon Vriesendorp's postcard collection.

Montage and the Metropolitan Unconscious

Fig. 6.14 Madelon Vriesendorp, *Eating Oysters with Boxing Gloves, Naked*, 1977. Pencil drawing, 4¾ × 4 in. (12 × 10 cm).

to innovations in the printing industry around 1900, precisely the moment when Manhattan was starting its ascent as the uncontested metropolis of the twentieth century.[115] It can therefore be argued that Koolhaas found in the mass-produced picture postcard an appropriate medium for the representation of the likewise "mass-produced" architecture of Manhattanism.

The degree to which *Delirious New York* relies on the evidence of reproduced images is well illustrated at a moment when Koolhaas's thesis of the picture postcard as a reservoir for the collective unconscious is purposefully taken to absurdity. His retroactive method essentially bases its theory on the discovery of preexisting images; if such pictorial evidence is missing, the theory is no longer tenable. What then becomes necessary, as in the case of the Downtown Athletic Club, is forgery. The author had studied a plan of the building and discovered the immediate proximity of a boxing ring and an oyster bar, which took on programmatic significance: "Eating oysters with boxing gloves, naked, on the nth floor—such is the 'plot' of the ninth story, or, the 20th century in action."[116] Since a visualization of this— surely purely imagined—situation could not be found, Koolhaas asked his wife, Vriesendorp, to produce a depiction; this "false evidence" would be smuggled into his manifesto (fig. 6.14). Vriesendorp "concealed" the

forgery by imitating the style of the artist Tom of Finland, whose illustrations were widely popular in gay magazines of the 1970s. Since the visual prototype of the retroactive thesis was not available, it was reproduced in the sense of a simulated ready-made.[117] Koolhaas defends this approach again with reference to the PCM: "Paranoid-Critical activity is the fabrication of evidence for unprovable speculations and the subsequent grafting of this evidence on the world, so that a 'false' fact takes its unlawful place among the 'real' facts."[118] Here Koolhaas provides a "manual" for his manifesto by self-referentially commenting on his methodology. At the same time, one notes the similarity between this literal act of forgery and Koolhaas's description, cited previously, of architectural creation as "the fabrication of objectifying 'souvenirs' of tourism . . . into the realm of paranoia."

The historical invention of the (picture) postcard is closely linked to the advent of mass tourism in the second half of the nineteenth century. The postcard is a visual cliché of a personal experience, much as modern tourism is a clichéd appropriation of the aristocratic Grand Tour for a broader (eventually, a mass) audience. The medium allows those staying home to experience an imagined, mental journey in a manner similar to what other contemporary escapist inventions such as the panorama, diorama, or, eventually, cinema had to offer.[119] As Mike Crang has pointed out, the picture postcard is characterized by the dialectic of "site" and "sight."[120] Actual topographical locales become invested with symbolic meaning, a process of transformation directly dependent on mass consumption and technological reproducibility. The cultural value of a sight is amplified; its power lies in the supersession of the represented object by its pictorial representation, its simulacrum. In this regard, Koolhaas has stated that his fundamental interest in New York resided in the fact that this city "had been a sort of exploratory terrain in the way in which the artificial would replace reality."[121] The passage clearly displays Koolhaas's indebtedness to French (post-)structuralist thinking, to which he was introduced by Hubert Damisch, a fellow at the Cornell University Society for the Humanities in 1972–73.[122] The postcard, then, stands for a cultural condition in which images and their circulation are more important than and potentially replace their referents.

The collecting and assembling of mass-reproduced popular images as a cultural activity was anticipated, among other things, by the British pop scene of the 1950s and in particular the Independent Group.[123] Charles Jencks has pointed out that Koolhaas and Vriesendorp's own collection must be seen in this context.[124] Koolhaas's take may be characterized as an attempt to install popular visual media as serious source material for architectural discourse and urban historiography, thus breaking the *cordon sanitaire* between high and popular culture. While his interest in the anonymous tradition of modernity can be traced back to the writings of Sigfried Giedion or Walter Benjamin, the method of using postcards for a historical account was first proposed by Alvin Boyarsky in his photo-essay "Chicago

à la Carte," published in *Architectural Design* in 1970 (fig. 6.15).[125] Koolhaas had studied with Boyarsky at the AA School of Architecture in London and also chaired a conference on his Berlin Wall research, in the framework of a summer session on the topic of Manhattan that was organized by Boyarsky's International Institute of Design.[126] It was during the 1970 summer session that Boyarsky presented his lecture on Chicago titled "Animal City," which like the later essay also derived its argument from popular images (this lecture was first delivered in January 1970 at ETH Zurich).[127]

Boyarsky collected postcards actively and, during his time as professor at the University of Illinois at Chicago Circle (1965–72), was a member of the Windy City Postcard Club. Igor Marjanović has pointed out the absence of high art or architecture in Boyarsky's collection, demonstrating an interest in anonymous and popular imagery also evident in Koolhaas and Vriesendorp's collection.[128] "Chicago à la Carte" depends almost entirely on the reproduction of postcards from Boyarsky's collection and lengthy captions that hold the narrative together. By contrast, *Delirious New York* is structured mainly as a text, with images serving a generally secondary, illustrative purpose. The significant role that the postcards played in the genesis of the argument is therefore largely hidden, while Boyarsky's strategy is ostentatious display.

Collecting postcards was a preferred form of artistic research into modernity's anonymous traditions throughout the twentieth century. The American photographer Walker Evans collected some nine thousand picture postcards throughout his lifetime, published a number of pictorial essays based on his collection in magazines such as *Fortune* and

Fig. 6.15 Alvin Boyarsky, "Chicago à la Carte," from *Architectural Design* (December 1970): 618–19.

Architectural Forum, and lectured repeatedly on the subject. Like Koolhaas and Vriesendorp, Evans aimed to compile a visual encyclopedia of the world as represented in mass-reproduced photographic images. He ordered his collection according to categories such as "railroad stations," "hotels," "factories," "American architecture," "Flatiron," "city views," "American street scenes," and "skyscrapers," the latter group including many of the same postcards that Koolhaas reproduced in *Delirious New York.* While, according to Jeff Rosenheim, picture postcards offered Evans "precisely the anonymous, anti-aesthetic, documentary quality that he sought to achieve in his own work," for Koolhaas they formed the base from which to reconstruct the history of the modern metropolis.[129] This tradition of collecting (anonymous) postcards has been continued into the present, most notably by artist Martin Parr and his *Boring Postcards* series.[130]

In light of Koolhaas's interest in surrealist strategies, it is significant that postcards were also very popular with the artists of this movement, who considered them representations of the modern collective unconscious. In 1933 the poet Paul Éluard published a contribution entitled "Les plus belles cartes postales" ("The most beautiful postcards") in the magazine *Minotaure* (fig. 6.16).[131] Along with a short literary introduction, the piece included a series of two-page spreads of Éluard's favorite postcards, arranged according to visual correspondences. One page showed views of Dublin, Graz, and the Eiffel Tower, though most of the selected images were human figures and heads, some of them in the fashion of Giuseppe Arcimboldi's grotesque portraits, others based on works of art. Many of the postcards in Éluard's selection were themselves photomontages, further evidencing the "vernacular," non-pedigreed origins of photomontage in popular visual culture.

Salvador Dalí considered postcards "the document that is the most alive of modern popular thought," seeing them as examples of the paranoid-critical phenomenon and a vital counter-model to the elitist art that he rejected.[132] In this vein (whether intentionally or not), and mediated by Boyarsky's approach, *Delirious New York* assembled postcards from Koolhaas's collection that most ostentatiously represented the so-far unwritten theory of "Manhattanism." The postcards were thus considered a visual repository of the unconscious culture of the modern metropolis. In order to write its history, its author would only have to select from these readymades and produce a narrative through the montage of the images.

The advent of digital photography in the 1990s brought about the obsolescence of the postcard. Moreover, with digital image storage and innovations in affordable color printing, the process of selecting individual images in the production of montage would become less significant when one could reproduce the entire archive. This development becomes thematic in *S,M,L,XL* (1995).

Fig. 6.16 Paul Éluard, Page spread from "Les plus belles cartes postales," *Minotaure* 3/4 (1933): 85–100.

Delirious New York, it could be said in conclusion, is an attempt at developing a new form of the historiography of the city whose structural principle is montage. Walter Benjamin's *Arcades Project* led the way in representing the material history of modernity on the basis of a montage of fragments. In the 1970s, when *Delirious New York* was conceived, the distrust in modernity's "master narratives" (as Jean-François Lyotard called them in his seminal report on postmodernism first published in 1979) became a key philosophical issue.[133] This problem was taken up and reflected upon by another figure who was frequently present at the Institute for Architecture and Urban Studies in New York during this period: the Italian architectural historian Manfredo Tafuri. We have already discussed elsewhere in this study Tafuri's leading role in appropriating the conceptual model of montage for the history and theory of architecture. In a critical assessment of Tafuri's intellectual outlook on history, Tomás Llorens pointed out somewhat dismissively in 1981 that the Italian architectural historian produced texts on the basis of a collection of preexisting fragments that he would select and arrange on any given occasion. To Llorens, this strategy accounted for the notoriously difficult and incoherent nature of Tafuri's texts: "In my opinion *Teorie e Storia* [*dell'architettura*] (1968) should be approached as a palimpsest, a document where the successive and often contradictory discourses of a crisis are superimposed rather than fused."[134] In a note, he goes on to explain:

> This applies, I think, to the whole of Tafuri's work. His writing seems like the flow of a river that preserves in its waters fragments and trophies from whatever regions it has traversed. Themes and arguments which had their origin in his early publications are carried through, intact, then years later, in spite of the radical change in direction that the author underwent around 1969. . . . It is as if he extracted from his readings in history, sociology, philosophy and journalism a continuous stream of notes and kept them in a range of assorted shoe boxes, ready to be used; given the occasion, he would sketch quickly the outline of an article or book, flesh in this pre-written material, and then return it all to the shoe boxes for further use. The reader expecting a linear exposition of an argument will be defeated. He should take each paragraph not as a link in a chain, but rather as a shot in a series aiming at a distant and not always discernible target.[135]

However, Tafuri deliberately proposed a model of history based on the montage of fragments in various writings, most explicitly in "The Historical 'Project,'" which serves as an introduction to his volume *The Sphere and the Labyrinth,* where he presents Sergei Eisenstein's theories of cinematic mon-

tage as a methodological framework for architectural history.[136] Likewise, in *Architecture and Utopia*, Tafuri characterizes "the law of assemblage" as "fundamental" for all the avant-garde movements, and implicitly proposes montage as a structural principle for a nonlinear history of architectural modernity.[137] In the same volume, he describes Piranesi's Campo Marzio reconstruction (1761–62) as an "assemblage of architectural pieces in the city,"[138] thereby interpreting the (negative) urban utopia of the Enlightenment as the anticipation of the modern urban condition under capitalism.[139]

Several of the theoretical sources of Tafuri's historiographical thinking have been recognized: broadly, Walter Benjamin (English and Italian translations of whose texts were first published in the 1960s), Antonio Gramsci, Benedetto Croce, and in particular Carlo Ginzburg's concept of "microhistories," as well as Michel Foucault's negation of the possibility of "objective" knowledge versus a piecemeal construction of it.[140] Koolhaas's thinking was doubtlessly informed by these theoreticians as well: as has been pointed out, he was introduced to French critical theory through Hubert Damisch during his time at Cornell, and it was through Damisch that he met Foucault in 1972. His agenda was nothing less than to devise an alternate methodology for architectural and urban history with far-reaching critical potential. By basing a historiographical account of (architectural) modernity on the concept of montage rather than on linear narration, and by allowing the resulting image of the city to include anonymous structures, the unconscious products of capital alongside the conscious products of art, he undertook a critical reassessment of received modernist master narratives. Ironically, Koolhaas's irreverent perspective went on to be installed as a new hegemonic discourse and methodology for the study of the contemporary city.

Conclusion

Montage is the cultural technique that, through its distinctive production of meaning in a gap bounded by disjunctive, prefabricated elements, has been singularly able to address the nature of perception in the age of technological reproducibility.[1] My study has attempted to trace the impact of montage thinking on the production of architectural imagery and the reconception of architectural and urban space throughout modernity. Mainly focusing on the historical avant-garde, my study suggests a *longue durée* relevance of montage thinking throughout the twentieth century, through its transit from the visual arts to film to architecture and architectural historiography. In so doing, I have argued that montage can be characterized as modernity's "symbolic form." Meanwhile, the material conditions from which montage was born have begun—or have continued—irrevocably to change.

Benjamin H. D. Buchloh has described the change in subjectivity and the need for new "models of perception" following industrialization: "The beginning of the Modernist avant-garde emerged at a historical turning point where, under the impact of the rising participation of the masses in collective production, all traditional models of perception that had served in the character formation of the bourgeois subject now had to be rejected in favor of models that acknowledged explicitly those social facts of a newly emerging historical situation where, as Benjamin would phrase it in his central essay, 'The Work of Art in the Age of Mechanical Reproduction' (1934), 'the sense of equality had increased to such a degree that equality was gained even from the unique, by means of reproduction.'"[2] We have seen that the poly-perspectivalism of montage represents motion and the mobility of the spectator as a necessary criterion for perceiving metropolitan space. While a photomontage may hypothetically represent an individual sequence of views seen by a particular, embodied, mobile viewer as his or her perspective changes, the different views that viewer sees, through their representation by mass images, are views anybody could see. Thus, the embodied and mobile viewing of the metropolis is represented as a mass experience. Moreover, in the act of contending with a work in which montage is employed as an epistemological principle, a collectivizing change occurs in the subjectivity of the viewer. Montage as an aesthetic

strategy aimed to create—and it could be argued that in some manner it did create—a politically activated mass subject, although the limitations to this subject's agency can be read in the history of the twentieth century.

By the 1970s, the collectivized subject became, in Rem Koolhaas's imagining, a self-divided structure itself modeled on the montage principle. In *Delirious New York,* Manhattan's structure of unrelated blocks organized by the equalizing form of the grid is duplicated in the division of the skyscraper, floor by floor, into unrelated blocks of program—"an unforeseeable and unstable combination of simultaneous activities"[3]; the psyche of the city dweller is just as multiply compartmentalized, and its compartments are subject to unforeseeable changes in content. Much may be gleaned from Madelon Vriesendorp's cover illustration of the book's first edition, in which two personified skyscrapers enjoy postcoital, dreaming slumber, each self-divided subject ruled by the conflicting desires and drives of the collective unconscious (see fig. 6.1).

While montage remained the guiding epistemological principle for cultural production from the early twentieth century to the late, the organization of the montage elements changed. We have examined in depth the dialectical alternatives of spatial juxtaposition and temporal sequence. Two further possibilities come out of *Delirious New York,* in its use of the medium of writing to understand montage as the structural principle of the city: first, individual montage elements can be subject to change over time (this is a mapping of sequence onto simultaneous montage); and second, montage elements can be nested one inside the other. It would be possible to argue that rudiments of these alternatives were already present in avant-garde montage: for example, that Citroen's *Metropolis* shows an interest in recursion by taking the mass of buildings of the metropolis at large and making it into a wall. However, in the late twentieth century, the rise of the computer, on the one hand, and the increasing rift between supposedly democratic political structures and those they claim to represent, on the other hand, make fractal self-similarity a compelling figure for the enforced inwardness of a collectivized subject no longer capable of meaningful political action.

A comparison of *Delirious New York* with *S,M,L,XL* (1995), written almost twenty years later, shows the continued development of these trends. The focus is simultaneously widened, so that instead of one quintessential metropolis we now have the "generic city" repeated across the globe, and turned inward, in that the book is fundamentally a survey of OMA's own projects and a meditation on what it means to be an architect. Meanwhile, with the introduction of the digital camera to the market in the mid-1990s, the "flood of images" threatens to overwhelm the text, a condition that *S,M,L,XL* reproduces and performs, page by page. It might be concluded that metropolitan montage is no longer possible, as in Citroen's example, on a single sheet, but now requires more than one thousand pages. In *S,M,L,XL,* the need for new forms of organization is answered

parodically. There is the sublimely banal ranking of buildings and projects from smallest to biggest; running through the margins, in the manner of a dictionary, is an alphabetical list of terms adjoined with passages of text illustrating their usage, which may be considered an alphabetized variation of the literary montage form of the cento.

The digital revolution has forever changed the possibility of montage as a meaningful tool for the exploration of the conditions of a modern spatiality. While the digital image has radically facilitated the combination of pictorial elements into new, virtual images, this logic of instantaneous combination and reassembly has at the same time led to the demise of the gaps, the spaces in between, as productive forces in the generation of meaning through active involvement of a critical audience (a process that was, as a matter of fact and as we have seen, initiated long before the advent of the digital age). As much as montage may be seen as a precursor to digital rendering practices, the underlying pictorial, and, by extension, urban politics could not be more radically opposed. As the conditions of technology and urbanism continue to change, it is inevitable that montage will become, or has already become, a principle that cannot adequately represent them. Rather than attempting to pinpoint this second defining crisis in montage's history, it is perhaps adequate for our present purpose to bear in mind that the crisis has been gradual and cumulative. Nevertheless, montage may continue to be used productively in isolated situations, side by side with new modes of the critical investigation of the built space we inhabit, long after its era has passed.

Notes

CHAPTER 1
INTRODUCTION

1. See Simmel, "Metropolis and Mental Life," 103–10.

2. Giedion, *Space, Time and Architecture*, 576. Giedion is referring to the strobo-scobic studies undertaken at MIT by Harold Eugene Edgerton.

3. "Dada montage served to recalibrate the viewer's perceptual apparatus to operate more effectively within the mediating conditions of the new optics of photography and publicity. The cognitive value of vision was directed not toward an idealist cosmology but toward living through the traumas, conflicts, and hidden politics of everyday life in the industrial metropolis." Mertins, "Architectures of Becoming," 112.

4. Eisenstein trained as an architect before turning to film.

5. Koolhaas, *Delirious New York*, 9.

6. On the notion of the plurality of images from a historical perspective, see Ganz and Thürlemann, *Das Bild im Plural*; for the distinction between simultane-ous and sequential works, see Stiegler, *Montagen des Realen*, 288.

7. Žmegač, "Montage/Collage," 286 (author trans.).

8. Blau and Troy, *Architecture and Cubism*, 6; Rosalind Krauss, "The Motivation of the Sign," in *Picasso and Braque: A Sympo-sium*, ed. Lynn Zelevanksy (New York: Museum of Modern Art, 1992), 273, as quoted in Blau and Troy, *Architecture and Cubism*. The opposing position, that the meaning of Picasso's *papiers collés* lies in the political message of the collaged newspaper clippings, can be found in Patricia Leighten, "Picasso's Collages and the Threat of War, 1912–13," *Art Bulletin* 67 (1985): 653–72. Bürger, *Theory of the Avant-Garde*, 73.

9. Raoul Hausmann, "Photomontage" (1931), in Phillips, *Photography in the Modern Era*, 178–81.

10. Žmegač, "Montage/Collage," 287.

11. Ibid.

12. Bloch, *Heritage of Our Times*; Adorno, *Aesthetic Theory*; Bürger, *Theory of the Avant-Garde*.

13. On the aesthetic of the fragment, see in particular Tronzo, *Fragment*; see also Nancy, "Die Kunst—Ein Fragment," 170–84. The relational theory of montage is particularly evident in the writings of Sergei Eisenstein.

14. See Didi-Huberman, "Was zwischen zwei Bildern passiert," 537–72. For an exploration of the concept of interposi-tion in various arts, see the international conference "Interpositions: Bildgrenzen," organized by the NCCR Iconic Criticism (*eikones*) at the Institut national d'his-toire de l'art (INHA) in Paris, February 1–3, 2011.

15. On Warburg's *Mnemosyne Atlas* and the production of meaning, see in particular Kurt W. Forster, "Die Hamburg-Amerika-Linie, oder: Warburgs Kulturwis-senschaften zwischen den Kontinenten," in *Aby Warburg: Akten des internationaien Symposions Hamburg 1990*, ed. Horst Bredekamp, Michael Diers, and Charlotte Schoell-Glass (Weinheim: VCH Acta Humaniora, 1991), 11–37; Benjamin H.D. Buchloh, "Warburgs Vorbild? Das Ende der Collage/Fotomontage im Nach-kriegseuropa," in Schaffner and Winzen, *Deep Storage*, 50–60; and Zumbusch, *Wissenschaft in Bildern*. On the notion of the exposition as montage, see in partic-ular Lugon, "Dynamic Paths of Thought," 117–44; see also Stiegler, *Montagen des Realen*.

16. Payne, "Architecture: Image, Icon, or *Kunst der Zerstreuung*?" 55–91, 70–71.

17. See Hofmann, *Die Moderne im Rückspiegel*.

18. Giedion, *Space, Time and Architecture*, 357, 356 (the use of "relatively" is with-out a doubt intended as a reference to Einstein's Theory of Relativity).

19. Lefebvre, *Production of Space*, 25.

20. See Giuliana Bruno, "Visual Studies: Four Takes on Spatial Turns," *Journal of the Society of Architectural Historians* 65, no. 1 (2006): 23–24; see also Bruno,

Atlas of Emotion; and Friedberg, *Window Shopping*.

21. For a discussion of Schmarsow's theories and their relationship to the concept of cinematic montage, see Chapter 5.

22. "Montage, terme de Batelier, action de celui qui remonte & facilite le mon-tage de bateaux." *Encyclopédie*, 10:672 (http://encyclopedie.uchicago.edu/)

23. Charles François Roland Le Virloys, *Dictionnaire d'architecture* (Paris: Librai-res Associés, 1770), 1:113, 115 (author trans.).

24. "The form favored by the 'progres-sive' artists of our time is . . . the open one which not only permits a free and constant interchange between art and life . . . but also enables the artist-engineer to add, subtract, dismantle and reassemble, almost at will, the parts which make up the artificial whole. This is precisely what we mean when we speak of *montage* as a characteristically modern technique." Weisstein, "Collage, Montage, and Related Terms," 131.

25. Boris Arvatov, "Die Kunst im System der proletarischen Kultur" (1926), in *Kunst und Produktion*, ed. and trans. Hans Günther and Karla Hielscher (Munich: Hanser, 1972), 33–34 (author trans.).

26. See Dorner, *The Way beyond "Art."* On Dorner and Bayer, see in particular Von Moos, "'Modern Art Gets down to Business.'"

27. For the French context, see in partic-ular Golan, *Muralnomad*.

28. On the newspaper as a quintessential element of modernity, see Fritzsche, *Reading Berlin 1900*, chap. 1. Fritzsche points out the metonymical relation-ship between the newspaper and the city itself: "Already in the 1860s Charles Dickens compared the disjointed assem-blage of articles on the front page to the haphazard space of the metropolis"; ibid., 23.

29. See Bergius, *Montage und Meta-mechanik*, 86–90; and Buchloh, "Faktura to Factography," 94.

30. See Schievelbusch, *Die Geschichte der Eisenbahnreise*; Eckhard Siepmann, "Was hat das Proletariat mit der Fotografie, die Fotografie mit der Montage und die Montage mit dem Proletariat zu tun?" in *Politische Fotomontage*, ed. Jürgen Holfreter (Berlin: Elefanten Press Galerie, 1975), 25–36 (author trans.).

31. Fritzsche, *Reading Berlin 1900*, 9, 34.

32. Teitelbaum, *Montage and Modern Life*, 7.

33. See Walter Benjamin, "Das Kunstwerk im Zeitalter seiner technischen Reproduzierbarkeit, Dritte Fassung," in *Abhandlungen, Gesammelte Schriften*, vol. 1.2, ed. Rolf Tiedemann and Hermann Schweppenhäuser (Frankfurt a. M.: Suhrkamp, 1991), 500.

34. Simmel, "Metropolis and Mental Life," 103.

35. Walter Benjamin, "What Is Epic Theater?" in *Illuminations*, ed. and introd. Hannah Arendt, trans. Harry Zohn (New York: Schocken, 1969), 147–54, 153.

36. "The greater the shock factor in particular impressions, the more vigilant consciousness has to be in screening stimuli; the more efficiently it does so, the less these impressions enter long experience [*Erfahrung*] and the more they correspond to the concept of isolated experience [*Erlebnis*]. Perhaps the special achievement of shock defense is the way it assigns an incident a precise point in time in consciousness, at the cost of the integrity of the incident's contents. This would be a peak achievement of the intellect; it would turn the incident into an isolated experience." Walter Benjamin, "On Some Motifs in Baudelaire," in *The Writer of Modern Life: Essays on Charles Baudelaire* (Cambridge, Mass.: Belknap Press of Harvard University Press, 2006), 170–210, 178. For a discussion of Benjamin's theories on the relationship of montage, urban perception, and architecture, see Brian Elliott, *Benjamin for Architects* (London: Routledge, 2011), 29–34; and Walter Benjamin, "What Is Epic Theater?" in *Illuminations*, 147–54.

37. See Michael W. Jennings, *Dialectical Images: Walter Benjamin's Theory of Literary Criticism* (Ithaca, N.Y.: Cornell University Press, 1987); Buck-Morss, *Dialectics of Seeing*; Zumbusch, *Wissenschaft in Bildern*. For an application of Benjamin's notion of the dialectical image to architectural photography, see Iain Borden,

"Imaging Architecture: The Uses of Photography in the Practice of Architectural History," *Journal of Architecture* 12, no. 1 (2007): 57–77, esp. 61–66.

38. See Akcan, "Manfredo Tafuri's Theory of the Architectural Avant-Garde."

39. "Assemblage, n." OED Online (Oxford University Press, June 2016). http://www.oed.com.

40. Tafuri, *Architecture and Utopia*, 86. ("Per tutte le avanguardie—e non solo pittoriche—la legge del montaggio è fondamentale"; Tafuri, *Progetto e utopia*, 80.)

41. See Möbius, *Montage und Collage*, 198.

42. See Seitz, *Art of Assemblage*. For subsequent surveys on the phenomenon, see Mon and Neidel, *Prinzip Collage*; Mahlow, *Prinzip Collage*; Ades, *Photomontage*; and William C. Seitz, "The Realism and Poetry of Assemblage" (1961), in K. Hoffman, *Collage: Critical Views*, 82.

43. It should be mentioned in passing that "assemblage" is also a concept employed by Gilles Deleuze and Felix Guattari in *Thousand Plateaus*, which was widely received in architectural discourse. For them, assemblage (like the rhizome) stands for a nonhierarchical order where objects/thoughts are placed next to each other rather than vertically aligned. Thus it becomes a metaphor for a radically democratic/anarchistic form of organization, again based on a spatial definition: "An assemblage has neither base nor superstructure, neither deep structure nor superficial structure; it flattens all of its dimensions onto a single plane of consistency upon which reciprocal presuppositions and mutual insertions play themselves out." Deleuze and Guattari, *Thousand Plateaus*, 90.

44. See Wescher, *Die Collage*; and Möbius, *Montage und Collage*.

45. See the proposal by Ulrich Weisstein: "Generally speaking, it is advisable . . . to use the terms montage and quotation only where intra-artistic processes (preferably within the same medium) are concerned, whereas collage should be limited to cases where art and reality intersect." Weisstein, "Collage, Montage, and Related Terms," 124–39.

46. Bürger, *Theory of the Avant-Garde*, 50, 73, 74, 75. For Heartfield and Dada Berlin, see also Siepmann, *Montage: John Heartfield*; Jürgens-Kirchhoff, *Technik und*

Tendenz; Peter Panicke and Klaus Honnef, eds., *John Heartfield*, exh. cat. Akademie der Künste zu Berlin (Cologne: DuMont, 1991); Bergius, *Montage und Metamechanik*. For a more recent assessment of Heartfield's photomontages, see Zervigón, *John Heartfield and the Agitated Image*. A recent, alternative account of montage in Weimar Germany considers its narrative dimension. See McBride, *Chatter of the Visible*.

47. Bürger, *Theory of the Avant-Garde*, 82.

48. See Rowe and Koetter, *Collage City*. An earlier version of the manifesto was published in *Architectural Review* 158 (August 1975): 66–91.

49. Pehnt, *Hans Hollein*, 50.

50. Rowe and Koetter, *Collage City*, 86–117.

51. Lévi-Strauss, *Savage Mind*, 17–18.

52. Charles Jencks and Nathan Silver, *Adhocism: The Case for Improvisation* (Garden City, N.Y.: Anchor, 1973), 171.

53. On the history of capriccio, see John Wilton-Ely, "Capriccio," in *Grove Art Online*. http://www.oxfordartonline.com. See also Ekkehard Mai and Joachim Rees, eds., *Kunstform Capriccio: Von der Groteske zur Spieltheorie der Moderne* (Cologne: König, 1998).

54. "The penal imagery was of less significance to the artist than the opportunities that these stark utilitarian structures provided for spatial experiment." Wilton-Ely, "Capriccio."

55. See Scully, *Modern Architecture*, 11–12; and Tafuri, "Dialectics of the Avant-Garde," 74. For a further discussion of this aspect, see Chapter 5.

56. Rossi, *Architecture of the City*, 166. I am indebted to Diogo Seixas Lopes for pointing this out to me. See Seixas Lopes, "Cut-Ups."

57. See Rowe and Koetter, *Collage City*, 178–79.

58. See Denise Scott Brown and Robert Venturi, *Architecture as Signs and Systems: For a Mannerist Time* (Cambridge, Mass.: The Belknap Press of Harvard University Press, 2004).

59. See Koolhaas's self-quotation from *Delirious New York* in OMA, Koolhaas, and Mau, *S,M,L,XL*, 22–43.

60. See K. Hoffman, *Collage: Critical Views*.

61. This essay originally was published in the *Anti-Aesthetic*, a major source

reader of postmodern theory, edited by Hal Foster.

62. Jacques Derrida, "Collages," quoted in Ulmer, "Object of Post-Criticism," 389.

63. The allegorical nature of montage was pointed out early by Walter Benjamin; see Benjamin, *The Origin of German Tragic Drama*, trans. J. Osborne (London: Verso, 1977); Buck-Morss, *Dialectics of Seeing*.

64. See Buchloh, "Faktura to Factography." This question was also addressed a few years later in Hays, "Photomontage."

65. See Buchloh, "Warburgs Vorbild?"

66. See, in particular, Tafuri, *Architecture and Utopia*; Tafuri, "Dialectics of the Avant-Garde"; Tafuri, *Theories and History of Architecture*; Tafuri, *Sphere and the Labyrinth*.

67. See Eisenstein, "Montage and Architecture," 116–31. Bois, "Introduction," 111–15.

68. See Friedberg, *Window Shopping*.

69. See Bruno, *Atlas of Emotion*.

70. Stan Allen, *Practice: Architecture, Technique + Representation*, expanded 2nd ed. (Routledge: Milton Park, 2009), 28–31, 30.

71. Especially worthy of note are the texts "Spaces of Passage," "The Explosion of Space," and "Metropolitan Montage." See Vidler, *Warped Space*. Vidler's methodology informs the present study in many significant ways.

72. See, for example, Cohen, "Misfortunes of the Image," 100–121; and Cohen, *Le Corbusier and the Mystique of the USSR*.

73. See Hubert Damisch, "Modernité," in *Le Corbusier: Une encyclopédie* (Paris: Centre Georges Pompidou, 1987), 252–59. Damisch bases his analysis on Le Corbusier's discussion of Auguste Choisy's interpretation of the Acropolis in Athens.

74. "Montage is a means to think spatially, to make unexpected connections between diverse ideas." Hill, *Actions of Architecture*, 4.

75. See Deriu, "Montage and Architecture." See also Heynen, *Architecture and Modernity*. By contrast, a recent publication on collage and architecture remains conceptually vague and reads more as an introduction to various forms of assembly in modern architectural culture; see Shields, *Collage and Architecture*.

CHAPTER 2
PHOTOMONTAGE AND
THE METROPOLIS

1. For this thesis, see, for example, Grasskamp, "Die Malbarkeit der Stadt," 265–84.

2. See Simmel, "Metropolis and Mental Life," 11–19; Walter Benjamin, "On Some Motifs in Baudelaire," in *The Writer of Modern Life: Essays on Charles Baudelaire* (Cambridge, Mass.: Belknap Press of Harvard University Press, 2006), 170–210. These authors' theories were also important for the valorization of the montage principle by the architectural historian Manfredo Tafuri. See Tafuri, *Architecture and Utopia*, 78–103.

3. For the concept of the "scopic regime" and on perspective as a historical convention of representation—in other words, a symbolic form—see Jay, "Scopic Regimes of Modernity," 3–23; and Panofsky, *Perspective as Symbolic Form*. The literature on the Renaissance invention of perspective and its impact on architectural and spatial representation is vast and cannot be discussed here in detail. The most important studies in this regard, besides those already cited, are Edgerton, *Renaissance Rediscovery*; and Damisch, *Origin of Perspective*.

4. More precisely, Raphael takes different stances as to the permissibility of perspective in architectural representation in the three different known versions of his letter. See John Shearman, *Raphael in Early Modern Sources (1483–1602)* (New Haven: Yale University Press, 2003), 500–545. For the history of architectural representation, see Yve-Alain Bois, "Metamorphosis of Axonometry," *Daidalos* 1 (1981): 47–50; Pérez-Gómez and Pelletier, "Architectural Representation beyond Perspectivism"; Christof Thoenes, "Vitruv, Alberti, Sangallo: Zur Theorie der Architekturzeichnung in der Renaissance," in *Hülle und Fülle: Festschrift für Tilmann Buddensieg*, ed. Andreas Beyer, Vittorio Lampugnani, and Gunter Schweikhart (Alfter: VDG, 1993), 565–84; and Pérez-Gómez and Pelletier, *Architectural Representation and the Perspective Hinge*.

5. See Pérez-Gómez and Pelletier, *Architectural Representation and the Perspective Hinge*, 27.

6. See Hofmann, *Die Moderne im Rückspiegel*; Scolari, *Oblique Drawing*. On the notion of the plurality of images, see also Ganz and Thürlemann, *Das Bild im Plural*.

7. Edgerton, *Renaissance Rediscovery*, 9, 7, 10.

8. See Pérez-Gómez and Pelletier, "Architectural Representation beyond Perspectivism," 31. On this topic, see also Lydia Massey, *Picturing Space, Displacing Bodies: Anamorphosis in Early Modern Theories of Perspective* (University Park: Pennsylvania State University Press, 2007).

9. Stan Allen, *Practice: Architecture, Technique + Representation* (Abingdon: Routledge, 2009), 19.

10. See Bois, "Metamorphosis of Axonometry," 56. Bois makes clear that axonometry and isometry were taught widely in engineering schools from the end of the nineteenth century, so the "reinvention" in avant-garde circles around 1920 may need to be seen more as a reinterpretation of an established tool for specific epistemic purposes. For a history of non-perspectival forms of architectural representation, see Scolari, *Oblique Drawing*, chap. 1. See also Allen, *Practice*, chap. 1.

11. George Grosz, quoted in Richter, *Dada*, 117. In a 1929 letter to Franz Roh, Grosz even dates the invention of photomontage to 1915; see Roh, *Foto-Auge*, 18, quoted in Ades, *Photomontage*, 19. For a more recent account of the genesis of photomontage from postcards to the front, see Zervigón, *John Heartfield and the Agitated Image*, chap. 2.

12. See Richter, *Dada*, 117.

13. Hannah Höch, quoted in Götz Adriani, "Biographische Dokumentation," in *Hannah Höch: Fotomontagen, Gemälde, Aquarelle*, ed. Götz Adriani (Cologne: DuMont, 1980), 16 (author trans.).

14. See Höch, *Eine Lebenscollage*, 1.2, 753. For a detailed discussion of such postcards with regard to gender construction in Prussia, see Elizabeth Otto, "Real Men Wear Uniforms: Photomontage, Postcards, and Military Visual Culture in Early Twentieth-Century Germany," *Contemporaneity* 2, no. 1 (2012): 18–44.

15. I am indebted to Martin Conrath, Berlin, for pointing out this postcard to me, which stands in a long line of similar depictions of the Döberitz drill ground. See Martin Conrath, *Ein Bild und seine Motivgeschichte: Das Döberitzer Barackenlager*, Zur Geschichte der Döberitzer

Heide, supplement no. 13 (Berlin: Privately published, 2012).

16. On Citroen's biography and training, see in particular Van Rheeden, Feenstra, and Rijkschroeff, *Paul Citroen*; Bool, *Paul Citroen*, vol. 7; and Molderings, "Paul Citroen." For Citroen's relationship to Walden and *Der Sturm*, see in particular Herbert van Rheeden, "Metropolis: The 1920s Image of the City," in *Metropolis*, Avantgarde 1, ed. Michael Müller and Ben Rebel (Amsterdam: Rodopi, 1988), 15.

17. See Van Rheeden, Feenstra, and Rijkschroeff, *Paul Citroen*, 27.

18. See Huelsenbeck, *Dada Almanach*, 102–4. In his short text, Citroen interestingly refers to readings of Kurt Schwitters's poems in the Netherlands; he does not consider them to be Dada; ibid., 103.

19. It is not quite clear how Citroen became aware of photomontage and photocollage as new artistic techniques. Both Kurt Schippers and Richard Hiepe argue that his friend Erwin Blumenfeld (Jan Bloomfield) may have been instrumental. See Schippers, *Holland Dada*, 25; Schippers, "Dada Holland," in *Tendenzen der Zwanziger Jahre*, 15. *Europäische Kunstausstellung Berlin* (Berlin: Dietrich Reimer, 1977), 3, 92–93, 95; and Hiepe, "Über Photographie und Photo-Collage," in *Dada: Photographie und Photocollage*, ed. Carl-Albrecht Haenlein, exh. cat. Kestner-Gesellschaft Hannover (Hannover: Kestner-Gesellschaft, 1979), 35. The catalog of the First International Dada Fair, held that year in Berlin, lists four works by Citroen's younger brother Hans, introducing him as a member of the "Jugendgruppe Dada," while his older brother's work was not included. The four works are *Die Angel, Wilsons 14 Punkte, Landkarte dada*, and *Das Netz. Erste Internationale Dada-Messe, Kunsthandlung Dr. Otto Burchhard*, Berlin 1920. Berlinische Galerie, Hannah Höch Archiv, 13.26.

20. Paul Citroen, quoted in Schippers, "Dada Holland," 3, 93.

21. See Van Rheeden, Feenstra, and Rijkschroeff, *Paul Citroen*, 38–41.

22. The exhibition is generally considered the end of the early, expressionist phase of the Weimar Bauhaus.

23. See Heyltjes, *Die Fotomontage und die Großstadt*, 49; Moholy-Nagy, *Malerei, Photographie, Film*, 8:116–29; Ades, *Photomontage*, 98–105.

24. See Van Rheeden, Feenstra, and Rijkschroeff, *Paul Citroen*, 109.

25. For a discussion of the discourse on the skyscraper in Germany after World War I, see Stommer, "Germanisierung des Wolkenkratzers"; Jochen Meyer, "Aspekte—Kontroversen—Tendenzen: Die Hochhausdiskussion in Deutschland Anfang der Zwanziger Jahre," in Zimmermann, *Der Schrei nach dem Turmhaus*, 186–214; and Jean-Louis Cohen, "German Desires of America: Mies's Urban Visions," in Riley and Bergdoll, *Mies in Berlin*, 363–71.

26. See Heyltjes, *Die Fotomontage und die Großstadt*. See also Anton Kaes, "Metropolis: City, Cinema, Modernity," in *Expressionist Utopias*, ed. Timothy O. Benson (Los Angeles: University of California Press, 1994), 146–65.

27. See Heyltjes, *Die Fotomontage und die Großstadt*, 74–78.

28. Sergei Eisenstein, "El Greco y el cine," in Eisenstein, *Cinématisme: Peinture et cinéma*, 21 (author trans.). Eisenstein goes on to interpret a whole group of paintings by El Greco as proto-cinematic representations, among them two additional topographic views of Toledo, *Toledo with the Alcantara Bridge* and *View of Toledo under Storm*.

29. Stoichita, *Das selbstbewußte Bild*, 200, 201 (author trans.).

30. Such remnants of a more traditionalist understanding of the image seem to be confirmed by Citroen's apparent disinterest in contemporary theoretical debates on issues such as spatial representation and simultaneity. See Van Rheeden, Feenstra, and Rijkschroeff, *Paul Citroen*, 45.

31. See Ades, *Photomontage*, 100; and Molderings, "Paul Citroen," 339.

32. See Tafuri, "Dialectics of the Avant-Garde," 73–80.

33. Moholy-Nagy makes this reference in the caption in the second edition of his book, published in 1927.

34. Georg Heym, *Dichtungen* (Stuttgart: Reclam, 1964), 3–4.

35. For Hannah Höch's use of photomontage, see Adriani, "Biographische Dokumentation"; Julia Dech, *Schnitt mit dem Küchenmesser Dada durch die letzte weimarer Bierbauchkulturepoche Deutschlands* (Frankfurt a. M.: Fischer Taschenbuch, 1989); Lavin, *Cut with the Kitchen Knife*; and Burmeister, *Hannah Höch*.

36. See Bergius, *Montage und Metamechanik*, 130–59. Eberhard Roters had previously put forward a political interpretation of this work, which was in turn rejected as "entirely inadequate" by Richard Hiepe. See Eberhard Roters, "Hintergrundanalyse der Collage 'schnitt mit dem Küchenmesseer' (1920) von Hannah Höch," in Mon and Neidel, *Prinzip Collage*, 42–44; Hiepe, "Über Photographie und Photo-Collage," 36. See Heyltjes, *Die Fotomontage und die Großstadt*, 80–82.

37. See Bergius, *Montage und Metamechanik*, 144.

38. For an interpretation of this photomontage, see Otto, *Tempo, Tempo!* 40–42. For the notion of monotony in modern architecture, see, for example, Otto Wagner, *Modern Architecture*, intro. and trans. Harry Francis Mallgrave (1895; repr., Santa Monica: Getty Center for the History of Art and the Humanities, 1988).

39. For this comparison, see Otto, *Tempo, Tempo!* 42. Rodchenko produced this photomontage to illustrate Vladimir Mayakovsky's poem "About This" ("*Pro eto*") (1923).

40. This montage had traditionally been dated to 1922, but Heyltjes convincingly argues that the terminus post quem is 1949. See Heyltjes, *Die Fotomontage und die Großstadt*, 90.

41. For a detailed discussion of the making of this photomontage, see ibid., 88–91.

42. For a discussion of the photomontage, see Otto, *Tempo, Tempo!* 43–45; and Otto, "'Schooling of the Senses,'" 89–131, 99–103.

43. Otto, "'Schooling of the Senses,'" 101.

44. William Rubin, *Dada, Surrealism, and Their Heritage* (New York: Museum of Modern Art, 1968), 42.

45. Sergei Tretyakov, *John Heartfield* (Moscow: OGIS, 1936), quoted in Ades, *Photomontage*, 7.

46. Varvara Stepanova, "Photomontage" (1928), in Phillips, *Photography in the Modern Era*, 234–37.

47. Raoul Hausmann, "Photomontage" (1931), in Phillips, *Photography in the Modern Era*, 180.

48. Franz Höllering, "Photomontage" (1928), in Phillips, *Photography in the Modern Era*, 129.

49. Ibid., 128, 129, 130.

50. For a similar, albeit politically even more radical statement than Höllering's, see an essay by Durus (Alfred Kemény), also first published in Der Arbeiter-Fotograf: "Photomontage as a Weapon in Class Struggle" (1932), in Phillips, Photography in the Modern Era, 204–6.

51. César Domela Nieuwenhuis, "Photomontage" (1931), in Phillips, Photography in the Modern Era, 307.

52. The Getty Research Institute, Special Collections, Jan and Edith Tschichold Papers, box 5, folder 6 ("Photomontage"). While the book remained unpublished, Tschichold discussed the problem of photomontage in his writings. See Jan Tschichold, "Fotografie und Typografie," Die Form 7 (1928): 221–37, translated as "Photography and Typography," in Phillips, Photography in the Modern Era, 121–27.

53. Fotomontage: Ausstellung im Lichthof des ehemaligen Kunstgewerbemuseums Prinz Albrechtstr. 7 (Berlin: Staatliche Museen, Staatliche Kunstbibliothek, 1931), Getty Research Institute, Special Collections, Jan and Edith Tschichold Papers, box 5, folder 6 ("Photomontage").

54. László Moholy-Nagy, "Abstract of an Artist" (1944), quoted in Otto, "'Schooling of the Senses,'" 92.

55. See Moholy-Nagy, Malerei, Photographie, Film, 94–97; see also the reprint of the 1927 edition (Mainz: Kupferberg, 1967), 105.

56. An exception to this is Citroen's montage Boxing Match in New York, which is also labeled a Photoplastik (photo sculpture). See Moholy-Nagy, Malerei, Photographie, Film, 97.

57. See Otto, "'Schooling of the Senses,'" 91, 96.

58. Moholy-Nagy, Malerei, Fotografie, Film, reprint (see n55), 35.

59. Paul Citroen, quoted in Molderings, "Paul Citroen," 340; Paul Citroen, "Notizen eines jungern Malers," Das Kunstblatt 7 (1927): 281, quoted in Herbert Molderings, Umbo: Otto Umbehr, 1902–1980 (Düsseldorf: Richter, 1995), 97.

60. For a comprehensive survey and discussion of Moholy's photomontages, see Irene-Charlotte Lusk, Montagen ins Blaue: Laszlo Moholy Nagy. Fotomontagen und -collagen, 1922–1943 (Gießen: Anabas, 1980), esp. 160–63, 201–2. See also Jeanpaul Goergen, "Lichtspiel und soziale Reportage: László Moholy-Nagy und die deutsche Film-Avantgarde," in László Moholy-Nagy: Die Kunst des Lichts, exh. cat. Martin Gropius Bau, Berlin (Madrid: La Fabrica, 2010), 201–4.

61. For this comparison, see Otto, "'Schooling of the Senses,'" 125–26.

62. The Getty Research Institute, Special Collections, Jan and Edith Tschichold Papers, box 1, folder 3 ("Bauhaus").

63. For Rodchenko's involvement with LEF, see "Introduction," in Dabrowski, Dickerman, and Galassi, Aleksandr Rodchenko, 10–17; see also Dickerman, "Fact and the Photograph."

64. "There can be little doubt that the artists of LEF—even Mayakovsky—both influenced and were influenced by the montage theories of Vertov and Eisenstein." Bordwell, "Idea of Montage," 15.

65. Buchloh, "Faktura to Factography," 84; Sergei Tretyakov, "Chto novogo?" Novyi lef 9 (1928): 4, trans. and quoted in Dickerman, "Fact and the Photograph," 138. Issue 118 of October, devoted to Soviet factography, included a number of important source texts on this literary and artistic current as well as several interpretations of it; Dickerman, "Fact and the Photograph," 148.

66. See Dickerman, "Fact and the Photograph," 135, and Kuchanova, "Osip Brik," 64–65.

67. [Gustav Klutsis?], "Photomontage," Lef 4 (1924): 43–44, reprinted in Phillips, Photography in the Modern Era, 211–12.

68. Buchloh, "Faktura to Factography," 99.

69. Siegfried Kracauer, From Caligari to Hitler: A Psychological History of the German Film (1947; repr., Princeton: Princeton University Press, 1974), 150, quoted in Neumann, Film Architecture, 33. As Anton Kaes has noted, "The papers on the morning following the premiere were almost unanimous in their criticism, pointing out the glaring contradiction between the film's strikingly innovative visual style and its atavistic, if not reactionary, ideology." Anton Kaes, "Metropolis: Cinema, City, Modernity," in Benson, Expressionist Utopias, 148.

70. Fritz Lang, "Was ich in Amerika sah: Neuyork—Los Angeles" (1924), quoted in Neumann, Film Architecture, 34; in his essay on the film, Neumann convincingly argues that a number of literary sources were influential as well, most importantly Oswald Spengler's Decline of the West and H.G. Wells's science-fiction novels.

71. According to more recent research by Michael Organ and René Clémenti-Bilinsky, this photomontage can be attributed to the graphic artist Boris Bilinsky, who was also responsible for the well-known advertisement poster for the promotion of the movie, as we will see. The photomontage was first published without credits in the Paris trade newspaper Ciné-Miroir on April 16, 1927. See Michael Organ and René Clémenti-Bilinsky, "Metropolis," University of Wollongong, http://www.uow.edu.au/~morgan/metrojc.htm.

72. For an illustrated account of Kesselhut's memoirs, see Werner Sudendorf, ed., Erich Kesselhut—Der Schatten des Architekten (Munich: Belleville, 2009).

73. See Molderings, Umbo, 89, 92, 94, 102. Molderings speculates that Ruttmann had commissioned Citroen for these photomontages and that the latter passed on the task to Umbo, who at the time was in financial need. According to Umbo's recollections, another artist working on the photomontage was the Berlin photographer Sasha Stone, who later collaborated with Umbo on the 1929 photomontage Der Alexanderplatz im Umbau (Alexanderplatz under Reconstruction).

74. Dziga Vertov, "Provisional Instructions to Kino-Eye Groups," in Vertov, Kino-Eye, 67. Vertov's thoughts are also reminiscent of Walter Benjamin's concept of the "optical unconscious" as developed in his Work of Art in the Age of Its Technological Reproducibility. See Walter Benjamin, "Das Kunstwerk im Zeitalter seiner technischen Reproduzierbarkeit, Dritte Fassung," in Abhandlungen, Gesammelte Schriften, vol. 1.2, ed. Rolf Tiedemann and Hermann Schweppenhäuser (Frankfurt a. M.: Suhrkamp, 1991), 471–508, 500.

75. See Stanisław Czekalski, "Kazimierz Podsadecki and Janusz Maria Brzeski: Photomontage between the Avant-Garde and Mass Culture," History of Photography 29, no. 3 (2005): 256–73, esp. 257.

76. "Człowiek w mieście przyszłości," Na szerokim świecie 13 (1931), trans. and quoted in ibid., 263.

77. See, in this connection, the seminal contribution by Rosalind Krauss in which she discusses the discursive practice of inscribing nineteenth-century geological

survey photographs into the realm of aesthetics/art: Krauss, "Photography's Discursive Spaces," 311–19.

78. William Lake Price, *A Manual of Photographic Manipulation*, 2nd ed. (1868; repr, New York: Arno, 1973); C. Jabez Hughes, "Art Photography: Its Scope and Characteristics," *Photographic News* 5, no. 122 (January 4, 1861): 4, quoted in Sobieszek, "Composite Imagery," 59.

79. See Sobieszek, "Composite Imagery," 58–65.

80. See Mary Warner Marien, *Photography: A Cultural History*, 3rd ed. (London: Laurence King, 2010), 88.

81. See Gottfried Jäger, "Bildsystem Fotografie," in Sachs-Hombach, *Bildwissenschaft*, 354.

82. See in this regard Mitchell, *Picture Theory*, 163.

83. See Daston and Galison, *Objectivity*.

84. Talbot, *Pencil of Nature*.

85. For the following argument and examples, see Sobieszek, "Composite Imagery," 40–45.

86. Ibid., 44.

87. Ibid.

CHAPTER 3
PHOTOMONTAGE IN
ARCHITECTURAL REPRESENTATION

1. The history of architecture has become a focus of research in more recent years. For a survey of the history of architectural photography, see in particular Cervin Robinson and Joel Herschman, *Architecture Transformed: A History of the Photography of Buildings from 1839 to the Present* (Cambridge, Mass.: MIT Press, 1987); Italo Zannier, *Architettura e fotografia* (Rome: Laterza, 1991); Sachsse, *Bild und Bau;* James Ackerman, "The Origins of Architectural Photography," in *Origins, Imitation, Conventions: Representation in the Visual Arts* (Cambridge, Mass.: MIT Press, 2002), 95–124; Elwall, *Building with Light;* Iain Borden, "Imaging Architecture: The Uses of Photography in the Practice of Architectural History," *Journal of Architecture* 12, no. 1 (2007): 57–77; Giovanni Fanelli, *Storia della fotografia di architettura* (Rome: Laterza, 2009); Higgott and Wray, *Camera Constructs;* Zimmerman, *Photographic Architecture.*

2. On mechanical objectivity, see Daston and Galison, *Objectivity.*

3. See Sachsse, *Bild und Bau.*

4. Rheinberger, "Gaston Bachelard," 297–310.

5. On the index, see Krauss, *Originality of the Avant-Garde,* 196–219; see also Geimer, *Theorien der Fotografie zur Einführung,* chap. 1.

6. For a discussion of such manipulation strategies in the works of Le Corbusier and Adolf Loos, see Colomina, *Privacy and Publicity,* 107–18, 270–71.

7. See Sachsse, *Bild und Bau,* 84. For a comprehensive general (German) history of the photographic reproduction in books and the various technologies involved, see Frank Heidtmann, *Wie das Photo ins Buch kam* (Berlin: Berlin Verlag Arno Spitz, 1984).

8. See Sachsse, *Bild und Bau,* 78–79.

9. See Hans R. Kerner and Horst W. Kerner, *Lexikon der Reprotechnik* (Mannheim: Reinhard Welz, 2007), 487. See also Sachsse, *Bild und Bau,* 95–96; Sachsse, "Mies und die Fotografen II," 255; M. Boblenz, *Die Technik der modernen Großretouche auf Bromsilberpapier* (Erkner: Privately published, 1911).

10. This conclusion is based on an evaluation of *Deutsche Bauzeitung* (1890–1914), *Süddeutsche Bauzeitung* (1902–14), and *Baumeister* (1902–14); Françoise Choay, *L'Allégorie du patrimoine* (Paris: Seuil 1992), 13.

11. Quoted in Horst Karl Marschall, *Friedrich von Thiersch: Ein Münchner Architekt des Späthistorismus* (Munich: Prestel, 1982), 342–43 (author trans.). Marschall also documents the history of the proposed reconstruction and the arguments of the final commission.

12. The German *Heimatschutzbewegung* was a cultural reaction in Germany and German-speaking countries against the negative consequences of the Industrial Revolution and urbanization processes. Though progressive voices such as Hermann Muthesius or Theodor Fischer contributed to the movement, it tended to romanticize nature and country life and strove for a strengthening of national identity. The movement was widely supported in intellectual circles and resulted in its own architectural style, the *Heimatstil,* or "national romanticism."

13. For a more detailed account of the use of pictorial comparison in architectural publishing and discourse around

1900, see Stierli, *Las Vegas in the Rearview Mirror,* 222–27.

14. See Buchloh, "Allegorical Procedures," 43–56; see also Benjamin H. D. Buchloh, "Warburgs Vorbild'? Das Ende der Collage/Fotomontage im Nachkriegseuropa," in Schaffner and Winzen, *Deep Storage,* 50–60.

15. See D. Hoffman, "Receding Horizon of Mies," 99–117, 104–5.

16. On Fischer, see Sachsse, *Bild und Bau,* 100, 103. To a lesser degree, Fischer's colleague Richard Riemerschmid seems also to have made occasional use of the technique, most prominently in his design for a Bismarck monument at Elisenhöhe. I am indebted to Wolf Tegethoff for pointing out the Hohenaschau project. See Marschall, *Friedrich von Thiersch,* 346–47. On von Thiersch's use of photography in general, see Sachsse, *Bild und Bau,* 86–91.

17. See Nerdinger and Zimmermann, *Die Architekturzeichnung,* 143. On the history of the project, see Marschall, *Friedrich von Thiersch,* 27–29.

18. See Sachsse, *Bild und Bau,* 90.

19. See Thomas Gnägi, "'das Einzelne als Teil des Ganzen zu betrachten': Kirchenbau als städtebauliche Aufgabe," in *Karl Moser: Architektur für eine neue Zeit, 1880 bis 1936,* ed. Werner Oechslin and Sonja Hildebrand (Zurich: gta Verlag, 2010), 1:193.

20. For a detailed history and discussion of the project, see Sonja Hildebrand, "Sanierung der Altstadt Zürich (Niederdorfstudie)," in Oechslin and Hildebrand, *Karl Moser,* 328–32; Daniel Kurz, "Karl Moser und das neue Zürich," in Oechslin and Hildebrand, *Karl Moser,* 241–55; see also Fröhlich and Steinmann, "Zürich, das nicht gebaut wurde," 30–33.

21. For a brief historical sketch of architectural photogrammetry in Germany, see Sachsse, *Bild und Bau,* 77–82; and A. Nothnagel, "Meßbildverfahren und Denkmäler-Archive," *Deutsche Bauzeitung* 40 (1906): 615 (author trans.).

22. For an introduction to this debate, see the excellent essay by Sokratis Georgiadis, his introduction to Sigfried Giedion, *Building in France,* 1–78, esp. 28–30. For a discussion of iron construction in the larger framework of German architectural theory around 1900, and centering on the key concepts *"Technik," "Kultur,"* and *"Zivilisation,"* see Romba,

Iron Construction and Cultural Discourse. Quotation from "Aufruf zur Gründung eines Bundes Heimatschutz," *Deutsche Bauhütte* 8, no. 15 (1904): 106 (in Georgiadis, "Introduction," 30).

23. For a recent reassessment of the relationship between suprematism and constructivism, see Tatiana Goriacheva, "Suprematism and Constructivism: An Intersection of Parallels," in Douglas and Lodder, *Rethinking Malevich*, 67–81. Goriacheva argues that Malevich and the constructivists started out with similar objectives of finding an alternative to traditional painterly composition, but that what could be called the utilitarian turn of the constructivists after 1921 provoked a break between the two camps. For Malevich, utility was "the functionality of pure form-building, independent of any considerations of practical use"; ibid., 71.

24. See Gisela Heinrich, *Kasimir Malewitsch: Architektonische Modelle für Utopia und ihr Nachwirken in der Kunst der Gegenwart* (Weimar: Verlag und Datenbank für Geisteswissenschaften, 2012), 30.

25. See Goriacheva, "Suprematism and Constructivism," 70.

26. See Alexandra Shatskikh, "Unovis: Epicenter of a New World," in Solomon R. Guggenheim Museum, *Great Utopia*, 53–64; see also Shatskikh, *Vitebsk*, 108–19. Kazimir Malevich, letter to the Dutch artists, 12 February 1922, quoted in Christina Lodder, "Living in Space: Kazimir Malevich's Suprematist Architecture and the Philosophy of Nikolai Fedorov," in Douglas and Lodder, *Rethinking Malevich*, 182.

27. Kazimir Malevich, letter to the Dutch artists, 7 September 1921, not sent, quoted in Goriacheva, "Suprematism and Constructivism," 72.

28. Lodder, "Living in Space," 192.

29. The same is the case for El Lissitzky's Prouns, as we will see.

30. Kasimir Malevich, "Suprematizm: 34 risunka," quoted in Lodder, "Living in Space," 183. As Lodder has argued, Malevich actually started to think about architecture as early as 1918, thus before his move to Vitebsk and the founding of UNOVIS. Lodder also discusses the Arcitectona and planits in the context of Malevich's theories on art as well as the Promethean ideas of Nikolai Fedorov.

31. See Ades, *Photomontage*, 151.

32. Kasimir Malevich, "I/46: Contemporary Art," in Malevich, *World as Non-Objectivity*, 3:217.

33. Aleksei Gan, "Spravka o Kazimire Maleviche," *Sovremennaia arkhitektura* 3 (1927): 105, quoted in Goriacheva, "Suprematism and Constructivism," 81.

34. On Vitebsk, see Shatskikh, "Unovis." For a general survey of early Soviet architecture, see Khan-Magomedov, *Pioneers of Soviet Architecture*. See Walter Kambartel, "Lissitzkys 'Rekonstruktion der Architektur': Zur Lenintribune und zum Wolkenbügel," in *El Lissitzky, 1890–1941: Retrospektive,* exh. cat. Sprengel Museum Hannover (Frankfurt a. M.: Propyläen, 1988), 54–63.

35. "Although considerable skepticism has been voiced in the last several decades with regard to the positing of radical breaks, epistemological rifts, and other ruptures of great magnitude, such skepticism is not warranted here, for in its localized practices and theories, Constructivism is fundamentally ruptured: All the Moscow Constructivists abandon easelism altogether after November 1921, with several also managing to enter, to varying degrees, into industrial production." Gough, *Artist as Producer*, 9.

36. Lissitzky's intermediary position between suprematism and constructivism cannot be discussed in detail here. It is directly related to his allegiance first to the UNOVIS group at Vitebsk, founded by Malevich, and then his membership in INKhUK in Moscow from 1920 onward, a stronghold of the constructivists. See Éva Forgács, "Definitive Space: The Many Utopias of El Lissitzky's Proun Room," in Perloff and Reed, *Situating El Lissitzky,* 50, 54–55. See El Lissitzky and Arp, *Die Kunstismen,* xi.

37. See Buchloh, "Faktura to Factography," 94.

38. On the history of Lissitzky's two Demonstrationsräume, see in particular Maria Gough, "Constructivism Disoriented"; see also Kai-Uwe Hemken, "Pan Europe and German Art: El Lissitzky at the 1926 Internationale Kunstausstellung in Dresden," in *El Lissitzky, 1890–1941: Architect—Painter—Photographer—Typographer,* exh. cat. Municipal Van Abbemuseum, Eindhoven (Eindhoven: Municipal Van Abbemuseum, 1990), 46–55.

39. Dorner, "Zur Abstrakten Malerei," 110; see Claire Bishop, *Installation Art: A Critical History* (London: Tate, 2005), 80–81.

40. See El Lissitzky, *Russland;* El Lissitzky, "Architecture in the USSR" (1925), in Lissitzky, *Life, Letters, Texts,* 371–73.

41. See Richard Anderson, "Our Reality: Montage and the Mediation of Constructivist Architecture," in Baltzer and Stierli, *Before Publication,* 24–43.

42. Lissitzky, "Architecture in the USSR," 49.

43. *ASNOVA News* was published by the eponymous avant-garde architecture group around Nikolai Ladovsky, of which Lissitzky had become a member in the mid-1920s. See Khan-Magomedov, *Pioneers of Soviet Architecture,* 141–42.

44. The detailed history of the project as well as its historical significance is discussed in Bürkle, *El Lissitzky.*

45. See El Lissitzky, "Idole und Idolverehrer" (1928), in El Lissitzky, *Proun und Wolkenbügel: Schriften, Briefe, Dokumente,* ed. Sophie Lissitzky-Küppers and Jan Lissitzky (Dresden: Verlag der Kunst, 1977), 41–54.

46. El Lissitzky, "PROUN. Not world vision, BUT – world reality" (1920), in *Life, Letters, Texts,* ed. Sophie Lissitzky-Küppers (London: Thames and Hudson, 1980), 348.

47. El Lissitzky, "A. and Pangeometry" (1925), in ibid., 356; El Lissitzky, "Wheel—Propeller and What Follows" (1923), in ibid., 349.

48. Talking in general about the relationship of elements constituting Lissitzky's works, Herbert Schuldt remarked in 1966: "The relationship between the parts is organic, not fragmentary. This distinguishes his work from the montages of type and photography produced by Grosz and Heartfield during the dada period, and from Baumeister's skeletal photo-drawings." Herbert Schuldt, "El Lissitzky's Photographic Works" (1966), in Lissitzky, *Life, Letters, Texts,* 396.

49. "America created a particular type of high building by transforming the European horizontal corridor into a vertical lift shaft. . . . The spread of this type took place entirely anarchically without any concern at all for the larger organisation of the city as a whole. . . . Therefore if there is not enough space on a given site for horizontal planning at ground level, we shall raise the required usable

area up on stilts and these will serve as the communication between the horizontal pavements of the street and the horizontal corridors of the building." El Lissitzky, "A Series of Skyscrapers for Moscow: Wolkenbügel 1 (1923–1925)" (1926), in Cooke, Russian Avant-Garde, 198.

50. See Bürkle, El Lissitzky, 40–41.

51. See Henk Puts, "El Lissitzky (1980–1941), His Life and Work," in Lissitzky and Arp, Die Kunstismen, 23; Letter, El Lissitzky, Zurich, 29 December 1924, the Getty Research Institute, Special Collections, El Lissitzky Letters and Photographs, box 1 (author trans.).

52. A. Manina, "Arte d'agitazione di masse e produttivista," in Architettura nel paese dei Soviet 1917–1933: Arte di propaganda e costruzione della città (Milan: Electa, 1982), 33. See Bürkle, El Lissitzky, 32, 34–39, also for a discussion of Lissitzky and Roth's construction drawings.

53. Quoted in Goriacheva, "Suprematism and Constructivism," 79.

54. Forgács, "Definitive Space," 47–48.

55. For example, Joan Ockman interprets Lissitzky's Cabinet of Abstract Art in Hannover as the quintessential example of Alexander Dorner's synesthetic concept of the atmosphere room. See Ockman, "Road Not Taken."

56. Gough, "Constructivism Disoriented," 93, quoting Lissitzky, "Exhibition Rooms," in Lissitzky, Life, Letters, Texts, 366–67.

57. Gough, "Constructivism Disoriented," 93, 97.

58. Buchloh "Faktura to Factography," 91–92.

59. See John Elderfield, "Private Objects: The Sculpture of Kurt Schwitters," Artforum 12, no. 5 (1973): 45–54; Rosemarie Haag Bletter, "Kurt Schwitters' Unfinished Rooms: The Unreal. Merzbau, Hanover, Germany," Progressive Architecture 58, no. 9 (1977): 97–99; Egidio Marzona, "Kurt Schwitters—an Architektur," in Kurt Schwitters, 1887–1948: dem Erfinder von MERZ zu Ehren und zur Erinnerung, ed. Joachim Büchner and Norbert Nobis (Berlin: Propyläen, 1986), 46–59; Dietmar Elger, Der Merzbau: Eine Werkmonographie (Cologne: König, 1999); Elizabeth Burns Gamard, Kurt Schwitters' Merzbau: The Cathedral of Erotic Misery (New York: Princeton Architectural Press, 2000); Karin Orchard, "Kurt Schwitters' Raumgewächse," in Kurt Schwitters:

Merz—ein Gesamtweltbild, exh. cat. Museum Tinguely, Basel (Wabern/Bern: Benteli, 2004), 32–49.

60. See Lotus international 123 (2004), special issue on "Merzarchitektur."

61. For a discussion of the impact of this friendship on their respective bodies of work, see Lugon, "Neues Sehen, neue Geschichte," 88–105, esp. 97–105.

62. Sigfried Giedion in Cicerone 18, no. 1 (1926), Giedion Archive 43-T-15-1926-7, gta Archive, ETH Zurich (author trans.).

63. See Heinrich Dilly, "Lichtbildprojektion: Prothese der Kunstbetrachtung," in Kunstwissenschaft und Kunstvermittlung, ed. Irene Below (Gießen: Anabas, 1975), 153–72; Heinrich Dilly, "Das Auge der Kamera und der kunsthistorische Blick," Marburger Jahrbuch für Kunstwissenschaft 20 (1981): 81–89; Susanne Neubauer, "Sehen im Dunkeln—Diaprojektion und Kunstgeschichte," Georges-Bloch-Jahrbuch des Kunsthistorischen Instituts der Universität Zürich 9/10 (2002–3): 177–89; Bader, Gaier, and Wolf, Vergleichendes Sehen.

64. For a discussion of the impact of these two events on the development of Giedion's "visual language" and in particular on his subsequent interest in modernist typography, see Geiser, "Giedion in Between," 188–94.

65. See ibid., 188–211.

66. See Georgiadis, "Introduction," 49–50.

67. Moholy-Nagy, letter to to S. and C. Giedion, 3 May 1927, Giedion Archive 43-K-1927_05_03, gta Archive, ETH Zurich (author trans.). For the article series, see Sigfried Giedion, "Zur Situation der französischen Architektur," Cicerone 19, no. 1 (1927): 15–23; "Zur Situation der französischen Architektur II," Cicerone 19, no. 6 (1927): 174–89; and "Zur Situation der französischen Architektur III," Cicerone 19, no. 10 (1927): 310–17.

68. Giedion, letter to to Moholy-Nagy, Giedion Archive 43-K-1928 (G):01; and Moholy-Nagy, postcard to Giedion, Giedion Archive 43-K-1928-05-25, gta Archive, ETH Zurich.

69. Giedion, Building in France, 83.

70. See Deriu, "Montage and Modern Architecture." Not all of Deriu's categories are equally convincing. His interpretation of "elevation," in the sense of an "aerial aesthetic," as an instantiation of the montage principle is merely based

on the meaning of the French verb monter, for climbing or ascending.

71. Giedion, Building in France, 142.

72. See Arthur Rüegg, "Beziehung und Durchdringung—Eiffelturm und Pont Transbordeur," in Oechslin and Harbusch, Sigfried Giedion und die Fotografie, 172–75.

73. Heynen, Architecture and Modernity, 33. Referring to an image of an industrial landscape in Building in France, Heynen interprets the juxtaposition of architecture with the everyday vernacular of the landscape as another more or less outspoken dimension of Giedion's aesthetics and another form of montage thinking: "These illustrations along with Giedion's commentary contain for me the most telling moment in the book: the point at which there is a clear indication that architecture may well have to merge with vulgar reality and accept juxtaposition and montage as design principles which allow for this merging. In this passage one can clearly see that the idea of 'montage' . . . is at work, even if the term as such is not used explicitly." Hilde Heynen, "'What Belongs to Architecture?' Avant-Garde Ideas in the Modern Movement," Journal of Architecture 4, no. 2 (Summer 1999): 129–47, 134–35.

74. László Moholy-Nagy, quoted in Heynen, Architecture and Modernity, 35.

75. Giedion, Building in France, 91.

76. See Rowe and Slutzky, "Transparency: Literal and Phenomenal," 45–54.

77. Giedion, Building in France, 43. For a short comment on these mock-ups as well as a complete set of reproductions, see Sokratis Georgiadis, "Appendix: The Book as a Gesamtkunstwerk," in ibid., 207–24.

78. Sigfried Giedion, letter to J.J.P. Oud, 22 June 1928, gta Archive, CIAM Archive, quoted in Gregor Harbusch, "Bauen in Frankreich, 1928," in Oechslin and Harbusch, Sigfried Giedion und die Fotografie, 184; Giedion, Building in France, 176.

79. Andrea Nelson, "László Moholy-Nagy and Painting Photography Film: A Guide to Narrative Montage," History of Photography 30, no. 3 (2006): 258–69. For a more recent account of the relationship of montage and narration, in particular in the work of Moholy-Nagy and Walter Benjamin, see McBride, Chatter of the Visible.

80. Moholy-Nagy, "New Instrument of Vision," 36. The plurality of images has more recently become the focus of historical and theoretical investigation. See in particular Ganz and Thürlemann, *Das Bild im Plural*.

81. See Fritzsche, *Reading Berlin 1900*. See also Krausse, "Architektonische Montage." Krausse likewise emphasizes the importance of the press and mechanical reproduction for the genesis of a montage aesthetic in the arts.

82. See Cohen, *Le Corbusier and the Mystique of the USSR*, 197. Cohen recounts the entire story of the Palace of Soviets competition in great detail in Chapter 7.

83. Interestingly, Bardi participated in a trip to Russia organized by the French architectural magazine *L'architecture d'aujourd'hui* in the summer of 1932. In an account published in this journal upon his return, he took a stand for the cause of modern architecture and Le Corbusier's scheme for the Centrosyuz building. See ibid., 218–20.

84. See Francesco Tentori, *Pietro Bo Bardi: primo attore del razionalismo* (Torino: Testo and Immagine, 2002), 53. I am indebted to Zeuler Lima for pointing this fact out to me.

85. See Wescher, *Die Collage*, 76; and Buchloh, "Faktura to Factography," 110. For an evaluation of the impact of Lissitzky's exhibition design on fascist propaganda exhibitions in Germany and Italy, see Ulrich Pohlmann, "El Lissitzkys Ausstellungsgestaltungen in Deutschland und ihr Einfluß auf die faschistischen Propagandaschauen 1932–1937," in Tupitsyn, *El Lissitzky*, 52–64.

86. For this and the following, see Dennis P. Doordan, "The Political Content in Italian Architecture during the Fascist Era," *Art Journal* 43, no. 2 (1983): 128. For a discussion of the Italian debates in their political context, see in particular Rifkind, *Battle for Modernism*.

87. See Zeuler R. M. de A. Lima, *Lina Bo Bardi* (New Haven: Yale University Press, 2013), 109.

88. See ibid., 44.

89. Pietro-Maria Bardi quoted in Doordan, "Political Content," 129.

90. Ibid., 128–29.

91. Ibid., 130. For a detailed interpretation of Terragni's contribution to fascist propaganda by means of (photo-)montage, see Nanni Baltzer, "Die Fotomontage im Dienste der faschistischen Propaganda," in *Revolutionsmedien— Medienrevolutionen*, ed. Sven Gampp et al. (Constance: UVK Verlagsgesellschaft, 2008), 387–405. Baltzer traces the further history of Terragni's design in the restaging of the 1932 exhibition in 1937, where, however, it was only shown in fragments and "bereft of its basic effect: the immersion [*Vereinnahmung*] of the observer"; ibid., 399. See also Baltzer, *Die Fotomontage*. For a "virtual" reconstruction of the tour through and visitor experience of the Exhibition of the Fascist Revolution, see Schnapp, "Fascism's Museum in Motion," as well Schnapp, *Anno X*. See also Thomas L. Schumacher, *Surface and Symbol: Giuseppe Terragni and the Architecture of Italian Rationalism* (New York: Princeton Architectural Press, 1991), 171–73.

92. Buchloh, "Faktura to Factography," 112.

93. See Schug and Sack, *Moments of Consistency*, 69. For biographical aspects, see Cohen, *Herbert Bayer*.

94. See Patrick Rößler, "Exil daheim: die neue linie und der braune Geist— Beobachtungen zur Avantgarde in Nazi-Deutschland," in *Deutsche Publizistik im Exil, 1933 bis 1945: Personen— Positionen—Perspektiven: Festschrift für Ursula E. Koch*, ed. Markus Behmer (Münster: LIT Verlag, 2000), 271.

95. See press release by the Museum of Modern Art to City Editors and News Photo Editors, December 2, 1938, http://www.moma.org/momaorg/shared/pdfs/docs/press_archives/467/releases/MOMA_1938_0047_1938-12-02_381202-31.pdf?2010.

96. The Getty Research Institute, Special Collections, Jan and Edith Tschichold Papers, box 1, folder 6 ("Herbert Bayer designs"). The text was written by Dr. Eberhard Hölscher (author trans.).

97. On these exhibitions, see Sabine Weissler, "Bauhaus-Gestaltung in NS-Propaganda-Ausstellungen," in Nerdinger, *Bauhaus-Moderne*, 48–63; see Ulrich Pohlmann, "Nicht beziehungslose Kunst, sondern politische Waffe," *Fotogeschichte* 8, no. 28 (1988): 17–31; see also Rolf Sachsse, "Propaganda für Industrie und Weltanschauung: Zur Verbindung von Bild und Technik in deutschen Photomessen," in *Inszenierung der Macht: Ästhetische Faszination des Faschismus*, ed. NGBK Neue Gesellschaft für Bildende Kunst (Berlin: Nishen, 1987), 273–85.

98. Sachsse, "Propaganda für Industrie und Weltanschauung," 279; see Ute Brüning, "Bauhäusler zwischen Propaganda und Wirtschaftswerbung," in Nerdinger, *Bauhaus-Moderne*, 28.

99. Ute Brüning implies that this use of photomontage no longer sought to produce visual meaning—and by extension, to provoke political agency—by means of dialectical juxtaposition and contrast, but rather to manipulate the viewer. Ute Brüning, "Herbert Bayers neue Linie: Standardisierte Gebrauchsgrafik aus dem Studio Dorland," in Schug and Sack, *Moments of Consistency*, 223.

100. See ibid., 29. For an early critical reading of Bayer's designs for this exhibition (as well as Alexander Dorner's rather depoliticized interpretation of Bayers's work in his *The Way beyond "Art"*), see Von Moos, "'Modern Art Gets down to Business," 93–105. See also Ockman, "Road Not Taken," 103.

101. *Das Wunder des Lebens: Ausstellung Berlin 1935, 23. März bis 5. Mai*, n. p., Getty Research Institute, Special Collections, Jan and Edith Tschichold Papers, box 1, folder 6 ("Herbert Bayer—Designs, 1925–1935") (author trans.).

102. Ibid.

103. The caption identifies the model as depicting a "Siedlung des Reichsheimstättenamtes der NSDAP und der DAF" ("Settlement of the Reich's Ministry of Homesteads of the Nazi Party" (author trans.).

104. Joseph Goebbels in *Berliner Tageblatt*, July 18, 1936, quoted in Weissler, "Bauhaus-Gestaltung in NS-Propaganda-Ausstellungen," 63 (author trans.).

105. Quoted in Sachsse, *Bild und Bau*, 170.

106. Buchloh, "Faktura to Factography," 112–14.

CHAPTER 4
MIES MONTAGE

Earlier versions of specific aspects of this chapter were presented before audiences at the Zentralinstitut für Kunstgeschichte, Munich, the Princeton University School of Architecture, and the Department of History of Art and Architecture, Harvard University. I am indebted to the many insightful comments by these

audiences. My special thanks go to Thomas Weaver and Andrei Pop, from whose critical feedback the chapter profited a great deal.

1. Postmodern critique has radically questioned this. See Zurfluh, "Der 'fließende Raum' des Barcelona-Pavillons."

2. For an exemplary rereading of Mies's contribution to architectural modernism in these terms, see Colomina, "Mies Not," 192–221.

3. The allegedly theoretical nature of the two country house projects has been questioned by Tegethoff, "From Obscurity to Maturity," 28–94. A number of more recent publications shed new light on the authorship and chronology of these important projects and their representation. See Marx and Weber, "Konventioneller Kontext der Moderne," 65–107; Andreas Marx and Paul Weber, "Zur Neudatierung von Mies van der Rohes Landhaus in Eisenbeton," architectura 38 (2008): 127–66; and Dietrich Neumann, "Neue Überlegungen zu Mies van der Rohes Bürohausentwurf von 1923," architectura 44 (2014): 159–72.

4. The extraordinary status of photomontage in Mies's architectural representations is reflected in a number of specific case studies on the subject. See Levine, "Significance of Facts," 70–101; Andres Lepik, "Mies and Photomontage, 1910–38," in Riley and Bergdoll, Mies in Berlin, 324–29; Phyllis Lambert, "Collage and Montage: A Cinematographic Approach to Space," in Lambert, Mies in America, 204–11; and Sachsse, "Mies montiert." Adrian Sudhalter undertook an important evaluation of Mies's early photomontages; see Sudhalter, "Mies van der Rohe and Photomontage in the 1920s." I am indebted to Sudhalter for granting me access to her work.

5. See in this regard Martin, "Atrocities"; and Scott, "Army of Soldiers or a Meadow."

6. For an earlier account of the competition, see Sachsse, Bild und Bau, 115–17.

7. Rolf Sachsse in particular has pointed out that photographic reproduction and manipulation were in common use in German handcraft around 1900. Sachsse, "Mies und die Fotografen II," 255.

8. Schmid, Hundert Entwürfe aus dem Wettbewerb für das Bismarck-National-Denkmal, 12 (author trans.).

9. See Sachsse, Bild und Bau, 115.

10. See Jean-Louis Cohen, Ludwig Mies van der Rohe (Basel: Birkhäuser, 2007), 176.

11. See Burkhard Rukschcio and Roland Schachel, Adolf Loos: Leben und Werk (Salzburg: Residenz Verlag, 1982), 437. In a photomontage of the Haus Tzara in Paris from 1930, a model photograph inserted into another photograph illustrates the proposed addition to an existing building. See Panayotis Tournikiotis, Adolf Loos (New York: Princeton Architectural Press, 1994), 88. Another interesting example is a photographic representation of the interior of the Landhaus Khuner, into whose large panoramic window a landscape photograph is inserted that does not correspond with the actual site of the building. This treatment of the landscape as an aestheticized, pictorial representation of itself anticipates similar strategies in Mies's later work. In contrast to Mies, Loos here uses an already existing interior space as the basis for his idealized vision, whereas Mies would make use of photomontage mainly to represent his projects. For an image of the Landaus Khuner montage, see Heinrich Kulka, Adolf Loos: Das Werk des Architekten (Vienna: Anton Schroll, 1931), fig. 250.

12. See in this context Drude, Historismus als Montage.

13. See Mitchell, Picture Theory, 163.

14. "Internationale Architektur-Ausstellung 1923: Verzeichnis der Zeichnungen und Fotos: Weimar," typescript, Bauhaus-Archiv, Berlin, Bauhaus Weimar 1923, folder 19. Marx and Weber have convincingly argued that the country house on view at the IAA was not one of Mies's visionary projects but likely the conventional Haus Kempner; see Marx and Weber, "Zur Neudatierung von Mies van der Rohes Landhaus"; see also Marx and Weber, "Konventioneller Kontext der Moderne," 82.

15. In fact, the photomontages would have led to a disqualification because they did not conform to the competition brief. See Zimmermann, Der Schrei nach dem Turmhaus; Marx and Weber, "Konventioneller Kontext der Moderne," 81–82.

16. Ludwig Hilberseimer recalled these events later: "The jury refused to accept our designs, probably because their clarity and soberness from an architectural point of view was at odds with the romantic spirit that reigned over the exhibition. During the same period the 'Arbeitsrat für Kunst' published a manifesto that carried some of Walter Gropius's and Bruno Taut's declarations on architecture that were characteristic of the dominant tendency in that period and that clearly illustrate the expressionism in architecture." Ludwig Hilberseimer, Berliner Architektur der 20er Jahre (Mainz: Kupferberg, 1967), 30, trans. and quoted in Hays, Modernism and the Posthumanist Subject, 217. Hilberseimer's polemics notwithstanding, the boundaries between expressionism and Mies's position were not always as clear, as is evidenced by Mies's famous experiments on the reflection of light on the surface of the model of his Friedrichstraße skyscraper.

17. Mies van der Rohe, interview with Ulrich Conrads, Berlin, 1966, quoted in Sandra Honey, "Mies in Germany," in Mies van der Rohe: European Works, Architectural Monographs 11 (London: Academy, 1986), 16.

18. Gene Summers, "Das Mies-van-der-Rohe-Symposium in der Neuen Nationalgalerie, Berlin, am 27. März 1992," in Neumeyer, Ludwig Mies van der Rohe: Hochhaus am Bahnhof Friedrichstraße, 46.

19. The significance of these relations has been pointed out earlier; see Tafuri, Architecture and Utopia, 148. For a recent, detailed account of Mies's connection with Berlin avant-garde circles, see Mertins, "Architectures of Becoming," 106–33, as well as Mertins and Jennings, G: An Avant-Garde Journal.

20. The photograph is stamped: "R. Sennecke. Internationaler Illustrations-Verlag. Berlin S. W. 11 Hallesches Ufer 9, Mitglied des Verbandes Deutscher Illustrations-Photographen." Berlinische Galerie, Hannah Höch Archive, 13.32 (author trans.). See also Höch, Eine Lebenscollage, 1.2, 674–75.

21. K. Michael Hays has discussed the "critical" potential of Dadaist photomontage as opposed to constructivism, but his argument seems hardly plausible because he, very much in the tradition of Adorno's negative dialectics, equates "critique" with "negation," thereby implying that any constructive impulse automatically leads to affirmation and

ultimately commodification. See Hays, "Photomontage and Its Audiences." For a different, synthetic reading of the relationship of Dada and constructivism, see John Elderfield, "On the Dada-Constructivist Axis," *Dada and Surrealist Art* 13 (1984): 5–16.

22. Höch, *Eine Lebenscollage*, 1.2, quoting Adolf Behne, "Dada," *Die Freiheit*, July 9, 1920 (evening edition), 680–84 (author trans.); ibid., quoting "Der gefährliche Dadaist," newspaper clipping, unknown source, 685. See Hanne Bergius, "Dada Berlin," in *Tendenzen der Zwanziger Jahre, 15. Europäische Kunstausstellung Berlin 1977*, exh. cat. Neue Nationalgalerie Berlin (Berlin: Reimer, 1977), sec. 3, 65–77, 72, which also includes a detailed description of all the exhibited objects and gallery spaces of the Dada Fair; Höch, *Eine Lebenscollage*, 1.2, quoting Johannes Baader, letter to Raoul Hausmann and Hannah Höch, 16 July 1920, 686 (author trans.).

23. See, in particular, Theodor W. Adorno, *Ästhetische Theorie, Gesammelte Schriften 7*, ed. Rolf Tiedemann (Frankfurt a. M.: Suhrkamp, 2003), 231–35; and Bürger, *Theorie der Avantgarde* (German ed.), 98–111.

24. Raoul Hausmann, "Fotomontage" (1931), in Hausmann, *Am Anfang war Dada*, 43–56.

25. Tafuri, *Architecture and Utopia*, 96; on dialectics in the montaged image, see Buchloh, "Allegorical Procedures," as well as Georges Didi-Huberman, *Wenn die Bilder Position beziehen*, trans. Markus Sedlaczek (Munich: Fink, 2011), 101–6.

26. See Heinz Ohff, *Hannah Höch* (Berlin: Gebr. Mann, 1968), 16; Höch, *Eine Lebenscollage*, 1.2, 635. Moreover, in 1925 Mies unsuccessfully used his reputation to advise the city of Berlin's committee of acquisitions to buy two of Höch's paintings, titled *Roma* and *Die Journalisten*, which she presented in the annual group exhibition of the Novembergruppe. See Eberhard Roters, "Novembergruppe," in Höch, *Eine Lebenscollage*, 2.1, 74–96.

27. This event is officially dated February 14, 1925; see Kurt und Ernst Schwitters Stiftung, "Künstlerbiografien," http://www.schwitters-stiftung.de/bio-ks1.html. However, since Schwitters and the Doesburgs would hardly have performed together again at the same place after only a few weeks, it seems

highly likely that Höch and Mies were indeed present. See Höch, *Eine Lebenscollage*, 1.2, 226. No recollections of the event on Mies's part seem to have survived. A few months earlier, Höch, on behalf of her friend Nelly van Doesburg, had asked Mies, then president of the Novembergruppe, for a possibility of a performance in the framework of the group's series of evening concerts. See Hannah Höch, letter to Mies van der Rohe, 28 March 1924, Private Correspondence 1923–40, Mies van der Rohe Papers, Library of Congress, Washington, D.C.

28. See Dietmar Elger, *Der Merzbau von Kurt Schwitters: Eine Werkmonographie* (Cologne: Walther König, 1999), 89–99.

29. Detlef Mertins has commented on the considerable influence of Lissitzky's "Proun" text on Mies's manifesto in *Nasci*. It was Lissitzky himself who drew the bone, modeled after a drawing by Raoul France. See Mertins, "Architectures of Becoming," 122.

30. See Richter, *Köpfe und Hinterköpfe*, 74; Motherwell, *Dada Painters and Poets*, 12.

31. See Hanne Bergius, *Das Lachen Dadas: Die Berliner Dadaisten und ihre Aktionen* (Giessen: Anabas, 1989), 284.

32. See Wyss, "Merzbild Rossfett," 72–84; Meyer Schapiro, "The Apples of Cézanne: An Essay on the Meaning of Still-Life" (1968), in *Modern Art: Nineteenth and Twentieth Centuries*, ed. Meyer Schapiro (London: Chatto and Windus, 1978), 1–38.

33. See Lissitzky and Arp, *Die Kunstismen*, 11.

34. See Simmel, "Metropolis and Mental Life"; Hays, "Critical Architecture," 19. Hays therefore interprets Mies's stance toward the modern metropolis and toward the modern age in general as "critical": "Mies's skyscraper project is not conciliatory to the circumstances of its context. It is a critical interpretation of its worldly situation"; ibid., 20. I would argue that Mies's stance is more ambiguous than portrayed in this interpretation.

35. See William Alciphron Boring, "Use of Models in the Study of Architecture," *Architecture: Professional Architectural Monthly* 45, no. 6 (1922): 200–202. I am indebted to Davide Deriu for this reference. The genre of the model photograph would deserve its own investigation. As Deriu has pointed out, the 1920s were marked by a "model

boom," which soon led to the invention of the professional model photograph. Model-making was pioneered as a tool for spatial thinking at the Moscow-based Vkutemas and the Bauhaus in Weimar, concurrently. See Davide Deriu, "Transforming Ideas into Pictures: Model Photography and Modern Architecture," in Higgot and Wray, *Camera Constructs*, 159–78.

36. See Corbett, "Architectural Models," 11, 12. I am indebted to Teresa Fankhänel for pointing out Corbett to me.

37. See Papapetros, "Malicious Houses," 23–27, also quoting Werner Graeff's interview with Ludwig Glaeser of 1972 (ibid., 24).

38. This is confirmed by other contemporary models as well. See, for example, the illustrations published in connection with the competition for a city and exhibition hall in Hannover, *Deutsche Bauzeitung* 44 (1910): 555.

39. As identified by Tegethoff, "From Obscurity to Maturity," 43.

40. See Jean-Louis Cohen, "German Desires of America: Mies's Urban Visions," in Riley and Bergdoll, *Mies in Berlin*, 362–71; Stommer, "Germanisierung des Wolkenkratzers"; Jochen Meyer, "Aspekte—Kontroversen—Tendenzen: Die Hochhausdiskussion in Deutschland Anfang der Zwanziger Jahre," in Zimmermann, *Der Schrei nach dem Turmhaus*, 186–214.

41. See Rowe and Koetter, *Collage City*. Bernhard Hoesli's teaching at ETH Zurich was in many ways indebted to Colin Rowe; he promoted collage both as a design tool and epistemological model. On Hoesli, see in particular Tom Steinert, *Komplexe Wahrnehmung und moderner Städtebau: Paul Hofer, Bernhard Hoesli und ihre Konzeption der "dialogischen Stadt"* (Zurich: Park, 2014).

42. For a detailed history of the project, see Zimmermann, *Der Schrei nach dem Turmhaus*, as well as Neumeyer, *Ludwig Mies van der Rohe: Hochhaus am Bahnhof Friedrichstraße*.

43. See Le Corbusier, *Vers une architecture*, 16.

44. See Sachsse, "Mies und die Fotografen II," 149.

45. On the antagonism between "dirty realism" and "philosophical calm," see Lambert, "Collage and Montage," 205.

46. Hays, "Critical Architecture," 22.

47. See Pommer, Spaeth, and Harrington, *In the Shadow of Mies*, 37. For Hilberseimer and his project of a *Großstadtarchitektur*, see also Hays, *Modernism and the Posthumanist Subject;* and Pier Vittorio Aureli, "Architecture for Barbarians: Ludwig Hilberseimer and the Rise of the Generic City," *AA Files* 63 (2011): 3–18.

48. Robin Evans, "Mies van der Rohe's Paradoxical Symmetries," in Evans, *Translations from Drawing to Building*, 233–76.

49. Mies's relationship to cinema and theories and practitioners of the moving image are discussed in depth in Lutz Robbers's so-far unpublished PhD dissertation, "Modern Architecture in the Age of Cinema: Mies van der Rohe and the Moving Image" (Princeton University, 2012). Robbers does not discuss the concept of montage at the intersection of architecture and the moving image, which is at the center of my own investigation.

50. See Sergei M. Eisenstein, "Dickens, Griffith und wir" (1942), in *Jenseits der Einstellung: Schriften zur Filmtheorie*, ed. Felix Lenz and Helmut H. Diederichs (Frankfurt a. M.: Suhrkamp, 2005), 301–66.

51. The complex montage theories of Eisenstein, Vertov, and other Soviet film theoreticians of the time would deserve a more detailed analysis than can be attempted here. For a general discussion, see Wolfgang Beilenhoff, "Nachwort," in Vertov, *Schriften zum Film*, 152–57. See also Bordwell, "Idea of Montage in Soviet Art and Film."

52. Eisenstein, "Montage and Architecture," 117.

53. I am using the term "moving image" here in its inherent ambiguity, both relating to the art of cinema proper as well as to the sequence of visual impressions generated by a promenade through architectural space.

54. Eisenstein, *Film Form*, 4.

55. See Lambert, "Collage and Montage," 204–11; Albera, "Glass House."

56. For *G* as a platform for avant-garde film theory, see Robbers, "Modern Architecture in the Age of Cinema," 134–245.

57. For a (disputed) account of the history of the *G* group by its protagonists, see Werner Graeff, "Concerning the So-Called G Group," *Art Journal* 23 (Summer 1964): 280–82; and Hausmann, "More on Group G." See also Schulze,

Mies van der Rohe: A Critical Biography, 89–91, 105–6; Richter, *Köpfe und Hinterköpfe*, 69.

58. See Ludwig Mies van der Rohe, "Industrielles Bauen," *G* 3 (June 1924): 8–13, quoted in Neumeyer, *Mies van der Rohe: The Artless Word*, 248–49.

59. Richter had gotten to know the plans through Theo van Doesburg in 1921. Richter, *Köpfe und Hinterköpfe*, 70 (author trans.).

60. See Deleuze, *Das Bewegungs-Bild*, 82. On the notion of "rhythm" in Richter's early abstract films, see also Turvey, "Dada between Heaven and Hell"; Robbers, "Modern Architecture in the Age of Cinema," 282–90.

61. Richter, *Köpfe und Hinterköpfe*, 117, 119.

62. See ibid., 145. For biographical information on Richter, see also Marion von Hofacker, "Hans Richter: Biografie," in *Hans Richter: Malerei und Film*, ed. Hilmar Hoffmann and Walter Schobert (Frankfurt a. M.: Deutsches Filmmuseum, 1989), 169–70.

63. Deutsche Liga für unabhängigen Film, Berlin, [April] 1931, information pamphlet, quoted in Höch, *Eine Lebenscollage*, 1.2, 425 (author trans.)

64. Richard Pommer, "Mies van der Rohe and the Political Ideology of the Modern Movement in Architecture," in Schulze, *Mies van der Rohe: Critical Essays*, 96–146.

65. See Levine, "Significance of Facts."

66. See Detlef Mertins, "Mies's Event Space," *Grey Room* 20 (2005): 60–73.

67. Levine, "Significance of Facts," 74.

68. On the notion of animation in architecture and animated materiality, see Papapetros, *On the Animation of the Inorganic*.

69. Neil Levine has pointed out that Clement Greenberg's characterization of Johns's paintings as "homeless representation," something between abstraction and illusionism, might also be applied to Mies. See Levine, "Significance of Facts," 74.

70. In the year when this montage was produced, the Democratic Party made the governor of Illinois, Adlai Stevenson, its presidential candidate. Mies, since 1944 a naturalized U.S. citizen, voted for him. See ibid.

71. "Der Faschismus läuft folgerecht auf eine Ästhetisierung des politischen

Lebens hinaus." Walter Benjamin, "Das Kunstwerk im Zeitalter seiner technischen Reproduzierbarkeit (Dritte Fassung)," in *Gesammelte Schriften* 1.2, ed. Rolf Tiedemann and Hermann Schweppenhäuser (Frankfurt a. M.: Suhrkamp, 1991), 506.

72. On Terragni's photomontage, see also Kurt W. Forster, "BAUgedanken und GEDANKENgebäude—Terragnis Casa del Fascio in Como," in *Architektur als politische Kultur*, ed. Hermann Hipp and Ernst Seidl (Berlin: Dietrich Reimer, 1996), 264–65; Diane Ghirardo, "Politics of a Masterpiece: The Vicenda of the Decoration of the Façade of the Casa del Fascio, Como, 1936–39," *Art Bulletin* 62, no. 3 (1980): 466–78; Schumacher, *Surface and Symbol*, 161–62.

73. The institutionalization of the visual aesthetics of the avant-garde has been brilliantly analyzed in Benjamin Buchloh, "From Faktura to Factography."

74. Neil Levine has performed an in-depth and thoughtful interpretation of this montage; see Levine, "Significance of Facts," 84–87. Mies used a photograph of the interior of the assembly hall published in a monograph on Kahn in 1939.

75. This inversion is by no means singular in Mies's American oeuvre and can be found in several drawings produced for the architect's Chicago high-rise projects. See Dietrich Neumann, "Promontory to Lake Shore Drive: The Evolution of Space in Mies van der Rohe's High-Rise Apartments," in *Modern Wohnen, Studien zur Architektur der Moderne und Gestaltung*, ed. Rudolf Fischer and Wolf Tegethoff (Berlin: Gebr. Mann, 2016), 3:363–84. I am indebted to Neumann for his insightful comments on various representational techniques related to photomontage.

76. Curt Gravenkamp pointed this out in 1930. See Neumeyer, *Mies van der Rohe: The Artless Word*, 115.

77. On the notion of Mies's architecture as a stage, see Manfredo Tafuri, "The Theatre as a Virtual City: From Appia to the Totaltheater," *Lotus International* 17 (December 1977): 30–53. See also Quetglas, "Loss of Synthesis," 384–91; and Tegethoff, "On the Development of the Conception of Space."

78. See Edgerton, *Renaissance Rediscovery*, 71.

79. See Evans, "Mies van der Rohe's Paradoxical Symmetries," 249, 268.

80. Max Horkheimer and Theodor W. Adorno, *Dialectic of Enlightenment*, trans. John Cumming (New York: Continuum, 1972). For a discussion of Horkheimer and Adorno in the light of Mies van der Rohe's Seagram Building, see K. Michael Hays, "Odysseus and the Oarsmen, or, Mies's Abstraction Once Again," in Mertins, *Presence of Mies*, 234–48; and Martin, "Atrocities." In this regard, see also Felicity Scott's discussion of Oswald Spengler's notion of modernity as being obsessed with the consumption of distance (and ultimately, the reduction of the world to a two-dimensional screen), a connection to Mies first established by Arthur Drexler. See Scott, "Army of Soldiers or a Meadow," 339–40.

81. Manfredo Tafuri and Francesco dal Co, *Modern Architecture*, trans. Robert Erich Wolf (New York: Rizzoli, 1986), 136 (Italian ed. 1976). On leisure and conspicuous consumption, see Thorstein Veblen, *The Theory of the Leisure Class* (Oxford: Oxford University Press, 2009).

82. For Hitler's domestic spaces, see also Despina Stratigakos, *Hitler at Home* (New Haven: Yale University Press, 2015).

83. This is not the place for a detailed discussion of the reception history of Mies's architecture and conception of space. The concept of "flowing space" to characterize Mies's architecture was first introduced by Philip Johnson in the catalog accompanying the Mies retrospective at the Museum of Modern Art in 1947, and it was subsequently taken up and elaborated by Ludwig Hilberseimer. Scholars such as Fritz Neumeyer, Robin Evans, Caroline Constant, and Josep Quetglas have since opened up avenues for alternate interpretations that underlie my own reading. For an excellent overview of the reception history of Mies's architecture through the example of the Barcelona Pavilion, see Zurfluh, "Der 'fließende Raum' des Barcelona-Pavillons."

84. Neumeyer has summarized the impact of Guardini's philosophy on the (dialectical) structure of Mies's thinking as follows: "Aside from sharing a common ideological basis, both men tended to conceptualize in terms of opposites. Guardini had brought this dialectical thinking into a system that Mies could adapt without hesitation as it confirmed and legitimized his own contradictory positions." Neumeyer, *Mies van der Rohe: The Artless Word*, 197.

85. For the most convincing differentiation and discussion of the pictorial concepts of "image," "icon," and "*Zerstreuung*" (distraction) in architecture, see Payne, "Architecture: Image, Icon or *Kunst der Zerstreuung*?" 55–91.

86. The term "aesthetic barrier" is from Dagobert Frey, "Wesensbestimmung der Architektur," in *Kunstwissenschaftliche Grundfragen: Prolegomena zu einer Kunstphilosophie* (Vienna: Rohrer, 1946), 93–106; see Martin, "Atrocities"; and Scott, "Army of Soldiers or a Meadow."

87. Ortega y Gasset, "Meditations on the Frame," 189.

88. See Wajcman, *Fenêtre*.

89. See Teyssot, *Topology of Everyday Constellations*, chap. 8; Georg Simmel, "Brücke und Tür," in *Das Individuum und die Freiheit: Essais* (Frankfurt a. M.: Fischer, 1993), 2–12.

90. See Martin, "Atrocities, Or, Curtain Wall as Mass Medium," 66–75.

91. Quoted in Tegethoff, "On the Development of the Conception of Space," 123.

92. Joselit, "Notes on Surface," provides a very illuminating discussion of Greenberg's take on flatness; in particular, see ibid., 22.

93. See Dietrich Neumann, "Mies van der Rohe's Patente zur Wandgestaltung und Drucktechnik von 1937–1950," in Reuter and Schulte, *Mies und das neue Wohnen*, 264–79.

94. Colomina, *Privacy and Publicity*, 139. The format and orientation of windows was a cause of heated dispute between Le Corbusier and his mentor, Auguste Perret. See Reichlin, "'Une petite maison' on Lake Leman."

95. Kwinter, "Mies and Movement," 86.

96. See Theo van Doesburg, "Zur elementaren Gestaltung," *G* 1 (July 1923): 1–2. See in this respect Ulrich Müller, *Raum, Bewegung und Zeit im Werk von Walter Gropius und Ludwig Mies van der Rohe* (Berlin: Akademie, 2004), 59–61.

97. Jean-Louis Cohen cites two further sources that he considers more important for Mies's spatial conception than Doesburg: Lissitzky's Prouns and Hans Richter's "Film Moments," published in 1923 in *De Stijl*. See Cohen, *Ludwig Mies van der Rohe*, 39. For a comparison with Proun, see also Schulze, *Mies van der Rohe: A Critical Biography*, 110.

98. The reference to modern painting seems at first sight to revoke the dogma of the "naked wall" that architects such as Mies or Walter Gropius had espoused in the 1920s, and that Bruno Taut had voiced as late as 1931 in his article "Der Schrei nach dem Bilde" ("The Cry for the Image"). On this debate, see Kliemann, *Die Novembergruppe*, 43.

99. Mies van der Rohe in "New Buildings for 194X," *Architectural Forum* 78 (May 1943): 84, quoted in Levine, *Modern Architecture*, 234.

100. Van Eyck, "Superlative Gift."

101. Bruno Latour, *We Have Never Been Modern* (Cambridge, Mass.: Harvard University Press, 1993); Bruno Malraux, *Le musée imaginaire* (Paris: Gallimard, 1965).

102. Giedion, *Architektur und Gemeinschaft*, 57.

103. Sigfried Giedion acknowledged Schmarsow's significance for the development of the notion of space as a constitutive element of architecture and discussed his theories against the writings of Heinrich Wölfflin and Alois Riegl. See the chapter "Research into Architectural Space" in Sigfried Giedion, *The Eternal Present: The Beginnings of Architecture, a Contribution on Constancy and Change* (New York: Pantheon, 1964), 499–502. See Neumeyer, *Mies van der Rohe: The Artless Word*, 220–46; Vidler, *Warped Space*, 6.

104. Schmarsow, *Das Wesen der architektonischen Schöpfung*, 59.

105. See Van de Ven, *Space in Architecture*.

106. See Heidegger, "Die Zeit des Weltbildes."

107. See Andreas Beyer, "Bilderbauten: Phantasie und Wirklichkeit der Baukunst in Renaissance und Moderne," in *Showreiff*, ed. Andreas Beyer (Tübingen: Wasmuth, 2001), 24–32.

108. I am using "utopia" in Ernst Bloch's sense of the term—that is, as an ideal state postponed into an indefinite future. See Ernst Bloch, *Geist der Utopie* (Munich: Duncker und Humblot, 1918).

CHAPTER 5
EMBODIED SPECTATORSHIP

1. See Eisenstein, "Montage and Architecture." Sections of the large "Montage"

manuscript were published under different headings, making navigation through Eisenstein's published writings something of a challenge. For a history of the editing of Eisenstein's manuscripts, see Bulgakowa, *Sergej Eisenstein—Drei Utopien*, 9–16.

2. For bibliographical information on Eisenstein, see Felix Lenz, "Kontinuität und Wandel in Eisensteins Film- und Theoriewerk," in *Jenseits der Einstellung: Schriften zur Filmtheorie*, by Sergei M. Eisenstein, ed. Felix Lenz and Helmut H. Diederichs (Frankfurt a. M.: Suhrkamp, 2006), 433–52; see also Sergei Eisenstein, "How I Became a Director," in Eisenstein, *Selected Works*, 3:284–90.

3. See Bulgakowa, *Sergej Eisenstein—Drei Utopien*, 25.

4. See ibid., 27.

5. Eisenstein, *Nonindifferent Nature*, 140.

6. On the Naltchik project, see Cohen, *Le Corbusier and the Mystique of the USSR*, 201–2.

7. See Albera, "Glass House," 44.

8. On Le Corbusier's discovery of Moscow and his contacts with the Russian avant-gardes, see Cohen, *Le Corbusier and the Mystique of the USSR*. Cohen not only traces the personal relationship between Le Corbusier and Eisenstein (as well as its implications for architectural and cinematic thought); he also points out the "convergences in opinion" between Eisenstein and Le Corbusier with regard to the glorification of machine culture, as is evident in the Soviet filmmaker's film *The General Line* (1927–29). See Cohen, *Le Corbusier and the Mystique of the USSR*, 119–22.

9. See Sergei Eisenstein, "Tolstoy's *Anna Karenina*—the Races," in Eisenstein, *Selected Works*, 2:289. It should be noted that Eisenstein apparently developed a more critical stance later in life, perhaps also as a consequence of the political situation in which he was working. The full quote from his text "Tolstoy's *Anna Karenina*—the Races" reads: "I confess that I used to be a great adherent of the architectural aesthetics of Le Corbusier and Gropius; it was only direct contact with the fullness of life that opened my eyes to the fact that this architecture (chiefly in the distorted products of its epigones) lacked any reflection of the full-blooded joyousness of modern man, just as an anatomical atlas can never be a portrait in which a man can recognise himself, his thirst for life and his joy in a socialist existence."

10. See Moisei Ginzburg, *Style and Epoch* (Cambridge, Mass.: MIT Press, 1982).

11. See Cohen, *Le Corbusier and the Mystique of the USSR*, 48–49.

12. Quoted in ibid., 49.

13. See ibid., 122.

14. See Edmund Husserl, "The Self-Movement and the Being-Moved of the Body: Limits of the Kinaesthetic Constitution of the Corporeal Body," in Husserl, *Thing and Space*, 240–45. Maurice Merleau-Ponty, *L'Oeil et l'esprit* (Paris: Gallimard, 1961); English translation: "Eye and Mind," in *The Primacy of Perception*, ed. James Edie, trans. Carleton Dallery (Evanston, Ill.: Northwestern University Press, 1964), 43–95. I am also indebted to Jean-Louis Cohen for pointing out to me that Eisenstein owned a copy of Choisy's study.

15. Sergei Eisenstein, "Montage 1937," in Eisenstein, *Selected Works*, 2:39.

16. Eisenstein, *Nonindifferent Nature*, 139.

17. Geoffrey Nowell-Smith, "Introduction," in Eisenstein, *Selected Works*, 2:xiii–xvi, xvi.

18. The following considerations are inspired by and indebted to Anthony Vidler's essay "Metropolitan Montage," in Vidler, *Warped Space*, 111–22.

19. Mallet-Stevens, "Le cinéma et les arts," 288 (author trans.). It should be added that Mallet-Stevens partially relativized his ideas in the second half of his text, where he reaffirms the significance of architecture's functional dimension in everyday life.

20. See Ilka Ruby, Andreas Ruby, and Philip Ursprung, *Images: A Picture Book of Architecture* (Munich: Prestel, 2004); Charles Jencks, *The Iconic Building* (New York: Rizzoli, 2005); Zimmerman, *Photographic Architecture*. Zimmerman's study in particular gives a detailed analysis of the complex interdependency of architecture and photography in the modern age.

21. Mallet-Stevens, "Le cinéma et les arts," 290. Mallet-Stevens distances himself here from a scenographic conception of architecture that is too literally deduced from the appearance of film sets.

22. Giedion, *Building in France*, 176.

23. Walter Benjamin, "The Work of Art in the Age of Its Technological Reproducibility (Third Version)," in Walter Benjamin, *Selected Writings*, vol. 4, *1938–40*, ed. Howard Eiland and Michael W. Jennings, trans. Edmund Jephcott et al. (Cambridge, Mass.: Belknap Press of Harvard University Press, 2003), 268.

24. Ibid., 268–69.

25. For this paradox and the ensuing fundamental differences between architectural and cinematic spectatorship, see Friedberg, *Virtual Window*, 170–74.

26. For the concept of tacit knowledge, see Michael Polanyi, *The Tacit Dimension* (London: Routledge and Kegan Paul, 1967). For immersion, see *Montage/av: Zeitschrift für Theorie und Geschichte audiovisueller Kommunikation* 17, no. 2 (2008), special issue "Immersion"; see also Laura Bieger, *Ästhetik der Immersion: Raum-Erleben zwischen Welt und Bild: Las Vegas, Washington und die White City* (Bielefeld: Transcript, 2007).

Benjamin's friend, the cultural theorist Siegfried Kracauer—like Eisenstein, an architect by training—wrote about distraction as a cultural phenomenon as early as 1926, again comparing architecture to film. Kracauer likened the "elegant surface splendor" of the interiors of the large Berlin cinemas (*Lichtspielhäuser*)—which he interprets as manifestations of modern metropolitan mass society—to the illusionistic play of light in film itself. See "Cult of Distraction: On Berlin's Picture Palaces," in Kracauer, *Mass Ornament*, 325–26. See also Friedberg, *Virtual Window*, 167–68. While Benjamin sees distraction as an alternative paradigm of aesthetic perception, Kracauer judges the phenomenon more critically as an instance of seduction. However, Kracauer's writings are interesting with regard to Eisenstein's theory of architectural montage in another aspect. As Anthony Vidler has pointed out, Kracauer deemed the street an important subject of realist film because it encapsulated modernity like nothing else. For both Kracauer and Benjamin, the spectating pedestrian, the flâneur, provided a suitable model for the filmmaker. See Vidler, "Metropolitan Montage," in *Warped Space*, 113.

The same observation is made by Bruno in *Atlas of Emotion*, 42–43. On Kracauer's writings on the city and urban space in general, see Henrik Reeh, *Ornaments of the Metropolis: Siegfried*

Kracauer and Modern Urban Culture (Cambridge, Mass.: MIT Press, 2004); on his interest in architectural surfaces, see Claire Zimmerman, "Siegfried Kracauer's Architectures," in Gemünden and Von Moltke, *Culture in the Anteroom*, 149–65. Elizabeth Otto has demonstrated the degree to which Kracauer's writing was informed by what she calls "montage thinking"; see Otto, "Siegfried Kracauer's Two Art Histories," in Gemünden and Von Moltke, *Culture in the Anteroom*, 128–48.

27. On the causes and impact of this famous performance and the ensuing article, see Levin, "Iconology at the Movies," 27–55.

28. Panofsky, "Style and Medium," 290.

29. Ibid., 300.

30. See ibid., 301.

31. Dorner and Panofsky famously disputed the relevance of their former teacher Alois Riegl's teleological art theory in a series of articles in mid-1925. See Ockman, "Road Not Taken," 86–87; see also Tafuri, *Theories and History of Architecture*, 190–91.

32. Panofsky, "Style and Medium," 291.

33. See *Iris* 12 (1991), special issue "Cinema and Architecture"; *AD Architectural Design* 64, no. 11/12 (1994), special issue "Architecture and Film"; Neumann, *Film Architecture*; *Wide Angle* 19, no. 4 (1997), special issue "Cityscapes I"; Penz and Thomas, *Cinema and Architecture*; David B. Clarke, ed., *The Cinematic City* (New York: Routledge, 1997); *Architectural Design* 70, no. 1 (2000), special issue "Architecture and Film II"; Juhani Pallasmaa, *The Architecture of Image: Existential Space in Cinema* (Helsinki: Rakennustieto, 2001); Edward Dimendberg, *Film Noir and the Spaces of Modernity* (Cambridge, Mass.: MIT Press, 2004). On June 13–14, 2013, the author and Henri de Riedmatten organized a conference titled *Architecture, Spatial Representation, and the Filmic Imaginary* at the Istituto Svizzero in Rome.

34. See Bruno, *Atlas of Emotion*; and Friedberg, *Virtual Window*.

35. Yve-Alain Bois had already applied his notion of peripatetic spectatorship to a work by Richard Serra in 1983. See Bois and Shepley, "Picturesque Stroll around Clara-Clara," 32–62. Here, Bois interprets the sculpture against the theory of the picturesque, which also calls for mobile and embodied spectatorship,

and against the notion of parallax, i.e., "displacement of the apparent position of a body, due to a change of position of the observer"; ibid., 40.

36. See Anthony Vidler, "Metropolitan Montage," in Vidler, *Warped Space*, 118–22.

37. See Bruno, *Atlas of Emotion*, 55–71.

38. See Tafuri, "Dialectics of the Avant-Garde," 73–80.

39. Eisenstein, *Cinématisme: Peinture et cinéma* (1980). See also the 2009 edition (Dijon: Les presses du réel, 2009).

40. Eisenstein, quoted in Eisenstein, *Cinématisme: Peinture et cinéma* (1980), 7. On the notion of *cinématisme* as a basic category in Eisenstein's theoretical thinking, see also Somaini, *Les possibilités du montage*, esp. 108–14.

41. Somaini, *Les possibilités du montage*, 162 (author trans.) (emphasis added).

42. See Eisenstein, *Nonindifferent Nature*, 112–23 ("El Greco") and 123–54 ("Piranesi, or the Fluidity of Forms"); Sergei Eisenstein, "'El Gréco y el cine' (Le Gréco et le cinema)," in Eisenstein, *Cinématisme: Peinture et cinéma*, 15–104.

43. Eisenstein, "Montage and Architecture," 117.

44. See Bois, "Introduction," 110–31.

45. Paul Klee, *Pedagogical Sketchbook* (1925), trans. Sibyl Moholy-Nagy (New York: Praeger, 1960), 33, quoted in Bois, "Introduction," 113.

46. On the genealogy of modern architectural space theory in connection with perceptual psychology, see Schwarzer, "Emergence of Architectural Space," 48–61, as well as Van de Ven, *Space in Architecture*. A collection of translations of the most important theoretical texts on the subject can be found in Mallgrave and Ikonomou, *Empathy, Form, and Space*.

47. Eisenstein, "Montage and Architecture," 128.

48. Ibid.

49. Eisenstein clearly differentiates between "cinema" (everything concerned vaguely with the production of moving images) and "cinematography" (a visual concept based on montage). Discussing Japanese film, Eisenstein concludes that it lacks montage and therefore is uncinematographic. See Bois, "Introduction," 112.

50. See Cohen, *Le Corbusier and the Mystique of the USSR*, 122.

51. For a similar, roughly contemporary interpretation of the Acropolis, see Constantinos A. Doxiadis, *Architectural Space in Ancient Greece*, ed. and trans. Jaqueline Tyrwhitt (1937; repr., Cambridge, Mass.: MIT Press, 1972). Doxiadis argues that "the Greeks employed a uniform system in the disposition of buildings in space that was based on principles of human cognition" (ibid., 3) and states, with regard to the large temple districts, "It is not always easy to remember that these complexes were built by the ancient Greeks not as isolated objects, as we see them today, but as parts of a dynamic urban environment. . . . They were not designed to satisfy the aesthetic demands of modern man for an ideal layout, an ideal city, unrelated to an actual time or place" (ibid., 4). Likewise, Sigfried Giedion underscored the significance of the panathenaeic procession, one of the most important religious festivals in ancient Greece that took place only every four years, for the spatial organization of the Acropolis. See Sigfried Giedion, *The Eternal Present: The Beginnings of Architecture, a Contribution on Constancy and Change* (New York: Pantheon, 1964), 400. Giedion's interpretation brings forward a processual understanding of architecture based on what Michel de Certau would later call "spatial practices."

52. Auguste Choisy, quoted in Eisenstein, "Montage and Architecture," 119.

53. Ibid., 117.

54. Eisenstein, "'El Greco y el cine,'" 16–17.

55. Eisenstein, "Montage and Architecture," 121.

56. See Le Corbusier, *Toward an Architecture*, 115, 121.

57. This, at least, is stated in Le Corbusier's note in his copy of the book now at the Fondation Le Corbusier in Paris. See Jacques Lucan, "Acropole: Tout a commencé là . . . ," in *Le Corbusier: Une encyclopédie*, ed. Jacques Lucan (Paris: Centre Georges Pompidou, 1987), 21.

58. See Etlin, *Frank Lloyd Wright and Le Corbusier*, 112–15; Lucan, "Acropole"; Lucan, "L'invention du paysage architectural, ou la vision péripatéticienne de l'architecture." See also Richard Etlin, "Le Corbusier, Choisy, and French Hellenism:

The Search for a New Architecture," *Art Bulletin* 69, no. 2 (1987): 264–78.

59. Le Corbusier and Pierre Jeanneret, *Oeuvre complète de 1910–1929*, ed. W. Boesiger and O. Stonorov, 4th ed. (Erlenbach-Zurich: Éditions d'Architecture, 1964), 60, quoted and translated in Etlin, *Frank Lloyd Wright and Le Corbusier*, 115.

60. Le Corbusier and Pierre Jeanneret, *Oeuvre complète de 1929–1934*, ed. W. Boesiger (Zurich: Éditions d'Architecture, 1964), 24, trans. in Bois, "Introduction," 56.

61. See ibid., 26–31. Stan Allen has also interpreted Le Corbusier's architecture in cinematic (Eisensteinian) terms, applying Deleuze's conception of the "movement-image" to the Carpenter Center for the Visual Arts. See Allen, "Le Corbusier and Modernist Movement."

62. "Les architectures se classent en mortes et en vivantes selon que la règle du *cheminement* n'a pas été observée, ou qu'au contraire la voilà exploitée brillamment." "Cheminement" refers to "le déroulement des faits architecturaux apparus à la suite l'un de l'autre," which produces "l'émoi, fruit de commotions successives." Le Corbusier, *Entretien avec les étudiants des écoles d'architecture* (Paris: Editions Denoël, 1943), quoted in Etlin, *Frank Lloyd Wright and Le Corbusier*, 210.

63. See ibid.

64. See Colomina, *Privacy and Publicity*, 139.

65. Eisenstein, "Montage and Architecture," 116.

66. Friedberg, *Virtual Window*, 173.

67. See Bordwell, "Eisenstein's Epistemological Shift." For a discussion of the montage principle in revolutionary and post-revolutionary Soviet film, see also Bordwell, "Idea of Montage in Soviet Art and Film."

68. See Iser, *Act of Reading*; Eco, *Open Work*.

69. On Nikolay Ladovsky's psychotechnic laboratory for architecture in Moscow, see in particular Vöhringer, *Avantgarde und Psychotechnik*, chap. 1.

70. Münsterberg, *Grundzüge der Psychotechnik*.

71. See Vöhringer, *Avantgarde und Psychotechnik*, 35. On Ladovsky, see also Khan-Magomedov, *Nikolay Ladovsky*.

72. Vöhringer, *Avantgarde und Psychotechnik*, 46–47.

73. See ibid., 67.

74. On Pudovkin's theory of montage, see Heather Puttock, "Vsevolod Pudovkin and the Theory of Montage," *AD Architectural Design* 70, no. 1 (2000), special issue "Architecture Film II," 9–11. For the reception of cinematic concepts of montage, rhythm, and movement in Soviet rationalist architecture, see Alla Vronskaya, "'Montage and Architecture': Movement and Rhythm in the Architectural Theory of Soviet Rationalism," paper delivered at the Annual Convention of the Association for Slavic, East European, and Eurasian Studies, New Orleans, 2012 (manuscript). I am indebted to Vronskaya for pointing out Ladovsky's fascinating psychotechnic experiments and their implications for modernist spatial thinking and montage.

75. See Vöhringer, *Avantgarde und Psychotechnik*, 83.

76. See Thilo Hilpert, *Die Funktionelle Stadt: Le Corbusiers Stadtvision— Bedingungen, Motive, Hintergründe* (Braunschweig: Vieweg, 1978).

77. See Hyacinthe Dubreuil, *Standards* (Paris: Grasset, 1929). Dubreuil is also the author of a study of the organization of labor and space by the Czech shoe manufacturer Bat'a, for whose French factories Le Corbusier produced a number of master plans in the 1930s. See Hyacinthe Dubreuil, *L'example de Bat'a* (Paris: Grasset, 1936); Winfried Nerdinger, ed., *Zlín: Modellstadt der Moderne*, exh. cat. Architekturmuseum der TU München in der Pinakothek der Moderne (Berlin: Jovis, 2009).

78. Le Corbusier, *The Radiant City* (London: Faber and Faber, 1967), 30.

79. Social and spatial engineering is also theorized in the writings of one of Le Corbusier's most avid Soviet followers, Moisei Ginzburg. In an article published in 1927, Ginzburg writes: "The processes of production or labor are normally associated with factories; the social and human processes with the dwelling or communal buildings. In essence, there is no difference here." Moisei Ginzburg, "Éxitos de la arquitectura moderna" (1927), in *Escritos, 1923–1930* (Madrid: El Croquis Editorial, 2007), 292 (author trans.).

80. Bruno, *Atlas of Emotion*, 16.

81. See ibid., 64.

82. Sergei Eisenstein, "Laocoön," in Eisenstein, *Selected Works*, 2:109.

83. Sergei Eisenstein, "Il Principio cinematografico e l'ideogramma" (1929), *Rassegna Sovietica* 2 (1969): 36, quoted in Tafuri, "Dialectics of the Avant-Garde," 76.

84. Sergei Eisenstein, "The Dramaturgy of Film Form (The Dialectical Approach to Film Form)," in Eisenstein, *Selected Works*, 1:61. Eisenstein's reference to Marxist thought and vocabulary has also been pointed out by Oksana Bulgakowa. According to her, it was particularly the Russian edition of Engels's "Dialectics of Nature" (1926) and fragments of Lenin's "Philosophical Notebooks" (1929) that prompted Eisenstein's turn to dialectics; see Bulgakowa, *Sergej Eisenstein—Drei Utopien*, 47–48.

85. Eisenstein, *Film Sense*, 4.

86. Tafuri, "Dialectics of the Avant-Garde," 77.

87. In an interesting study, Giovanni Careri extensively draws from Eisenstein's montage theories in order to interpret Bernini's concept of the *composto*. See Giovanni Careri, *Bernini: Flights of Love, the Art of Devotion*, trans. Linda Lappin (Chicago: University of Chicago Press, 1995), 4–6, 75–84. I am indebted to Evonne Levy for pointing this out to me.

88. See Bois, "Introduction," 115.

89. See Bruno, *Atlas of Emotion*, 63.

90. Eisenstein, "Montage and Architecture," 121.

91. Ibid., 128.

92. For a description of the "Kuleshov effect" see Richter, *Köpfe und Hinterköpfe*, 119. Richter also afforded Dziga Vertov a leading role in the theoretical foundation of (intellectual) montage; ibid., 115. Conversely, both David Bordwell and Oksana Bulgakowa have suggested that Eisenstein's theory of dialectical montage may need to be seen in opposition to rather than in continuation of Kuleshov's theories, which seem to rely more on an additive notion of linkage. See Bordwell, "Eisenstein's Epistemological Shift," 35; Bulgakowa, *Sergej Eisenstein—Drei Utopien*, 46–47.

93. Richter, *Köpfe und Hinterköpfe*, 119. Richter also mentioned Dziga Vertov as one of the masterminds behind the theoretical concept of intellectual montage; ibid., 115.

94. See Bordwell, "Eisenstein's Epistemological Shift."

95. Ibid., 33.

96. Ibid., 34–35.

97. Ibid., 35.

98. Ibid., 39.

99. Ibid., 41–43. On the "afterlife" of Wagner's theories in modernism, see Koss, *Modernism after Wagner*.

100. See Bordwell, "Eisenstein's Epistemological Shift," 45.

101. See François Albera, "Introduction," in Eisenstein, *Cinématisme: Peinture et cinema* (2009), 9–19, 14–15.

102. See Bourriaud, *Relational Aesthetics*.

103. Puttock, "Vsevolod Pudovkin," 10. See also Pudovkin, *Film Technique and Film Acting*.

104. See Schmarsow, *Das Wesen der architektonischen Schöpfung*, 6, translated as August Schmarsow, "The Essence of Architectural Creation," in Mallgrave and Ikonomou, *Empathy, Form, and Space*, 281–97. See also Schmarsow, "Ueber den Werth der Dimensionen," 1:44–61.

105. Schmarsow, *Das Wesen*, 5.

106. See ibid., 292.

107. August Schmarsow, "Zur Bedeutung des Tiefenerlebnisses im Raumgebilde," *Zeitschrift für Ästhetik und Allgemeine Kunstwissenschaft* 15 (1921): 104–9.

108. Schmarsow, *Das Wesen der architektonischen Schöpfung*, 289 (author trans.).

109. Schmarsow, "Ueber den Werth der Dimensionen," 57 (author trans.).

110. See Moravánszky, *Architekturtheorie im 20. Jahrhundert*, 126. The idea of three axes of design, namely the symmetric, the proportional, and the directional axis, had already been voiced in Semper's *Der Stil in den technischen und tektonischen Künsten* (1860), and Schmarsow obviously agreed with this conception; see Jasper Cepl, "August Schmarsow Barock und Rokoko—Ein Beitrag zur ästhetischen Erziehung des modernen Architekten," in Schmarsow, *Barock und Rokoko*, 7–8.

111. See Schmarsow, "Ueber den Werth der Dimensionen," 53.

112. See ibid., 55.

113. See ibid., 59.

114. Friedberg, *Window Shopping*, 28.

115. Lutz Robbers argues along similar lines, but also brings into discussion the contributions of figures such as Hermann Sörgel or Paul Zucker; see Robbers, "Modern Architecture in the Age of Cinema," 58–64.

116. For a discussion of this relationship between experimental physiology, perceptual psychology, and film based on a reading of Münsterberg's theories, see Kittler, *Grammophon, Film, Typewriter*, 237–43.

117. Benjamin, "Work of Art," 265.

118. Ibid., 267.

119. See Vöringer, *Avantgarde und Psychotechnik*, 125.

120. For this summary, see Bulgakowa, *Sergej Eisenstein—Drei Utopien*, 114. For a slightly different account of Eisenstein's synopsis, see Peter Lyssiotis and Scott McQuire, "Liquid Architecture: Eisenstein and *Film Noir*," *AD Architectural Design* 70, no. 1 (2000): 7.

121. For the editorial history of the project, see Somaini, *Les possibilités du montage*, 76–77.

122. See Bulgakowa, *Sergej Eisenstein—Drei Utopien*.

123. See ibid., 119–23.

124. François Albera, "Formzerstörung und Transparenz: Glass House—vom Filmprojekt zum Film als Projekt," in Bulgakowa, *Eisenstein und Deutschland*, 124 (author trans.).

125. See ibid., 131–32.

126. Ibid., 140.

127. See Somaini, *Les possibilités du montage*, 96–108. The importance of the works of these writers for Eisenstein had already been pointed out in Albera, "Formzerstörung und Transparenz," 130.

128. See Somaini, *Les possibilités du montage*, 86–94.

129. Rowe and Slutzky, "Transparency: Literal and Phenomenal."

130. Sergei Eisenstein, "Glashaus," in Bulgakowa, *Eisenstein und Deutschland*, 22.

131. See Albera, "Formzerstörung und Transparenz," 125–26. I am also indebted to Jörg Schweinitz for pointing out this important aspect to me.

132. See Richards, *Commodity Culture*.

133. Eisenstein, "Glashaus," 26.

134. Ibid., 35.

135. Quoted in Albera, "Formzerstörung und Transparenz," 127.

136. Eisenstein, "Glashaus," 26.

137. See Haag Bletter, "Opaque Transparency," *Oppositions* 13 (1978): 121–26.

138. Mies van der Rohe, "Hochhaus Bahnhof Friedrichstraße," 124 (author trans.). By analyzing the photographs of the glass model that Mies used for his experiments, Spyros Papapetros has rightly pointed out that this was not the only effect Mies was interested in; the photographs also show an interest in "opaque transparency" and the "theatrical effect of nocturnal impressions." Papapetros, "Malicious Houses," 21.

139. As Oksana Bulgakowa has noted, "The photographic experiments with the glass surface quality become the subject of the film." Bulgakowa, *Sergej Eisenstein—Drei Utopien*, 115.

140. See Sergei M. Eisenstein, "Rodin et Rilke," in Eisenstein, *Cinématisme: Peinture et cinema*, 248–82.

141. Ibid., 256.

142. Ibid.

143. Ibid., 265.

144. Ibid., 275.

145. See Somaini, *Les possibilités du montage*, 87.

146. For a discussion of Lacan's theory of the mirror stage with regard to the phenomenon of transparency, see in particular Anthony Vidler, "Transparency," in Vidler, *Architectural Uncanny*, 217–25. For a slightly different reading, see also Johannes Binotto, *TAT/ORT: Das Unheimliche und sein Raum in der Kultur* (Zurich: diaphanes, 2013), 263–65.

147. Mahmoud Sami-Ali, "L'espace de l'inquiétante étrangeté," *Nouvelle Revue de Psychoanalyse* 9 (Spring 1974), quoted in Vidler, "Transparency," 222.

148. See Giedion, *Space, Time and Architecture*, 401, 403. As a matter of fact, in the English original edition the two images are not next to each other, but follow one another in the manner of a flip-book; in subsequent German editions the images are juxtaposed on a two-page spread.

149. In the case of the Picasso painting, Giedion speaks of the "transparency of overlapping planes"; in the case of the Bauhaus building, he notes the "hovering relations of planes and the kind of 'overlapping' which appears in contemporary painting." Giedion, *Space, Time and Architecture*, 401, 403.

150. Detlef Mertins, *Modernity Unbound* (London: AA, 2011), 12.

151. See Rowe and Slutzky, "Literal and Phenomenal" and "Literal and Phenomenal, Part 2."

152. Rowe and Slutzky, "Literal and Phenomenal," 46. It is not possible here to discuss in detail Rowe and Slutzky's ambiguous notion of transparency as well as its relationship to Giedion's understanding of the term. Nevertheless, Detlef Mertins has identified these two authors' radically different conceptions. In contrast to Giedion's "relational" understanding of space briefly discussed above, he deems Rowe and Slutzky's interpretation of transparency "reductive and restrictive": "For them [Rowe and Slutzky], transparency relied on an observer stationed on axis with a two-dimensional plane (a painting or the facade of a building), immobile and devoid of thought and action." Mertins, *Modernity Unbound*, 11–12. For a more detailed discussion of this antagonism, see his essay "Transparency: Autonomy and Relationality" in ibid., 70–87. See also Mertins, "Transparencies Yet to Come."

153. Eve Blau, "Transparency and the Irreconcilable Contradictions of Modernity," *PRAXIS* 9 (Fall 2007): 50–59, 51.

154. Gyorgy Kepes, "Language of Vision," quoted in Rowe and Slutzky, "Literal and Phenomenal," 45.

155. See Tafuri, "Dialectics of the Avant-Garde," 74–81; Sergei Eisenstein, "Piranesi, or the Fluidity of Forms," 84–110.

156. See Tafuri, *Sphere and the Labyrinth*.

157. For a discussion of Tafuri's conception of the architectural avant-garde, see Akcan, "Manfredo Tafuri's Theory of the Architectural Avant-Garde."

158. See Manfredo Tafuri, "The Dialectic of the Avant-Garde," in *Architecture and Utopia: Design and Capitalist Development*, trans. Barbara Luigia La Penta (Cambridge, Mass.: MIT Press, 1976). Note that this essay has an entirely different scope than the chapter in *The Sphere and the Labyrinth*, even though they have almost identical titles.

159. Tafuri saw in the concept of montage the cultural technique equivalent to the economic principle of standardization and the assembly line in modernity. Interestingly, while in his original Italian contributions, Tafuri used the term "*montaggio*" to refer to the cultural side related to this economic principle, in the English translation of his text the term was substituted with "assemblage," thus hinting at a different scope of the concepts in the two respective languages.

160. Tafuri, "Dialectic of the Avant-Garde," 86. It is interesting to note that in October 1986, MIT Press launched a "Critical Journal of Architecture and Design Culture" under the title *Assemblage*, edited by K. Michael Hays. While the initial editorial makes no reference to Tafuri's writings, the short statement nevertheless makes clear that its approach is similar to Tafuri's methodology both in its inter-disciplinary scope and the dialectics of its argument: "Dealing adequately with architecture and its worldly condition must often involve crossing institutionally defined disciplinary boundaries. . . . The notion of *Assemblage* suggests a framework for discussion, but one that includes sharply differing positions. It suggests borrowed and transformed material, from history, literary criticism, philosophy, politics; it suggests heterogeneity, collision, incompleteness." "About Assemblage," *Assemblage* 1 (1986): 4–5.

161. See Bürger, *Theory of the Avant-Garde*, 73.

162. Tafuri, "Dialectic of the Avant-Garde," 101.

163. See ibid.

164. Scully, *Modern Architecture*, 11–12. For a discussion of these conflicting notions with regard to the concept of the picturesque, see Bois, "Introduction," 44–45.

165. Tafuri, "Dialectics of the Avant-Garde," 74.

166. Ibid.

167. Ibid., 75.

168. Mario Gandelsonas, "Postscript," *Oppositions* 11 (1977): 81.

169. Tafuri, "Dialectics of the Avant-Garde," 77.

170. Ibid.

171. Philip Johnson, "Whence and Whither: The Processional Element in Architecture," *Perspecta* 9–10 (1965): 168.

172. On Johnson's historicism see Hesse, "Moderne als Postmoderne"; Michael Hesse, "Moderne und Klassik: Kunstzitat und Kunstbewußtsein bei Philip Johnson," *Zeitschrift für Kunstgeschichte* 63, no. 1 (2000): 372–86.

173. Rem Koolhaas, quoted in Maggie Toy, "Editorial," in "Architecture and Film," *AD Architectural Design* 64, no. 11/12 (1994): 7.

174. For the detailed project description, see "OMA/Rem Koolhaas, 1987–1998," *El Croquis* 53+79 (1998): 116–18.

175. See Bernard Tschumi, *The Manhattan Transcripts* (London: Academy, 1994).

176. Ibid., 7.

177. On Bernard Tschumi's spatial conceptions and notational techniques, see Bernard Tschumi, *Architecture: Concept and Notation*, ed. Frédéric Migayrou (Paris: Centre Pompidou, 2014).

178. Tschumi, *Manhattan Transcripts*, 9.

179. Ibid.

180. Ibid., 11.

181. Ibid., 12.

182. Ibid.

183. Bernard Tschumi in "Concept and Notation: Bernard Tschumi Interviewed by Frédéric Migayrou," in Tschumi, *Architecture: Concept and Notation*, 76. Tschumi came across Eisenstein's books *Film Form* and *Film Sense* while living in New York in the 1970s.

184. See Tschumi, *Architecture: Concept and Notation*, 227, 230.

185. Tschumi, *Manhattan Transcripts*, 30. In a slightly later text, Tschumi would return to the comparison of the Parc de la Villette with the *Manhattan Transcripts*, now stressing in the former the deconstructivist operations and affinity to Derrida's theories. See Tschumi, "Disjunctions," *Perspecta* 23 (1987): 108–19.

186. "I was looking for people to support and confirm what I was doing in certain 1920s work, like the films of Sergei Eisenstein such as *Battleship Potemkin*, and the work of the Dadaists, Surrealists, and Constructivists." Bernard Tschumi in Tschumi, *Parc de la Villette, Supercrit #4*, ed. Samantha Hardingham and Kester Rattenbury (Abingdon: Routledge, 2012), 61.

187. Bernard Tschumi, *Cinégramme folie: Le Parc de la Villette, Paris Nineteenth Arrondissement* (Seyssel: Champ Vallon, 1987), 12.

188. Ibid.

189. Giovanni Damiani, ed., *Bernard Tschumi* (London: Thames and Hudson, 2003), 84.

190. Bernard Tschumi, "The Architectural Project of Le Fresnoy," in *Le Fresnoy: Architecture In/Between* (New York: Monacelli, 1999), 36. Tschumi explains

how his interest in film theory led to the *Manhattan Transcripts;* ibid., 36–37.

191. According to Tschumi, this kind of spatial configuration "has fascinated architects throughout the second half of the twentieth century, positing a tension between the event inside the box and the box as container of the event." Tschumi, "Architectural Project of Le Fresnoy," 39.

192. Ibid., 40.

193. Thus, in his introduction, Herbert Eagle states: "Two of the most intriguing analyses in the *pathos* section of *Nonindifferent Nature* concern the art of El Greco and of Piranesi. In both cases, Eisenstein describes meticulously the structural 'explosion' of an early variant to yield a more ecstatic (and justifiably more famous) later variant. He explores the harmonic transition of certain forms into other forms; a sequence of forms 'overflowing' into new forms. Entire movements in art show a similar mechanism: The Gothic 'explodes' the preceding features of Romanesque architecture; impressionism and cubism explode the contours and the spatial bounds of realism's objects." Herbert Eagle, "Introduction," in Eisenstein, *Nonindifferent Nature*, 13. It should be added that, in their respective interpretations of Eisenstein, both Manfredo Tafuri and Anthony Vidler consider the notion of explosion extensively. See Tafuri, "Dialectics of the Avant-Garde"; Anthony Vidler, "The Explosion of Space" and "Metropolitan Montage," in Vidler, *Warped Space*, 99–110, 111–22.

194. Jean Nouvel, quoted in Kester Rattenbury, "Echo and Narcissus," in *AD Architectural Design* 64, no. 11/12 (1994): 35.

195. See Henry Keazor, "'L'architecte fait son spectacle': Medienrekurse in der Architektur Jean Nouvels," in Beyer, Burioni, and Grave, *Das Auge der Architektur*, 384–87.

196. See Colomina, *Privacy and Publicity*, 139.

197. See Virilio, *Aesthetics of Disappearance*. With regard to the "media" quality of transparent façades and their impact on the image of the city, see also Virilio's "The Overexposed City," in *The Paul Virilio Reader*, ed. Steve Redhead (New York: Columbia University Press, 2004), 83–99.

198. See Keazor, "'L'architecte fait son spectacle,'" 396–97.

199. See ibid., 394.

200. See Bruno, *Surface*.

201. Dimendberg, *Diller Scofidio + Renfro*, 193.

202. Virilio, *Aesthetics of Disappearance*, 74.

CHAPTER 6
MONTAGE AND THE
METROPOLITAN UNCONSCIOUS

1. On the differentiation between narrative and structural historiography, see Peter Burke, "History of Events and the Revival of Narrative," in New Perspectives on Historical Writing (Cambridge: Polity, 1991), 233–48.

2. It is interesting that while Giedion relied on the montage principle as a visual tool, Koolhaas uses it to (implicitly) critique Giedion's narrative in *Space, Time and Architecture.*

3. "Delirious New York is composed almost entirely of dialectical tropes—opposites, odd couples or alter egos—on the level of verbal devices, buildings, symbols and movements." Hsu, "End of Modernism," 4, 31–32.

4. See Manfredo Tafuri, "The Disenchanted Mountain: The Skyscraper and the City," in Ciucci, Dal Co, Manieri-Elia, and Tafuri, *American City*, 389–528.

5. S. Frederick Starr, "Delirious New York," *Architectural Design* 49, nos. 5–6 (1979): 138.

6. "Not necessarily because of the content but rather because of the book as an object, as a way of talking about a subject in architecture . . . I also realized at that point . . . that you could no longer write manifestos, but that you could write about cities as if they themselves were a manifesto." Rem Koolhaas, "Flâneurs in Automobiles: A Conversation between Peter Fischli, Rem Koolhaas, Hans Ulrich Obrist," in *Las Vegas Studio: Images from the Archives of Robert Venturi and Denise Scott Brown,* ed. Hilar Stadler and Martino Stierli (Zurich: Scheidegger and Spiess, 2008), 169. See also "Relearning from Las Vegas: An Interview with Denise Scott Brown and Robert Venturi by Hans Ulrich Obrist and Rem Koolhaas," in *Harvard Design School Guide to Shopping,* ed. Chuihua Judy Chung, Jeffrey Inaba, Rem Koolhaas,

and Sze Tsung Leong (Cologne: Taschen, 2001), 590–617. For Henry-Russell Hitchcock's early excursions into anonymous architectural historiography, see Stierli, *Las Vegas in the Rearview Mirror*, 227–29.

7. Michel Foucault Info, "Documents," http://foucault.info/documents/heteroTopia/foucault.heteroTopia.en.html.

8. See Vidler, *Warped Space.*

9. See, for example, Robert Venturi, *Complexity and Contradiction in Architecture* (New York: Museum of Modern Art, 1966).

10. See Krauss, "Sculpture in the Expanded Field," 276–90.

11. See Bernard Tschumi, "On Delirious New York: A Critique of Critiques," *UIA International Architect* 1, no. 3 (1979): 69. See also Colomina, *Privacy and Publicity.* On the issue of "writing architecture," see also *GAM Graz Architecture Magazine* 11 (2015), special issue "Archiscripts."

12. On Koolhaas's intellectual biography, see, for example, Gargiani, *Rem Koolhaas/OMA;* see also Martino Stierli, "Koolhaas, Rem," in *Allgemeines Künstlerlexikon* (Berlin: De Gruyter, 2014), 81:285–88.

13. Koolhaas, "Why I Wrote Delirious New York," 42–43.

14. Ibid., 42.

15. For the conceptual nature of architecture, see also Koolhaas, "La deuxième chance," 8.

16. On this, see, for example, Moravánszky and Kirchengast, *Experiments.*

17. See Koolhaas, "Why I Wrote Delirious New York," 42.

18. Koolhaas, *Delirious New York,* 9.

19. Walter Fähnders, "Manifest," in *Historisches Wörterbuch der Rhetorik,* ed. Gert Ueding (Tübingen: Niemeyer, 2001), vol. 5, col. 927. On the theory of the manifesto in literature and art, see also *Littérature* 39 (1980), special issue "Les Manifestes."

20. See Petit, "Other Architectual [*sic*] Manifesto: Caricature," 7.

21. Koolhaas, *Delirious New York,* 9.

22. Ibid., 11.

23. Ibid.

24. See Hsu, "End of Modernism," 116–17. For *S,M,L,XL,* see also Catherine de Smet, "'Je suis un livre': À propos de *S,M,L,XL* par Rem Koolhaas et Bruce Mau," *Les*

cahiers du musée national d'art moderne
68 (1999): 94–111.

25. Koolhaas, *Delirious New York*, 11.

26. Koolhaas, "Why I Wrote Delirious New York," 43.

27. See Lessing, *Laokoon*.

28. Koolhaas, *Delirious New York*, 21. For an interesting analysis of the historical narratives of *Delirious New York*, see Jose R. Kos, "Experiencing the City through a Historical Digital System," in *New Heritage: New Media and Cultural Heritage*, ed. Yehuda E. Kalay, Thomas Kvan, and Janice Affleck (London: Routledge, 2008), 132–52.

29. Koolhaas, *Delirious New York*, 89. In this regard, see also Ian Buruma, "The Sky's the Limit" (1995), in *What Is OMA? Considering Rem Koolhaas and the Office for Metropolitan Architecture*, ed. Véronique Patteeuw (Rotterdam: NAi, 2003), 62.

30. The definition of the urban based on the criteria of density, bigness, and heterogeneity is among the fundamentals of urban sociology. It was Louis Wirth who first defined the city along those lines as a relatively large, dense, and permanent settlement of heterogeneous individuals. See Wirth, "Urbanism as a Way of Life."

31. Koolhaas, *Delirious New York*, 296.

32. For a critique of Koolhaas's literary style, see William S. Saunders, "Rem Koolhaas's Writing on Cities: Poetic Perception and Gnomic Fantasy," *Journal of Architectural Education* 51, no. 1 (1997): 61–71.

33. See Koolhaas, "La deuxième chance," 38; Ungers et al., "Cities within the City." See in this respect Kees Christiaanse, "Ein grüner Archipel: Ein Berliner Stadtkonzept 'revisited,'" *DISP* 156 (2004): 21–29. This influential text has recently been critically edited; see Hertweck and Marot, *City in the City*.

34. See Koolhaas, "La deuxième chance," 2.

35. See Rowe and Koetter, *Collage City*; see also Thomas Will and Jörg Stabenow, "Im Kontext der modernen Stadt," *ARCH+* 105, no. 6 (1990): 88–94.

36. Colin Rowe and Fred Koetter, "Collage City," *Architectural Review* 158, no. 942 (1975): 66.

37. See Koolhaas, "La deuxième chance," 3.

38. See ibid.

39. See Rem Koolhaas, letter to Adolfo Natalini, 8 February 1972, Natalini Archives, quoted in Gargiani, *Rem Koolhaas/OMA*, 21.

40. See Koolhaas, "La deuxième chance," 3.

41. Jean-Louis Cohen has likewise argued that Koolhaas's understanding of collage is different from that of Rowe and Koetter; see Jean-Louis Cohen, "Der rationale Rebell oder der Stadtbegriff des OMA," in Lucan, *OMA: Rem Koolhaas*, 11–13.

42. See Gargiani, *Rem Koolhaas/OMA*, 24.

43. Konrad Wohlhage, "Das Objekt und die Stadt: Erinnerungen an eine Berliner Tradition," *ARCH+* 105, no. 6 (1990): 53.

44. See Christiaanse, "Ein grüner Archipel," 22.

45. See Rem Koolhaas/OMA, "Melun-Sénart," *ARCH+* 105, no. 6 (1990): 78; see also Gargiani, *Rem Koolhaas/OMA*, 118–24.

46. Rem Koolhaas/OMA, "Melun-Sénart," 78 (author trans.).

47. Ibid.

48. See Cohen, "Der rationale Rebell," 16–17.

49. See Superstudio, "Deserti naturali e artificiali." On Superstudio and the Monumento Continuo in particular, see Stauffer, *Figurationen des Utopischen*.

50. See Gargiani, *Rem Koolhaas/OMA*, 14.

51. On Emilio Ambasz, see, in particular, Felicity D. Scott, "Italian Design and the New Political Landscape," in Sorkin, *Analyzing Ambasz*, 109–56. Scott also briefly mentions the kinship between Ambasz's and Koolhaas's writings on Manhattan; ibid., 148. On the history of the IAUS, see also Kim Förster, "The Institute for Architecture and Urban Studies, New York (1967–1985): Ein kulturelles Projekt in der Architektur" (PhD thesis, ETH Zurich, 2011).

52. See Emilio Ambasz, ed., *Italy: The New Domestic Landscape. Achievements and Problems of Italian Design*, exh. cat. (Greenwich, Conn.: New York Graphic Society, 1972). In a letter to Adolfo Natalini of the Florence-based Superstudio dated February 8, 1973, Koolhaas delivers an account of his first impressions of the United States. While he does not mention Ambasz's exhibition at MoMA, Koolhaas describes Ambasz as "interesting and at least somewhat eager and curious, with funny stories." See Gargiani, *Rem Koolhaas/OMA*, 21.

53. Ambasz, "University of Design and Development," 362. While also published in *Casabella* 359/360 (1971), I am quoting from the publication in *Perspecta* 13/14 (1971) here and throughout.

54. Ibid.

55. See Benjamin, "Paris—Capital of the Nineteenth Century."

56. Koolhaas, *Delirious New York*, 85, 138.

57. On the relationship between delirium and historiography (according to Manfredo Tafuri), see Stoppani, "Delirium and Historical Project," 22–29.

58. For a recent discussion of the role of architecture and the modern metropolis in Benjamin's thinking, see Hartoonian, *Walter Benjamin and Architecture*; and Brian Elliott, *Benjamin for Architects* (London: Routledge, 2011).

59. Benjamin, "Paris—Capital of the Nineteenth Century," 88.

60. Benjamin, *Arcades Project*, 388.

61. Ibid., 461.

62. Ibid., 463.

63. Ibid., 458 (Benjamin here quotes Rudolf Borchardt).

64. For a detailed discussion of the relationship between Giedion and Benjamin, see Heinz Brüggemann, "Walter Benjamin und Sigfried Giedion oder die Wege der Modernität," *Deutsche Vierteljahrsschrift für Literaturwissenschaft und Geistesgeschichte* 70, no. 3 (1996): 434–74; and Brüggemann, *Architekturen des Augenblicks*.

65. This letter, formerly in the archives of Sigfried Giedion in the gta Archive at ETH Zurich, has since been lost. Quoted in Georgiadis, "Introduction," 53.

66. Benjamin, *Arcades Project*, 154.

67. Walter Benjamin, *Gesammelte Briefe*, vol. 5, *1935–1937*, ed. Christoph Gödde and Henri Lonitz (Frankfurt a. M.: Suhrkamp, 1999), 296 (author trans.). See Heinz Brüggemann, "Passagen: Terrain vague surrealistischer Poetik und panoptischer Hohlraum des XIX. Jahrhunderts," in Beyer, Simon, and Stierli, *Zwischen Architektur und literarischer Imagination*, 219.

68. Koolhaas, *Delirious New York*, 10.

69. Benjamin, *Arcades Project*, 456.

70. Ibid.

71. Ibid., 458.

72. Ibid., 460.

73. Ibid., 476.

74. Ibid., 460. For a (literal) interpretation of Benjamin's use of textual rags, see Georges Didi-Huberman, "The Drapery of Sidewalks," in *Herzog and de Meuron: Natural History*, ed. Philip Ursprung (Montreal: Canadian Centre for Architecture; Baden: Lars Müller, 2002), 269–78.

75. Ibid., 160.

76. On the history and theory of the genre of the tableau, see Karlheinz Stierle, "Baudelaire and the Tradition of the Tableau de Paris," *New Literary History* 11, no. 2 (1980): 345–61.

77. Quoted in Wolfgang Tschöke, "Nachwort," in Mercier, *Pariser Nahaufnahmen*, 339.

78. See Louis-Sébastien Mercier, *Mein Bild von Paris* (Leipzig: Insel, 1979), 13.

79. Stierle, "Baudelaire and the Tradition of the Tableau de Paris," 347.

80. Mercier, *Mein Bild von Paris*, 13, trans. in Stierle, "Baudelaire and the Tradition of the Tableau de Paris," 347.

81. See Didi-Huberman, *Quand les images prennent position*, 1:26. For a more recent discussion of the relationship of montage and narrative in Weimar Germany, see Patrizia C. McBride, *Chatter of the Visible*.

82. See Walter Benjamin, "Surrealism: The Last Snapshot of the European Intelligentsia," in Benjamin, *Selected Writings*, vol. 2, *1927–30*, trans. Rodney Livingstone et al., ed. Michel W. Jennings, Howard Eiland, and Gary Smith (Cambridge, Mass.: Belknap Press of Harvard University Press, 1999), 221.

83. See Koolhaas, *Delirious New York*, 235–37.

84. Benjamin, *Arcades Project*, 459.

85. Koolhaas, *Delirious New York*, 235–82.

86. Benjamin, *Arcades Project*, 458.

87. Rem Koolhaas, "Surrealism," in OMA, Koolhaas, and Mau, *S,M,L,XL*, 1190.

88. See Dalí, *Collected Writings*, sec. 7 and 8.

89. Salvador Dalí, "The Rotting Donkey" (1930), in Dalí, *Collected Writings*, 223.

90. "Lacan's work . . . situates [the paranoiac process] at the very antipodes of the stereotype of automatism and dream. Far from constituting a passive element, as are the latter, propitious for interpretation and suitable for intervention, the paranoiac delirium already constitutes in itself a form of interpretation." Salvador Dalí, "New General Considerations Regarding the Mechanism of the Paranoiac Phenomenon from the Surrealist Point of View," in ibid., 260.

91. Koolhaas, *Delirious New York*, 237. On the paranoid-critical method and Koolhaas's involvement with surrealism, see also Hsu, "End of Modernism," 44–56.

92. Salvador Dalí, "The Moral Position of Surrealism" (1930), in Dalí, *Collected Writings*, 221.

93. Haim Finkelstein, "Surrealist Doctrine and Its Subversion," in Dalí, *Collected Writings*, 216.

94. Salvador Dalí, "New General Considerations," in Dalí, *Collected Writings*, 262.

95. Koolhaas, *Delirious New York*, 238.

96. Ibid., 246.

97. Ibid., 273.

98. Ibid., 294.

99. Dalí, "Rotting Donkey," 224.

100. See Salvador Dalí, "The Tragic Myth of Millet's *L'Angélus*: Paranoiac-Critical Interpretation (excerpts)" (1963), in Dalí, *Collected Writings*, 282–97.

101. See Gargiani, *Rem Koolhaas/OMA*, 12.

102. Salvador Dalí, "The Object as Revealed in Surrealist Experiment" (1932), in Dalí, *Collected Writings*, 234–44, 414n34.

103. Koolhaas, *Delirious New York*, 256.

104. See "Théâtre National de Danse," *L'Architecture d'aujourd'hui* 238 (1985): 84–95. For the project history and what followed, see Gargiani, *Rem Koolhaas/OMA*, 109–14.

105. See Gargiani, *Rem Koolhaas/OMA*, 109; Jacques Lucan, "Der Architekt des 'modernen Lebens,'" in Lucan, *OMA: Rem Koolhaas*, 34. See also Damisch, "Cadavre Exquis," 22.

106. See "Théâtre National de Danse," 84.

107. Louis Aragon, *Oeuvres poétiques complètes*, vol. 1, ed. Olivier Barbarant (Paris: Gallimard Bibliothèque de la Pléiade, 2007), 191. In a letter to Theodor Adorno from May 31, 1935, Benjamin characterized Argon's opus, hardly coincidentally, as the beginning of his *Arcades Project*. See Walter Benjamin, *Gesammelte Briefe*, vol. 5, *1935–1937*, ed. Christoph Gödde and Henri Lonitz (Frankfurt a.M.: Suhrkamp, 1999), 96–97. I am indebted to Heinz Brüggemann for pointing out these connections; see Heinz Brüggemann, "Passagen: Terrain vague surrealistischer Poetik und panop-tischer Hohlraum des XIX. Jahrhunderts," in Beyer, Simon, and Stierli, *Zwischen Architektur und literarischer Imagination*, 197–240, 219.

108. "If such research in iconographic documentation was 'still rare' among historians, it was unheard of among philosophers." Buck-Morss, *Dialectics of Seeing*, 71. See also Kos, "Experiencing the City," 140. This album has been lost.

109. "Seminal buildings are represented again and again [in Madelon Vriesendorp and Rem Koolhaas's postcard collection], before actual construction begins, and then several times after. You can see the shifts from idealism to realism to retrospectivism." Shumon Basar and Charlie Koolhaas, "Disasters, Babies, Glass Bricks: Postcard Archaeology," in Basar and Trüby, *World of Madelon Vriesendorp*, 77.

110. See Koolhaas, "La deuxième chance," 3.

111. See Basar and Koolhaas, "Disasters, Babies, Glass Bricks," 77.

112. Quoted in Gargiani, *Rem Koolhaas/OMA*, 20.

113. For a discussion of the role of the image atlas in postmodern artistic production, see in particular Benjamin H.D. Buchloh, "Warburgs Vorbild? Das Ende der Collage/Fotomontage im Nachkriegseuropa," in Schaffner and Winzen, *Deep Storage*, 50–60. Craig Owens has theorized the postmodern production of images under the heading of allegory; see Owens, "Allegorical Impulse" and "Allegorical Impulse, Part 2." Specifically on Rem Koolhaas and *Delirious New York*, see Stierli, "Architect as Ghostwriter," 136–39.

114. Koolhaas, "La deuxième chance," 3 (author trans.).

115. On the history and the technical developments leading to the invention of the picture postcard, see Kent Lydecker, "Konstruierte Bilder: Ansichtskarten von New York," in Kramer, *New York auf Postkarten*, 16–32; and Kent Lydecker, "Constructing Memory: Picture Postcards of New York City," *Hopkins Review* 4, no. 2 (2011): 229–70.

116. Koolhaas, *Delirious New York*, 155.

117. See Madelon Vriesendorp, "Disaster Follows Ecstasy Like Form Follows Function: Beatriz Colomina Interviews Madelon Vriesendorp, Part II," in Basar and Trüby, *World of Madelon Vriesendorp*, 43.

118. Koolhaas, *Delirious New York*, 241.

119. In this regard, see Friedberg, *Window Shopping*.

120. See Mike Crang, "Envisioning Urban Histories: Bristol as Palimpsest, Postcards, and Snapshot," *Environment and Planning A* 28 (1996): 429–52.

121. Koolhaas, "La deuxième chance," 3.

122. Rem Koolhaas in conversation with Bernard Tschumi and Stephan Trüby, ETH Zurich, May 18, 2011.

123. See David Robbins, ed., *The Independent Group: Postwar Britain and the Aesthetics of Plenty* (Cambridge, Mass.: MIT Press, 1990).

124. "Madelon and Rem collected thousands of postcards, as did Eduardo Paolozzi, Richard Hamilton and Alvin Boyarsky and every 'knowing consumer' educated in the hothouse of London pop. Lectures of the Independent Group during the 1950s established this form of intellectual research. It became the way to fashion an alternative image-bank." Charles Jencks, "Madelon Seeing through Objects," in Basar and Trüby, *World of Madelon Vriesendorp,* 21.

125. See Boyarsky, "Chicago à la Carte." On Boyarsky and the postcard, see Igor Marjanović, "Wish You Were Here: Alvin Boyarsky's Chicago Postcards," in *Chicago Architecture: Histories, Revisions, Alternatives,* ed. Charles Waldheim and Katerina Rüedi Ray (Chicago: University of Chicago Press, 2005), 207–25; and Marjanović, "Alvin Boyarsky's Chicago," 45–52. For Boyarsky's pedagogy in general, see Sunwoo, "Pedagogy's Progress." On Koolhaas's use of postcards in view of the context of postmodern pictorial theory, see Stierli, "Architect as Ghostwriter," 136–39.

126. See "Manhattan Workshop," *Architectural Design* 43, no. 5 (1973): 284–93, 302–8; Gargiani, *Rem Koolhaas/OMA,* 13–14. For a personal account of his relationship to Boyarsky, see Koolhaas, "Atlanta."

127. See Marjanović, "Alvin Boyarsky's Chicago," 49.

128. See ibid.

129. See Jeff L. Rosenheim, *Walker Evans and the Picture Postcard* (New York: Museum of Modern Art; Göttingen: Steidl, 2009), 19.

130. See Martin Parr, *Boring Postcards* (London: Phaidon, 1999).

131. See Éluard, "Les plus belles cartes postales," 85–100.

132. The quote is from Dalí, "The Moral Position of Surrealism" (1930), in Dalí, *Collected Writings,* 221.

133. See Lyotard, *Postmodern Condition.*

134. Llorens, "Manfredo Tafuri," 85.

135. Ibid., 93–94. It should be considered that the writing process described by Llorens ought not be limited specifically to Tafuri, but that all writing to some degree depends on earlier, intertextual references.

136. Manfredo Tafuri, "The Historical 'Project,'" in Tafuri, *Sphere and the Labyrinth,* 1–21; in this regard, see Carla Keyvanian, "Manfredo Tafuri: From the Critique of Ideology to Microhistories," *Design Issues* 16, no. 1 (2000): 6.

137. Tafuri, *Architecture and Utopia,* 86.

138. Ibid., 14.

139. This assertion is indebted to Eisenstein's reading of Piranesi and reiterated in another of Tafuri's essays, "Dialectics of the Avant-Garde."

140. See Keyvanian, "Manfredo Tafuri," 5–6. On Tafuri's relationship with Walter Benjamin, see, in particular, Leach, "Tafuri and the Age of Historical Representation," 5–21.

CONCLUSION

1. Or "mechanical reproduction," in the previously standard translation of Benjamin's "*technische Reproduzierbarkeit.*"

2. Buchloh, *Formalism and Historicity* (Cambridge, Mass.: MIT Press, 2015), 178.

3. Koolhaas, *Delirious New York,* 85.

Select Bibliography

ARCHIVES

Architekturmuseum, der TU München, Sammlung

Bauhaus-Archiv, Berlin

Berlinische Galerie, Berlin

Getty Research Institute, Los Angeles, Special Collections

gta Archiv, Institut für Geschichte und Theorie der Architektur, ETH Zurich

Rem Koolhaas and Madelon Vriesendorp, London, private collection

Library of Congress, Washington, D.C., Mies van der Rohe Papers

Museum of Modern Art, New York, Architecture and Design Study Center, Ludwig Mies van der Rohe Archive

Sprengel Museum, Hannover, Kurt Schwitters Archiv

WORKS

Ades, Dawn. *Photomontage*, rev. and enlarged ed. London: Thames and Hudson, 1986.

Adorno, Theodor W. *Aesthetic Theory*. London: Continuum, 2004.

Akcan, Esra. "Manfredo Tafuri's Theory of the Architectural Avant-Garde." *Journal of Architecture* 7, no. 2 (2002): 135–70.

Albera, François. "Glass House." *Faces* 24 (1992): 42–52.

Albera, François, and Maria Tortajada, eds. *Cinema beyond Film: Media Epistemology in the Modern Era*. Amsterdam: Amsterdam University Press, 2010.

Allen, Stan. "Le Corbusier and Modernist Movement." *Any* 5 (March–April 1994): 42–47.

Ambasz, Emilio. "I. The University of Design and Development. II: Manhattan: Capital of the Twentieth Century. III: The Designs of Freedom." *Perspecta* 13/14 (1971): 359–65.

Bader, Lena, Martin Gaier, and Falk Wolf, eds. *Vergleichendes Sehen*. Munich: Fink, 2010.

Baltzer, Nanni. *Die Fotomontage im faschistischen Italien: Aspekte der Propaganda unter Mussolini*. Berlin: De Gruyter, 2015.

Baltzer, Nanni, and Martino Stierli, eds. *Before Publication: Montage in Art, Architecture, and Book Design*. Zurich: Park, 2016.

Basar, Shuman, and Stephan Trüby, eds. *The World of Madelon Vriesendorp: Paintings/Postcards/Objects/Games*. London: AA, 2008.

Benjamin, Walter. *The Arcades Project*. Translated by Howard Eiland and Kevin McLaughlin. Cambridge, Mass.: Belknap Press of Harvard University Press, 1999.

———. *Illuminations*. Edited and introduction by Hannah Arendt. New York: Schocken, 1969.

———. "Paris—Capital of the Nineteenth Century." *New Left Review* 48 (1968): 77–88.

Bergius, Hanne. *Montage und Metamechanik: Dada Berlin—Artistik von Polaritäten*. Berlin: Gebr. Mann, 2000.

Beyer, Andreas, Matteo Burioni, and Johannes Grave, eds. *Das Auge der Architektur: Zur Frage der Bildlichkeit in der Baukunst*. Munich: Fink, 2011.

Beyer, Andreas, Ralf Simon, and Martino Stierli, eds. *Zwischen Architektur und literarischer Imagination*. Munich: Fink, 2013.

Blau, Eve, and Nancy J. Troy, eds. *Architecture and Cubism*. Montreal: Canadian Centre for Architecture; Cambridge, Mass.: MIT Press, 1997.

Bloch, Ernst. *Heritage of Our Times*. 1935. Reprint, Cambridge: Polity, 1991.

Bois, Yve-Alain. Introduction to "Montage and Architecture," by Sergei Eisenstein. *Assemblage* 10 (December 1989): 111–15.

Bois, Yve-Alain, and John Shepley. "A Picturesque Stroll around 'Clara-Clara.'" *October* 29 (1984): 32–62.

Bool, Flip, ed. *Paul Citroen, 1896–1983*. Amsterdam: Focus, 1998.

Bordwell, David. "Eisenstein's Epistemological Shift." *Screen/SEFT* 15, no. 4 (1974): 32–46.

———. "The Idea of Montage in Soviet Art and Film." *Cinema Journal* 11 (Spring 1972): 9–17.

Bourriaud, Nicholas. *Relational Aesthetics*. Dijon: Les presses du reel, 2002.

Boyarsky, Alvin. "Chicago à la Carte: The City as an Energy System." *Architectural Design* 40, no. 12 (1970): 595–622, 631–40.

Brüggemann, Heinz. *Architekturen des Augenblicks: Raum-Bilder und Bild-Räume einer urbanen Moderne in Literatur, Kunst und Architektur des 20. Jahrhunderts*. Hannover: Offizin, 2002.

Bruno, Giuliana. *Atlas of Emotion: Journey in Art, Architecture, and Film*. London: Verso, 2002.

———. *Surface: Matters of Aesthetics, Materiality, and Media*. Chicago: University of Chicago Press, 2014.

Buchloh, Benjamin H. D. "Allegorical Procedures: Appropriation and Montage in Contemporary Art." *Artforum* 11 (September 1982): 34–56.

———. "From Faktura to Factography." *October* 30 (1984): 82–119.

Buck-Morss, Susan. *The Dialectics of Seeing: Walter Benjamin and the Arcades Project*. Cambridge, Mass.: MIT Press, 1989.

Bulgakowa, Oksana, ed. *Eisenstein und Deutschland: Texte, Dokumente, Briefe*. Berlin: Akademie der Künste, 1998.

———. *Sergej Eisenstein—Drei Utopien: Architekturentwürfe zur Filmtheorie*. Berlin: Potemkin, 1996.

Bürger, Peter. *Theorie der Avantgarde*. Frankfurt a. M.: Suhrkamp, 1974.

———. *Theory of the Avant-Garde*. Translated by Michael Shaw. Minneapolis: University of Minnesota Press, 1984.

Bürkle, J. Christoph. *El Lissitzky: Der Traum vom Wolkenbügel. El Lissitzky—Emil Roth—Mart Stam*. Zurich: gta, 1991.

Burmeister, Ralf, ed. *Hannah Höch, Aller Anfang ist DADA!* Ostfildern: Hatje Cantz, 2007. Exhibition catalog. Berlinische Galerie, Berlin, and Museum Tinguely, Basel.

Cennamo, Michele. *Materiali per l'analisi dell'architettura moderna: Il M.I.A.R.* Napoli: Società Editrice Napoletana, 1976.

Ciucci, Giorgio, Francesco Dal Co, Mario Manieri-Elia, and Manfredo Tafuri. *The American City: From the Civil War to the*

New Deal. Cambridge, Mass.: MIT Press, 1979.

———. *Città americana dalla guerra civile al New Deal*. Rome: Laterza, 1973.

Cohen, Arthur Allen. *Herbert Bayer: The Complete Work*. Cambridge, Mass.: MIT Press, 1984.

Cohen, Jean-Louis. *Le Corbusier and the Mystique of the USSR: Theories and Projects for Moscow, 1928–1936*. Princeton: Princeton University Press, 1991.

———. "The Misfortunes of the Image: Melnikov in Paris, 1925." In *Architecture-production*, edited by Beatriz Colomina, 100–121. New York: Princeton Architectural Press, 1988.

Colomina, Beatriz, ed. *Architecturepro-duction*. New York: Princeton Architectural Press, 1988.

———. "Mies Not." In *The Presence of Mies*, edited by Detlef Mertins, 192–221. New York: Princeton Architectural Press, 1994.

———. *Privacy and Publicity: Modern Architecture as Mass Media*. Cambridge, Mass.: MIT Press, 1994.

Cooke, Catherine. *Russian Avant-Garde—Theories of Art, Architecture, and the City*. London: Academy, 1995.

Corbett, Harvey Wiley. "Architectural Models of Cardboard." *Pencil Points* 3, no. 4 (1922): 11–14.

Dabrowski, Magdalena, Leah Dickerman, and Peter Galassi. *Aleksandr Rodchenko*. New York: Abrams, 1998. Exhibition catalog. Museum of Modern Art, New York.

Dalí, Salvador. *The Collected Writings*. Edited and and translated by Haim Finkelstein. Cambridge: Cambridge University Press, 1998.

Damisch, Hubert. "Cadavre Exquis." *AMC Architecture Mouvement Continuité* 18 (1987): 21–22.

———. *The Origin of Perspective*. Cambridge, Mass.: MIT Press, 1994.

Daston, Lorraine, and Peter Galison. *Objectivity*. New York: Zone, 2007.

Deleuze, Gilles. *Das Bewegungs-Bild*. Kino 1. Frankfurt: Suhrkamp, 1997.

Deleuze, Gilles, and Felix Guattari. *A Thousand Plateaus: Capitalism and Schizophrenia*. London: Athlone, 1988.

Deriu, Davide. "Montage and Architecture: Sigfried Giedion's Implicit Manifesto." *Architectural Theory Review* 12, no. 1 (2007): 36–59.

Dickerman, Leah. "The Fact and the Photograph." *October* 118 (2006): 132–52.

Didi-Huberman, Georges. *Quand les images prennent position, L'oeil de l'historie*. Vol. 1. Paris: Éditions de Minuit, 2009.

———. "Was zwischen zwei Bildern passiert. Anachronie, Montage, Allegorie, Pathos." In *Vergleichendes Sehen*, edited by Lena Bader, Martin Gaier, and Falk Wolf, 537–72. Munich: Fink, 2010.

Dimendberg, Edward. *Diller Scofidio + Renfro: Architecture after Images*. Chicago: University of Chicago Press, 2013.

Doherty, Brigid. "Berlin Dada: Montage and the Embodiment of Modernity, 1916–1920." PhD diss., University of California, Berkeley, 1996.

Dorner, Alexander. *The Way beyond "Art": The Work of Herbert Bayer*. New York: Wittenborn, Schultz, 1949.

———. "Zur Abstrakten Malerei: Erklärung zum Raum der Abstrakten in der Hannoverschen Gemäldegalerie." *Die Form* 3, no. 4 (1927): 110–14.

Douglas, Charlotte, and Christina Lodder, eds. *Rethinking Malevich: Proceedings of a Conference in Celebration of the 125th Anniversary of Kazimir Malevich's Birth*. London: Pindar, 2007.

Drude, Christian. *Historismus als Montage: Kombinationsverfahren im graphischen Werk Max Klingers*. Mainz: von Zabern, 2005.

Eco, Umberto. *The Open Work*. Translated by Anna Cancogni. Introduction by David Robey. Cambridge, Mass.: Harvard University Press, 1989.

Edgerton, Samuel Y. *The Renaissance Rediscovery of Linear Perspective*. New York: Basic, 1975.

Eisenstein, Sergei M. *Cinématisme: Peinture et cinema*. Edited by François Albera. Brussels: Editions Complexe, 1980.

———. *Cinématisme: Peinture et cinema*. Edited and introduction by François Albera. Dijon: Les presses du réel, 2009.

———. *Film Form: Essays in Film Theory and Film Sense*. Edited by Jay Leyda. New York: Meridian, 1957.

———. *The Film Sense*. Edited by Jay Leyda. San Diego: Harcourt Brace, 1942.

———. "Montage and Architecture." Introduction by Yve-Alain Bois. *Assemblage* 10 (1989): 101–31.

———. *Nonindifferent Nature*. Translated by Herbert Marshall. Cambridge: Cambridge University Press, 1987.

———. *Selected Works*. Vol. 1, *Writings, 1922–34*, edited by Richard Taylor.

London: BFI; Bloomington: Indiana University Press, 1988.

———. *Selected Works*. Vol. 2, *Towards a Theory of Montage*. London: BFI, 1991.

———. *Selected Works*. Vol. 3, *Writings, 1934–47*, edited by Richard Taylor. London: BFI, 1996.

Éluard, Paul. "Les plus belles cartes postales." *Minotaure* 3, no. 4 (1933): 85–100.

Elwall, Robert. *Building with Light: The International History of Architectural Photography*. London: Merrell, 2004.

Etlin, Richard. *Frank Lloyd Wright and Le Corbusier: The Romantic Legacy*. Manchester: Manchester University Press, 1994.

Evans, Robin. *Translations from Drawing to Building and Other Essays*. London: Architectural Association, 1997.

Foster, Hal. ed. *The Anti-Aesthetic: Essays on Postmodern Culture*. Port Townsend, Wash.: Bay, 1983.

Frank, Hilmar et al. *Montage als Kunstprinzip: Internationales Kolloquium, 16. und 17. Mai 1991*. Berlin: Akademie der Künste, 1991.

Friedberg, Anne. *The Virtual Window: From Alberti to Microsoft*. Cambridge, Mass.: MIT Press, 2006.

———. *Window Shopping: Cinema and the Postmodern*. Berkeley: University of California Press, 1993.

Fritzsche, Peter. *Reading Berlin 1900*. Cambridge, Mass.: Harvard University Press, 1996.

Fröhlich, Martin, and Martin Steinmann. "Zürich, das nicht gebaut wurde, 2: Das Niederdorf als 'Village Radieux.'" *Archithese* 3 (1972): 30–33.

Ganz, David, and Felix Thürlemann, eds. *Das Bild im Plural: Mehrteilige Bildformen zwischen Mittelalter und Gegenwart*. Berlin: Reimer, 2010.

Gargiani, Robert. *Rem Koolhaas/OMA: The Construction of Merveilles*. Translated by Stephen Piccolo. Lausanne: EPFL, 2008.

Geimer, Peter. *Theorien der Fotografie zur Einführung*. Hamburg: Junius, 2009.

Geiser, Reto. "Giedion in Between: A Study of Cultural Transfer and Transatlantic Exchange, 1938–1968." PhD diss., ETH Zurich, 2010.

Gemünden, Gerd, and Johannes von Moltke, eds. *Culture in the Anteroom: The Legacies of Siegfried Kracauer*. Ann Arbor: University of Michigan Press, 2012.

Georgiadis, Sokratis. Introduction to *Building in France, Building in Iron, Building in Ferroconcrete*, by Sigfried

Giedion, 85–100. Translated by J. Duncan Berry. Santa Monica: Getty Center for the History of Art and the Humanities, 1995.

Giedion, Sigfried. *Architektur und Gemeinschaft: Tagebuch einer Entwicklung.* Hamburg: Rowohlt, 1956.

———. *Befreites Wohnen.* Zurich: Orell Füssli, 1929.

———. *Building in France, Building in Iron, Building in Ferroconcrete.* Santa Monica: Getty Center for the History of Art and the Humanities, 1995.

———. *Space, Time and Architecture: The Growth of a New Tradition.* Cambridge, Mass.: Harvard University Press, 1941.

Golan, Romy. *Muralnomad: The Paradox of Wall Painting, Europe, 1927–1957.* New Haven: Yale University Press, 2009.

Gough, Maria. *The Artist as Producer: Russian Constructivism in Revolution.* Berkeley: University of California Press, 2005.

———. "Constructivism Disoriented: El Lissitzky's Dresden and Hannover *Demonstrationsräume.*" In *Situating El Lissitzky: Vitebsk, Berlin, Moscow,* edited by Nancy Perloff and Brian Reed, 76–125. Los Angeles: Getty Research Institute, 2003.

Grasskamp, Walter. "Die Malbarkeit der Stadt: Die Krise der Vedute im deutschen Expressionismus." In *Die Großstadt als "Text,"* edited by Manfred Smuda, 265–84. Munich: Fink, 1992.

Haag Bletter, Rosemarie. "Opaque Transparency." *Oppositions* 13 (1978): 121–26.

Hartoonian, Gevork, ed. *Walter Benjamin and Architecture.* London: Routledge, 2010.

Hausmann, Raoul. *Am Anfang war Dada.* Edited by Karl Riha and Günter Kämpf. 2nd ed. Gießen: Anabas, 1980.

———. "More on Group G." *Art Journal* 24 (Summer 1965): 350–52.

Hays, K. Michael, ed. *Architecture Theory since 1968.* Cambridge, Mass.: MIT Press, 1998.

———. "Critical Architecture: Between Culture and Form." *Perspecta* 21 (1984): 14–29.

———. *Modernism and the Posthumanist Subject: The Architecture of Hannes Meyer and Ludwig Hilberseimer.* Cambridge, Mass.: MIT Press, 1992.

———. "Photomontage and Its Audiences, Berlin, Circa 1922." *Harvard Architecture Review* 6 (1987): 18–31.

Heidegger, Martin. "Die Zeit des Weltbildes" (1938). In *Holzwege: Gesamtausgabe Band 5, 1. Abteilung,* 75–113. Frankfurt a. M.: Klostermann, 1977.

Hertweck, Florian, and Sébastien Marot, eds. *The City in the City: Berlin: A Green Archipelago.* Zurich: Lars Müller, 2013.

Hesse, Michael. "Moderne als Postmoderne: Philip Johnson's Glass House in New Canaan, 1949." *Werk, Bauten + Wohnen* 78, no. 9 (1991): 34–43.

Heyltjes, Karin, *Die Fotomontage und die Großstadt: Entwicklungsbedingungen des dadaistischen Fotomontageverfahrens am Beispiel der Großstadtmontagen der 1910/20er Jahre.* Saarbrücken: VDM Verlag, 2008.

Heynen, Hilde. *Architecture and Modernity: A Critique.* Cambridge, Mass.: MIT Press, 1999.

Hiepe, Richard, ed. *Die Fotomontage: Geschichte und Wesen einer Kunstform.* Ingolstadt: Kunstverein, 1969. Exhibition catalog. Kunstverein Ingolstadt.

Higgot, Andrew, and Timothy Wray, eds. *Camera Constructs: Photography, Architecture, and the Modern City.* Farnham, UK: Ashgate, 2012.

Hill, Jason. *Actions of Architecture: Architects and Creative Users.* London: Routledge, 2003.

Höch, Hannah. *Eine Lebenscollage.* Vol. 1.2, *1919–20.* Berlin: Argon, 1989.

———. *Eine Lebenscollage.* Vol. 2.1, *1921–45.* Berlin: Argon, 1995.

Hoffman, Dan. "The Receding Horizon of Mies: Work on the Cranbrook Architecture Studio." In *The Presence of Mies,* edited by Detlef Mertins, 99–117. New York: Princeton Architectural Press, 1994.

Hoffman, Katherine, ed. *Collage: Critical Views.* Ann Arbor: UMI Research Press, 1989.

Hofmann, Werner. *Die Moderne im Rückspiegel: Hauptwege der Kunstgeschichte.* Munich: Beck, 1998.

Holtfreter, Jürgen. *Politische Fotomontage.* Berlin: Elefanten Press Galerie, 1975.

Hsu, Frances. "The End of Modernism: Structuralism and Surrealism in the Work of Rem Koolhaas." PhD thesis, ETH, Zurich, 2003.

Huelsenbeck, Richard, ed. *Dada Almanach.* 1920. Reprint, Hamburg: Edition Nautilus, 1987.

Husserl, Edmund. *Thing and Space: Lectures of 1907.* Translated by Richard Rojcewicz. London: Kluwer, 2007.

Iser, Wolfgang. *The Act of Reading: A Theory of Aesthetic Response.* Baltimore: Johns Hopkins University Press, 1980.

Jameson, Fredric. *Postmodernism, or, The Cultural Logic of Late Capitalism.* Durham, N.C.: Duke University Press, 1991.

Jansen, Jürg, ed. *Architektur lehren: Bernhard Hoesli an der ETH Zürich.* Zurich: gta, 1989.

Jay, Martin. "Scopic Regimes of Modernity." In *Vision and Visuality,* edited by Hal Foster, 3–23. Seattle: Bay, 1988.

Joselit, David. "Notes on Surface: Toward a Genealogy of Flatness." *Art History* 23, no. 1 (2000): 19–34.

Jürgens-Kirchhoff, Annegret. *Technik und Tendenz der Montage in der bildenden Kunst des 20. Jahrhunderts. Ein Essay.* Lahn-Gießen: Anabas, 1978.

Kepes, György. "Notes on Expression and Communication in the Cityscape" (1957). *Daedalus* 90, no. 1 (1961): 147–65.

Khan-Magomedov, Selim O. *Nikolay Ladovsky, Heroes of Avant-Garde.* Translated by Alexei Voronin. Moscow: Sergey Gordeev, 2001.

———. *Pioneers of Soviet Architecture: The Search for New Solutions in the 1920s and 1930s.* London: Thames and Hudson, 1987.

Kittler, Friedrich. *Grammophon, Film, Typewriter.* Berlin: Brinkmann und Bose, 1986.

Kliemann, Helga. *Die Novembergruppe.* Berlin: Gebr. Mann, 1969.

Koolhaas, Rem. "Atlanta." In *Architectural Associations: The Idea of the City,* edited by Robin Middleton, 84–91. London: Architectural Association, 1996.

———. *Delirious New York: A Retroactive Manifesto for Manhattan.* New York: Monacelli, 1994.

———. "La deuxième chance de l'architecture moderne . . . Entretien avec Rem Koolhaas." *L'Architecture d'aujourd'hui* 238 (1985): 2–9.

———. "Why I Wrote Delirious New York and Other Textual Strategies." *Any* (May/June 1993): 42–43.

Koss, Juliet. *Modernism after Wagner.* Minneapolis: University of Minnesota Press, 2010.

Kracauer, Siegfried. *The Mass Ornament: Weimar Essays.* Edited by Thomas Y. Levin. Cambridge, Mass.: Harvard University Press, 1995.

Kramer, Thomas, ed. *New York auf Postkarten, 1880–1980. Die Sammlung*

Andreas Adam. Zurich: Scheidegger und Spiess, 2010.

Krauss, Rosalind. *The Originality of the Avant-Garde and Other Modernist Myths*. Cambridge, Mass.: MIT Press, 1985.

———. "Photography's Discursive Spaces: Landscape/View." *Art Journal* 42, no. 4 (1982): 311–19.

———. "Sculpture in the Expanded Field." In *The Originality of the Avant-Garde and Other Modernist Myths*, 276–90. Cambridge, Mass.: MIT Press, 1985.

Krausse, Joachim. "Architektonische Montage und die Genese einer Informationsarchitektur." *ARCH+* 41 (2008): 54–59.

Kuchanova, Natasha. "Osip Brik and the Politics of the Avant-Garde." *October* 134 (2010): 52–73.

Kwinter, Sanford. "Mies and Movement: Military Logistics and Molecular Regimes." In *The Presence of Mies*, edited by Detlef Mertins, 85–98. New York: Princeton Architectural Press, 1994.

Lambert, Phyllis, ed. *Mies in America*. New York: Abrams; Montreal: Canadian Centre for Architecture, 2001.

Lavin, Maud. *Cut with the Kitchen Knife: The Weimar Photomontages of Hannah Höch*. New Haven: Yale University Press, 1993.

Le Corbusier. *Entretien avec les étudiants des écoles d'architecture*. Paris: Denoël, 1943.

———. *Toward an Architecture*. Introduction by Jean-Louis Cohen. Los Angeles: Getty Research Institute, 2007.

———. *Vers une architecture*. Paris: Crès, 1923.

Leach, Andrew. "Manfredo Tafuri and the Age of Historical Representation." In *Walter Benjamin and Architecture*, ed. Gevork Hartoonian, 5–21. London: Routledge, 2010.

Lefebvre, Henri. *The Production of Space*. Translated by Donald Nicholson Smith. Oxford: Blackwell, 2009.

Lessing, Gotthold Ephraim. *Laokoon, oder, Über die Grenzen der Malerei und Poesie*. Stuttgart: Reclam, 1994.

Lévi-Strauss, Claude. *The Savage Mind*. Chicago: University of Chicago Press, 1966.

Levin, Thomas Y. "Iconology at the Movies: Panofsky's Film Theory." *Yale Journal of Criticism* 9, no. 1 (1996): 27–55.

Levine, Neil. *Modern Architecture: Representation and Reality*. New Haven: Yale University Press, 2009.

———. "The Significance of Facts: Mies's Collages up Close and Personal." *Assemblage* 37 (1998): 70–101.

Lissitzky, El. *1890–1941: Retrospektive*. Frankfurt a. M.: Propyläen, 1988. Exhibition catalog. Sprengel Museum Hannover.

———. *Life, Letters, Texts*. Introduction by Herbert Read. Edited by Sophie Lissitzky-Küppers. London: Thames and Hudson, 1980.

———. *Russland: Die Rekonstruktion der Architektur in der Sowjetunion*. Vienna: Anton Schroll, 1930.

Lissitzky, El, and Hans Arp. eds. *Die Kunstismen*. Baden: Lars Müller, 1990.

Llorens, Tomas. "Manfredo Tafuri: Neo-Avant-Garde and History." *Architectural Design* 51, no. 6/7 (1981): 83–95.

Lucan, Jacques. "L'invention du paysage architectural, ou la vision péripatéticienne de l'architecture." *Matières* 2 (1998): 21–31.

———. *OMA: Rem Koolhaas*. Zurich: Verlag für Architektur, 1991.

Lugon, Olivier. "Dynamic Paths of Thought: Exhibition Design, Photography and Circulation in the Work of Herbert Bayer." In *Cinema beyond Film: Media Epistemology in the Modern Era*, edited by François Albera and Maria Tortajada, 117–44. Amsterdam: Amsterdam University Press, 2010.

———. "Neues Sehen, neue Geschichte: László Moholy-Nagy, Sigfried Giedion und die Ausstellung Film und Foto." In *Sigfried Giedion und die Fotografie: Bildinszenierungen der Moderne*, edited by Werner Oechslin and Gregor Harbusch, 88–105. Zurich: gta, 2010.

Lukacher, Brian. *Joseph Gandy: An Architectural Visionary in Georgian England*. London: Thames and Hudson, 2006.

Lynn, Greg. *Folding in Architecture*. Chichester: Wiley-Academy, 2004.

Lyotard, Jean-François. *The Postmodern Condition: A Report on Knowledge*. Minneapolis: University of Minnesota Press, 1984.

Mahlow, Dietrich, ed. *Prinzip Collage: Ausstellung, Dokumentation*. Stuttgart: Institut für Auslandsbeziehungen, 1981.

Malevich, Kasimir. *The World as Non-Objectivity: Unpublished Writings, 1922–25*. Vol. 3, edited by Troels Andersen, translated by Xenia Glowacki-Prus

and Edmund T. Little. Copenhagen: Borgen, 1976.

Mallet-Stevens, Robert. "Le cinéma et les arts: L'architecture" (1925). In *Intelligence du cinématographe*, edited by Marcel L'Herbier, 288–90. Paris: Edition Coréa, 1946.

Mallgrave, Harry Francis, and Eleftherios Ikonomou, eds. *Emphathy, Form, and Space: Problems in German Aesthetics, 1873–1893*. Santa Monica: Getty Center for the History of Art and the Humanities, 1994.

Marjanović, Igor. "Alvin Boyarsky's Chicago." *AA Files* 60 (2010): 45–52.

Martin, Reinhold. "Atrocities, or, Curtain Wall as Mass Medium." *Perspecta* 32 (2001): 66–75.

Marx, Andreas, and Paul Weber. "Konventioneller Kontext der Moderne: Mies van der Rohes Haus Kempner 1921–23. Ausgangspunkt einer Neubewertung des Hochhauses Friedrichstraße." In *Berlin in Geschichte und Gegenwart: Jahrbuch des Landesarchivs Berlin 2003*, edited by Jürgen Wetzel, 65–107. Berlin: Gebr. Mann, 2003.

McBride, Patrizia. *The Chatter of the Visible: Montage and Narrative in Weimar Germany*. Ann Arbor: University of Michigan Press, 2016.

Mercier, Louis-Sébastien. *Pariser Nahaufnahmen. Tableau de Paris*. Selected, translated, and with an afterword by Wolfgang Tschöke. Frankfurt a. M.: Eichborn, 2000.

Merleau-Ponty, Maurice. *Das Auge und der Geist: Philosophische Essays*. Hamburg: Meiner, 2003.

Mertins, Detlef. "Architectures of Becoming: Mies van der Rohe and the Avant-Garde." In *Mies in Berlin*, edited by Terence Riley and Barry Bergdoll, 106–33. New York: Museum of Modern Art, 2001.

———, ed. *The Presence of Mies*. New York: Princeton Architectural Press, 1994.

———. "Transparencies Yet to Come: Sigfried Giedion and the Prehistory of Architectural Modernity." PhD diss., Princeton University, 1996.

Mertins, Detlef, and Michael W. Jennings, eds. *G: An Avant-Garde Journal of Art, Architecture, Design, and Film*. Translated by Steven Lindberg, with Margareta Ingrid Christian. Los Angeles: Getty Research Institute, 2010.

Mies van der Rohe, Ludwig. "Hochhaus Bahnhof Friedrichstraße." *Frühlicht* 1, no. 4 (1922): 122–24.

———. "Industrielles Bauen." *G* 3 (June 1924): 8–13.

———. "New Buildings for 194X." *Architectural Forum* 78 (May 1943): 84.

Mitchell, W.T.J. *Picture Theory: Essays on Verbal and Visual Representation.* Chicago: University of Chicago Press, 1994.

Möbius, Hanno. *Montage und Collage: Literatur, bildende Künste, Film, Fotografie, Musik, Theater bis 1933.* Munich: Wilhelm Fink, 2000.

Moholy-Nagy, László. *Malerei, Photographie, Film.* Bauhausbücher, vol. 8. Munich: Albert Langen, 1925.

———. "A New Instrument of Vision" (1932). *Telehor* 1, nos. 1–2 (1936): 34–36.

———. *Von Material zu Architektur.* 1929. Reprint, Berlin: Kupferberg, 1968.

Molderings, Herbert. "Paul Citroen: Maler, Fotograf und Fotomonteur." In *Die Moderne der Fotografie,* 337–52. Hamburg: Philo Fine Arts, 2008.

Mon, Franz, and Heinz Neidel, eds. *Prinzip Collage.* Neuwied: Luchterhand, 1968.

Moravánszky, Ákos, ed. *Architekturtheorie im 20. Jahrhundert: Eine kritische Anthologie.* Vienna: Springer, 2003.

Moravánszky, Ákos, and Albert Kirchengast, eds. *Experiments: Architecture between Sciences and the Arts.* Berlin: Jovis, 2011.

Motherwell, Robert, ed. *The Dada Painters and Poets: An Anthology.* New York: Wittenborn, 1951.

Münsterberg, Hugo. *Grundzüge der Psychotechnik.* Leipzig: Barth, 1914.

Nancy, Jean-Luc. "Die Kunst—Ein Fragment." In *Bildstörung: Gedanken zu einer Ethik der Wahrnehmung,* edited by Jean-Pierre Dubost, 170–84. Leipzig: Reclam, 1994.

Nerdinger, Winfried, ed. *Bauhaus-Moderne im Nationalsozialismus: Zwischen Anbiederung und Verfolgung.* Munich: Prestel, 1993.

Nerdinger, Winfried, and Florian Zimmermann, eds. *Die Architekturzeichnung. Vom barocken Idealplan zur Axonometrie. Zeichnungen aus der Architektursammlung der Technischen Universität München.* Munich: Prestel, 1986.

Neumann, Dietrich, ed. *Film Architecture: Set Designs from Metropolis to Blade Runner.* New York: Prestel, 1996.

———. "Mies van der Rohe's Patente zur Wandgestaltung und Drucktechnik von 1937–1950." In *Mies und das neue Wohnen: Räume, Möbel, Fotografie,* edited by Helmut Reuter and Birgit Schulte, 264–79. Ostfildern: Hatje Cantz, 2008.

Neumeyer, Fritz, ed. *Ludwig Mies van der Rohe: Hochhaus am Bahnhof Friedrichstraße.* Berlin: Wasmuth, 1993.

———. *Mies van der Rohe: The Artless Word.* Translated by Mark Jarzombek. Cambridge, Mass.: MIT Press, 1991.

Norberg-Schulz, Christian. "Ein Gespräch mit Mies van der Rohe." *Baukunst und Werkform* 11, no. 11 (1958): 615–18.

Ockman, Joan. "The Road Not Taken: Alexander Dorner's Way beyond Art." In *Autonomy and Ideology: Positioning an Avant-Garde in America,* edited by Robert E. Somol, 82–118. New York: Monacelli, 1997.

Oechslin, Werner. "Vom Umgang mit Fragmenten—die Unzulänglichkeiten der Collage." *Daidalos* 16 (1985): 16–30.

Oechslin, Werner, and Gregor Harbusch, eds. *Sigfried Giedion und die Fotografie: Bildinszenierungen der Moderne.* Zurich: gta, 2010.

OMA, Rem Koolhaas, and Bruce Mau. *S,M,L,XL.* New York: Monacelli, 1995.

Ortega y Gasset, José. "Meditations on the Frame" (1943). *Perspecta* 26 (1990): 185–90.

Otto, Elizabeth. "A 'Schooling of the Senses': Post-Dada Visual Experiments in the Bauhaus Photomontages of László Moholy-Nagy and Marianne Brandt." *New German Critique* 36, no. 2 (2009): 107, 89–131.

———, ed. *Tempo, Tempo! Bauhaus-Fotomontagen von Marianne Brandt.* Berlin: Jovis, 2005. Exhibition catalog. Bauhaus-Archiv Berlin.

Owens, Craig. "The Allegorical Impulse: Toward a Theory of Postmodernism." *October* 12 (1980): 67–86.

———. "The Allegorical Impulse: Toward a Theory of Postmodernism, Part 2." *October* 13 (1980): 58–80.

Panofsky, Erwin. *Perspective as Symbolic Form.* Translated by Chris Wood. New York: Zone, 1991.

———. "Style and Medium in the Motion Pictures" (1934–47). In *Film Theory and Criticism: Introductory Readings,* 6th ed., edited by Leo Braudy and Marshall Cohen, 289–302. New York: Oxford University Press, 2004.

Papapetros, Spyros. "Malicious Houses: Animation, Animism, Animosity in German Architecture and Film—From Mies to Murnau." *Grey Room* 20 (2005): 6–37.

———. *On the Animation of the Inorganic: Art, Architecture, and the Extension of Life.* Chicago: Chicago University Press, 2012.

Payne, Alina. "Architecture: Image, Icon, or *Kunst der Zerstreuung*?" In *Das Auge der Architektur,* ed. Andreas Beyer, Matteo Burioni, and Johannes Grave, 55–91. Munich: Fink, 2011.

Pehnt, Wolfgang. *Hans Hollein: Museum in Mönchengladbach. Architektur als Collage.* Frankfurt a. M.: Fischer, 1989.

Penz, François, and Maureen Thomas, eds. *Cinema and Architecture: Méliès, Mallet-Stevens, Multimedia.* London: British Film Institute, 1997.

Pérez-Gómez, Alberto, and Louise Pelletier. "Architectural Representation beyond Perspectivism." *Perspecta* 27 (1992): 20–39.

———. *Architectural Representation and the Perspective Hinge.* Cambridge, Mass.: MIT Press 1997.

Perloff, Nancy, and Brian Reed, eds. *Situating El Lissitzky: Vitebsk, Berlin, Moscow.* Los Angeles: Getty Research Institute, 2003.

Petit, Emmanuel J. "The Other Architectural [sic] Manifesto: Caricature" (thesis). *Wissenschaftliche Zeitschrift der Bauhaus-Universität Weimar* 49, no. 4 (2003): 6–13.

Phillips, Christopher, ed. *Photography in the Modern Era: European Documents and Critical Writings, 1913–1940.* New York: Aperture, 1989.

Pommer, Richard, David Spaeth, and Kevin Harrington. *In the Shadow of Mies: Ludwig Hilberseimer—Architect, Educator, and Urban Planner.* Chicago: Art Institute of Chicago, 1988.

Pudovkin, Vsevold I. *Film Technique and Film Acting.* Translated and edited by Ivor Montagu. London: Vision, 1958.

Quetglas, José. "Loss of Synthesis: Mies's Pavilion" (1980). In *Architecture Theory since 1968,* edited by K. Michael Hays, 384–91. Cambridge, Mass.: MIT Press, 1998.

Reichlin, Bruno. "'Une petite maison' on Lake Leman: The Perret-Le Corbusier Controversy." *Lotus* 60 (1988): 59–83.

Reuter, Helmut, and Birgit Schulte, eds. *Mies und das neue Wohnen: Räume, Möbel, Fotografie.* Ostfildern: Hatje Cantz, 2008.

Rheinberger, Hans-Jörg. "Gaston Bachelard und der Begriff der "Phänomenotechnik." In *" . . . immer im Forschen bleiben." Rüdiger vom Bruch*

zum 60. Geburtstag, edited by Marc Schalenberg and Peter T. Walther, 297–310. Stuttgart: Steiner, 2004.

Richards, Thomas. *The Commodity Culture of Victorian England: Advertising and Spectacle, 1851–1914.* Stanford: Stanford University Press, 1990.

Richter, Hans. *Dada: Art and Anti-Art.* London: Thames and Hudson, 1965.

———. *Köpfe und Hinterköpfe.* Zurich: Arche, 1967.

———. *Malerei und Film.* Edited by Hilmar Hoffmann and Walter Schobert. Frankfurt a. M.: Deutsches Filmmuseum, 1989.

Rifkind, David. *The Battle for Modernism: Quadrante and the Politization of Architectural Discourse in Fascist Italy.* Venice: Marsilio, 2012.

Riley, Terence, and Barry Bergdoll, eds. *Mies in Berlin.* New York: Museum of Modern Art, 2001. Exhibition catalog.

Robbers, Lutz. "Modern Architecture in the Age of Cinema: Mies van der Rohe and the Moving Image." PhD diss., Princeton University, 2012.

Roh, Franz. *Foto-Auge/Oiel et Photo/Photo-Eye.* Stuttgart: Wedekind, 1929.

Romba, Katherine. *Iron Construction and Cultural Discourse: German Architectural Theory 1890–1918.* Saarbrücken: VDM Verlag Dr. Müller, 2008.

Rossi, Aldo. *The Architecture of the City.* Translated by Diane Ghirardo and Joan Ockman. Cambridge, Mass.: MIT Press, 1982.

Rowe, Colin, and Fred Koetter. *Collage City.* Cambridge, Mass.: MIT Press, 1978.

Rowe, Colin, and Robert Slutzky. "Transparency: Literal and Phenomenal." *Perspecta* 8 (1963): 45–54.

———. "Transparency: Literal and Phenomenal, Part 2." *Perspecta* 13, no. 14 (1971): 287–301.

Sachs-Hombach, Klaus, ed. *Bildwissenschaft. Disziplinen, Themen, Methoden.* Frankfurt a. M.: Suhrkamp, 2005.

Sachsse, Rolf. *Bild und Bau: Zur Nutzung technischer Medien beim Entwerfen von Architektur.* Braunschweig: Vieweg, 1997.

———. "Mies und die Fotografen II: Medium und Moderne als Enigma." In *Mies und das neue Wohnen: Räume, Möbel, Fotografie,* edited by Helmut Reuter and Birgit Schulte, 254–63. Ostfildern: Hatje Cantz, 2008.

———. "Mies montiert." *Arch+* 35 (2005): 58–61.

Schaffner, Ingrid, and Matthias Winzen, eds. *Deep Storage: Arsenale der Erinnerung. Sammeln, Speichern, Archivieren in der Kunst.* Munich: Prestel, 1997.

Schievelbusch, Wolfgang. *Die Geschichte der Eisenbahnreise.* Frankfurt a. M.: Fischer, 2000.

Schippers, Kurt. *Holland Dada.* Amsterdam: Querigo, 1974.

Schmarsow, August. *Barock und Rokoko: Das malerische in der Architektur. Eine kritische Auseinandersetzung.* Berlin: Mann, 2001.

———. *Das Wesen der architektonischen Schöpfung.* Inaugural lecture held in the auditorium of the Royal University Leipzig on November 8, 1893. Leipzig: Hiersemann, 1894. http://www.cloud-cuckoo.net/openarchive/Autoren/Schmarsow/Schmarsow1894.htm.

———. "Ueber den Werth der Dimensionen im menschlichen Raumgebilde." In *Berichte über die Verhandlungen der Königlich-Sächsischen Gesellschaft der Wissenschaften zu Leipzig, Philologisch-Historische Classe,* vol. 1, 44–61. Leipzig: S. Hirzel, 1896.

Schmid, Max, ed. *Hundert Entwürfe aus dem Wettbewerb für das Bismarck-National-Denkmal auf der Elisenhöhe bei Bingerbrück-Bingen.* Düsseldorf: Düsseldorfer Verlags-Anstalt, 1911.

Schnapp, Jeffrey T. *Anno X. La Mostra della Rivoluzione fascista del 1932: Genesi—sviluppo—contesto culturale-storico—ricezione.* Rome: Istituti Editoriali e Poligrafici Internazionali, 2003.

———. "Fascism's Museum in Motion." *Journal of Architectural Education* 45, no. 2 (1992): 87–97.

Schug, Alexander, and Hilmar Sack. *Moments of Consistency: Eine Geschichte der Werbung.* Edited by Stefan Hansen. Bielefeld: Transcript, 2004.

Schulze, Franz. *Mies van der Rohe: A Critical Biography.* Chicago: University of Chicago Press, 1985.

———, ed. *Mies van der Rohe: Critical Essays.* New York: Museum of Modern Art, 1989.

Schwarzer, Mitchell W. "The Emergence of Architectural Space: August Schmarsow's Theory of 'Raumgestaltung.'" *Assemblage* 15 (1991): 48–61.

Scolari, Massimo. *Oblique Drawing: A History of Anti-Perspective.* Cambridge, Mass.: MIT Press, 2012.

Scott, Felicity D. "An Army of Soldiers or a Meadow: The Seagram Building and the 'Art of Modern Architecture.'" *Journal of the Society of Architectural Historians* 70, no. 3 (2011): 330–53.

Scully, Vincent. *Modern Architecture.* New York: Braziller, 1965.

Seitz, William C., ed. *The Art of Assemblage.* Garden City: Doubleday, 1961.

Seixas Lopes, Diogo. "Cut-Ups: The Architecture of the City as a Collage." Unpublished manuscript.

Shatskikh, Alexandra. *Vitebsk: The Life of Art.* New Haven: Yale University Press, 2007.

Shields, Jennifer A. E. *Collage and Architecture.* New York: Routledge, 2014.

Siepmann, Eckhard. *Montage: John Heartfield. Vom Club Dadas zur Arbeiter-Illustrierten Zeitung.* Berlin: Elefanten Press Galerie, 1977.

Simmel, Georg. "The Metropolis and Mental Life" (1902). In *The Blackwell City Reader,* 2nd ed., edited by Gary Bridge and Sophie Watson, 103–10. Malden, Mass.: Blackwell, 2002.

Sobieszek, Robert A. "Composite Imagery and the Origins of Photomontage." *Artforum* 17, no. 1 (September 1978): 58–65; and *Artforum* 17, no. 2 (October 1978): 40–45.

Solà-Morales, Ignasi de. *Differences: Topographies of Contemporary Architecture.* Translated by Graham Thompson. Cambridge, Mass.: MIT Press, 1999.

Solomon R. Guggenheim Museum. *The Great Utopia: The Russian and Soviet Avant-Garde 1915–1932.* New York: Solomon R. Guggenheim Foundation, 1992. Exhibition catalog.

Somaini, Antonio. *Les possibilités du montage: Balázs, Benjamin, Eisenstein.* Paris: Mimesis, 2012.

Somol, Robert E., ed. *Autonomy and Ideology: Positioning an Avant-Garde in America.* New York: Monacelli, 1997.

Sorkin, Michael. *Analyzing Ambasz.* New York: Monacelli, 2004.

"Soviet Factography." Special issue, *October* 118 (2006).

Stauffer, Marie Theres. *Figurationen des Utopischen: Theoretische Projekte von Archizoom und Superstudio.* Munich: Deutscher Kunstverlag, 2008.

Stiegler, Bernd. *Montagen des Realen: Photographie als Reflexionsmedium und Kulturtechnik.* Munich: Fink, 2009.

Stierle, Karlheinz. "Baudelaire and the Tradition of the Tableau de Paris." *New Literary History* 11, no. 2 (1980): 345–61.

Stierli, Martino. "The Architect as Ghostwriter: Rem Koolhaas and Image-Based

Urbanism." In *Postmodernism: Style and Subversion, 1970–1990*, edited by Glenn Adamson and Jane Pavitt, 136–39. London: V&A, 2011.

———. "The Architect as Ghostwriter: On Rem Koolhaas's Delirious New York." *GAM. Graz Architecture Magazine* 11 (2015): 46–65.

———. *Las Vegas in the Rearview Mirror: The City in Theory, Photography, and Film*. Los Angeles: Getty Research Institute, 2013.

———. "Mies Montage." *AA Files* 61 (2010): 54–73.

———. "Mies Montage: Mies van der Rohe, Dada, Film und die Kunstgeschichte." *Zeitschrift für Kunstgeschichte* 74, no. 3 (2011): 401–36.

———. "Photomontage in/as Spatial Representation." *Photoresearcher* 18 (2012): 32–43.

Stoichita, Victor I. *Das selbstbewußte Bild: Vom Ursprung der Metamalerei*. Translated by Heinz Jatho. Munich: Fink, 1998.

Stommer, Rainer. "Germanisierung des Wolkenkratzers: Die Hochhausdebatte in Deutschland bis 1921." *Kritische Berichte* 10, no. 3 (1982): 36–53.

Stoppani, Teresa. "Delirium and Historical Project" (thesis). *Wissenschaftliche Zeitschrift der Bauhaus-Universität Weimar* 49, no. 4 (2003): 22–29.

Sudhalter, Adrian. "Mies van der Rohe and Photomontage in the 1920s." Seminar paper submitted to Jean-Louis Cohen, Institute of Fine Arts, New York University, December 1997.

Sunwoo, Irene. "Pedagogy's Progress: Alvin Boyarsky's International Institute of Design." *Grey Room* 34 (2009): 28–57.

Superstudio. "Deserti naturali e artificiali." *Casabella* 358 (1971): 18–22.

Tafuri, Manfredo. *Architecture and Utopia: Design and Capitalist Development*. Cambridge, Mass.: MIT Press, 1976.

———. "The Dialectics of the Avant-Garde." *Oppositions* 11 (1977): 73–80.

———. *Progetto e utopia: Architettura e sviluppo capitalistico*. Rome: Laterza, 1973.

———. *The Sphere and the Labyrinth: Avant-Gardes and Architecture from Piranesi to the 1970s*. Translated by Pellegrino d'Acierno and Robert Connolly. Cambridge, Mass.: MIT Press, 1990.

———. *Theories and History of Architecture*. New York: Harper and Row, 1979.

Talbot, Henry Fox. *The Pencil of Nature*. Facsimile of the original 1844–46 edition. New York: Capo, 1969.

Tegethoff, Wolf. "From Obscurity to Maturity: Mies van der Rohe's Breakthrough to Modernism." In *Mies van der Rohe: Critical Essays*, edited by Franz Schulze, 28–95. New York: Museum of Modern Art, 1989.

———. "On the Development of the Conception of Space in the Works of Mies van der Rohe." *Daidalos* 13 (1984): 114–23.

Teitelbaum, Matthew, ed. *Montage and Modern Life, 1919–1942*. Boston: Institute of Contemporary Art; Cambridge, Mass.: MIT Press, 1990.

Teyssot, Georges. *A Topology of Everyday Constellations*. Cambridge, Mass.: MIT Press, 2013.

Tronzo, William, ed. *The Fragment: An Incomplete History*. Los Angeles: Getty Research Institute, 2009.

Tschumi, Bernard. *Architecture: Concept and Notation*. Edited by Frédéric Migayrou. Paris: Centre Pompidou, 2014.

———. *The Manhattan Transcripts*. London: Academy, 1994.

Tupitsyn, Margarita. *El Lissitzky: Jenseits der Abstraktion. Fotografie, Design, Kooperation*. Hannover: Sprengel Museum, 1999.

Turvey, Malcolm. "Dada between Heaven and Hell: Abstraction and Universal Language in the Rhythm Films of Hans Richter." *October* 105 (2003): 13–36.

Ulmer, Gregory L. "The Object of Post-Criticism." In *The Anti-Aesthetic: Essays on Postmodern Culture*, edited and with an introduction by Hal Foster, 83–110. Port Townsend, Wash.: Bay, 1983.

Ungers, Oswald Mathias et al. "Cities within the City." *Lotus* 19 (1979): 82–97.

Van de Ven, Cornelis. *Space in Architecture: The Evolution of a New Idea in the Theory and History of Modern Movements*. Assen: Van Gorcum, 1987.

Van Eyck, Aldo. "A Superlative Gift." In *Texts by Lina Bo Bardi, Aldo Van Eyck*, n.p. São Paulo: Instituto Lina Bo e P.M. Bardi/Editorial Blau, 1997.

Van Rheeden, Herbert, Monique Feenstra, and Bettina Rijkschroeff, eds. *Paul Citroen: Künstler, Lehrer, Sammler*. Zwolle: Waanders Uitgevers, 1994.

Vertov, Dziga. *Kino-Eye: The Writings of Dziga Vertov*. Edited by Annette Michelson. Translated by Kevin O'Brien. Berkeley: University of California Press, 1984.

———. *Schriften zum Film*. Edited by Wolfgang Beilenhoff. Munich: Carl Hanser, 1973.

Vidler, Anthony. *The Architectural Uncanny: Essays in the Modern Unhomely*. Cambridge, Mass.: MIT Press, 1992.

———. *Warped Space: Art, Architecture, and Anxiety in Modern Culture*. Cambridge, Mass.: MIT Press, 2000.

Virilio, Paul. *The Aesthetics of Disappearance*. 1980. Reprint, translated by Philip Beitchman. Los Angeles: Semiotext[e], 2009.

Vöhringer, Margarethe. *Avantgarde und Psychotechnik: Wissenschaft, Kunst und Technik der Wahrnehmungsexperimente in der frühen Sowjetunion*. Göttingen: Wallstein, 2007.

Von Moos, Stanislaus. "'Modern Art Gets down to Business': Anmerkungen zu Alexander Dorner und Herbert Bayer." In *Herbert Bayer: Das künstlerische Werk 1918–1938*, 93–105. Berlin: Gebr. Mann, 1982. Exhibition catalog. Bauhaus-Archiv Berlin.

Wajcman, Gérard. *Fenêtre: Chroniques du regard et de l'intime*. Lagrasse: Verdier, 2004.

Weisstein, Ulrich. "Collage, Montage, and Related Terms: Their Literal and Figurative Use in and Application to Techniques and Forms in Various Arts." *Comparative Literature Studies* 15 (1978): 124–39.

Wescher, Herta. *Die Collage: Geschichte eines künstlerischen Ausdrucksmittels*. Cologne: DuMont Schauberg, 1968.

Wirth, Louis. "Urbanism as a Way of Life." *American Journal of Sociology* 44, no. 1 (1938): 1–24.

Wyss, Beat. "Merzbild Rossfett: Kunst im Zeitalter der technischen Reproduktion." In *Kurt Schwitters: Merz—ein Gesamtweltbild*, 72–84. Bern: Benteli, 2004. Exhibition catalog. Museum Tinguely, Basel.

Zervigón, Andrés Mario. *John Heartfield and the Agitated Image: Photography, Persuasion, and the Rise of Avant-Garde Photomontage*. Chicago: University of Chicago Press, 2012.

Zimmerman, Claire. *Photographic Architecture in the Twentieth Century*. Minneapolis: University of Minnesota Press, 2014.

Zimmermann, Florian, ed. *Der Schrei nach dem Turmhaus: Der Ideenwettbewerb am Bahnhof Friedrichstraße, Berlin 1921/22*. Berlin: Argon, 1988.

Žmegač, Viktor. "Montage/Collage." In
Moderne Literatur in Grundbegriffen,
edited by Dieter Borchmeyer and Viktor
Žmegač, 286–91. Tübingen: Niemeyer,
1994.

Zug, Beatrix. *Die Anthropologie des Rau-
mes in der Architekturtheorie des frühen
20 Jahrhunderts.* Berlin: Wasmuth, 2006.

Zumbusch, Cornelia. *Wissenschaft in
Bildern: Symbol und dialektisches Bild
in Aby Warburgs Mnemosyne-Atlas
und Walter Benjamins Passagen-Werk.*
Berlin: Akademie-Verlag, 2004.

Zurfluh, Lukas. "Der 'fließende Raum' des
Barcelona-Pavillons—Eine Metamor-
phose der Interpretation?" *Wolkenkuck-
ucksheim* 13, no. 1 (2009). http://www
.cloud-cuckoo.net/journal1996-2013/
inhalt/de/heft/ausgaben/108/Zurfluh/
zurfluh.php.

Index

Page numbers in *italics* indicate illustrations.

Illustration Credits

The photographers and the sources of visual material other than the owners indicated in the captions are as follows. Every effort has been made to supply complete and correct credits; if there are errors or omissions, please contact Yale University Press so that corrections can be made in any subsequent edition.

Courtesy of Emilio Ambasz: 6.9

© 2017 Artists Rights Society (ARS), New York / ADAGP, Paris: 4.19

© 2017 Artists Rights Society (ARS), New York / c/o Pictoright Amsterdam: 2.4, 2.9, 2.21

© 2017 Artists Rights Society (ARS), New York / VG Bild-Kunst, Bonn: 1.2, 2.5, 2.18, 2.19, 3.29, 3.30, 3.32, 4.1, 4.2, 4.3, 4.11, 4.14, 4.16, 4.18, 4.22, 4.24, 4.25, 4.28, 4.29, 4.31-.33, 4.34, 4.38

© 2017 Estate of László Moholy-Nagy /Artists Rights Society (ARS), New York: 2.8, 2.22, 2.36, 3.22, 5.10

© 2017 Frank Lloyd Wright Foundation. All Rights Reserved. Licensed by Artists Rights Society (ARS), New York: 5.9

© 2017 The Heartfield Community of Heirs / Artists Rights Society (ARS), New York / VG Bild-Kunst, Bonn: 1.6

Photo by author: 6.13

Courtesy of Bayerische Staatsbibliothek München/Bildarchiv: 4.30

Courtesy of the Alvin Boyarsky Archive: 6.15

Courtesy of René Clément-Bilinsky: 2.26, 2.28

Courtesy of Martin Conrath: 2.6, 2.7

© F.L.C. / ADAGP, Paris / Artists Rights Society (ARS), New York 2017: 5.5

Photo by Hedrich-Blessing: 4.18 (site photo)

Courtesy of Instituto Lina Bo e P.M. Bardi, São Paulo: 3.26

Courtesy of Rem Koolhaas/OMA: 6.1–6.7, 6.12, 6.13

© Paul & Peter Fritz AG, Zurich: 1.1, 3.21, 3.23–3.25, 5.13

Courtesy of Bernard Tschumi: 5.14–5.16

Courtesy of Madelon Vriesendorp: 6.11, 6.14